Art After Conceptual Art

edited by Alexander Alberro and Sabeth Buchmann

Generali Foundation Collection Series
edited by Sabine Breitwieser

The MIT Press
Cambridge, Massachusetts
London, England

Generali Foundation
Vienna, Austria

Art After Conceptual Art
edited by Alexander Alberro and Sabeth Buchmann

Generali Foundation Collection Series
edited by Sabine Breitwieser

for
Generali Foundation
Vienna, Austria
foundation@generali.at
http://foundation.generali.at
ISBN: 3-901107-50-9

Text edited by Gudrun Ratzinger
Copy edited by Lisa Rosenblatt
Produced by Julia Heine
Photo edited by Iris Ranzinger, Julia Seyr
Designed by Andreas Pawlik (AD), Stephan Pfeffer

Paper: Munken Premium Cream, Munken Pure
Typeface: Sabon, Neue Helvetica
Total Production: Generali Foundation
Printed and bound in Austria

Library of Congress Cataloging-in-Publication Data
Art After Conceptual Art / edited by Alexander Alberro and Sabeth Buchmann.
 p. cm
 Includes bibliographical references and index.
 ISBN-13: 978-0-262-51195-7 (pbk. : alk. paper)
 ISBN-10: 0-262-51195-9 (pbk. : alk. paper)
 1. Conceptual art. 2. Conceptual art—Influence.
 I. Alberro, Alexander. II. Buchmann, Sabeth.

N6494.C63A735 2006
709.04'075—dc22 2006044881

The MIT Press
Cambridge, Massachusetts
London, England

MIT Press books may be purchased at special quantity discounts
for business or sales promotional use.
For information, please email special_sales@mitpress.mit.edu.

Foreword

Since its creation in 1988, the Generali Foundation has presented innovative contemporary art in numerous exhibitions, and built a collection of important artistic positions. In contrast to public institutions, which are obliged to offer a broad overview of developments in the arts, the Foundation has been able to concentrate on very specific themes within the art of the last 40 years. The focus has been on the work of artists that strive to expand the means of their art, and who actively engage in exchanges with society on important questions of our times.

The mediation of contemporary art and the questions it raises, which are often experienced as highly complex, have been central to the Generali Foundation's mission from the beginning. This is why the Foundation has already produced and published more than 60 books, many of which have sustained in their relevance in the examination of contemporary art. I am very pleased that with this new publication series, themes of this institution are once again addressed in a comprehensive and scholarly way and made available to an interested readership.

Dietrich Karner
President, Generali Foundation

Sabine Breitwieser

Series Editor's Note

Specifically, an identification [of the contemporary corporation] with the Arts will do the following: a. Improve the image of your company by making your public more aware of what you are doing in the community. b. Assist in developing a more fully rounded personality for your corporation by adding a Cultural dimension. c. Provide a bold, unique and exiting element in the presentation of your products and services. d. Promote greater public acceptance of your corporation and its products and services by making yourself more attractive and visible in the marketplace.
Seth Siegelaub, 1967[1]

Conceptual practices are often discussed in reference to the aspect of a »dematerialization« of the art-object, and of a democratization of the art world that, it is hoped, will accompany it. Or this notion, introduced into the discussions on Conceptual art in the late 1960s by Lucy Lippard, is referenced in order to develop, from its critical scrutiny, alternative proposals as to what is in fact to be understood by it. Whether the means of Conceptual art are capable of »[affecting] the world any differently than, or even as much as, its less ephemeral counterparts« was disputed early on.[2] From a later vantage point, Benjamin Buchloh questioned such goals in general, stating that »Conceptual Art was distinguished, from its inception, by its acute and critical sense of discursive and institutional limitations, its self-imposed restrictions, its lack of totalizing vision, its critical devotion to the factual conditions of artistic production and reception without aspiring to overcome the mere facticity of these conditions …«[3]

Even considering that critics as well as artists have varying ideas about what the notion of »Conceptual art« comprises, it has become an accepted term for those positions that »understand the visual arts not merely as a synonym for physical objects but as a field of negotiation of the changed cultural significances of image, language, and representation.« For many this

1 Quoted in Alexander Alberro, *Conceptual Art and the Politics of Publicity* (Boston, MA/London: MIT Press, 2003), 14.

2 Lucy Lippard, »Postface« in *Six Years: The Dematerialization of the Art Object* (New York: Praeger, 1973), 264.

3 Benjamin H. D. Buchloh, »From the Aesthetic of Administration to Institutional Critique,« in *L'art conceptuel: Une perspective*, ed. Claude Gintz, exh. cat. (Paris: Musée d'Art Moderne de la Ville de Paris, 1989), 53.

field has become the »basis for a practice focused on actions and processes along the lines that conjoin the arts, the everyday, and politics.«[4]

In view of these considerations, collecting Conceptual art becomes a difficult endeavor; not because, as the notion of dematerialization might suggest, there are no objects on the art market, but because there is the danger that the critical impetus that is—despite the skepticism expressed by critics—inherent to many of these works gets lost in the process of their »institutionalization.« As is evident from the passage above, quoted from a brochure for potential buyers, Seth Siegelaub, the great advertising strategist of early North American Conceptual art, highlighted the compatibility of critical art with the marketing goals of private corporations already in 1967. Almost 40 years later, Siegelaub's statement is of interest insofar as it paints in garish colors the situation in which both private institutions of art, such as the Generali Foundation, and the artists continue to find themselves.

Funded by an insurance corporation, the Generali Foundation has built a collection of works that transcend the conventional boundaries of art. A large group of these works can be subsumed under the term »Conceptualism,« and a significant part of these in turn engages the institutional conditions of art or the economic realities of our society. Contrary to the opinion represented by Siegelaub, however, these works cannot simply be used for purposes of advertising by the organization that funds them. The reasons, of course, lie primarily in the works themselves, which resist such direct instrumentalization by virtue of their content and especially of their aesthetic structure; but also in the fact that exhibitions of »great« artists that move within conventional generic limits have been, and still are, much more suited to purposes of prestige advertising than the positions of Conceptualism, which are often seen as »cumbersome,« »hermetic,« or »too intellectual,« if audiences are familiar with them at all.

Of course, the current questions surrounding the collection and exhibition of works of art whose nearly intangible »tactics« are directed against both »the fetishization of art and its systems of production and distribution in late capitalist society«[5] are incumbent also upon the socially and politically committed and institution-critical artists who cooperate with the Generali Foundation.[6] A paradox situation arises in which the artists know that »the institution« acknowledges the dilemma they are in, and permits, even explicitly calls for, a critical reflection upon their involvement with and work for that institution. This brings us back to the point of departure of the present consideration, and to the question, frequently raised, to what degree a substantial critique of the economic, political, and social status quo is even possible under these conditions. The answer can be a positive one when the cultural field in which the Generali Foundation operates is understood as a system of individual actors that continue to sound out the margins of free play, of the spaces of action available to them. These processes of negotiation occur on widely different planes, between artists and the institution, but also between the

4 Sabeth Buchmann, »Conceptual Art«, in: *DuMonts Begriffslexikon zur zeitgenössischen Kunst*, ed. Hubertus Butin (Cologne: DuMont, 2002), 49.

5 Mari Carmen Ramírez, »Tactics for Thriving on Adversity: Conceptualism in Latin America, 1960–1980,« in *Vivências/Life Experience*, ed. Sabine Breitwieser (Vienna: Generali Foundation), 63.

6 See for example Andrea Fraser's *A project in two phases* (1994–1995) and Andrea Fraser, *Report* (Vienna: EA-Generali Foundation, 1995).

Generali Foundation and its benefactor or—as in the present case—between the editors of this volume, whose background is in the academy, and the art institution. Furthermore, one may argue—following, in fact, Seth Siegelaub's first point—that the creation of a public for critical positions by means of exhibitions or publications carries positive value in itself.

The thematic foci of the Generali Foundation Collection Series, in which the volume at hand is the first, correspond to the Foundation's general artistic orientation, as it is evident in the collection and—at least as importantly—in the exhibition and publication program. They include conceptual and performative aspects of art, crossovers to architecture and design, and artistic approaches that analyze and critically interrogate social parameters and the role of the media. This new publication series, for which we have created a special design, will be developed in close cooperation with scholars in art history and art criticism with the aim of academic investigation and broadly conceived contextualization of these topics. It explores those discourses that have been crucial for the formation of art practices central to the Generali Foundation Collection. Furthermore, it makes visible their social, historical, and theoretical contexts, and the relevant shifts and disruptions within them. Newly commissioned texts on individual thematic fields permit seeing aspects that have in the past gone underrepresented, and are brought together with important previously published essays. The anthology does not intend to engage directly with individual positions represented in the collection—that is to say, in the present case, with all works that fall into the category of »art after Conceptual art.« I would thus like to use this opportunity to thank all of the artists who have been cooperating with the Generali Foundation for years, and whose trust allows us to make the critical potential inherent in these artistic positions accessible to an interested public.

I would especially like to thank Alexander Alberro and Sabeth Buchmann for sharing their profound knowledge with us and for shaping this well-founded compilation. Further, I want to express my gratitude to the authors of the individual essays. Their highly informative contributions are an enormous enrichment, and I am especially delighted about the continuity of cooperation with several of the authors. Like all our publications, this present one was produced by a small, dedicated and competent team of the Generali Foundation; it has been a pleasure working with them. From the outset, Gudrun Ratzinger has overseen this project with me in its substance; Julia Heine has once more proven an accomplished publication manager.

Alexander Alberro

Introduction
The Way Out is the Way In

At the end of Henrik Olesen's »Pre Post: Speaking Backwards« that closes this volume, the artist states a paradox. He declares that »The way out [of Conceptual art] is the way in.« Like all of the other texts in this book, Olesen's forcefully affirms that art after Conceptual art continues to thrive, steadily changing and moving in new directions both methodologically and thematically. Indeed, the title of the anthology, an obvious riff on Joseph Kosuth's polemical 1969 treatise »Art After Philosophy,« is meant to suggest not only art practices and histories that follow the time of Conceptual art, but also those like Jarosław Kozłowski's (the subject of Luiza Nader's essay), Christopher D'Arcangelo's (taken up by Thomas Crow and Helmut Draxler in this volume), and Maria Eichhorn's (see Elizabeth Ferrell's contribution) that are (or were in the case of the late D'Arcangelo) *in search of* that consequential movement. Importantly, the pursuit of Conceptualism by art practices that follow it turns the established wisdom of what constituted this artistic tendency on its head: questions of theoretically rigorous and critical art versus performative and technological, let alone expressive and design-based formalist practices, for example, give way to Conceptual art because concepts are revealed as the base *below* the formal base. Interestingly, such perspectives do not dissolve the specificity of artworks into mere examples for a study of culture (and especially of visual culture, as Crow emphasizes in his essay). Rather, conceptual artworks and those that derive from them provide an understanding (gained only through close attention to the specificity of those works) of the manner by which culture becomes stratified, and hence offer privileged access to the potential and actuality of ambitious contemporary art. Olesen's text is thus one of several in *Art After Conceptual Art* that seek to provide counter histories to those currently in circulation.

The essays in this volume contribute to a new evaluation of Conceptual art and its legacies. We dispute claims, made as early as Rosalind Krauss's »Sense and Sensibility« (1973) and continuing in various forms in the present, that this art movement was merely a period style that has had its day. Instead, we suggest that, although in highly reconfigured forms, it thrives today more than ever before. Clearly, there is a danger of disproportion. Set against the fundamental problems addressed in the current debates about relationality and the claims that art induces new behaviors and new forms of social relationships, the legacies of a 1960s art movement could appear insignificant. Understood in this way, an investigation of art after Conceptual art

would trivialize the substantive problems of contemporary art. But the texts anthologized in the following pages pose questions in relation to Conceptual art in a different manner: what can the legacies of Conceptual art, as art practices and aesthetic and cultural problems, reveal about contemporary art's unprecedented open-ended position? It is not the emergence of new art movements, per se, we contend, that makes art after Conceptual art consequential. It is, rather, the powerful ways in which much of that art negotiates between, and reveals the interdependence of art and the broader cultural and institutional context that we believe is most important.

Conceptualism was pivotal in breaking art from the constraints of self-containment. That reframing of art was not due to representations of social structures, contradictions, or identities. Rather, it was the result of a greater aesthetic open-endedness that allowed art to intersect with an expanded range of social life. Indeed, the legacies of Conceptual art often counter the brazen abandonment of public sphere discourse in established politics by staging social and political issues within the context of art. Postconceptual manifestations of what has come to be called institutional critique have linked the specific places and practices devoted to the exhibition and distribution of art and the framing of the social and political community. It is as though the narrowing of the public sphere and the lack of political invention in recent decades have given the projects of critically minded artists working with the legacies of Conceptualism a new urgency and new possibilities. How far they might be able to contribute to the reconstruction of a political space instead of working as mere substitutes is an issue taken up by a number of authors in this volume.

When assembling this collection we were particularly interested in contributions by scholars, critics, and artists from different backgrounds and cultures. Four of the following essays are reprints of articles that have had an important impact on the field. Yet, the bulk of the volume comprises newly written texts representing novel theories and perspectives. Not surprisingly, there are significant incongruities among European-based writers' approaches to »Conceptual art,« and those discrepancies only increase when the approaches are compared to those by North and/or South American scholars. The anthology also makes strikingly clear that there are many histories and legacies of Conceptualism. This movement has had an enormous impact on art of the past forty years. As Isabelle Graw provocatively argues in her contribution to the volume, even practices as seemingly at odds with Conceptual art as neo-expressionist painting have negotiated the legacy of the former. It is therefore necessary to recognize from the outset the limits of this compilation, which, within the framework of presenting an analysis of art after Conceptual art, is necessarily incomplete. The reader will find here neither a detailed descriptive genealogy of all of the strands of Conceptualism, nor an exhaustive analysis of the work of artists who have mediated aspects of the movement. The critical position that Conceptual art holds in the field of contemporary art is indisputable; it is now time to investigate its most important legacies and how they have mediated and transformed the central premises that initially gave Conceptualism definition.

The reader will undoubtedly be struck by particular constellations, of theories, approaches, and artists, developed by the contributors to this book. Thus, for example, certain figures and artworks that may not have played a significant role in earlier histories of Conceptual art are now brought to the fore by a new generation of scholars and critics. Rather than artists such

as Sol LeWitt, Art & Language, or Joseph Kosuth, considerable attention is now paid to the sig-
nificance of Lygia Clark, Piero Manzoni, Mierle Laderman Ukeles, Mary Kelly, and others in the
formation of Conceptualism. Furthermore, it is remarkable how often the authors discuss the
same works by particular artists. For instance, Martha Rosler's *The Bowery in two inadequate
descriptive systems* (1974–75) appears at a key critical juncture in both Benjamin Buchloh's and
Thomas Crow's essays, with the former situating the photo-text within the aesthetic practices of
allegory, montage, and appropriation, and the latter as an example of Conceptualism's dogged
pursuit of »truth-telling.« Helen Molesworth, in her text, also reflects on Rosler's production,
in this case locating the subject matter of the artist's videotapes within the context of feminist
exposés of the invisibility of domestic labor in patriarchal societies. A considerable number of
the essays also take up the work of Michael Asher, especially the artist's *The Museum as Site:
Sixteen Projects* (1981), which is foregrounded by both Buchloh and Gregor Stemmrich. Dan
Graham's importance to art after Conceptualism is also plainly evident, as his early works for
magazine pages (*Homes for America*, 1966), his later forays into television (*Project for a Local
Cable TV*, 1971) and film (*Cinema, 1981)*, as well as his critical writing (»Art as Design,
Design as Art,« 1986), are considered by several authors.

In addition to these well-established names, all of whom are either first or second generation
conceptual artists, the third section of this collection centers on newcomers, younger artists who
work in the legacy of Conceptualism: Mathias Poledna, Dorit Margreiter, Simon Leung, Maria
Eichhorn, Henrik Olesen, and Little Warsaw (Bálint Havas and András Gálik). Interestingly,
these artists are based in Berlin and Los Angeles, and Little Warsaw works from Budapest, which
signals a notable shift away from the previous predominance of the cultural centers of New
York, Paris, and London on the Conceptual art movement. Our goal in compiling these essays
is to demonstrate the vitality of art after Conceptual art and to highlight new, currently active
directions and strategies. We also hope that the contributions to the volume will illuminate
dimensions of Conceptualism that had previously been occluded or under-acknowledged.

Along with exploring the vicissitudes of art after Conceptual art, the common denominator
of the diverse array of writings featured in this collection is that they locate and track artistic
practices that engage in a form of *institutional critique*. As the following texts reveal, critique
in the work of Conceptual art comes to mean different things. For some it indicates sustained
criticism from a specific viewpoint, with the critical consideration also functioning as an expla-
nation of what is being criticized. For others it signifies an investigation of an entity's internal
contradictions exposed by that entities own terms. For yet others it implies a procedure of
analysis whereby the given conditions of art are shown to be not natural facts but socially and
historically constituted, and thus changeable, realities. However, none of the authors treat the
legacy of Conceptual art and the critique of institutions as mutually exclusive. On the contrary,
their interdependence is nothing short of a central theme of this book. Whether institutions are
taken to be concrete entities (such as the Generali Foundation, which Sabeth Buchmann reveals
to be the focus of Poledna's 1998 *The making of* project), or more abstract but equally material
things (such as »unpaid and underpaid labor,« which Molesworth reveals to be the focus of
Judy Chicago's, Mary Kelly's, Martha Rosler's, and Mierle Ukeles's work of the 1970s), the
critique of institutions drives much of the art that is located as »after« Conceptual art.

Part I. After Conceptual Art

The first essay in the volume, Benjamin Buchloh's »Allegorical Procedures: Appropriation and Montage in Contemporary Art,« traces a history of Conceptual art as it emerges from modernist avant-garde practices. In particular, the author examines how the literary trope of allegory is translated into an aesthetic practice of appropriation and montage within the conceptual and postconceptual contexts. Significant for Buchloh in the early history of this reception are two artworks: Robert Rauschenberg's *Erased de Kooning Drawing* (1953) and Jasper Johns' *Flag* (1954), both examples of objects that function allegorically in the tradition of Marcel Duchamp. Buchloh, however, views Pop art's fusion of the spheres of high art and mass culture as a form of »liberal reconciliation« and »compromise« rather than dialectical critique. He insists that allegorical practice that adopts the historical avant-garde legacy of »mythifying in turn« was not actualized until the late 1960s with the conceptualist work of Michael Asher, Marcel Broodthaers, Daniel Buren, Hans Haacke, Lawrence Weiner, and others. These artists, he maintains, produced work that interrogated »the framework that determines the reading conventions of artistic signs« and expanded those investigations to »a critique of the institutional conventions of exhibition and display.«

Buchloh's essay is also concerned with the practice of postconceptual artists whose work emerged in direct opposition to the reconciliation of social contradictions by neo-expressionist painters in the 1970s. If the paintings of the neo-expressionists recentered art and artists, Buchloh shows how the work of postconceptualists, such as Dara Birnbaum, Barbara Kruger, Louise Lawler, Sherrie Levine, Martha Rosler, and Cindy Sherman, shifted the emphasis onto the viewer by strategically mobilizing practices of appropriation and montage to focus on »mass cultural discourses that condition and control the experience of everyday life.« The author explores the various ways in which the allegorical investigations of these artists continue the groundwork laid by their recent (1960s) and distant (1920s and 1930s) predecessors to, for instance, negate »the mythical singularity of the work of art and its indisputable status as a commodity« (Levine), change the administrative sobriety of Conceptual art with a »social dimension« (Rosler), and render transparent the manner in which »television conventions and their technological implementation« function as »the ultimate representational system in which ideology constitutes its subjects« (Birnbaum). Buchloh pessimistically concludes with the observation that the critical achievements of the new generation of conceptual artists will undoubtedly only be temporary, for inevitably institutional »acculturation will find new ways to accommodate their production.« And in part it is the pursuit of new strategies of cultural resistance and critique that might escape such assimilation that many of the texts included in this volume take up.

The anthology's second essay, Thomas Crow's »Unwritten Histories of Conceptual Art,« begins with the observation that although »consciousness of precedent has [today] become very nearly the condition and definition of major artistic ambition,« many art historians continue to display little interest in contemporary artistic practice. Crow is careful to emphasize that art history's blindness to new art is not an unfamiliar story. But he notes that recent calls by postmodernist scholars for the idea of a history of art to be set aside in favor of a »forward-looking 'history of images'« capable of attending to »the entire range of visual culture« uncannily echo

high modernism's »fetish of visuality.« Crow suggests that if postmodernist art historians would pay more attention to contemporary aesthetic practices, they might be better prepared to recognize that Conceptualism, in its challenge of modernist assumptions, transgressed beyond what could be contained within the category of the image. Furthermore, Crow is concerned that the pessimistic assertions of the failure of Conceptual art made by the movement's most formidable historians only serve to buttress »the apparent triumph of visuality.« For the mobilization of the critical dimension of Conceptualism to take place, he insists, it and its legacies must be shown to be »living and available,« accessible to lay audiences, and capable of referencing the world beyond the esoteric realm of the fine arts. According to Crow, the work of the Los Angeles-based artist Christopher Williams answers these concerns, powerfully revealing not only connections »between global consumption and global repression,« but also the utter bankruptcy of visual representations produced by the proliferation of mass culture.

Crow goes on to discuss in detail Williams's *Bouquet* (1991), which the artist dedicated to two conceptual artists, Bas Jan Ader and Christopher D'Arcangelo, whose work has remained relatively obscure due to the effectiveness of their pursuit of self-effacement. *Bouquet* directly references Ader's video *Primary Time* (1974), where the Dutch artist clad in black top and pants arranges flowers in a vase to successively arrive at red, yellow, and blue bouquets. Crow explains how the installation of Williams's piece, which the artist specified should be either hung on a temporary section of wall, or leaned against an existing wall, relates to the subversiveness of D'Arcangelo's art practice. For Crow, the complex investigations that Williams's postconceptual *Bouquet* prompts function to commemorate and pay tribute to the fierce reticence of the work of conceptual artists such as Ader and D'Arcangelo, who even historians of the movement had all but forgotten by the 1990s.

If Buchloh's essay sketches a linear history of Conceptual art and Crow's seeks to expand the field by summoning figures whose work has been occluded in that history and might, with the advent of visual studies, be altogether forgotten, Molesworth sets out to revise the history of ambitious art of the 1970s. As signaled by her title, »House Work and Art Work,« Molesworth's focus is on labor, generally, and more specifically on a theory of immaterial labor as it relates to the art of Judy Chicago, Mary Kelly, Mierle Laderman Ukeles, and Martha Rosler. Whereas Buchloh's essay downplayed the importance of feminist and gender theory when discussing the work of female artists of the 1970s, Molesworth considers this interpretative framework crucial. Nonetheless, she argues that »the bitter binary opposition between ... feminist work based in 'theory,' poststructuralism, or social constructionism, and work derived from the principles of 'essentialism,'« has functioned to blunt the complexity of this art and to stifle its interpretation. By contrast, Molesworth maintains that the conjunction »and« rather than the binary »either/or« is more productive in analyzing the work of these artists, and she sets out to investigate heretofore unacknowledged »moments of contestation and difference« as well as »moments of affinity and shared concerns« discernable in these artworks. As a point of entry, she turns to the writings of feminist philosopher Moira Gatens that theorize the process by which unacknowledged labor is naturalized in both the public and private spheres. »The problematic of public and private spheres,« Molesworth writes, is present in the art of both Chicago and Kelly, »but the essentialism/theory debate has occluded its importance, disallowing the debate to be framed in

terms of a political economy as well as a bodily or psychic one.« This leads her to consider the art of Chicago and Kelly within an expanded interpretive field, including art by Ukeles and Rosler that is explicitly concerned with interrogating »how 'ideologically appropriate subjects' are created, in part, through the naturalizing of unpaid and underpaid domestic [and maintenance] labor.« By undoing the essentialist/poststructuralist binary that has hitherto handicapped interpretations of the work of these artists, Molesworth is able to view this body of work through an entirely different lens, one that can adequately address the manner in which it engages with the most »advanced« artistic practices of the day and opens channels to »questions of value and institutionality that critique the conditions of everyday life, as well as art.« But insofar as these artists' investigations of art's own meaning, value, and institutionality—based, as these explorations were, on an understanding of the relations between private acts and public institutions, and on the reciprocity and mutual dependence of the categories of private and public—differ markedly from the work of artists such as Asher, Broodthaers, Haacke, and Buren, they significantly expand the established notion of institutional critique that is one of the most important developments of the conceptualist legacy.

The final essay in this section, Ricardo Basbaum's »Within the Organic Line and After,« represents a radical theoretical and paradigmatic break from the first three. Basbaum's point of departure is neither the European avant-garde nor the North American tradition. Rather, his study addresses the important work of Brazilian artist Lygia Clark. Basbaum contemplates the ramifications of Clark's development of the »organic line,« which he sees as functioning to establish »a continuity between artwork and real world, between art and life.« For Clark, Basbaum explains, the organic line is the means by which the autonomous artwork intersects with real space (and vice versa), and points to new ways out of the cul-de-sac of high modernism. The framework remains very much within the orbit of modernism, though now a very different model of modernism than the one that had become orthodox in the Northern hemisphere in the 1950s and 1960s. Clark's line is located *between* the spaces of art and life, rather than wholly crossing the threshold into art or life, or, even more dramatically, into the mythical space of metaphysical depth that Basbaum claims Clark's contemporary, Yves Klein, developed at around the same time. Yet the author notes that, although Clark and Klein (as well as, among others, Robert Rauschenberg, Jasper Johns, and Piero Manzoni) set out from different vantage points and arrived at disparate conclusions, they confronted similar problems concerning »emptiness, borders, and lines.« Basbaum sees Manzoni's work, in particular, with its dual striving for an »absolute *beyond* infinite purity« and a »preoccupation with the body in all its proper immanent limits,« as grappling with many of the same issues that concerned Clark. Manzoni's conceptual operation, Basbaum maintains, »renews the comprehension of the surface, taken as a 'vehicle,' and the line as 'membrane,'« to highlight the permeable condition of the subject.

Basbaum notes that Conceptual art is usually considered to be a movement in which artists strategically decided to emphasize the discursive over the visual component of their practices in the process of dematerializing art. But he objects to this binary of visible and enunciative matters, and turns to Michel Foucault's »théorie des énoncés« developed in *Ceci n'est pas une pipe* (1968) to formulate a relationship between discourse and visuality that is free of hierarchy. What he finds most productive about Foucault's theory is the manner in which it posits an

»in-between space« between words and images, discursive and visible dimensions, while not reducing either into the other's terms. This leads Basbaum to argue that conceptual artists were not so much in pursuit of the dematerialization of the art object as of the »borderline«—«the hotspot where processes become productive«—between images and words, art and life. That hotspot, he argues, was what Clark's organic line introduced, as it progressively gained thickness and involved more and more spaces, issues, elements, and concepts. The organic line becomes a »membrane,« an active and autonomous structure, functioning as the region of contact between neighboring territories of various kinds. Thus, Basbaum offers a fresh new interpretation of Conceptual art that urges the reader to reconsider this art movement's relationship to modern art as a whole, and to the dynamic connection between »discourse« and »visuality« that has concerned modernism for quite some time.

Part II. Dismantling Binaries

The second section of the volume comprises essays that further problematize and expand conventional understandings of Conceptual art. Luiza Nader's »Language, Reality, Irony: The Art Books of Jarosław Kozłowski,« places the bookworks produced by the Polish artist in the 1970s firmly within the legacy of Conceptualism. Although much has been written on North American and Western European Conceptual art, relatively little attention has thus far been focused on parallel practices in Central and Eastern Europe. Nader's essay provides an important correction to this Western bias by demonstrating the highly sophisticated conceptually-based work in Poland, and the importance of that work within its national context. More specifically, she shows how Kozłowski mobilized Conceptualism to oppose official state power that sought control over all forms of what Andrzej Turowski has termed »ideosis,« or »individual choice.« Freedom of choice within the state-sanctioned art world consisted of the options of realism and abstraction in painting and other traditional artistic media. By opting instead to produce philo-sophically based bookworks, Kozłowski was able not only to escape the stifling binary of realist versus abstract art, but also to direct the beholder/recipient toward modes of aesthetic experi-ence that were alien to the fine arts in postwar Poland. Nader suggests that the novel modes of production, exhibition, and reception spearheaded by Kozłowski's conceptualist bookworks supplied these objects with metaphors of resistance against the governing regime.

Isabelle Graw, in »Conceptual Expression,« provocatively argues for a re-examination of both Conceptual art and neo-expressionism. These two practices have traditionally been viewed by critics and historians as completely antithetical. Whereas Conceptual art is lauded as a con-scientious aesthetic practice that avers the decadence of the art market, neo-expressionism is often disparagingly dismissed as a pure market phenomenon that advances spurious myths of subjectivity rendered in form. Graw, however, rejects this binary and sets out to demonstrate that »expression can be conceptualized in seemingly expressive painterly gestures without per-mitting conclusions as to any authentic emotional state, just as works resulting from thorough conceptual planning can exhibit a sort of 'residual expression.'« Conceptual art and neo-expres-sionism, she maintains, are neither as pure and unadulterated as has hitherto been claimed nor irreconcilable opponents.

Graw then boldly dismantles the traditional front between conceptual and expressive pictorial practices by recalling that conceptual painting has existed at least since Andy Warhol's *Do It Yourself* paintings of the early 1960s. The legacy of this practice, according to Graw, includes not only the paintings of Jörg Immendorf, David Salle, and Martin Kippenberger, but even those of Julian Schnabel, who gave central importance to the frames of his compositions and thereby cast doubt upon the status and value of painting. »Could not the potential of certain painterly approaches,« Graw asks, »lie precisely in the fact that they accepted the market as an objective institutional power and defined their relationship to it, instead of falling into the naïve belief that one could elude it?« Yet, Graw differentiates between neo-expressionist painters who produced gestures that wholeheartedly conformed to the market, and those, like Kippenberger, Albert Oehlen, and Jutta Koether, who she contends reflected greatly on the market, attempting to hamper its grasp by elevating an »ostentatious lack of complexity« to a principle. But it is the manner in which the best of the neo-expressionist artists problematized the self and subjectivity as a whole that Graw wants to reconsider. Unlike conceptual artists, who adopted predetermined schemas in order to ensure that subjectivity and personal expression would play virtually no role in artistic production, artists such as Kippenberger mobilized exaggerated signs for expressivity and immediacy with full knowledge of their status *as* signs. As such, expression in their work no longer refers to something originary or authentic, but instead, is exhibited as the effect of a specific procedure that creates »the impression of immediacy in order to demonstrate the fact that it is mediate.« From Graw's perspective, rather than attest to authentic emotions, the effect of neo-expressionism's conceptualization of immediacy is to address »the radical insubstantiality of being.«

In »Heterotopias of the Cinematographic: Institutional Critique and Cinema in the Art of Michael Asher and Dan Graham,« Gregor Stemmrich brings together art and cinema using the lynchpin of institutional critique. He observes that recently there has been an explosion of artworks and exhibitions that consider cinema and locates this cinematic turn within the legacy of Conceptual art. According to Stemmrich, »references to cinema in art have become ubiquitous« since the 1970s and 1980s, when artists such as Cindy Sherman and Jeff Wall took up Conceptualism's photojournalistic dimension and directed it toward visual worlds that Conceptualism had initially excluded. The author then turns to the practice of institutional critique, which he argues was initially developed to break open the institutional framework of the gallery and the museum structurally, under its own functional conditions in order to explore the hidden underpinnings of »the experience of art.« One of the consequences of this practice, which Stemmrich maintains »could only be achieved effectively if the broader cultural context was, at the same time, included in the analysis,« was a foray by artists into the field of mass media: first print media (in the 1960s) and television (in the 1970s), and then cinema (in the 1980s).

Stemmrich's investigation leads to a series of projects Dan Graham and Michael Asher produced in the 1970s and early 1980s in dialogue with one another. He explores the manner in which both of these artists critically investigated the artistic potential of cable television in the 1970s, and then turned in the 1980s to cinema as the institution within which to perform their critiques. Stemmrich contrasts the art practices of Asher and Graham, showing that whereas the former remained focused on art institutions in order to expose connections to a broader cultural,

social, and historical context, the latter developed proposals that from their inception transcend-
ed the realm of art. Interestingly, the author focuses on the same Asher piece, *The Museum as
Site* (1981), discussed by Buchloh in this volume, but arrives at very different conclusions. For
Stemmrich, the most important aspect of this project by Asher is the dialogue it establishes with
cinema, revealing »the way in which art and cinema participate in each other as institutions.«
Stemmrich then turns to Graham's *Cinema* (1981), which he argues is »designed to translate
a psychological structure that locates in an metapsychological film theory unconscious 'private'
sphere into the architecture of cinema itself,« and connects it to Michel Foucault's concept of
»heterotopias«: places that are at once autonomous and heteronymous, isolated and intercon-
nected. According to Stemmrich, both Graham and Asher, each in his own way, examine the
systems of opening and closing that are normal to institutions such as the museum and the cine-
ma in order to exceed these institutions following their own premises. This leads him to con-
clude that Graham's and Asher's interventions, insofar as they transfer different heterotopias
that normally seem incompatible into an immediate and inseparable context, open up the space
between art and cinema, inside and outside, for critical awareness. Indeed, in the end, it is once
again the employment of an »and«—the same conjunction effectively mobilized by Molesworth
to dismantle the binary opposition between feminist art based in poststructuralism and work
derived from the principles of essentialism—that Stemmrich posits as the most fruitful hermeneu-
tical tool with which to grasp the critical function of the projects by Asher and Graham that are
the central focus of his study. For the author, these projects are effective inasmuch as they are
the experience of that *and*. It grounds the work of the artists to the extent that it connects that
work to the broader cultural and institutional context. According to Stemmrich, matters would
be much easier if we could merely say that the esotericism of Asher's and Graham's work with
television and cinema must be subtracted from any form of institutionalization, or that the
alleged effectiveness of their practice disguises its dependence on the institution of art. But
Stemmrich clarifies that this is not at all the case: Asher's and Graham's works reveal the same
knot binding together institutional critique and the institution of art, avant-garde art and instru-
mentalizing culture.

The final essay in this section, Helmut Draxler's »Letting Loos(e): Institutional Critique and
Design,« also seeks to do away with an oft-encountered binary, in this case of art versus design,
that hierarchically structures culture. Similar to the manner in which Graw problematizes the
familiar opposition between conception and expression, Draxler proposes that the divide between
the categories of art and design is neither as large nor as impermeable as critics and scholars
have hitherto presumed. Moreover, according to the author, the myth that there is an inviolable
schism between the two practices is inherently conservative and highly limiting. He takes issue
with critics and scholars who, caught up in the old modernist oppositions, fail to recognize that
artists have long sought to explore the space between art and design—an endeavor that has only
increased since the advent of Conceptual art in the 1960s.

Draxler's starting point is the hypothesis advanced by Hal Foster in *Design and Crime*
(2002) that design practices have increasingly infiltrated and contaminated everyday life. Draxler
takes issue with this assumption, countering that it is fundamentally reactionary, and »an
expression of a totalizing approach.« In response, he calls for a mode of thinking that does not

maintain a rigid division between art and design, and instead, contemplates where the common ground might lie, what these two categories might learn from one another, and how the historical division between them came about in the first place. Draxler points out that the categorical division between art and design articulated by Foster and others today, in fact, only goes back as far as the 1950s. By contrast, a number of progressive movements in the early twentieth century, including Bauhaus design, Soviet Productivism and elements of Surrealism, insisted on permeable borders between art and design. According to Draxler, what finally undermined design's political function was the embrace of the discipline by the new post-Fordist service economies.

Draxler insists that the influence of design on Conceptual art is much greater than has been conventionally maintained. Conceptual artists' rejection of formalism, he argues, led them to seek out areas forbidden by modernism, such as design, in their search for new tactics and forms of presentation. Thus, he sees points of reference to design in conceptualist works as diverse as On Kawara's postcards, John Knight's journal pieces, Daniel Buren's stripes, Hans Haacke's data sheets and charts, Michael Asher's sculptural interventions, and Marcel Broodthaers's use of typography. Indeed, Draxler maintains that it is not possible to fully grasp the operation of institutional critique, once again presented as one of the strongest legacies of Conceptual art, without understanding its connection to design. The various facets of a working relationship within and with the institution of art that design provided artists in the 1960s and 1970s, have subsequently been reinterpreted productively by those who, for example, make works that consist entirely of invitations and announcements (e.g., D'Arcangelo), or design small gifts for the visitors to an exhibition (e.g., Lawler), or consider exhibition and catalogue designs as original artistic contributions (e.g., Knight). These and other similar gestures, especially when they maintain a tension between the institutional logic and the artistic intervention, allow the ambitious work of art to be seen not as an autonomous whole, but rather, as the interface where discourses and practices, institutional and design initiatives, meet. There is nothing within the hybrid of conceptual design that necessarily leads to a post-Fordist economic logic, Draxler maintains in a manner that resonates strongly with Graw's argument for the dismantling of the rigid binary between conception and expression. Such interfaces between disciplines and media, he concludes, should be seen as spaces within which »freedoms« can be found and critique practiced.

Part III. Post-, Neo-, and New Genre Conceptual Art

The anthology's third section is comprised of texts that explore the legacy of Conceptual art in the present. Edit András's »Transgressing Boundaries in New Genre Conceptual Art,« complements the essays of Basbaum and Nader in presenting a view of Conceptual art that geopolitically extends beyond the Western European and North American context. András argues that many strategies developed by conceptual artists in the West to resist the increasing commodification of art were irrelevant to artists working under socialist conditions. Also absent from Eastern European Conceptual art was the critique of modernism engaged in by its Western counterpart. Similar to Nader, who explains that modernism provided Polish conceptual artists an alternative to state-sanctioned culture, András observes that Hungarian conceptual artists of the countercultural underground also remained deeply embedded in modernism, and as such,

did not expand their critical scope to encompass questions of identity, representation, and insti-
tutional critique as did their counterparts in the West. Rather, the focus of Hungarian (as with
most Eastern Bloc) conceptual artists was on a critique of the official culture of the socialist
regime. The state, for its part, did not consider these artists to be a serious threat and therefore
put up a façade of openness and liberality with respect to their cultural gestures.

But, as András shows, with the collapse of the Soviet satellite system in 1989, everything
changed in Hungary. First, there was a rush to canonize the former oppositional artists, primarily
figures working in a conceptualist vein during the previous cultural administration. These artists
in turn became the new art establishment. At the same time, the dramatic growth of the art mar-
ket commodified even the most immaterial works of the now-glorified conceptualist generation.
And with the euphoria prompted by entry into the European Union and the eagerness to bury
the history of the preceding generation, the limited scope of conceptual practice in Hungary dur-
ing the socialist era and the implications of its failure to expand beyond the modernist mindset
were not deemed worthy of investigation.

This, then, is the context in which neo-Conceptualism, what András calls »new genre
Conceptual art,« in Hungary has operated in the past decade-and-a-half. The author focuses in
particular on two recent controversial projects by the Budapest-based artist duo, Little Warsaw,
and the related local reactions. By taking up critical legacies of Conceptualism that even opposi-
tional artists in the Eastern European context during the Socialist era had kept clear of, Little
Warsaw at once exposed the limits of the work and practice of conceptual artists working in
Hungary in the 1970s and 1980s, and revealed the hypocrisy of these now state-sanctioned
artists, who have also become the darlings of the new local art market. Thus, András shows how
Little Warsaw makes a practice of digging up the wounds and scars of the past that have never
properly healed in order to pose questions that many in Hungary and eastern Europe would
rather forget. These include not only, who has the right to excavate the past, to break apart
and examine the structures of interdependency that existed in the socialist era, but also, who
is entitled to assess and recontextualize practices and ideas of the past into the present?

Sabeth Buchmann's »Under the Sign of Labor« examines the exhibition, *The making of*,
organized by the artist Mathias Poledna and held at the Generali Foundation in Vienna in 1998.
Buchmann proposes that the manner in which this exhibition configures issues of labor within
the context of art provides a new way to understand the relationship between the 1960s notion
of artistic dematerialization and transformations in the structure of labor in society. In particular,
she posits Maurizio Lazzarato's concept of »immaterial labor,« defined as the activity that pro-
duces the informational and cultural content of the commodity, capable of revealing the manner
in which the logic of dematerialization corresponded to the reconfiguration of labor relations
in the industrial core of society toward a new service economy. As such, Buchmann's argument
dovetails neatly with Molesworth's presented earlier in this volume, for both adopt a theory
of immaterial labor as a point of departure in order to overcome aporias in conventional
accounts of Conceptual art.

Poledna's exhibition, which took the form of a collaborative project with several other
artists (including Simon Leung, Nils Norman, and Dorit Margreiter), actively questioned the
legitimating role of the art institution, in general, and that of the Generali Foundation, in partic-

ular. Buchmann explores the various ways in which *The making of* revises »techniques of site specificity, identity, institutional critique, post-production, and cultural studies research,« and argues that the exhibition as a whole underscored the labor (»at the intersection with the material conditions of public labor«) of theoretical and methodological reflection on art. From her point of view, although the exhibition's direct reference to previous projects by Michael Asher and Daniel Buren positioned it in the legacy of first generation Conceptual art, the ability of the younger artists to develop the critical and dynamic dimension of Conceptualism in new ways attests to the movement's continued relevance in the present.

Elizabeth Ferrell's essay, »The Lack of Interest in Maria Eichhorn's Work,« also addresses the manner in which contemporary conceptual practices interrogate economic issues. Ferrell focuses on several recent projects by the Berlin-based artist Maria Eichhorn that short-circuit and in fact reveal the speculative nature of art. She traces the ways in which Eichhorn's working methods mediate early Conceptual art, and the importance in particular of the »Artist's Reserved Rights Transfer and Sale Agreement,« drafted by the Conceptual art impresario Seth Siegelaub together with the lawyer Robert Projansky in the early 1970s. Ferrell takes issue with art historians, who maintain that conceptual artists capitulated to the forces of capitalism, as much as she does with critics, who see the future of Conceptual art in relational and project based work, and convincingly argues that Eichhorn's engagement with the structures that govern the material conditions of art provides an alternative to these models.

The volume ends with a conceptual work by Henrik Olesen, »Pre Post: Speaking Backwards,« designed specifically for this publication. In a manner that recalls Walter Benjamin's reading of Paul Klee's *Angelus Novus*, Olesen reflects on what he deems to be the catastrophic past of Conceptualism's history that is being propelled backwards into an uncertain future. Olesen's text »posts« a series of informational pieces, some referencing historical facts, such as, the mid-nineteenth century erection of public urinals in London, others theoretical observations by philosophers, such as, Gilles Deleuze and Felix Guattari, and yet others, artworks and art historical details. These posts create a montage that culminates in an alternative history of Conceptualism. In particular, the artist draws attention to the troubling persistence of critics and scholars of Conceptual art in framing the movement from a heterosexual perspective. This has meant not only the marginalization of the impact of artists such as John Cage on the movement, but also the necessary blindness to the »conceptual and critical cultural production« of figures such as Jack Smith who explicitly thematized homosexual imagery. As Olesen observes, »The relentless chronological non-existence of homosexual sites and images in the canonized history of visual culture suggests that no adequate language existed to either repress or promote a homosexual imagery outside its own culturally ghettoized site.« By cross-cutting between history presented through facts and documents and aesthetic practices that locate a gay sensibility, Olesen's piece produces new ways of reading texts. Like the filmic Kuleshov effect (in which the shot sequence directly preceding and proceeding an image helps to determine the latter's meaning), by placing, for example, a post regarding the use of public urinals for homosexual activity directly after Vito Acconci's *Untitled (Project for Pier 1)* of 1971, Olesen successfully »queers« Acconci's work and in so doing presents the possibility for other such radical revisions of Conceptual art.

But it is not merely through a structure of montage and appropriation—let alone allegory—that Olesen finds a »way out« of the aporias of Conceptualism. That »way out« as a »way in« is also performed on the level of dissemination. By placing »Pre Post: Speaking Backwards« in a printed matter venue rather than a public exhibition, Olesen mobilizes and revitalizes an early strategy of Conceptualism. But now Olesen's work penetrates the site where history is written and validated—i.e., an academic collection of essays targeted to an international audience of readers interested in contemporary art. In so doing, he ensures that his work and its revision of Conceptualism will not be ghettoized in the »blind spots« and »non-sites« of homosexual cultural production, and will, instead, make these sites publicly visible and critically available. The way out of Conceptual art is for him the best way into an adequate understanding of the movement and its legacies—a methodology that the editors of this volume wholeheartedly embrace.

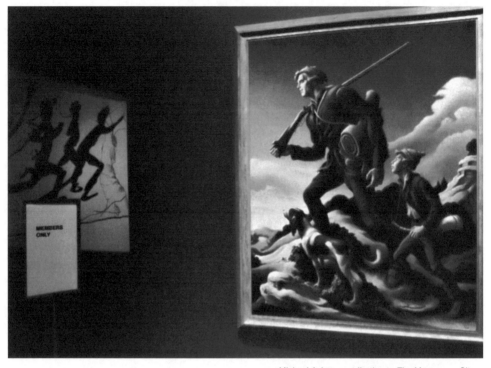

Michael Asher, contribution to *The Museum as Site*,
Los Angeles County Museum (1981), 1 of 3 elements

Benjamin H. D. Buchloh

Allegorical Procedures:
Appropriation and Montage in Contemporary Art

From the very moment of its inception, it seems that the inventors of the strategy of mon-
tage[1] were aware of its inherently allegorical nature: to speak in public with hidden meaning,
in response to the prohibition of public speech. George Grosz, for one, reminisces as follows:

> In 1916, when Johnny Heartfield and I invented photomontage... we had no idea of the
> immense possibilities or of the thorny but successful career that awaited the new invention.
> On a piece of cardboard, we pasted a mishmash of advertisements for hernia belts, student
> songbooks, and dogfood, labels from Schnaps and wine bottles and photographs from picture
> papers, cut up at will, in such a way as to say in pictures, what would have been banned by
> the censors if we had said it in words.[2]

In a highly condensed form, Grosz charts the terrain of montage as well as its allegorical
methods of confiscation, superimposition, and fragmentation. He outlines its materials as much
as he points to the dialectic of montage aesthetics: ranging from a meditative contemplation
of reification to a powerful propaganda tool for mass agitation. Historically, this dialectic is
embodied most eminently in the oppositional practices of two German Dada artists, the opposi-
tion between the collage work of Kurt Schwitters and the montage work of John Heartfield.
The inventors of the collage/montage techniques understood just as clearly that they performed
operations on the pictorial or poetical signifying practice that ranged from the most subtle and
minute interference in linguistic and representational functions to the most explicitly and power-

1 The introduction of this essay largely follows an argument that has been developed in Ansgar Hillach's attempt to define
 a notion of montage in the avant-garde of the 1920s and its relationship to Walter Benjamin's concept of allegory. See:
 Ansgar Hillach, »Allegorie, Bildraum, Montage,« in *Theorie der Avantgarde* (Frankfurt: Edition Suhrkamp, 1976), 105–42.
 For a more specific analysis of the complexities and historical changes of Benjamin's allegory-model, I would refer to
 Harald Steinhagen, »Zu Walter Benjamin's Begriff der Allegorie,« in *Form und Funktionen der Allegorie* (Stuttgart: Metzler,
 1979), 666 ff, and Jürgen Naeher, *Walter Benjamin's Allegorie-Begriff als Modell* (Frankfurt: Klett-Cotta, 1975). For a
 more recent English account of Benjamin's theory of allegory, see Bainard Cowan, »Walter Benjamin's Theory of Allegory,«
 in *New German Critique*, no. 26 (1982): 109–22. Cowan's claim that Benjamin's theory of allegory »...has gone virtually
 without thorough explication,« however, indicates, as does his text, that he is not at all familiar with the German literature
 on the subject.
2 George Grosz, quoted in Hans Richter, *Dada: Kunst und Antikunst* (Cologne: DuMont, 1963). English translation
 in Dawn Ades, *Photomontage* (London: Phaidon, 1976), 10.

fully programmatic propaganda activities. This becomes apparent in Raoul Hausmann's recollections of 1931, when he ponders the development from phonetic Dada poems to the political polemics of the Berlin Dada group:

> In the conflict of opinions, people often argue that photomontage is only possible in two ways: one being the political, the other being the commercial The dadaists, after having »invented« the static, the simultaneous and the purely phonetic poem, now applied the same principles with consequence to pictorial representation. In the medium of photography, they were the first to create out of structural elements from often very heterogeneous materials or locales a new unity that tore a visually and cognitively new mirror image from the period of chaos in war and revolution; and they knew that their method had an inherent propagandistic power which contemporary life was not courageous enough to absorb and to develop.[3]

The dialectical potential of the montage technique to which Hausmann refers found its historical fulfillment in the fundamental contradiction of the consequences spawned by the collage/montage model. On the one hand, we witness its increasing psychological interiorization and aestheticization in the work of Max Ernst and of Surrealism at large (and its subsequent, still continuing exploitation in advertising and product propaganda). On the other hand, we encounter the historically simultaneous development of politically revolutionary montage and agitprop practices in the work of El Lissitzky, Aleksandr Rodchenko, and Heartfield (and the logical conclusion of an almost complete disappearance of montage's public social function from history, except for some isolated pursuits in contemporary individual practices that we will focus on in the following).

Parallel to the emergence of montage practices in literature, film, and the visual arts, we witness the development of a theory of montage in the writings of numerous authors since the late 1920s: Sergei Eisenstein, Lev Kuleshov, and Sergei Tretiakov in the Soviet Union; Bertolt Brecht, Heartfield, and Walter Benjamin in Weimar Germany, and Louis Aragon in France. It is in particular the theory of montage as it was developed in the later writings of Walter Benjamin, in close association with his theories on allegorical procedures in modernist art, that is of significance if one wants to develop a more adequate reading of certain aspects of montage models in the present, their historical predecessors, and the meaning of the transformations of these models in contemporary art.

In his analysis of the historical conditions that generated allegorical practices in European Baroque literature, Benjamin suggests that the rigid immanence of the Baroque—its worldly orientation—leads to the loss of an anticipatory, utopian sense of historical time, and thereby generates a static, almost spatially conceivable experience of time. The desire to act and produce and the idea of a public political practice recede behind a generally dominant attitude of melancholic contemplation. Similar to the general perception of the world's perishable nature during the Baroque, the world of material objects is perceived as becoming invalid in the emerging transformation of objects into commodities, a transformation that occurred with the general intro-

3 Raoul Hausmann, »Fotomontage,« in A–Z, no. 16 (May 1931). Reprinted in Raoul Hausmann, exh. cat. (Hannover: Kestnergesellschaft, 1981), 51 ff. (Own translation).

duction of the capitalist mode of production. This devaluation of objects, their split into use
value and exchange value and the fact that they would ultimately function exclusively as pro-
ducers of exchange value, would—still according to Benjamin—profoundly affect the collective
experience of objects under the conditions of modernity.

But it is in particular in his later writings, especially in the »fragments« on Baudelaire, that
Benjamin developed a theory of allegory and montage based on the structure of the commodity
fetish as it had been defined by Karl Marx. Planning to write a chapter entitled »The Commodity
as Poetical Object,« in the Baudelaire study, one of the preparatory fragments contains *in nuce*
an almost programmatic description of collage/montage aesthetics: »The devaluation of objects
in allegory is surpassed in the world of objects itself by the commodity. The emblems return as
commodities.«[4]

Language and image, taken into the service of the commodity by advertising, were allego-
rized by the montage techniques of juxtaposing and fragmenting depleted signifiers.[5] The allegori-
cal mind sides with the object and protests against its devaluation to the status of a commodity
by devaluating it for the second time in allegorical practice. By splintering signifier and signified,
the allegorist subjects the sign to the same division of functions that the object has undergone in
its transformation into a commodity. It is this repetition of the original act of depletion and the
new attribution of meaning that redeems the object.

The allegorist perceives the essential site of the procedure in the scriptural element of writ-
ing, where language is incorporated into a spatial configuration. Thus, dadaist poets deplete
words, syllables, and sounds of all traditional semantic functions and references until they
become purely visual, opaque and concrete shells and skeletons. The purely phonetic dimension
of language signals their dialectical complement in the Dada and Cubo-Futurist sound poems,
where psychosomatic expression is freed from the spatial shells and skeletons of language and
the usages of imposed and instrumentalized forms of communicative meaning.

The procedure of montage is therefore one in which all allegorical principles are executed
simultaneously: appropriation and depletion of meaning, fragmentation and dialectical juxtapo-
sition of fragments, and the systematic separation of signifier and signified. In the sense of
Walter Benjamin's definition of the allegorical, one could say that the allegorical mind arbitrari-
ly selects from the vast and disordered material that a person's knowledge has to offer. It tries

4 Walter Benjamin, »Zentralpark,« in *Gesammelte Schriften*, vol. I, 2, (Frankfurt: Suhrkamp, 1974), 657–90. (Own translation).

5 The spatialization of time and the adoption of a contemplative stance towards the world that Benjamin discussed in 1935
 as the experiential conditions of allegory in the European Baroque were discussed in 1928 by Georg Lukacs as
 the essential features of the collective condition of reification:
 »Neither objectively nor in his relation to his work does man appear as the authentic master of the process; on the con-
 trary, he is a mechanical part incorporated into a mechanical system. He finds it already pre-existing and self-sufficient,
 it functions independently of him and he has to conform to its laws whether he likes it or not. As labour is progressively
 rationalized and mechanized, his lack of will is reinforced by the way in which his activity becomes less and less active
 and more and more contemplative. The contemplative stance adopted towards a process mechanically conforming to
 fixed laws and enacted independently of man's consciousness and impervious to human intervention, i.e., a perfectly
 closed system, must likewise transform the basic categories of man's immediate attitude to the world: it reduces space
 and time to a common denominator and degrades time to a dimension of space.«
 See: Georg Lukacs, »Reification and the Consciousness of the Proletariat,« in *History and Class Consciousness*
 (Cambridge, MA/London: MIT Press, 1971), 89.

to match one piece with another to figure out whether the pieces can be combined: This meaning with that image, or that image with this meaning. The result is never predictable since there is no organic mediation between the two.[6]

Benjamin's theory of montage ultimately outlines a historical critique of perception. The beginning of the modernist avant-garde emerged at a historical turning point where, under the impact of the rising participation of the masses in collective production, all traditional models of perception that had served in the character formation of the bourgeois subject now had to be rejected in favor of models that acknowledged explicitly those social facts of a newly emerging historical situation where, as Benjamin would phrase it in his seminal essay »The Work of Art in the Age of Mechanical Reproduction« (1934), the »'sense of … equality of things' has increased to such a degree that it extracts it even from a unique object by means of reproduction.«[7]

These perceptual changes denied any qualification of subject or object as singular and unique, dismantling by implication the hierarchical social order as much as the system of the bourgeois character structure. Techniques and strategies of montage, dismantling hierarchies and emphasizing tactility, established a new physiology of perception, anticipating and initiating transformations of the individual psyche as well as those of the larger social organization.

The transformation of the commodity into an emblem—a phenomenon that Benjamin had observed primarily in the poetry of Baudelaire—had come full circle in Duchamp's ready-mades. Here, the willful declaration of the unaltered object as meaningful, and the act of its appropriation, had allegorized the very act of creation by bracketing it with the anonymous procedures of mass production. It seems that the traditional separation of the pictorial or sculptural construct into procedures and materials of construction, as much as the division between a pictorial/sculptural signifier and a signified no longer occur in Duchamp's ready-mades. Rather, all three coalesce in the allegorical gesture of appropriating a preexisting object, thus negating any individual conception and production of the pictorial/sculptural sign altogether.

Duchamp's proposal for an inverted ready-made, his infamous *Rembrandt as Ironing Board* (1919) suggested the transformation of an actual cultural icon into an object of use value. It would find less of a following since it went beyond the culturally accepted limits of iconoclasm. Yet, the desire for communicative use value has not resurfaced in art since the 1930s—most likely because it has been generally submerged by the emphasis on pictorial exchange value in the period after World War II.

At the same time, this emphasis on the manufactured signifier and its mute existence, made apparent those hidden factors that determine the work and the conditions under which it is perceived. These latent structures of a discursive system range from presentational devices and the institutional framework to the conventions of meaning-assignment within art itself. It seems that what Yve-Alain Bois observed in regard to Robert Ryman's paintings, is only half the truth in

6 The famous anecdote in which Kurt Schwitters described the origin of the term »Merz« as a result of his encounter with an advertisement for the »Kommerzbank« contains equally *in nuce* all the essential features of the allegorical procedure: fragmentation and depletion of conventional meaning are followed by acts of willful meaning-assignment, which generate the poetical experience of primary linguistic processes.

7 Walter Benjamin, »The Work of Art in the Age of Mechanical Reproduction,« in *Illuminations* (New York: Schocken, 1978), 223.

Duchamp's work: »...the narrative of process establishes a primary meaning, an ultimate originating referent that cuts off the interpretive chain.«[8]

The mechanically reproduced image of the once unique auratic work functions as the ideological complement to the manufactured commodity that the ready-made frames in its allegorical schema. Duchamp's *L.H.O.O.Q.* (1919) could be recalled as one of the first instantiations of a dadaists' allegorical montage, driven by the principle of appropriation. In his citation of a mass-reproduced icon of cultural history, Leonardo's *Mona Lisa,* Duchamp subjected the printed image, first of all, to the essentially allegorical procedure of confiscation. Subsequently, he inscribed the image with a textual insertion that could only come alive in its phonetic performance.

As is well known, beginning in the late 1950s and throughout the development of Pop art, commodity images/objects were juxtaposed with mechanically reproduced high-cultural icons in the work of Robert Rauschenberg, Andy Warhol, and Roy Lichtenstein. More importantly, as an example of an allegorical operation in the tradition of Duchamp's *L.H.O.O.Q.,* however, one would have to recognize the amazing complexity of an early work within that emerging reception of Dada practices in the early 1950s.

In 1953 Rauschenberg obtained a drawing from Willem de Kooning after having informed him of his intention to erase the drawing, and to make it the subject of a work of his own. Once Rauschenberg had executed the erasure as carefully as possible, a process that left vestiges of pencil and the imprint of the drawn lines visible as clues of an earlier drawing that had been based on similitude, the erasure was framed in a gold frame and an engraved metal label attached to the frame identified it as a work by Robert Rauschenberg entitled *Erased de Kooning Drawing,* dating it 1953.[9]

At the climax of the abstract expressionist idiom, this work may have been perceived as a sublimated patricidal assault by the new generation's seemingly most advanced artist. By now it appears to us, however, rather to have been one of the first examples of allegorization in postwar New York school art. Its procedures of appropriation, its depletion of the confiscated image, the superimposition or doubling of a visual text by a second text, and the shift away from purely perceptual attention to an act of reading, from the central substantive structure of the »work« to the device of the frame, all make it eminently within the demands of the allegory in the definition that we have suggested. Where perceptual data are withheld or removed from the traditional surface of display, the gesture of erasure shifts the focus of attention to the appropriated historical construct on the one hand, and to the devices of framing and presentation on the other.

Furthermore, Rauschenberg's appropriation confronts two opposite paradigms of drawing almost programmatically: that of de Kooning's traditional denotative lines, and that of the purely indexical functions of the erasure. And yet, all the dispersed elements of this work seem to have become materially and semiotically congruent: the traditional drawing procedure as deno-

8 Yve-Alain Bois, »Ryman's Tact,« in *October* 19 (Winter 1981): 94.

9 More recently, Calvin Tomkins has argued that the label, identifying the work as a project by Robert Rauschenberg, was actually designed and produced by Jasper Johns. See Calvin Tomkins, »Everything in Sight: Robert Rauschenberg's New Life,« in *The New Yorker* (23 May 2005): 75.

tative gesture is displaced by *drawing* as erasure. And the proposition that a constructed sign now might have to critique the traditional substantive or organic models of figurative representation sublates and sublimates the pronunciation of a merely parricidal motivation.

A second, equally conspicuous example of an emerging allegorical aesthetic within that moment would be Jasper Johns's *Flag* (1955). This painting not only indicated the beginning of the Duchamp reception in American art, and thus the beginning of Pop art, but more precisely, it introduced a pictorial method to New York school painting that had been previously unknown: the appropriation of an object/image whose structural, compositional, and chromatic aspects determined the painter's decision-making process in advance of the execution of the painting.

Thus, the rigid iconic/symbolic structure of the flag functions like a template or a matrix, bracketing first of all the two apparently exclusive discourses of high art and mass culture. Yet this semblance of a fusion of the oppositional spheres paradoxically reveals the irreconcilable gap between them all the more. One could argue that to the very degree that the work emerging from the reception of the ready-made aesthetic in American Pop art addresses mass culture and mechanically reproduced imagery as abstract universal conditions, this work fails to clarify its historically specific framing conditions: those of its proper reification as art within the institutional framework of the museum, those of the ideology of modernism, and those of the distribution form of painting as a commodity.

Therefore, we encounter only well-balanced and well-tempered modes of appropriation at that moment in American painting. And the successful synthesis of relative radicality and relative conventionality, would demarcate the positions of American Pop art from the mid 1950s onwards, in general. Its program would always remain one of liberal reconciliation, aiming at the mastery of the conflict between individual artistic practice and collective mass cultural production, between the mass-produced imagery of low culture and the icon of individuation that each painting within the sphere of high culture mythically embodies.

Here lies one of the explanations of the social success of Pop art, and the secret behind its present rediscovery and glamorous institutionalization. If read against the historical moment, which was dominated by abstract expressionist aesthetics and ideology, Rauschenberg's *Erased de Kooning Drawing* and Johns's first *Flag* might have appeared at first to be scandalous representations that denied the validity of traditional concepts of individual expression and authorship. Compared to the radical epistemology and seemingly inexhaustible shock of Duchamp's three-dimensional, unaltered ready-made, however, they are delicate constructs of compromise, refining gestural definition and juxtaposing individualized painterly craftsmanship with seemingly anonymous mechanicity.

It could easily turn out to be one of the great ironies of history that an element of truth was contained in Clement Greenberg's conservative formalism after all. He refrained from acknowledging the impact of Duchamp's work—and of the work of the Pop artists, for that matter—because it lacked, as he perceived it, the specific self-referentiality that could empirically and critically verify itself with regard to all the perceptual and material conditions determining the perception of the painterly object. For all of its obvious failures, Greenberg's empirico-critical position at least did not succumb to the delusion of a premature reconciliation between high art and mass culture, as it was implicit in the work of Duchamp's followers.

It would take the work of two more generations for other practices to emerge in the mid 1960s that would reflect simultaneously on both legacies in their recent emanation as pop and minimalist strategies. Conceptualism would finally integrate Greenberg's self-referential formalist analysis of the pictorial/sculptural construction with the historical ramifications of Duchamp's ready-made and its consequences.

In the work of artists such as Michael Asher, Marcel Broodthaers, Daniel Buren, Dan Graham, Hans Haacke, and Lawrence Weiner, we encounter both an examination of the framework that determines the reading conventions of artistic signs, as well as an analysis of the structuring principles of the sign itself. A work such as Graham's 1966 *Homes for America* [10] was conceived as an article for an art magazine, and it becomes now fully readable as an early example of allegorical deconstruction in Conceptual art. In this work, the institutional framework, as much as the distribution form, the economic materiality of the support system, as much as the physical site of the work's ultimate existence, are foregrounded as the very parameters that determine the function and reading of the work from its very inception.

Since his *Homes for America* focused on what was then the primary form of distribution for aesthetic information, the printed magazine page and the photo reproduction, Graham would refer to that form—not surprisingly—as a sort of »disposable ready-made.« On the one hand, the work inscribed itself within the historical context of minimalist sculpture's self-reflexivity. Yet simultaneously it denied the validity of such self-reflexivity by introducing a public and popular »subject matter« (in this case, serialized, standardized, suburban prefabricated architecture).

The linguistic and semiotic interests of these early conceptual artists led to a renewed reading and rediscovery of Stéphane Mallarmé, in particular, his investigations of the spatialization of the linear, temporal dimension of reading and writing. Independently of each other, both Graham and Broodthaers, for example, had become aware of the historical consequences of Mallarmé's work. In his essay »Information,« written and partially published in 1967, Graham discussed Mallarmé's 1866 project for *Le Livre*.[11] The symbolist poet had conceived a book whose multidimensional geometry implied a complete restructuring of reading and writing, one that was fundamentally different from the reading conventions as they had been known since the invention of the printed letter.

Two years later, in 1969, Broodthaers published his version of an »hommage« to Mallarmé, citing his *Un coup de dés jamais n'abolira le hasard*,[12] which exercised literally all the principles of allegorical appropriation and montage as Benjamin had developed them. Broodthaers's own *Coup de dés* confiscated the presentational details, format, design, and typography of the cover of Mallarmé's *Coup de dés* as it had been published posthumously by Editions Gallimard in Paris in 1914. Mallarmé's name on the cover, however, was now replaced in a semblance of bold parricidal displacement by that of Marcel Broodthaers's own.

10 Dan Graham, »Homes for America,« in *Arts Magazine* (December/January, 1966–67).

11 Dan Graham, »The Book as Object,« in *Arts Magazine* (May 1967), reprinted first in an extended version in Dan Graham, *End Moments*, self published, New York, 1969. Reprinted in Dan Graham, *Rock My Religion*, ed. Brian Wallis (Cambridge, MA/London: MIT Press, 1993), 26–30.

12 Marcel Broodthaers, *Un coup de dés jamais n'abolira le hasard* (Antwerp: Wide White Space Gallery, Cologne: Michael Werner Gallery, 1969).

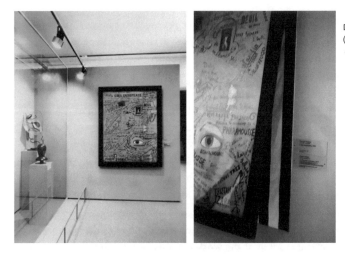

Daniel Buren, *Les formes: peinture*
(1977), installation view and detail

In a manner reminiscent of Rauschenberg's erasure of de Kooning's drawing, Broodthaers operated on the scriptural configurations of Mallarmé's poem: the actual text of the poem was reduced from its spatial and graphic extensions, and was newly condensed and conventionalized as a continuous text. Its textual and graphic avant-gardism seemingly downgraded and disarticulated, Broodthaers's *Coup* relocated the poem to the site of the original's preface, a text that was now dropped from the book altogether.

While the text's semantic and lexical information were depleted, the visual and spatial dimensions of the poem's original configuration were maintained on the page, as it were, in the shadowy opaque black bars (*sous rature*) that followed the former textual display down to the minutest detail. Mallarmé's typographical modifications of his lexical structures (the position, placement, size, weight, and direction of the poem's spatialized scripture) disappeared, or rather, were sublated, within the pure graphic/linear demarcations of the erasures.

Since Broodthaers's book was printed on semi-transparent tracing paper, the pages could be »read« not only in the traditional linear, horizontal left to right reading pattern that is ordered on a vertical plane: the translucency of the pages also invited reading along an axis of lateral, superimposed planes as well as an inversion of the recto/verso reading order. Thus, Broodthaers's allegorical procedures deconstructed the prison house of modernism, alternating between a focus on the institutions of artistic practice and on the discursive structure determining modernism's objects.[13]

In a rather different manner, yet central to our study of the phenomenon of allegorical appropriation, one should see how Daniel Buren employed this strategy in 1972 in order to transfer the viewer's attention from exhibited objects to the underlying frameworks that deter-

13 Beginning with his foundation of a fictitious museum in Brussels in 1968 where the icons of modernism were presented as postcard images, the project culminated with his large-scale installation *The Eagle from the Oligocene until Today (The Museum of Eagles)*, presented in Düsseldorf in 1972, where 266 artifacts representing the image of the eagle were once again submitted to the process of abstraction from history in the construction of a secondary mythical fiction. See Marcel Broodthaers, *Der Adler vom Oligozän bis Heute* (The Eagle from the Oligocene until Today), exh. cat., vols. I and II (Düsseldorf: Kunsthalle Düsseldorf, 1972).

mine the conditions of their presentation and their perception. In a work entitled *Exhibition of an Exhibition*, his installation for *Documenta 5* in Kassel in 1972, Buren inserted his work into each of the previously determined sections of the exhibition (painting, sculpture, advertising, propaganda posters, *art brut*, etc.).[14]

His interventions consisted of the attachment of identical wall elements (white stripes 8.7 cm wide printed on white paper) that served to demarcate the framing and display devices of the seemingly neutral institution's gallery space and its architectural conventions. Covered in each exhibition segment by another type of work or object (paintings, posters, or sculpture when the paper elements covered a base), it was only in one exhibition segment (the section on Post-Minimal and Conceptual art, curated by Konrad Fischer and entitled *Light and Idea*), that Buren's element was actually presented as an autonomous, self-sufficient structure in the manner of an abstract painting.

The most spectacular collision occurred when by apparent coincidence Johns's *Flag* was placed on one of the demarcated wall areas. This »chance encounter« not only revealed the historical distance between the two works, and more importantly, the specificity with which Buren had overcome the randomness of Johns's attempt to fuse high art and mass culture, but it also pointed further back to the problematic implications of Duchamp's aesthetic of the ready-made, as discussed briefly above. Buren's critique of Duchamp was directed first of all at the anarchist willfulness of Duchamp's decision to ignore the institutional and discursive framing devices that made the conception of the ready-made possible at all. Second, his critique was directed against the purely iconic mediation between avant-garde and mass culture that Duchamp, and after him Johns and the American pop artists, had engaged in.

By contrast, Buren's analytic approach to the governing institutional and discursive conditions of presentation, mediation, and reception of a work of art in the present historical situation, was infinitely more specific. It recognized the actually existing frames within which spectatorial desire and reading competence are currently contained, and that make a merely iconic and populist mediation between mass culture, commodity object, and avant-garde art, ultimately pointless and abstract.

One of the first works of that post-minimalist generation to actually incorporate the commodity structure directly into the conception of the work and into the elements of its presentation, was Hans Haacke's contribution to the summer festival *L'art vivant américain* at the Maeght Foundation, St. Paul de Vence, France, in 1970. Haacke complied with the organizer's request to contribute to a »non-profit avant-garde festival« by linking his contribution to the concealed promotion of saleable objects at the foundation. Haacke's »performance« consisted of a tape-recorded litany of prices and descriptions of prints for sale in the bookstore of the Maeght Gallery foundation. The recording was interrupted only by news agency teletype reports, read over the phone from the office of the newspaper *Nice-Matin*, and it seems that only the fear of audience protest deterred the organizers from banning Haacke's work.

The historical record of attempts by museum authorities and exhibition organizers to censor Haacke's strategies in order to reintroduce the repressed elements of culture into the official

14 Daniel Buren, »Exposition d'une exposition,« in *Documenta 5*, exh. cat. (Munich: Bertelsmann, 1972). See also Daniel Buren, *Rebondissements/Reboundings* (Brussels: Daled-Gevaert, 1977).

faces and functions of cultural institutions, attests to the truly allegorical qualities of Haacke's work. In a number of projects Haacke has chosen to write *art history* as *commodity history*. This is most prominent, for example, in the chronology and genealogy of the succession of own- ers of the *Asparagus Still Life* by Edouard Manet (a work by Haacke banned from an exhibition in Cologne in 1974), and in a similar work delineating the provenance of Seurat's *Les Poseuses*.[15] More recently, Haacke has investigated the economic practices and maneuvers of Peter Ludwig, the major cultural »benefactor« and collector, uncovering the actual benefits and privileges that the apparently selfless generosity of the patron implies, for example, in his work *Der Pralinen- meister* (The Master Chocolate Maker, 1981).[16]

In an American context, two works from the late 1970s must also be mentioned as prefig- uring contemporary allegorical strategies of appropriation: Louise Lawler's untitled 1978 instal- lation at Artists Space in New York,[17] which—among several other elements—incorporated a painting from 1824 by Henry Stullmann representing a racehorse (loaned by the New York Racing Association), and Michael Asher's contribution to the 73rd American Exhibition at the Art Institute of Chicago in 1979, which appropriated a bronze replica of Jean-Antoine Houdon's life-size marble sculpture of George Washington. Due to their enigmatic procedures, these works have received little or no critical attention,[18] yet they both anticipated and prefigured the newly developing strategies of the crucial practices of the 1980s under consideration in this essay.

Lawler's installation made those supplemental elements, generally considered marginal, yet necessary for the production of a work and its exhibition, the central subject of her installation. Thus the actual objects of Lawler's contribution to the exhibition consisted first of all of the appropriated painting of a racehorse, appearing displaced and decontextualized. It functioned as the mere allegorical shell of painting at the moment of painting's reactionary reemergence in the culture at large. Furthermore, two stage lights illuminated the arrangement and spectacularized the innocuous racehorse painting. One of the lights confronted the viewer's eyes directly from above the painting (interfering thus with perception of the painting itself, almost inhibiting it), and the other was directed outward, through the exhibition space, projecting its light out of the window and casting a large shadow of the window frame onto the street. It thereby connected the isolated exhibition space with its urban setting and brought the presence of the institution and exhibition to the attention of the immediate neighborhood. Lawler's catalogue contribution

15 The work traced the transfer of Manet's *Asparagus Still Life* from its original French owners, through various German Jewish families and its forced sale under the Nazi regime, to its eventual »donation« by Hermann Josef Abs, the former chief financial officer of the Nazi regime, to the Wallraf Richartz Museum on the occasion of its 150th Anniversary in 1972.

16 The works referred to are documented in the following publications: Edward Fry, *Hans Haacke* (Cologne: DuMont, 1972); Hans Haacke, *Framing and Being Framed* (Halifax: Press of the Nova Scotia College of Art and Design, New York: New York University Press, 1975); Hans Haacke, *Der Pralinenmeister* (Cologne: Paul Maenz Gallery, 1981), English edition (Toronto: Art Metropole, 1982).

17 See the exhibition catalogue, — — — — —, *Louise Lawler, Adrian Piper, Cindy Sherman* (New York: Artists Space, 1978). The blank space in the catalogue title signals artist Christopher d'Arcangelo's intentionally anonymous participation.

18 For a notable exception of a discussion of Michael Asher's installation, see Anne Rorimer, »Michael Asher: Recent Work,« in *Artforum* (April 1980), and my own essay »Michael Asher and the Conclusion of Modernist Sculpture« (1979), published in *The Centennial Lectures at the Art Institute of Chicago*, ed. Susan Rossen (Chicago: The Art Institute of Chicago, 1983). Republished in revised and expanded form in Benjamin Buchloh, *Neo-Avantgarde and Culture Industry* (Cambridge, MA/London: MIT Press, 2000).

Louise Lawler, untitled installation at Artists Space, New York (1978), exterior installation view

for the exhibition, by contrast, consisted solely in the graphic design for a new logo for the institution, Artists Space in New York, that exhibited her work. Lastly, a poster with that logo as its sole information was distributed outside of the exhibition to disseminate knowledge about Artists Space and increase its visibility in the manner of a newly emerging product or corporation.

It was with the work of this group of artists that questions of site specificity were programmatically expanded to include the analysis of the discursive framing devices and a critique of the institutional conventions of exhibition and display (their material and economic support systems, as much as the physical, socio-political, and linguistic components of those elements that previous reflections on site specificity had considered exclusively in spatial, or at best, in architectural terms). Ultimately, as a result of this expanded concept of site specificity, new questions, specifically concerning the mode of address, and the actually existing audience expectations towards contemporary culture, became integral for the production of these artists.

Anyone taking seriously the implications of this project of a *situational aesthetics* as it was developed in the late 1960s, would have to recognize its ramifications for the cognitive and perceptual conditions of future art production. Furthermore, one would have to realize from now on —so it seemed at least—that any return to an unconditional autonomy of art would be extremely problematical if not outright impossible.

Of course this did not imply *a doxa* either. Lawrence Weiner's reduction of aesthetic practice to its linguistic definition, Buren's and Asher's analysis of the historical place and function of aesthetic constructs within institutions, or Haacke's and Broodthaers's operations revealing the material conditions of those institutions as ideological frameworks, would articulate positions that could be logically continued and that would have to be developed further.

Yet it is important to understand that the dialectical response to these positions would not be, as some seem to have thought, a return to some obscure historical conventions of figurative and neo-expressionist painting and sculpture, or, more importantly, to the commodity camouflage that they provide. Rather, what the new generation of artists emerging in the mid- to late 1970s confronted, was not only the precision with which the conceptual generation of the 1960s and early 1970s had analyzed the place and function of aesthetic practice within the discourses and

institutions of modernism: the new generation would now re-orient its attention and address the ideological discourses *outside* of the modernist framework, focusing on those mass cultural discourses that condition and control the experience of everyday life. And it was this constellation of conceptualist precision and critical mass cultural analysis that brought about the paradigmatic shift in the work of artists such as Dara Birnbaum, Jenny Holzer, Barbara Kruger, Louise Lawler, Sherrie Levine, Martha Rosler, and Cindy Sherman.

In their projects, the languages of television, advertising, and photography, and the ideology of everyday life, were subjected to a formal and linguistic analysis that essentially followed Roland Barthes's model of a secondary mythification in his classic essays *Mythologies* (1957) which, according to Barthes, attempts to deconstruct the mythical constructions of ideology. Barthes's strategy of secondary mythification publicly repeats the semiotic and linguistic devaluation of primary language by myth. Therefore, it could be considered as both a historical sequel and a structural analogue to Benjamin's theorization of allegorical procedures that were defined —as argued above—by the reiterated devaluation of the object once it had become the commodified object.

It seems justifiable, therefore, to transfer the notion of montage and allegory from the context of the avant-garde practices of the first half of the century, into a reading of recent and contemporary work, and to extend the ramifications of an aesthetics of allegorical montage into the present, modified and mediated through a method of critical mythology.

The political spectrum within which these artists operate—inasmuch as it can be read in the work itself and inasmuch as it can be isolated at all from the current climate of cynical pessimism—encompasses a variety of positions. They range from the apparently outright denial of production and dialectical construction in the work of Levine, to the position of cultural activism in Rosler's work. By contrast, Holzer's anarcho-situationist position trusts the strategy of an unmediated street activity in which anonymous posters confront language and its daily ideological performances with acts of a seemingly self-generated linguistic *détournement*. Birnbaum's videotapes and video installations deploy a similar set of situationist strategies of *détournement* with regard to the language conventions operative within the spectacularized framework of corporate media production.

The risk of Levine's position of a programmatic aesthetic passivity is that it might ultimately function in secret alliance with the static conditions of social life in general. These had been previously reflected in Warhol's passive affirmative practices that were ultimately only concerned with the work's finite commodity structure, considering the innovation of artistic product design as the sole accessible space of social variance.

By contrast, Rosler's activist position runs the risk of ignoring the structural specificities of the work's circulation form and of the determining factors of its distribution system within contemporary art institutions (the gallery, the museum, the fashion circuit). In isolating itself from this system completely, Rosler's work risks a failure of communication already on the first level of a mere reception of current art practices. This is all the more problematic when the work's larger claims are, in fact, to engage the spectators in types of communicative action that would lead towards radical political awareness and change. The dilemma underlying Holzer's work is that it ignores the mediating framework of the institutions within which language as ideology

is historically placed, for the sake of her direct actions upon this particular condition of language. As a consequence, the work has to claim an apparent independence from these institutions (i.e., the museum and the gallery space) and it can pretend to a false immediacy and radicality (i.e., direct action on language in the street), which inevitably leads towards an increasing number of compromises with the very framework that the work's false radicality claims to have dismissed. Finally, the risk for Birnbaum's work is that it could be integrated so successfully into the advanced technologies and linguistic perfection of governing television ideology that its original impulse of critical deconstruction could disappear in a perfect blending of a technocratic aestheticization of art practices, and the media's perpetual need to rejuvenate its looks and products by grafting itself onto the aesthetics of the avant-garde.

The inability of current art history and criticism to recognize the necessity and relevance of this new generation of artists working within the parameters of allegorical appropriation results partially from art history's almost total failure to develop an adequate reading of Dada and productivist theory and practices, particularly of the activities of »factography« and documentary work and the range of agitprop production that emerged from it—for example, in the work of Ossip Brik, Vladimir Mayakovsky, Liubov Popova, and Sergei Tretiakov, as much as the still essentially ignored key figure of montage practice, John Heartfield. Once these activities are admitted to the framework of legitimization that art history provides, their consequences for contemporary practice will become more readable.

At the very moment when even the analysis of the institutional framework could be safely absorbed and integrated into the codex of exhibition topics since the supremacy of the museum had been widely reaffirmed by a general return to traditional production procedures, Michael Asher abandoned the liberally delegated option to adorn the institution's repressive tolerance by expanding the focus of the field of critical deconstruction. An untitled installation, consisting of a number of spatially dispersed elements, was his contribution to the exhibition *The Museum as Site: Sixteen Projects* in 1981 at the Los Angeles County Museum of Art. Asher's work integrated three fragments from heterogeneous discourses: the first element was a wooden sign with the inscription »Dogs Must Be Kept On Leash Ord. 10309.«

Asher replaced the sign that had been previously lifted by vandals from the park surrounding the museum, and he had the park authorities produce a sign that matched the rustic, handcrafted look of the original. The second element was a poster, displaying a color reproduction and a black-and-white still photograph showing the same scene from the movie *The Kentuckian* (1955).

This poster was placed on a brass placard in the main entrance court where the museum normally announces its special events and lectures. Along with those two images (which showed Burt Lancaster as »The Kentuckian« stepping out of a forest with a child, a woman, and a dog, facing two men with rifles), a map of the museum's park indicated the location of the replaced wooden sign, and identified it as one element of Asher's contribution to the exhibition. In a third element, the viewer was furthermore informed that the museum's permanent collection housed a painting by Thomas Hart Benton entitled *The Kentuckian* (1955) which had been commissioned on the occasion of the film's original release. The painting, depicting Lancaster and a little boy, a dog, and a blossoming plant on the top of a mountain, was originally in Lancaster's collection, and had been later donated by the actor to the museum.

Inside the museum, the visitor could in fact find Benton's painting in its usual place in the permanent collection, without any additional information referring to Asher's temporary appropriation. Asher provided fewer clues or instructions here than in his previous works, enticing the viewers to assemble and synthesize the various elements of his installation. The work's utterly ephemeral existence and the dispersion of its elements made it likely that parts (or all) of the installation remained unrecognized by those viewers who had recently become, once again, readjusted to traditional works of painting and sculpture with highly condensed and centralized visual regulations.

Placed within the context of Asher's project, Benton's stridently anti-modernist painting signaled all the more the artist's overtly sexist, racist, and chauvinist positions dating from the McCarthy era. But Asher's project also contemplated the absurd historical situation of an easel painting that had been commissioned by a movie corporation from a reactionary master of representational painting, that had served as a promotional gadget for the release of a film, and that had been donated subsequently by the movie star to the collection of the museum.

The constellation of elements in Asher's allegorical construction also provided a discomforting historical example of the political implications of a breakdown of modernist thinking, and a concomitant return to traditional models of representation. Asher's work seemed to perceive itself as operating from within a historically comparable situation. It responded to the cultural symptoms of a newly asserted cultural and political authoritarianism by confronting its viewers with a work that demanded an allegorical analysis of a disseminated and decentered structure.

The reinstallation of the dog sign in the park of the museum—as an act bordering on travesty in response to the exhibition's topic *The Museum as Site*—evidently denied the historical interest of an academicized notion of site-specificity. It allegorizes simultaneously—as a textual and iconic reference—the hidden dimension of authoritarianism in representational painting. Furthermore, the reference to the movie and its star (who—as the donor of the painting—functions as a new type of patron of the museum) confronts the museum's ever increasing entanglement with the entertainment industry. Asher's brilliant diagnostics specifically pointed to the then imminent and henceforth rapid transformation of the institutions of high culture into mere

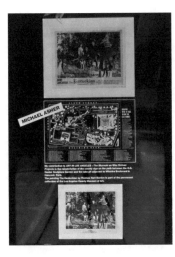

Michael Asher, contribution to *The Museum as Site*, Los Angeles County Museum (1981), 2 of 3 elements

appendices of the culture industry (which has since become an uncontested rule). And while the work's analytical specificity focused, first of all, on the local cultural contradictions in Los Angeles, the installation transcended the limits of that context, developing a model that critically reflected the universal conditions of artistic production.

Ultimately it is in the materiality and status of objects in Asher's installation, their placement as much as their interrelationship, that the work's complex references become fully evident. Each element continues to exist within its own context to the same degree that it enters the super-imposition of discourses that now constitute Asher's »work.« By repositioning Benton's painting within its historical context (i.e., its place and function, its patron and original purpose), it also acquired a sudden, exemplary significance for contemporary painting and its conceits.

Whereas the technically reproduced images, the poster and still photograph that were placed in the museum's showcase doubled their representational status by assuming temporarily and peripherally the status of art objects, clarifying the unique, auratic object's dependence on technical reproduction. The only element manufactured specifically for the purposes of this installation was paradoxically the most quotidian, the most functional of all objects, the wooden sign in the park.

In Asher's appropriations, the discursive fragments are, however, never transformed into a finite status as art objects. Their given historical status and functions (e.g., as ideological discursive elements) are always maintained. The ephemerality of these elements (e.g., lobby card, park sign), as much as their dispersed presentation, operate in tandem with an apparent lack of productive artistic presence and authorial identity. And to the extent that the reading and viewing of this work suggest the absence of a unified, authorial subject, the work opposes the condition of becoming merely an aesthetic fetish and resists the commodification of cultural practice.

Thus, while the refusal of production in Asher's work primarily decenters reading, it also attempts to generate an awareness of the various layers of ideological overdetermination within the production and reception of cultural practice in the present. Unlike Levine's negation of production, however, which suggests a position of self-effacing complacency or melancholic contemplation, Asher's allegories manifest the hidden network of relations and discourses, the

institutionally mediated interests and powers that constitute the framing devices of contemporary culture. Nevertheless, it has to be said, that within the distributional system of the gallery framework itself, Levine's work functions—for the time being, at least—as one of the strongest negations of the mythical singularity of the work of art and its indisputable status as a commodity. Her work's melancholic strategies not only threaten the current reaffirmation of an expressive creativity, but also myth's implicit affirmation of private property and corporate enterprise as the economic parameters of culture.

At the very historical moment when a reactionary middle class struggles to expand its privileges, buttressing an oligarchic hegemony searching for cultural legitimation, and when hundreds of minor talents in painting obediently provide gestures of free expression, Levine's work subverts this spectacle of mythical individuality. While continuing practices defined by Duchamp and updated by Warhol, her allegorical appropriations prove that Baudelaire's sexist diagnosis was wrong when he argued that the poetical was necessarily alien to female nature since melancholy was outside the female emotional experience. With Levine and Lawler enter the female dandy, whose disdain has been sharpened by the experience of phallocratic oppression in the so-called art world, and whose sense of resistance to domination is therefore more alert than that of their male colleagues practicing painting in the present.

In the current historical situation, male artists inevitably adopt the psychosexual standards of obsolete role models and provide products for the market, but they fail to change aesthetic practice as much as they fail to challenge the conventions of subject construction. By contrast, artists like Asher, Lawler, and Levine, radically redefine artistic practice by transcending traditional character formation and social role play. And to the very extent that they criticize the commodity form of culture and the current practices of instant institutionalization, they fail to enter cultural reception altogether since they do not fulfill the public's expectations, and do not abide by the rules of culturally acceptable deviation. As one author stated lucidly, »to exemplify an attitude within which the bourgeois world can first and foremost find its identity, that of the enchanted consumer.... By doing so, the ideological condition of the *posthistoire* which late capitalism claims for itself, would equally be reaffirmed by art practice.«[19]

The contemporary allegories use methods of appropriation and montage without aestheticizing them in a newly auratic disguise of the commodity. We might even find strategies and procedures of quotation and appropriation in contemporary painting (for example in the work of David Salle or Julian Schnabel), but painting inevitably proposes a reconciliation with the very social contradictions that contemporary culture should precisely articulate. With few exceptions, the ultimate subject of painting is always a newly centralized author, whereas in contemporary montage procedures the ultimate subject is—following Barthes's brilliant prognosis —always the reader/viewer.

After all, it is in the critical analysis of the actual procedures and materials of production and reception that a work's historical legitimacy will become evident. In expanding the spacing of its elements,[20] in isolating the discursive fragments of its appropriation, and by redirecting the viewing/reading to the frame, the new montage work decenters authorial subjectivity as much

19 Annegret Jürgens-Kirchhoff, *Technik und Tendenz der Montage* (Giessen: Anabas Verlag, 1978), 191.

as it confronts the viewing/reading subject with acts of its proper dispersal. Yet the viewing/reading subject remains always within a dialectical relation to the text, since it is simultaneously constituted and negated in these acts of quotation. Precisely to the degree that the various sources and authors of quoted »texts« are left intact and fully identifiable in a truly contemporary montage, the viewers/readers encounter a decentered text that completes itself in the acts of their reading/viewing and through the comparison of the original and subsequent layers of meaning that the appropriated text/image has acquired.

It is important to recognize in what way and to what extent the notion of fragmentation in allegorical procedures differs from the phallocratic tendency in painting, which associates fragmentation with broken saucers, burnt wood, and crumpled straw. Levine confiscates historical objects, canceling their innate authenticity, their historical function, and their meaning—in true allegorical fashion. In her seemingly random selection of imagery from the history of modernism, representations are literally torn from the hermetic totality of the ideological discourses within which they now operate. Just as Benjamin had identified devalorization as one of the fundamental principles of allegory, Levine devalues the objects of appropriation by negating the aestheticized commodity status of photographs (for example, those by Walker Evans, Edward Weston, Eliot Porter) in her willful, seemingly random acts of re-photographing and re-presentation, emphatically restating their actual status as multiplied, technically reproduced imagery.

Levine's apparently radical denial of authorship—like Warhol's before her—might fail to recognize the socially acceptable, if not ideologically desirable, features it implies: to publicly affirm the final dismantling of the subject, and to sustain a detached and passive complacency in the face of the static conditions of a totally reified existence. And these faint historical spaces, opened between original and reproduction, easily seduce the viewer into a fatalistic acceptance, since they do not enact a dimension of critical negativity that would imply an activist model of practice, but merely an affirmative and melancholic contemplation.

Levine's position and that of Martha Rosler differ precisely in their attitudes regarding social context and the historic authenticity of their objects of appropriation. Levine's work embodies the ambivalence of the artist (and intellectual) who lacks or disavows class identity and political perspective, inevitably exerting a certain fascination over those contemporary critics who are equally ambivalent toward their affiliations with the powers and privileges that the middle class provides. This attitude is evidenced in the following statement by Levine:

> Instead of taking photographs of trees or nudes, I take photographs of photographs. I choose pictures that manifest the desire that nature and culture provide us with a sense of order and meaning. I appropriate these images to express my own simultaneous longing for the passion of engagement and the sublimity of aloofness. I hope that in my photographs of photographs an uneasy peace will be made between my attraction to the ideals these pictures exemplify and my desire to have no ideals or fetters whatsoever. It is my aspiration that my photographs, which contain their own contradiction, would represent the best of both worlds.[21]

20 Rosalind Krauss introduced the linguistic concept of »spacing« into the discussion of collage/montage aesthetics in the period from 1910 through the 1920s. See, for example, her essay »The Photographic Conditions of Surrealism,« in *October* 19 (Winter 1981).

In spite of his devotion to allegorical theory and its concrete implementation as he discerned it in the work of Baudelaire and the surrealist montage work of the 1920s, Benjamin was aware of the inherent danger of melancholic complacency and of the violence of passive denial that the allegorical subject imposes upon itself as well as upon the objects of its choice. The contemplative stance of the melancholic subject, the »comfortable view of the past,« as he argued, must be exchanged for the political view of the present.[22] This theoretical position was developed further in »The Author as Producer,«[23] a text in which all reflection upon allegorical procedures has been abandoned and in which Benjamin comes closest to the development of a factographic, productivist position, as it had already been outlined for example in the late 1920s in the writings of Ossip Brik and Sergei Tretiakov.

Now, according to Benjamin, the new author must first of all address the modernist framework of isolated producers and try to change the artist's position from that of a caterer of aesthetic goods to that of an active force in the transformation of the existing cultural apparatus itself. This differentiation in Benjamin's positions could help us to elucidate in the present a comparison between Levine's allegorical work and Rosler's activist communicative work, specifically her approach toward photographic conventions and the histories that they embody. Such a comparative reading is specifically suggested by Rosler's *The Bowery in two inadequate descriptive systems* (1974–75) and her critical essay »In, around, and afterthoughts (on documentary photography).«[24]

Both works address photographic conventions as language practices, analyze their historical and ideological functions, and consider the varying affiliations with the social and political conditions at large, rather than assuming a stance of aesthetic neutrality that the program of photographic modernism had prescribed. *The Bowery in two inadequate descriptive systems* is a photo-text work whose photographic component consists of black-and-white images of Bowery store fronts, reciting and restaging the conventions of street photography and social documentary, paraphrasing photographs from Berenice Abbott to Walker Evans. The complementary language component of the work consists of type-written word lists, in a design that mockingly embraces the highly serious administrative sobriety of the looks of Conceptual art. Language, however, returns here with the vengeance of its repressed somatic and social dimension, since it lists a vast array of linguistic variations on the subject of drunkenness. At the same time, Rosler's seemingly crude attempts to mimic the style of the great urban »documentarians« is of course as thoroughly disappointing to the eye cultivated in photographic modernity as Levine's photographs are to the collector's hand. It is not surprising then that in an interview on the work, Rosler describes *The Bowery* in an explicitly allegorical terminology:

In *The Bowery* the photographs are empty and the words are full of imagery and incident....
A lot of photographers made pictures of Bowery bums. That upset me because I thought it was a false endeavor, that it involved a pretense that such photos were about the people when they

21 Sherrie Levine, unpublished, undated statement, ca. 1980.
22 Walter Benjamin, *Angelus Novus* (Frankfurt: Suhrkamp, 1966), 204.
23 Walter Benjamin, »The Author as Producer,« in *The Essential Frankfurt School Reader*, ed. Andrew Arato and Eike Gebhardt (New York: Urizen Books, 1978), 254–69.
24 Martha Rosler, *Three Works*, ed. Benjamin Buchloh (Halifax: Press of the Nova Scotia College of Art and Design, 1981).

were really about the sensibility of the photographers and the viewers. It's an illicit exchange between the photographer and the viewer. They provide the raw materials for a confirmation of class and privilege. ... I wanted to make a point about the inadequacy of that kind of documentary by contrasting it with verbal images. ... I didn't want to use words to underline the truth value of the photographs, but rather words that undermined it. I felt that just as the images are expected to be poetic but aren't even »original«—they follow a tradition of street-photography and have more to do with commerce than with anything else, since they're shop-fronts—the words would be a kind of unexpected poetry. Their ironic humor would cut against and be cut against by the deadpan photographs.[25]

In the same interview, not surprisingly, Rosler introduces the question of a contemporary collage practice and its historical functions into the discussion of her work. Her definitions coincide with an outline of contemporary montage as I have tried to develop it in the course of this essay:

I think it's even more valid to talk about contradiction than about collage, because much of the collaging consists of contradiction, putting things together that don't go together, but that are connected in some way.... Many of the contradictions I want to talk about in my work are not simple riddles of existence but things that arise from the system we live under which makes impossible and conflicting demands on us. I like to point to situations in which we can see the myths of ideology contradicted by our actual experience.[26]

Rosler insists on a model of artistic practice as critical intervention, clarifying in acts of allegorical repetition, the historical meaning and the inadequacy of contemporary documentary production when reiterating photographic conventions. Thus, her essay »In, around, and afterthoughts (on documentary photography),« analyzes the historical and political implications of contemporary (documentary) photography. Confronting the material reality of the »subjects,« i.e., the present day living conditions of the famous »victims« of photography, Rosler transforms the current interest of certain photographers who have turned back to the history of their own discipline by re-photographing »in the manner of the masters.«

If Levine's abstract and radical denial of production and authorship would place her cultural model ultimately on the side of the existing power structure, Rosler's strategy, by contrast, constructs a photographic and artistic practice outside of modernism's claims for neutrality and autonomy. It positions her, paradoxically, within a cultural tradition of political commitment that could fail to communicate in the present precisely because of its lack of power within the governing discursive conventions and institutions.

The work of Dara Birnbaum inhabits a third position that is equally distant from Levine's and from Rosler's work. While it embodies all the concerns that had originated in Pop art, and had been subsequently developed in Minimal and Post-Minimal art of the late 1960s and early 1970s, it does not merely employ rediscovered Pop art strategies, as is fashionable in the context of 1980s painting. Thus, Birnbaum states, for example, that she wants »to define the language

25 Martha Rosler, interview by Martha Gever, in *Afterimage* (October 1981): 15.
26 Ibid.

of video-art in relation to the institution of television in the way that Buren and Asher had defined the language of painting and sculpture in relation to the institution of the museum...«[27]

Birnbaum's work operates programmatically within both frames: looking at the conditions of high culture—its isolation and privileged position, its commodity status and fetish existence—while simultaneously adopting the perspective of mass culture in its most advanced form: the television industry. This strategy to integrate both perspectives in a dialectical exchange has the potential to affect the languages of both art and television, though the work has not assumed a comfortable position in either institution.

In a traditional gallery situation, the work's references (both implicit and explicit) to the past decade of sculptural thinking become instantly readable. Birnbaum's video work emerges out of that historical moment in sculpture, when artists such as Bruce Nauman and Dan Graham began to use video to radicalize a phenomenological understanding of viewer-object relationships, as they had been introduced in the context of minimalist sculpture. The analytical video installations and performances of the post-minimalist artists not only focused increasingly on the phenomenology of the viewing process, but involved author and audience, audience and object, or audience and architecture in an explicit and active interchange.

With the growing theatricalization of video and Performance art in the mid-1970s and its increasing tendency towards narcissistic aestheticization, video activities of politically conscious artists would increasingly address television. At that time, video tapes such as Richard Serra's *Television Delivers People* (1973) emerged. Rather than addressing the language of television itself, previously produced videotapes simply channeled artistic performance material on videotape through television.

Nam June Paik's pioneering video/television work of the mid to late 1960s argued in the context of Fluxus that the visual culture of the future would be contained within television as the primary social practice of visual meaning production, just as visual culture in the nineteenth century had been profoundly affected by the invention of photography. Birnbaum logically refers

27 Dara Birnbaum, interview with the author, unpublished.

Martha Rosler, *The Bowery in two inadequate descriptive systems* (1974–75), detail and installation view

to Paik as one of her prime influences. Equally important for the development of her work was her collaboration with Dan Graham on a major project entitled »Local Television News Program Analysis for Public Access Cable TV.«[28]

It is crucial to understand to what extent Birnbaum's work is anchored in the structures that determine collective perceptual experience, considering that it appropriates segments from broadcast television and focuses first and foremost on the meaning of the techniques and television's specific language conventions and genres. The ideological functions and effects of the genres become transparent in the formal analysis of the conventions and the allegorical juxtapositions of the genre quotations. Due to its revelatory deconstructive procedures, the work does not participate in the proliferation of artist-produced, innovative media-strategies, which only aesthetically update television ideology. Birnbaum's videotapes appropriate television footage ranging from sitcoms and soap operas such as *Laverne and Shirley* and *General Hospital* to live broadcast material such as *Olympic Speedskating* and commercials for the Wang Corporation. The artist's works are ideally destined for television broadcast, where they could most effectively clarify their functions in situ and operate in the manner of a typical *détournement*. But the work's contradictory status of being situated primarily within art world production and distribution position it—for the time being—solely within the framework of an avant-garde discourse within the sphere of high art. Were her works to be actually shown at some point on commercial television, their essentially aesthetic strategies might become all the more apparent, and their critical potential might decrease. The striving for a process of acceptance by the media— necessary as it is for Birnbaum—is therefore also her work's most vulnerable aspect. This becomes most evident in a work such as Birnbaum's *Remy/Grand Central: Trains and Boats and Planes* (1980) where a corporation's »support« for young artists results in a commissioned simulacrum of an advertisement that at best could be perceived as a parody and at worst could be misperceived as merely a more sophisticated form of advertisement. It is not surprising then that the work's potential for affirming a final, totalitarian synthesis of the culture industry and

28 Dan Graham, *Video—Architecture—Television*, ed. Benjamin Buchloh (Halifax: Press of the Nova Scotia College of Art and Design, 1979).

of aesthetic production, would occur *in nuce* in Birnbaum's own production of new footage that mimics advertising conventions rather than addressing itself with her typical critical acuity to found footage and its genres, which is the rule in almost all of Birnbaum's other tapes.

Technology/Transformation: Wonder Woman (1978–79) unveils *Wonder Woman*, a favorite emblem of American pubescent fantasies, which has grown historically from a comic-book figure to a nationally broadcast television series. This advance to a status of national cult provides an image of crisis, which, like the resurrection of Superman in film, feeds on a collective desire for icons that represent monolithic powers: heroes, parents, and the nation state. The seemingly inexhaustible special effects that corporate television and film producers draw upon when state power most urgently needs to be mystified, appear to be the prime focus of this tape. Birnbaum's video work on the iconography of *Wonder Woman* runs parallel to the manner in which Lichtenstein's paintings had placed themselves within and against the graphic techniques of comic-book reproduction in the 1960s.

At the same time, Birnbaum's deployment of filmic loops recalls Bruce Conner's strategy of repeating found film segments, as much as it reminds us of Warhol's strategies of serializing commodity imagery. The quotational loops in Birnbaum's work break the temporal continuity of the television narrative and split it into self-reflexive elements. As a result of the precision with which Birnbaum employs these allegorical procedures, we discover with unprecedented clarity to what degree the theater of professional facial expressions, performed by television actors in close-ups on the screen, has become the site of domination itself.

This becomes particularly evident in the ingenious juxtaposition of segments from a live broadcast of women speedskating at the Olympics and a segment from the »real-life« soap opera *General Hospital* in her tape *POP-POP-VIDEO: General Hospital/Olympic Women Speed Skating* (1980). Here the artist juxtaposes a series of reverse-angle shots in which a female doctor confesses to her paternal male colleague her failure in handling a communication break-down with a tightly counterpointed spectacle of Olympic vigor and velocity. The splendor of this neo-futuristic imagery that celebrates the subjection of the female body to athletic instrumen-talization only fails to become a new Leni Riefenstahl series on color TV because of the constant intercutting with the spectacle of neurotic collapse in the features of the female doctor.

The tape *1979*, which extracts segments from the game show *Hollywood Squares*, confirms Walter Benjamin's enigmatic observation that neurosis has become the psychological equivalent of the commodity. Birnbaum's selection of details and the formal procedures to which she sub-mits her quotations, reveal the extent to which even the facial expressions of hyperactive televi-sion performers implement ideology. The serial repetition allows for sudden insight into the extent to which the actors' faces, themselves, have become the site of the total instrumentaliza-tion of the individual, down to the very last feature of a spectacle of the physiognomic. Thus, the patterns of behavior on the screen already exemplify what television ultimately aims to achieve within the viewer: pure exercises in mimetic submission.

In contrast to other video artists of her generation, Birnbaum does not use her competence in the analysis of television techniques to develop new video gadgetry employed for the sake of »pure pleasure« or »formal play,« whose purpose is always to aestheticize ideology. In all instances we find that the »visual pleasure« of Birnbaum's tapes is balanced by cognitive shock.

Dara Birnbaum, *Technology/Transformation* (1979), video still

For example, in her work *Wonder Woman*, where the citation of special effects manifestly serves to reveal their patriarchal violence, offering sexualized images of power and technological mirages as a diversion from the reality of social and political life; here the cognitive shock originates partially in the recognition that these sexist representations of a female figure correspond to an actual historical situation in which radical political practice seems to have been restricted to feminist practice alone.

This dialectical approach becomes all the more transparent in the juxtaposition of sound and imagery that occurs in the second part of the tape. While in the first part, staccato serializations and freeze-frame images of a spinning, running, fighting Wonder Woman are accompanied by an original soundtrack that is subjected to the same formal procedures as the images, the second part of the tape consists merely of the lyrics (in white letters on a blue background) of a disco song, by chance also called »Wonder Woman.«[29]

These graphic, scriptural representations of pure phonetics, of female sighs, and of lyrics that we are normally supposed to hear, but not to read, inverts the split of the phonetic and graphic elements of language that we saw earlier in Duchamp's pun. Here, in the scriptural allegorization of the disco song, we become aware that even the most minute and discrete phonetic elements of such popular music (sighs, moans, etc.) are as soaked in sexist and reactionary political ideology as the larger syntactic and semantic structures of the lyrics, or the physiognomic performances of the actors. The dimension of sound plays a very important role in Birnbaum's tapes in general—it does not merely serve as a phonetic illustration to which sound in film and television have been usually reduced. Thus, the restoration of sound to a separate discursive element, running as an equivalent parallel to the visual text, makes the viewer aware of the hidden functions that sound fulfills in industrially produced television.

In one of Birnbaum's recent works, *PM Magazine* (1982), a four-channel video and sound installation,[30] the function of sound is extrapolated even further. At the same time, the presenta-

29 Birnbaum happened to come across this relatively obscure disco song while she was editing the television footage.

30 Variations of the work have been installed at the Hudson River Museum, at the Art Institute of Chicago's *74th American Exhibition*, and at *Documenta 7* in Kassel.

tional devices of the video work are deliberately positioned in a dialogue with painting and sculpture, which make the work emphatically self-conscious of the museum framework within which it is constituted.[31] In this complex installation, the framework of the museum is bracketed on the one hand with the design language of commercial display and advanced media technology, and the historic dimension of avant-garde agitprop montage, on the other. In the video element of the installation, the *PM Magazine* trailer, state-of-the-art animation techniques are juxtaposed with recycled icons of the 1950s American dream of leisure time and consumption. In the same way that the visual material is processed in four three-minute loops, the soundtrack of the trailer —or the key motifs of it—are run through four channels. Once again it is the auditory dimension that generates the work's effects of decentralization. The elements of the installation could only become congruent as »text« within the individual experience of an active viewer. As a result of Birnbaum's self-reflexive structuring of the material, the television conventions and their techno-logical implementation become transparent as the ultimate representational system in which ideology constitutes its subjects.

While it is essential for the work of Birnbaum and Rosler that it operates simultaneously inside and outside the framework of institutionalized art distribution, Levine's work functions exclusively within this framework. Only as a commodity can the work fulfill all its functions, and yet, paradoxically, for the time being it cannot be sold. Its ultimate triumph is to repeat and anticipate in a single gesture the abstraction and alienation from historical context to which work is subjected in the process of commodification and acculturation. In this respect, Levine's and Birnbaum's works reveal a historical affinity to the position of Warhol, the first American dandy to systematically deny individual creation and productivity in favor of a blatant reaffirmation of the conditions of cultural reification. Warhol's once subversive trajectory ended in the institutions of fame and fashion, as surely as de Sade had ended in the Bastille. The fate of his work, which had once subverted painting by precisely the same allegorical techniques of confiscating imagery, bracketing high-art and mass-cultural discourses, individual production and mechanical repro-duction, was to produce the most singularized and rarefied icons of Pop art.

As we have seen, all the artists discussed here appropriate and quote the images and materi-als that they use for their allegorical investigations, in the very manner that the radical conceptual artists of the late 1960s had questioned why artistic practice should be relegated to the status of a spectacularized commodity of individuation. If they have been successful in their critiques, it will be only a temporary success—until acculturation will find new ways to accommodate their

31 Two panels on opposing walls—one framing one monitor, and one three monitors—featured large black-and-white photostat images that had been extracted from the television footage screened in the installation's videotape. A wall surface was painted bright blue for the three-monitor panel and bright red for the one-monitor panel. The panels pos-sessed the qualities of the kind of enlarged photographic imagery that might be encountered in trade-show displays, yet at the same time they were slightly reminiscent of the grand-scale exhibition panels in the later productivist work of El Lissitzky, such as his installation for the Soviet Pavilion of the *International Pressa Exhibition* in Cologne in 1928 with Sergei Senkin, or the *International Hygiene Exhibition* in Dresden in 1930, in which photomontage techniques were expanded onto the level of agitprop architecture. Birnbaum's panels have lost their »agit« dimension for the sake of the museum »prop.« As such, they enter a dialectical relationship with the current return to large-scale figurative multi-panel painting that uses quotation merely as an end to legitimize historicism.

production. For ultimately, it is the visual representation rather than the textual articulation of a construct that imbues it with material reality: the basis of both the commodity form and institutional acculturation. Unlike the artists we considered here, Roland Barthes, when deconstructing the reigning contemporary myths of design, of objects of consumption, and of advertising in his *Mythologies* (1957) did not have to consider the problems of ownership and copyright. In certain respects his approach can still be considered as the originary model for the critique of ideology as it has been developed in the work of the artists analyzed here. But the visual object/image transformed into artistic practice has become—and remains—the essential ideological correlate of private property.

Christopher Williams, *Bouquet, for Bas Jan Ader and Christopher D Arcangelo* (1991)

Thomas Crow

Unwritten Histories of Conceptual Art

Historical objectification ought to be sped up while there is still a collective experience
and memory which can assist in the clarity of an analysis while, simultaneously, opening
up a space to ask fundamental questions regarding history-making.
Michael Asher, 1989[1]

Almost every work of serious contemporary art recapitulates, on some explicit or implicit
level, the historical sequence of objects to which it belongs. Consciousness of precedent has
become very nearly the condition and definition of major artistic ambition. For that reason
artists have become avid, if unpredictable, consumers of art history. Yet the organized discipline
of the history of art remains largely blind to the products of this interest and entirely sheltered
from the lessons that might accrue from them.

That art historians of a traditional cast should display little interest in new art, however
historically informed, is of course a familiar story: within living memory, all art produced since
1600 was merged into the single category of »post-Renaissance.« But recent changes in art his-
tory have not greatly altered the situation, despite the growing prominence in the discipline of
theorists pursuing a postmodern vision of culture. Their particular postmodernism has not grown
from within visual art itself, but derives instead from the contentions within literary theory, most
of all the drive to relax the distinctions between a canon of great authors and the universe of
other texts once excluded from the teaching and learning of literature. Influential voices, im-
pressed by that example, have lately recommended that the idea of a history of art be set aside,
to be replaced by a forward-looking »history of images,« which will attend to the entire range
of visual culture. One benefit of such a change, the argument goes, will be that »the cultural
work of history of art will more closely resemble that of other fields than has been the case in
the past,« and that transformation temptingly »offers the prospect of an interdisciplinary dia-
logue ... more concerned with the relevance of contemporary values for academic study than
with the myth of the pursuit of knowledge for its own sake.«[2]

1 From text by Michael Asher in *L'art conceptuel: Une perspective*, ed. Claude Gintz, exh. cat. (Paris: Musée d'Art
Moderne de la Ville de Paris, 1989), 112.

This is a fair definition of what postmodernism has come to mean in academic life. But as a blueprint for the emancipation of art history, it contains a large and unexamined paradox: it accepts without question the view that art is to be defined by its essentially visual nature, by its working exclusively through the optical faculties. As it happens, this was the most cherished assumption of high modernism in the 1950s and 1960s, which constructed its canon around the notion of opticality: as art progressively refined itself, the value of a work more and more lay in the coherence of the fiction offered to the eye alone. The term visual culture, of course, represents a vast vertical integration of study, extending from the esoteric products of fine-art traditions to handbills and horror videos, but it perpetuates the horizontal narrowness entailed in modernism's fetish of visuality. Its corollary in an expanded history of images (rather than art) likewise perpetuates the modernist obsession with the abstract state of illusion, with virtual effects at the expense of literal facts.[3]

What is plainly missing in this project is some greater acknowledgment of the challenges to modernist assumptions that changed the landscape of artistic practice from the later 1950s onwards. The postmodern art historian of the 1990s cites for support »consequences of the theoretical and methodological developments that have affected other disciplines in the humanities.«[4] But the revival of Duchampian tactics in the hands of artists like Jasper Johns, Robert Morris, and Donald Judd long ago erased any effective elite/vernacular distinctions in the materials of art, while at the same time opening contexts and hidden instrumental uses of art to critical scrutiny. The great theoretical advantage of this activity, as opposed to doctrines imported from other disciplines, was its being made from existing art and as such requiring no awkward and imprecise translation in order to bear upon the concerns of art history. Nor could these practical artistic ventures be contained within the category of the image, a fact which a succeeding generation of overtly conceptual artists then took as fundamental. The »withdrawal of visuality« or »suppression of the beholder,« which were the operative strategies of Conceptualism, decisively set aside the assumed primacy of visual illusion as central to the making and understanding of a work of art.[5]

During the early 1970s, the transitory, hazardous, and at times illegal performances staged by Chris Burden remained, apart from a select group of collaborators, unavailable to spectatorship.[6] The photographic documentation by which such events were subsequently publicized serves to mark the inadequacy of recorded image to actual phenomenon. Conceptual work of a materially substantial and permanent character was no more amenable to the category of visual culture. Works like the *Index* of the Art & Language group dared the spectator to overcome a positively forbidding lack of outward enticement in order to discover a discursive and philosophical content recorded in the most prosaic form possible.

2 Editors' introduction in *Visual Culture: Images and Interpretations*, ed. Norman Bryson, Michael Ann Holly, and Keith Moxey (Hanover, NH: Univ. Press of New England, 1994), xvii.

3 The classic polemic advancing this position is Michael Fried, »Art and Objecthood,« in *Minimal Art*, ed. Gregory Battcock (New York: Dutton, 1968), 116–47.

4 Bryson et al., *Visual Culture*, xvii.

5 These two formulae are the coinages of Benjamin H. D. Buchloh and Charles Harrison respectively.

6 The most notorious instance is *Shoot* (1971), to which could be added *TV Hijack* (1972), *747*, *Icarus*, and *Trans-Fixed* (1973); see Anne Ayres, and Paul Schimmel, eds., *Chris Burden: a twenty-year survey* (Newport Beach, CA: Newport Harbor Art Museum, 1988), 53–54, 59–60, 66.

Even in discrete objects in traditional formats there is something of a tradition—stretching from Elaine Sturtevant to Sherrie Levine—whereby the visual appeal of painting or photography is acknowledged but expelled by tactics of replication.[7] Perhaps as revealing as any theoretical exegesis is a bantering remark made in a recorded conversation between two collectors, both perceptive enough to have supported Sturtevant:

> I am sure that you have often noticed that visitors to your apartment—like the visitors to our loft—shrug off the Warhol or the Stella before you tell them that it is Sturtevant. Watch how their eyes roll! Their hair stands on end! Their palms collect sweat! Over and over they fall to fighting, arguing, debating. If this isn't the shock of the new, then the term is meaningless. Art is involved with so much more than visual appearance, as television has very little to do with the eye, or radio with the ear.[8]

His interlocutor replies, with equal accuracy and equal heat, that Sturtevant suffered abuse and ostracism during the 1960s and 1970s for having so acutely defined the limitations of any history of art wedded to the image. Those now defining themselves as historians of images rather than art have so far shown little capacity to grasp the practice of artists on this level, certainly none that adds anything to that already achieved by the practitioners themselves. Instead, they reproduce the exclusions traditional to their discipline, validating the past centrality of painting and its derivatives, which are most easily likened to the image world of the modern media and to unschooled forms of picturing.

But Conceptualism, which long anticipated recent theory on the level of practice, can be encompassed only within an unapologetic history of art. Its arrival in the later twentieth century recovered key tenets of the early academies, which, for better or worse, established fine art as a learned, self-conscious activity in Western culture. One of those tenets was a mistrust of optical experience as providing an adequate basis for art: the more a painting relied on purely visual sensation, the lower its cognitive value was assumed to be. The meaning of a work of art was mapped along a number of cognitive axes, its affinities and differences with other images being just one of these—and not necessarily the strongest. Art was a public, philosophical school; manipulative imagery serving superstitious belief and private gratification could be had from a thousand other sources.

It was only in the later nineteenth century that the avant-garde successfully challenged a decayed academicism by turning that hierarchy on its head: the sensual immediacy of color and textured surfaces, freed from subordination to an imposed intellectual program, was henceforth to elicit the greater acuity of attention and complexity of experience in the viewer. The development of Conceptual art a century later was intended to mark the limited historical life of that strategy, but postmodern theory has had the effect of strengthening conventional attachments to painting and sculpture. The art market quite obviously functions more comfortably with

7 See the discussion in Crow, »The Return of Hank Herron: Simulated Abstraction and the Service Economy of Art,« in *Modern Art in the Common Culture*, 69–84.
8 Douglas Davis in Eugene W. Schwartz and Davis, »A Double-Take on Elaine Sturtevant,« File, December 1986, n.p. Davis also relates the remarkable story of Duchamp's reaction, in the year before his death, to Sturtevant's restaging of his performance *Relache*.

discrete, luxury objects to sell; and the secondhand, quotation-ridden character of much of the neotraditionalist art of the 1980s has been well served by theorists (Jean Baudrillard being a leading example) who have advanced the idea of an undifferentiated continuum of visual culture.

The aspirations of Conceptualism have been further diminished by a certain loss of heart on the part of its best advocates, who are united in thinking (amid their many differences) that the episode is essentially concluded. Benjamin H. D. Buchloh has voiced this general conclusion when writing that Marcel Broodthaers »anticipated that the enlightenment-triumph of Conceptual Art, its transformation of audiences and distribution, its abolition of object status and commodity form, at best would only be short-lived and would soon give way to the return of the ghost-like re-apparitions of (prematurely?) displaced painterly and sculptural paradigms of the past.«[9]

Charles Harrison, editor of the journal *Art-Language*, laid down the requirement for any Conceptual art aspiring to critical interest that it conceive a changed sense of the public alongside its transformation of practice. But on precisely these grounds, he finds the group's own achievement to be limited: »Realistically, Art & Language could identify no *actual* alternative public which was not composed of the participants in its own projects and deliberations.«[10]

In Jeff Wall's view, that isolated imprisonment was the cause of the pervasive melancholy of early Conceptualism: both »the deadness of language characterizing the work of Lawrence Weiner or On Kawara« and the »mausoleum look« embodied in the gray texts, anonymous binders, card files, and steel cabinets of Joseph Kosuth and Art & Language. »Social subjects,« he observes, »are presented as enigmatic hieroglyphs and given the authority of the crypt,« pervasive opacity being an outward betrayal of art's rueful, powerless mortification in the face of the overwhelming political and economic machinery that separates information from truth.[11] The ultimate weakness of this entire phase of art for him lies in its consequent failure to generate any subject matter free from irony. For both Harrison and Wall, their pessimistic verdicts on the achievements of Conceptual art have led them to embrace monumental pictorialism as the most productive way forward, a move that sustains the idea of an encompassing visual culture as the ultimate ground for discussion.

These three names represent the most formidable historians of Conceptual art, and their strictures must be treated with all possible seriousness. If the history of Conceptual art is to maintain a critical value in relation to the apparent triumph of visuality, it must meet the conditions implied in their judgment on its fate: 1) it must be living and available rather than concluded; 2) it must presuppose, at least in its imaginative reach, renewed contact with lay audiences; and 3) it must document a capacity for significant reference to the world beyond the most proximate institutions of artistic display and consumption.

Christopher Williams is by no means the only artist whose body of work offers significant individual pieces that answer these conditions. Among the many important aspects of his work is a careful attention to the precise, contingent history of Conceptual art practices, which puts

9 Benjamin H. D. Buchloh, »From the Aesthetic of Administration to Institutional Critique,« in Gintz, *L'art conceptuel*, 53.
10 Charles Harrison, »Art Object and Artwork,« in Gintz, *L'art conceptuel*, 63.
11 See Jeff Wall, *Dan Graham's Kammerspiel* (Toronto: Art Metropole, 1991), 19. William Wood offered helpful comments on this and other points in this essay.

his enterprise on an equal footing with the written histories of the phenomenon. *SOURCE: The Photographic Archive, John F. Kennedy Library* ..., for example, marked an overt return to the mimicry of bureaucratic information and classification that characterized Conceptualism in its early years, the reflex that Buchloh has termed »the aesthetic of administration.« [12] With that 1981 piece, in advance of Wall calling explicit attention to Conceptualism's »authority of the crypt,« Williams undertook his own remapping of material stored in an institution that is both a funerary monument and an index of official secrecy and power.

The analysis of the imaginary regime of power takes place through mechanical sorting, a simple identification of flaws or noise in a system. Its instant evocation of similar devices deployed by first-generation conceptualists amounts to a claim to satisfy the first condition, the continuity of Conceptual art in the present. An inescapable point of comparison exists in Andy Warhol's immediate response to the first Kennedy assassination, his manipulation of a limited, rudimentary repertoire of images. The simple diagnostic device that Williams applied to the system of the presidential archive yielded a series that is likewise comprehensible within popular narrative and for that reason potentially available to a much wider audience.

His *Angola to Vietnam** of 1989 incorporates the lay spectator even more firmly within an analysis of information and power, while simultaneously addressing the enormous inherent difficulty of figuring political reality into serious art. On the surface, this seems a surprising result, in that the method of the piece adheres so closely to the procedures of early Conceptualism. Like the Kennedy archive intervention, however, it disputes Wall's assertion that Conceptual art could undertake no subject matter in good faith. This is to say, Williams demonstrates that even if Conceptual art rarely found its subject matter, it possessed the keys to new modes of figuration, to a truth-telling warrant pressed in opposition to the incorrigible abstraction that had overtaken painting and sculpture in traditional materials.

The strict symmetry in *Angola to Vietnam** between photograph and written caption had its precedent in one signal instance of such strong descriptive meaning from the 1970s—Martha Rosler's *The Bowery in two inadequate descriptive systems*.[13] Though not primarily identified as a Conceptualist, Rosler added a milestone to the practice with this single piece. *The Bowery* juxtaposed a series of strictly depopulated photographs of derelict storefronts with a running list of American slang expressions for drunks and drunkenness, from familiar to arcane, from whimsical to despairingly bleak. The anti-expressive intensity in the combination of text and photograph defies both ordinary pathos and critical paraphrase. And that rigorous formal regulation and documentary exactness is in turn undergirded by the fundamental precedent of Hans Haacke's *Shapolsky et al. Manhattan Real Estate Holdings, a Real-Time Social System, as of May 1, 1971*, which framed the economic system underlying urban decay and homelessness. [14] There, the artist operated entirely within the established systemic and serial logic that governed the advanced art of the moment. But by introducing only one allowable shift in the matter disposed

12 Buchloh, »From the Aesthetic of Administration to Institutional Critique,« in Gintz, *L'art conceptuel*.

13 Published in Martha Rosler, *Three Works* (Halifax: Press of the Nova Scotia College of Art and Design), 1981.

14 *Hans Haacke: Unfinished Business*, exh. cat. (New York: New Museum of Contemporary Art, 1986), 92–97; he also produced a parallel piece *Sol Goldman and Alex DiLorenzo Manhattan Real Estate Holdings, a Real-Time Social System, as of May 1, 1971*, illustrated on 88–91.

in the system—in this case the interlocking, clandestine ownership network of a fabulously lucrative network of slum properties—he generated an economic X-ray of both the geography and class system of New York City. *Shapolsky et al.* generated a mode of description likewise beyond paraphrase, which then turned around on the art world with notoriously explosive consequences, when the director and board of the Guggenheim Museum banned its exhibition.[15]

In addition to the strongly referential mapping established in these examples, Williams also shares Haacke's recognition of audience composition, as manifested in the polls and visitor profiles that the latter elicited in various installations from 1969 to 1973.[16] *Angola to Vietnam** takes that preoccupation one step further in its choices of primary material, thereby forcing the gallery-bound viewer imaginatively to enter a directly analogous, but distinctly different space of confrontation between exhibits and spectators. Williams enlisted *in absentia* the alternative public attracted by the Harvard glass flowers in order to undo the mordant assumption of failed communication common in orthodox Conceptualism. In that space, the artist is in no position to make judgments about competence, as he or she shares the incompetence of many of the visitors—and is likely to be inferior to the expertise of the truly impressive amateurs of horticulture (just as audiences in public museums and galleries are more various and more alert to difficult work than many art professionals assume). Despite the pessimistic conclusions of Art & Language, among others, the pretensions of ostentatious art lovers need never have been confused with the potential state of any and all audiences.

Lingering aura may have become an embarrassment when attached to fine-art objects but it exists in any form of relic, which is necessarily a repository of memory, and a relic may be turned to critical use without violating its other functions. Early Conceptual art had taken the work of art, conventionally understood as a synthesis of warmly subjective visual expression, and mapped it onto coldly utilitarian categories of information. Williams proceeded in a symmetrically opposite direction: he began with actual, abstract taxonomies (one scientific, one ethical and political) and presented them through their existing visual tokens, strictly adhering to the requirements of administrative rationality. But through these very means he arrived at the subjective depth, the inseparability of feeling and form, once plausibly promised by traditional artistic means, while investing the work with a moral intelligence that is thoroughly contemporary.

At the end of the twenty-seven captioned photographs of *Angola to Vietnam**, Williams placed a single image entitled *Brasil*, which was no more than a tear sheet cover from the French edition of the fashion Magazine *Elle* (hence the spelling) featuring the smiling faces of a multi-ethnic group of models, each wearing a hat labeled with a different country of origin. This was a further palimpsest, a ghastly map of the world drawn by multinational image production. Without any declamatory moralizing, he put his finger on the connection between global consumption and global repression, a recognition that gains much of its force by the disparity startlingly opened up between fine print and pure ready-made.

At the level of comparative practices in art, *Brasil* deftly called the bluff of certain image appropriators, the so-called Simulationists, who had enjoyed their brief success in the later

15 For a recent account of the incident, see Rosalyn Deutsche, »Property Values: Hans Haacke, Real Estate, and the Museum,« in ibid., 20–37.
16 See ibid., 76–79, 82–87, 98–106.

1980s by illustrating academic enthusiasm for the idea of an image-saturated, postmodern culture. The bluff is called because the political incisiveness of Williams's appropriation depends on the complete non-identity, the severing of continuity, between *Brasil* and the universe of images to which it materially belongs down to the last molecule: the framed sheet is not advertising-image-plus-ironic-frame; it is a marker for the utter bankruptcy of administered imagery, an uncompromising cancellation of the visual rendered in paradoxically visible form.[17]

This device also proved to be the key to a further, more recondite return to the history of Conceptual art. The *Brazil/Brasil* repetition singled out the only country found in both the Amnesty International list and the *Elle* cover. In *Bouquet* (1991), Williams redoubled his displaced cross-references, pushing the list of countries ready-made in the magazine photograph back through a botanical map of the world to generate the names of eight varieties of flower available as live specimens. Los Angeles floral designer Robert C. Smith was then enlisted to arrange the cut blossoms across a damask-covered tabletop. At the center of the work is a photograph in color of the Smith arrangement.

The published version of the piece also features a plain, monochrome frontispiece showing the art-historical archives maintained by the Getty Center for the History of Art and the Humanities in a warehouse in the Marina del Rey district of Los Angeles.[18] For Wall, Conceptual art figures the crypt that art becomes when rendered into information; Williams records a ready-made stand-in for that characteristically deadened and hermetic mode of presentation. As in his earlier pieces, however, he instantly shifts the resonance of institutional morbidity to one of actual human loss, dedicating the installation to two Conceptual artists who took their own lives: Bas Jan Ader and Christopher D'Arcangelo.

The deliberately solipsistic means used by Williams to generate the botanical varieties of *Bouquet* reproduce the hermeticism so often adopted by Conceptual art as simultaneous provocation of and protection from inappropriate forms of attention. At the same time, the declared referents and the vernacular subject of the photograph force the committed viewer to confront a large gap in the collective memory. Existing accounts of Conceptual art are notably selective; their emphasis on the lessons of a closed episode limits analysis to a high level of abstraction; individual works enter these histories only if they exemplify a general characteristic, speak to general conditions, and look forward to that end with particular vividness or strength. The task of recovering the living potential of Conceptualism, however, requires awareness of the fullest possible range of precedents. Ader and D'Arcangelo both closed their careers pursuing different but equally extreme forms of self-effacement, and to that extent they stand for a lost continent of forgotten activity. *Bouquet* is an example of a work of art that demands further work not only from the professional historian of art, but also from the historian inside every serious viewer.

17 For an opposite, illuminating (if inelegantly titled) reflection on the link between multiculturalist sentiment and the demands of international marketing, see David Rieff, »Multiculturalism's Silent Partner: It's the newly globalized consumer economy, stupid,« in *Harper's Magazine*, CCLXXXVII (August 1993): 62–72; *Brasil* makes more or less the same points instantaneously.

18 See Christopher Williams, *Bouquet, for Bas Jan Ader and Christopher d'Arcangelo* (Cologne: Galerie Max Hetzler, 1991). Louise Lawler, Allen Ruppersberg, and Catherine Gudis offered advice and information that greatly aided my research for this section of the essay.

Had Ader not been lost at sea in 1975, during an attempt to complete his three-part performance *In Search of the Miraculous,* his subsequent recognition might have been substantial. The second element of this work, completed in 1973, embodies much of that promise. Subtitled *One Night in Los Angeles*, it documents a dusk-to-dawn journey, undertaken by the artist on foot, from an inland valley in southern California to the sea. The evocations of the place and its mythology are manifold: the freeways (along which walking is forbidden), the nocturnal crime scenes of Hollywood *film noir:* the Pacific as the stopping point of westward migration. Ader's slight, indistinct presence is doubled in another register by a contrastingly emphatic and rhythmically sharp voice, rendered in white script in a line linking the rows of images. Each photograph is secured in the sequence by a phrase from the Coasters' hit of 1957, *Searchin'* (written by Jerry Lieber and Mike Stoller, its narrator elsewhere invokes the pulp detectives Sam Spade and Bulldog Drummond in his pursuit of a lover). Even viewers who have never heard the song will pick up its rollicking beat; the script gives the piece movement and flair, mocks incipient self-importance, and through its good humor manages to elicit a poignancy from the hackneyed theme of the quest.

Knowledge of what came after can make that poignancy almost unbearable. The third element of *In Search of the Miraculous* represented a literal going on from the last photograph in *One Night in Los Angeles,* though he transferred his point of departure from the West Coast to the East, looking back toward his European origins. In 1974, he conceived the idea of completing the work with a solo voyage in a small sailboat from Cape Cod to Cornwall in Britain (a wildly ambitious leap beyond Chris Burden's *B.C. Mexico* of 1973). During the spring of the following year, his notion became a firm project, undertaken with every apparent expectation of success: he had arranged for a show documenting the project to take place in Amsterdam, and plans were in place to exploit success in the sixty-day crossing with further exhibitions of material generated by his feat.[19]

But all these signs of calculated sensationalism in the service of career are belied by the fragility of his thirteen-foot craft and by the fact that, despite having some experience on boats, his seamanship seems to have been entirely untested at the requisite level. The voyage calls to

Christopher Williams, *Bouquet, for Bas Jan Ader and Christopher D Arcangelo* (1991), detail and installation view

mind less Burden's Robinson-Crusoe foray in the Sea of Cortez and more the suicidal venture across the Gulf of Mexico by the unstable Dada provocateur Arthur Craven. Deliberately or not, Ader's adventure amounted to reckless self-endangerment and was the nearest thing to suicide.

Though Dutch-born, Ader had received most of his art training in southern California and joined the first wave of West-Coast Conceptualism at the end of the 1960s (Williams's catalogue illustrates the postcard piece *I'm Too Sad To Tell You* from 1970.[20] Almost entirely overshadowed since by the sustained careers of Burden and Bruce Nauman, his work was at that stage operating in similar territory, including the translation of elementary verbal constructions into performance—notably a photograph and film series on falling, as from the roof of his California bungalow or into an Amsterdam canal from a bicycle. With similar simplicity, Williams's horizontal bundle of flowers mirrors both the falling performances and the terrible, unseen moment when Ader must have been pitched from his boat (which was found half-submerged six months later off the coast of Ireland). The position and framing of the bouquet further echo Williams's memorials to political martyrdom in *Angola to Vietnam**.

At the same time, *Bouquet* leavens that funereal cast by evoking the humor of Ader's work, notably evident in an untitled photo-montage and the video *Primary Time* of 1974, where he

19 See Paul Andriesse, *Bas Jan Ader* (Amsterdam: Openbaar Kunstbezit, 1988), 82–83, 89–90. (I am grateful to Patrick Painter for providing me with this document), 82: »On July 9, 1975 he sails from Cape Cod with Falmouth, England as his destination. He estimates that the trip will last sixty days. In order to record the voyage, he takes along a camera and tape recorder. Ader's gallery Art & Project publishes a bulletin, designed by him, in July 1975 which gives publicity to this voyage *In Search of the Miraculous*. The bulletin consists of a large photograph of Ader in his boat at sea and the sheet music for the song »Life on the Ocean Wave.« Ocean Wave is also the name of the boat. Agreements have been made with the Groninger Museum to make an exhibition which would constitute the third part of the triptych«.

On Burden's piece, see his own description in Ayres, Schimmel, *Chris Burden*, 62:

»Newspace, Newport Beach, California, May 25–June 10, 1973. I was dropped off in San Felipe, Mexico, on the Sea of Cortez. In a small canvas kayak I paddled southward to a remote beach, carrying some water with me. I survived there for 11 days; the average daily temperature was 120 degrees. On June 7, I paddled back to San Felipe and was driven to Los Angeles. The piece had been announced by Newspace, and during my stay in Mexico a notice in the gallery informed visitors of my absence. On June 10 at Newspace, I showed a short movie of my departure and read a diary I had kept«.

20 Andriesse, *Ader*, 86–87.

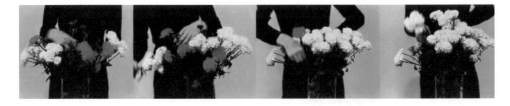

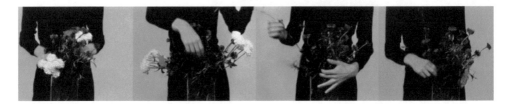

awkwardly arranged and disarranged a bunch of flowers in a vase. Removing and replacing individual stems, using a reserve supply strewn on a tabletop out of camera range, his actions gradually shift the arrangement toward one of its three primary colors. When a single color is achieved, the slow, apparently aimless procedure begins again, passing slowly through heterogeneity towards another monochrome. Making their belated appearance in *Bouquet* are stand-ins for the flowers that once lay on the invisible table as Ader carried out his wry homage to, and mockery of, Mondrian, Rietveld, and the floral clichés about his native country.

The eclipse of Ader's disorganized but burgeoning career overtook him in a fit of romantic, even mystical self-dramatization; D'Arcangelo's obscurity as an individual creator was willed by him from the start. In one important group exhibition at Artists Space in 1978—which helped to launch his co-participants toward wide acclaim—his contribution consisted in the removal of his name from the installation, catalogue, and publicity. No intervention could have caused greater difficulties for the critic and historian, in that any precise citation of D'Arcangelo's piece would destroy the grounds of its existence; indeed, it is probably impossible to cite the contributions of the other three artists in light of his participation without doing the same (silence will be maintained here).

The bulk of D'Arcangelo's work, ended by his unexpected suicide in 1979, comprised nominating utilitarian carpentry (generally alterations to New York loft spaces) as works of art, which he defined by his input of labor and materials rather than by any phenomenal aspect they might possess. In the installation of *Bouquet*, Williams hung the framed floral photograph on a temporary section of wall, standing out in the space of the gallery. This stud and sheetrock construction faithfully adheres to the materials specified in *Thirty Days Work*, an exhibition space that D'Arcangelo had executed with Peter Nadin and Nick Lawson at 84 West Broadway, New York, in preparation for a 1979 show which included Nadin, Dan Graham, Louise Lawler, and Lawrence Weiner. Williams, in his positive extrusion of what was once deliberately anonymous background matter, puts certain obvious metaphors to work: the burial of D'Arcangelo's work as part of its premise makes Williams's wall into a tomb of the unknown artist; it recalls the romance of the »art-worker« period of the 1970s; it extracts from lost history an *artistic* defla-

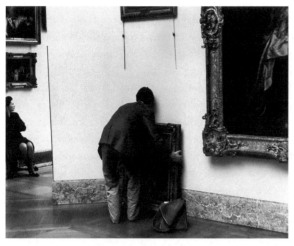

Bas Jan Ader, *Untitled* (*flowerwork*, 1974),
8 of 21 color photographs

Christopher D'Arcangelo, performance
(c. 1976), Musée du Louvre, Paris

tion of Minimalism's pretentious phenomenology which can stand with Graham's seminal *Homes for America* of 1966.[21] As *Homes* assumed a disguise that made it difficult to detect against its art-magazine background, D'Arcangelo's collaborative work often owed the most substantial part of its existence to the postcard announcing the exhibition, which was otherwise more or less inaccessible to actual viewing.

The public manifestation of *Bouquet* coexists with another mode of presentation: private owners of the work (which exists as a multiple edition) may or may not have the same wall built, but in its absence the framed photograph must be leaned against rather than hung on an existing wall. That offering-like position at floor level in turn recalls a second aspect of D'Arcangelo's practice, this one in the realm of performance, when he would enter museums, surreptitiously lower paintings to the floor and leave them leaning against a wall. A ritualistic motif of falling, sacrifice, and commemoration continually recurs in the life of *Bouquet*, encoded in this instance in a plain instruction concerning its position in a room.

The complex investigations invited by the piece (no more than sketched here) transform Conceptual art from something cold and impersonal into a drama of lives driven onto treacherous emotional shoals. This move carries some risk in a postmodern intellectual culture imbued with suspicion of all reference, especially to themes of self-sacrifice in biographies of artists. But Williams makes plain that an attitude of complacent superiority to the real pain and loss that artistic commitment can entail is part and parcel of a regime of art-historical ignorance. And in these two cases, the impact of *Bouquet*, its power to compel curiosity, has in fact begun to dispel some of that indifference.[22]

But Williams risks, it must be said, a potentially high aesthetic and ethical cost for that accomplishment. This is less the case with the photograph as a tribute to Ader, buttressed as

21 Wall, as it happens, admits this last work as the unique piece of Conceptual art to have managed non-ironic subject matter (*Kammerspiel*, 28), this being the hidden coincidence between minimalist principles and the production logic of postwar housing under conditions of military-spending inflation. On both logical and historical grounds, however, there cannot possibly be just a single exception.

22 See James Roberts, »Bas Jan Ader: the artist who fell from grace with the sea,« in *Frieze* (Summer 1994): 32–35, and a thoughtful, well-informed piece by Collier Schorf, »This Side of Paradise,« in ibid.: 35–37.

it is by its participation in the system of *Angola to Vietnam**, and congruent as it is with its subject's public flamboyance in life (though the very success of the piece runs the danger of encouraging others to make Ader into a retrospectively romanticized cult figure, leaving the same deeper amnesia to be dislodged all over again). Calling attention to D'Arcangelo's private despair is more of an intrusion, most of all because the enterprise of historical narrative can only violate the fierce reticence of the artist's work. The wall, when installed in a 1990s gallery, may well appear as an alien architecture belonging to another time and another set of ethical priorities. But in quoting *Thirty Days Work* as a demarcated object—the phenomenal antithesis of what it once stood for—*Bouquet* takes upon itself the fallen condition of the merely visual. In an important way, the piece has to make this sacrifice of an imaginary state of integrity: that gesture in itself constitutes a tribute to the severity of its predecessor, and its risk of compromise has proven to be the condition of anything at all being said about its subject. The solidity of the wall marks a temporal boundary, dividing the time during which D'Arcangelo's intentions were respected by silence from a future that cannot afford that respect, lest it lose all memory of why those intentions mattered.

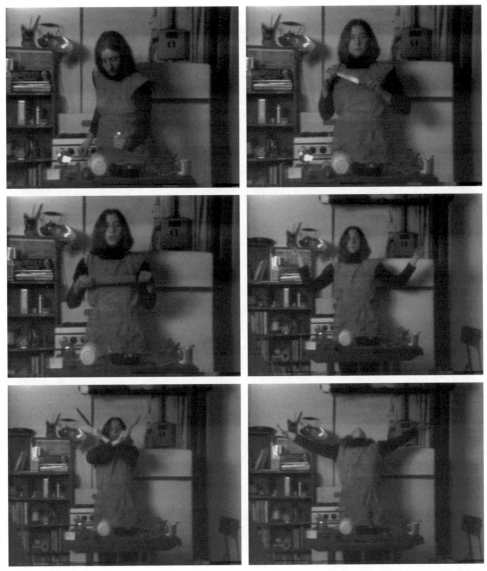

Martha Rosler, *Semiotics of the Kitchen*
(1973–74), video stills

Helen Molesworth

House Work and Art Work

Laughter in the face of serious categories is indispensable for feminism.
Judith Butler, *Gender Trouble*, 1990

The much-noted eclecticism of 1990s art practice appears to have been countered only by a steady fascination with and revival of art from the 1970s. This interest, shared by artists, critics, historians, and curators, generated numerous exhibitions and publications dedicated to the feminist work of the period.[1] That such interest in 1970s feminist practice is long overdue perhaps goes without saying, although for many it has emerged as either a mysteriously forgotten moment or the return of the repressed. In both guises many of these stagings have continued, unfortunately, to consolidate a logic of »us« and »them,« a structure of bitter binary opposition, an intellectual disjuncture between feminist work based in »theory,« poststructuralism, or social constructionism, and work derived from the so-called principles of »essentialism.«[2] Far from an attempt to set the record straight, or to ascertain definitively what did or did not happen, this essay is motivated by a need to rearticulate the current reception's account of the relations

This essay has benefited from many interlocutors. An audience at UCLA asked particularly probing questions, especially Michael Asher, who encouraged me to examine the work of Martha Rosler. Amelia Jones generously shared her thoughts and expertise on *The Dinner Party*. Moyra Davey, Rosalyn Deutsche, Christina Kiaer, Janet Kraynak, Miwon Kwon, Sowon Kwon, Frazer Ward, and Faith Wilding all helped as critical readers. An earlier version of this essay was published in *Rewriting Conceptual Art*, ed. Michael Newman and Jon Bird (London: Reaktion Books, 1999).

1 In the past few years, numerous exhibitions have taken place, to name but a few: Mary Kelly's *Post Partum Document* was reassembled in its entirety by the Generali Foundation in Vienna, Austria (25 September–20 December 1998); Martha Rosler is the subject of a traveling retrospective organized by Ikon Gallery in Birmingham, UK; Mierle Laderman Ukeles's *Maintenance Art Series* was shown in its entirety at the Ronald Feldman Gallery, New York; Judy Chicago's *The Dinner Party* was the centerpiece of an exhibit curated by Amelia Jones at the Armand Hammer Museum, Los Angeles (24 April–18 August 1996); *Division of Labor: Women and Work* was held at The Bronx Museum (1996); and the *Bad Girls* exhibition took place at the New Museum, New York (14 January–27 February and 5 March–10 April 1994). So, too, books and journals have proliferated: *October* dedicated an entire issue to the question of feminism, replete with a questionnaire and a roundtable (*October* 71 [Winter, 1995]); Laura Cottingham produced *Not For Sale* (1998), a video essay designed for teaching feminist art; *Feminism and Contemporary Art: The Revolutionary Power of Women's Laughter* by Jo Anna Isaak appeared in 1996 (London: Routledge); Mira Schor's award-winning *Wet: On Painting, Feminism, and Art Culture* (Durham/London: Duke University Press, 1997) also appeared recently; and *The Power of Feminist Art* brought together in one volume a commanding overview of American feminist art of the 1970s (New York: Harry N. Abrams, 1994).

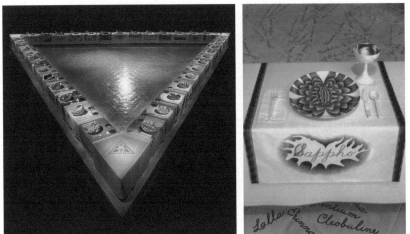

Judy Chicago,
The Dinner Party
(1979), installation
view and detail

between these two bodies of work. More precisely, it seeks to reconsider four artists at work in the 1970s—Judy Chicago, Mary Kelly, Mierle Laderman Ukeles, and Martha Rosler—artists whose works have been caught in an interpretive blind spot created by the current reception's perpetuation of the antagonism between feminist art of the 1970s and 1980s.[3]

Despite the breadth and complexity of the issues—the diversity of practices within each, somewhat loosely defined, »camp«—a certain reduction has taken place in the current reception of 1970s feminist work, an intellectual fault line broadly described in generational terms. And as the disjuncture between feminist practices from the 1970s and 1980s is repeatedly historicized as a permanent rupture, we currently receive these strained relations in the form of a caricature. This situation is perhaps most problematic and prevalent in the classroom, where the debate is often hypostatized into an art-historical compare-and-contrast, iconically represented by two seemingly antithetical art works: Judy Chicago's *The Dinner Party* and Mary Kelly's *Post Partum Document*—works taken to be exemplary of an essentialist approach in Chicago's case, and a theory-based feminist practice in Kelly's case. Although both works were completed in 1979, they have been rendered crudely oppositional and hierarchized, and are often asked to bear the weight of a generational split—from the 1970s to the 1980s—as well as presenting, equally self-evidently, the »progression« in feminist art *from* essentialism *to* theory.[4] The language of progress is used across the board; listen as Lisa Tickner argues that the »adolescent vitality of 1970s feminism matured successfully into a body of rigorous 1980s art and criticism.«[5]

2 Under the umbrella of »essentialism,« I am referring to artists and critics such as Norma Broude, Mary D. Garrard, Judy Chicago, Harmony Hammons, Suzanne Lacy, Lucy Lippard, Ana Mendieta, Faith Ringgold, Miriam Schapiro, Mira Schor, Faith Wilding, the artists involved in Womanhouse, and the Feminist Art Program. And with regard to poststructuralism, I'm thinking here of the work of Victor Burgin, Mary Kelly, Silvia Kolbowski, Barbara Kruger, Kate Linker, Laura Mulvey, Griselda Pollock, Cindy Sherman, and Lisa Tickner.

3 For a more elaborated account of this debate, see my »Cleaning Up in the 1970s: The Work of Judy Chicago, Mary Kelly and Mierle Laderman Ukeles,« in Newman, Bird, *Rewriting Conceptual Art*.

4 Given that the works were made in the same period, clearly this is not the case. However, they were made in different geographical locations within which extremely different types of feminist discussion were taking place. See Mary Kelly's remarks to this effect in »A Conversation on Recent Feminist Art Practices,« in *October* 71 (Winter 1995): 46–69.

Mary Kelly, *Post Partum
Document I. Prototype*
(1974), 1 of 10 elements,
and *Post Partum
Document VI* (1977–78),
1 of 18 elements

Similarly, Griselda Pollock demarcates a shift from a politics of »liberation« to a »structural
mode of analysis.«[6] And Faith Wilding, a member of Womanhouse, described some 1970s artistic
experiments, particularly cunt imagery, as »crude ... precursors for a new vocabulary for repre-
senting female sexuality and the body in art.«[7]

The logic of progress has done much to codify this classic pairing of post-1960s art into a
stale binarism: all contrast, no comparison. Yet perhaps we can loosen the starched opposition
of essentialism »versus« theory, by acknowledging that the model of compare-and-contrast need
not only produce dismissive hierarchies, or generational or oppositional binarisms. It is a model
equally well designed to elaborate on moments of affinity and shared concerns (not yet acknowl-
edged), *as well as* moments of contestation and difference (which have been insisted on more
forcefully).

Despite various challenges to this generational/progressive frame, it has stiffly endured. The
tenacity of the division occludes a more pedestrian question: Why is this particular art-historical
debate so problematic? For instance, why don't we simply say »Both sides have strong and weak
points,« and pluralistically be done with it? As unproductive as this debate has been, merely to
paper over significant aesthetic, ideological, and philosophical differences would be to run the
risk of consolidating the category heading »feminist art.« As a codified »movement« (however
internally fractured), feminist art is stripped of its transformative power.[8] Rendered separate and
distinct, and hence easier to marginalize, it is unable to challenge and modify our definitions of
other artistic categories, the result of which has been to prohibit articulations of the connective
tissue between these works and the putatively »dominant« conversations simultaneously being

5 Lisa Tickner, *October* 71 (Winter 1995): 44.

6 Griselda Pollock, »Painting, Feminism, History,« in *Destabilizing Theory*, ed. Michele Barrett and Anne Phillips
(Stanford, CA: Stanford University Press, 1992), 154.

7 Faith Wilding, »The Feminist Programs at Fresno and Cal Arts, 1970–75,« in *The Power of Feminist Art*, ed. Norma
Broude and Mary D. Garrard (New York: Harry N. Abrams, 1994), 35.

8 Mary Kelly has frequently argued against the category »feminist art.« Arguing against the notion of a cohesive »style«
of feminist art, she proposes instead the notion of art »informed by feminism.« See the exchange between Kelly and
Silvia Kolbowski in »A Conversation on Recent Feminist Art Practices« in *October* 71 (Winter 1995): 49–69.

held in the art world.[9] One way, perhaps, to reread the theory/essentialism split is to see artists during the 1980s—in the Pictures group, for instance—as consciously working with ideas such as the theory of representation precisely as a way to avoid the problems of the marginalization of »feminism.«[10] So, too, we could see that it was clearly important for feminists to be able to disagree, and even fight with, previous generations of feminists, as a way both to open the field of inquiry and to proliferate its influence. Currently, however, the continual rehearsing of the theory/essentialism debate, only to choose sides at the end, has disallowed other interpretive formations to arise. For instance, the division may serve to maintain, rather than expand, the rather limited range of feminist theory that operates in the art world. There currently exist critical feminist discourses other than Anglo-American empiricism and continental theory; and the chasm between them has been navigated, most notably, by political philosophers. In other words, we need not be bound only to the interpretive models that have traditionally accompanied each body of work, but we can also look to the tools and interpretive possibilities offered by the feminist critique of political philosophy.

In *Feminism and Philosophy*, Moira Gatens has staged the feminist debate in terms of those who privilege a model of equality and those who think in terms of difference.[11] These terms are analogous to the essentialism/theory split and Gatens astutely problematizes both positions. First, she sets out to dismantle the idea of equality. She argues that the problem with the model of »equality in the public sphere« is that »… the public sphere is dependent upon and developed around a male subject who acts in the public sphere but is maintained in the private sphere, traditionally by women. This is to say that liberal society assumes that its citizens continue to be what they were historically, namely male heads of households who have at their disposal the services of an unpaid domestic worker/mother/wife.«[12]

These services have become so naturalized that »clearly, part of the privilege accorded to members of a political body is that their needs, desires, and powers are converted into rights and virtues.«[13] In other words, Gatens suggests that the political realm within which women struggle for equality, such as democracy, must be disarticulated, not presumed a priori to be a »neutral« system, except for its *inability to grant women equality*. The system is founded on inequality; hence »equality in this context can involve only the abstract opportunity to become men.«[14] Democracy's dependence upon inequality has been naturalized as the public and private spheres have been used to shore up distinctions and inequities between men and women, particularly in that the private sphere has been »intricate[ly] and extensive[ly] cross-reference[d] …

9 This is the effect of Laura Cottingham's video essay, designed for pedagogical purposes, *Not For Sale*. This tape's structure is based on that of the art history survey: it casts a wide net, includes a barrage of artists without explanation or justification for their inclusion (save their gender). The effect of which is that we are left with an alternative »canon.« The separatist quality of the tape means that the practice of many artists is radically de-contextualized and the work of nearly all the artists is ghettoized. For more on this tape see my »Not For Sale,« in *Frieze* 41 (Summer 1998).

10 My thanks to Janet Kraynak for a discussion of this point.

11 Moira Gatens, *Feminism and Philosophy: Perspectives on Difference and Equality* (Bloomington: Indiana University Press, 1991).

12 Moira Gatens, »Powers, Bodies and Difference,« in *Destabilizing Theory*, 124.

13 Gatens, *Feminism and Philosophy*, 138.

14 Ibid., 124–25.

with the body, passions, and nature.«[15] This critique of equality (as found in much Anglo-American feminist theory) reveals the very notion of equality and its symbolic representation in the public sphere to be historically dependent on the unacknowledged (and unequal) labor of the private sphere.[16]

Gatens is also suspicious of the discursive move from equality to difference. Noting that feminist writing and art practice—after freeing itself from the tyranny of nature—took up explorations of female sexuality, she cautions that such a move runs the risk of reducing women's subjectivity to their sexuality. While Gatens is sympathetic to critical feminist explorations of psychoanalytic models of subjectivity fundamentally rooted in sexuality, she counters the ahistorical logic of psychoanalysis by submitting it to a Foucauldian analysis that conceives of the body as »an effect of socially and historically specific practices.«[17] She argues that »bodies are turned into individuals of various kinds« by »discourses and practices [which] create ideologically appropriate subjects« and »practices [which] construct certain kinds of bodies with particular kinds of power and capacity.«[18] Furthermore, »to insist on sexual difference as *the* fundamental and eternally immutable difference would be to take for granted the intricate and pervasive ways in which patriarchal culture has made that difference its insignia.«[19] She is wary, then, of feminists who place sexuality (as the extension of or outcome of sexual difference) at center stage, theoretically or aesthetically. One effect of Gatens's critique is to register the extent to which *both* groups of feminist work explored issues of sexuality to the exclusion of other attributes of subjectivity and also to the exclusion of political philosophy's critique of the role of the private sphere in the democracy-capitalism covenant.

As Gatens problematizes the equality/difference dichotomy through a feminist analysis of political philosophy, so, too, a similar operation can be performed on the iconic pairing of the *Post Partum Document* and *The Dinner Party*, by considering them in conjunction with Mierle Laderman Ukeles's *Maintenance Art Performances* (1973–74) and Martha Rosler's videos *Semiotics of the Kitchen* (1975) and *Domination and the Everyday* (1978)—works produced around the same time and under similar cultural pressures. Ukeles's and Rosler's work is explicitly concerned with how »ideologically appropriate subjects« are created, in part, through the naturalizing of unpaid and underpaid domestic labor. By placing the *PPD* and *The Dinner Party* within this expanded interpretive field, labor, particularly domestic or maintenance labor, emerges as a thematic shared by these four artists (as well as many others of the period). The introduction of the problem of such labor leads, in turn, to a consideration of the relations between public and private, which emerges as a defining issue in the discussion of 1970s art and the legacy of feminism's intervention in it. The problematic of public and private spheres is,

15 Ibid., 122–23.
16 For an elaboration of this argument see Carole Pateman's *The Sexual Contract* (Stanford, CA: Stanford University Press, 1988). This critique elaborates on the problem of »equality« within liberal thought that is based in part on the inability of capitalism to function without the unpaid labor of maintenance. This subsequently permits a critique of democracy's historical dependence upon slavery. Here, the implications of political theory are indispensable for thinking through the perennial blind spot of both Anglo-American and continental feminism, the problem of racial and ethnic difference.
17 Gatens, »Powers, Bodies and Difference,« 131.
18 Ibid., 128.
19 Ibid., 135.

of course, present in both *The Dinner Party* and *Post Partum Document*, but the essentialism/theory debate has occluded its importance, disallowing the debate to be framed in terms of a political economy as well as a bodily or psychic one.[20]

In her 1969 *Maintenance Art Manifesto* Ukeles divided human labor into two categories: development and maintenance. She writes: »Development: pure individual creation; the new; change; progress; advance; excitement; flight or fleeing. Maintenance: Keep the dust off the pure individual creation; preserve the new; sustain the change; protect progress; defend and prolong the advance; renew the excitement; repeat the flight.«[21] Ukeles's manifesto insists that ideals of modernity (progress, change, individual creation) are dependent on the denigrated and boring labor of maintenance (activities that make things possible—cooking, cleaning, shopping, child rearing, and so forth). Incisively, Ukeles does not refer to maintenance as domestic labor, or housework, for it is evident that such labor is not confined solely to the spaces of domesticity. Included in this manifesto was a proposal that Ukeles live in the museum and perform her maintenance activities; while the gallery might look »empty,« she explained that her labor would indeed be the »work.«[22] Her offer went unaccepted.

In 1973, however, the Wadsworth Athenaeum agreed to the *Maintenance Art Performances*. In *Hartford Wash: Washing Tracks, Maintenance Inside*, Ukeles scrubbed and mopped the floor of the museum for four hours. In *Hartford Wash: Washing Tracks, Maintenance Outside*, she cleaned the exterior plaza and steps of the museum. She referred to these activities as »floor paintings.« In *Transfer: The Maintenance of the Art Object*, she designated her cleaning of a protective display case as an art work—a »dust painting.« Normally this vitrine was cleaned by the janitor; however, once Ukeles's cleaning of the case was designated as »art,« the responsibility of the cleaning and maintenance of this case became the job of the conservator. The fourth performance, *The Keeping of the Keys*, consisted of Ukeles taking the museum guards' keys and locking and unlocking galleries and offices, which when locked were subsequently deemed to be works of »maintenance art.« In each performance, Ukeles's role as »artist« allowed her to reconfigure the value bestowed upon these otherwise unobtrusive maintenance operations, and to explore the ramifications of making maintenance labor visible in public. Martha Rosler's

20 Additionally, the essentialism/theory debate may also have restricted feminist discourse to notions of the subject that reside (rhetorically) outside of the dominant structure of capitalism, hence further marginalizing the political potential of feminism, and art that operates within its concerns.

21 For a reprint of Ukeles's »Maintenance Art Manifesto« in its entirety, see »Artist Project: Mierle Laderman Ukeles Maintenance Art Activity (1973) with responses from Miwon Kwon and Helen Molesworth,« in *Documents* 10 (Fall 1997).

22 It is Ukeles's insistence on the structural aspect of everyday maintenance labor, as opposed to a fetishized notion of the »everyday,« that distinguishes her performances from recent practices that merely represent or stage the everyday, such as Rirkrit Tiravanija's recent exhibition in which he placed a facsimile of his apartment in the gallery and allowed visitors to use the space as they saw fit. For instance, part of the »Maintenance Art Manifesto« included an exhibition proposal called »Care,« in which Ukeles proposed to do the following: »live in the museum as I customarily do at home with my husband and my baby, for the duration of the exhibition, (Right? or if you don't want me around at night I would come in every day) and do all these things as public Art activities: I will sweep and wax the floors, dust everything, wash the walls (i.e., 'floor paintings, dust works, soap sculpture, wall paintings'), cook, invite people to eat, make agglomerations and dispositions of all functional refuse. The exhibition area might look 'empty' of art, but it will be maintained in full public view. MY WORKING WILL BE THE WORK.« Needless to say no one ever accepted this proposal. For an account of Tiravanija's practice, see Janet Kraynak's »Rirkrit Tiravanija's Liability,« in *Documents* 13 (Fall 1998).

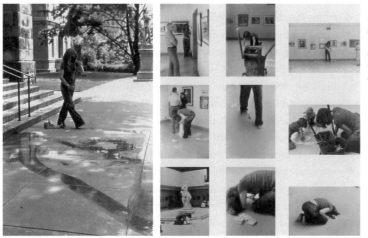

Mierle Laderman Ukeles, *Hartford Wash: Washing Tracks, Maintenance Outside* and *Maintenance Inside* (1973), Wadsworth Atheneum, Hartford, CT

videos *Semiotics of the Kitchen* and *Domination and the Everyday* also critically engaged the problem of housewifery. In the relatively new medium of video, *Semiotics of the Kitchen* humorously skewered both the mass-media image of the smiling, middle-class, white housewife and theories of semiotics, suggesting that neither was able to provide an adequate account of the role of wife/mother/maintenance provider. Informed by Marxist and feminist critique, *Domination and the Everyday* considers the everyday household labors of women in tandem with global politics. Like the *Maintenance Art Performances*, *Domination* suggests that the domestic chores of cooking and child rearing are not exclusively private, but, instead, that such labors are intimately connected to public events, and furthermore that unpaid and underpaid maintenance labor needs to be thought of as equivalent to other forms of oppression.

What happens if the *Maintenance Art Performances* and Rosler's early video work are insinuated into *The Dinner Party* and *Post Partum Document* binarism, creating a four-way compare-and-contrast? Might such an expanded field allow us to see previously unacknowledged aspects of each of the works? For instance, as well as seeing the stark contrast between Chicago's cunt-based central core imagery and Kelly's pointed refusal to represent the female body, we might also see that all four artists deal in varying degrees with putatively »private« aspects of women's lives and experience: motherhood, cleaning, cooking, and entertaining. Similarly, as opposed to the intractable contrast between the lush tactile quality of *The Dinner Party* and the diagrammatic aspect of the *Post Partum Document*, we might see the importance of text in each of the works. The women's names that cover the floor and place settings mean that reading is also integral to viewing *The Dinner Party*. Rosler's *Domination and the Everyday* contains a running text at the bottom of the screen and Ukeles's works contain charts, posted announcements, and the »Maintenance Art« verification stamp. Each artist participated in the assault on the privileged role of vision in aesthetics, as did so many of their 1970s contemporaries. When the binarism is undone we can see that these works were directly engaged with the most »advanced« artistic practices of the day—Minimalism, Performance, and Conceptual art—and that they were also in the process of forming the practice of institutional critique.[23] This is, again, to insist on the linkages between art informed by feminism and most of the advanced or critical

artistic practices of the 1960s and '70s that took as part of their inquiry the institutions within which art is encountered. The artists who worked in this manner—whose work's content was bound up with domesticity or maintenance and its structural relation to the public sphere—have been by and large neglected by the historians and archivists of Minimalism, Conceptual art, and institutional critique.[24] Their omission was caused not by active suppression but rather a fundamental *misrecognition* of the terms and strategies they employed. The overtly domestic/maintenance content of such works was read as being equivalent to their meaning. Therefore, little or no attention was paid to these works' engagement with the Duchampian legacy of art's investigation of its own meaning, value, and institutionality. What has not been fully appreciated are the ways in which this usually »degraded« content actually *permits* an engagement with questions of value and institutionality that critique the conditions of everyday life as well as art. Hence, when we compare *The Dinner Party, Semiotics of the Kitchen* and *Domination and the Everyday*, and the *Post Partum Document* with Ukeles's explicit feminist address of the museum, we are able to reframe them in such a manner as to see that they were each bound up with a critique of the institutional conditions of art. Among the four artists this critique-manifested itself in varying degrees and was shaped by different concerns. There is no denying that Chicago's work may seem to us now the most problematic of the four, in that her work supports a notion of genius and »artist« in keeping with the ideal model of bourgeois subjectivity offered by the Western art museum. Yet, despite the differences between the works (or because of them), the feminist critique of the institutions of art should no longer be misrecognized, for its understanding of the relations between »private« acts and public institutions will reframe the work of contemporaneous figures in the field. Such a comparison will ultimately expand our notion of institutional critique, precisely because the feminist critique differs so markedly from the paradigmatic works of figures such as Marcel Broodthaers, Daniel Buren, or Hans Haacke. For, as we will see, it insisted on the reciprocity and mutual dependence of the categories of private and public.

Ukeles's performances, by establishing domestic (read private, natural) labor as »maintenance,« help to articulate the structural conditions of the relations between the public and private sphere. It is the »hidden« and unrecognized nature of this labor that permits the myth that the public sphere functions as a self-contained and independent site, a site devoid of interest (in classic Habermasian terms). However, by staging such labors in the museum, a traditional institution of the bourgeois public sphere, Ukeles's work establishes maintenance labor as a subject for public discussion. For, as Rosalyn Deutsche has argued, »what is recognized in public space

23 Griselda Pollock has argued that the »radical reconceptualization of the function of artistic activity—its procedures, personnel, and institutional sites—is the major legacy of feminist interventions in culture since the late sixties.« See Griselda Pollock, »Painting, Feminism, History,« 155.

24 For instance, no women artists are discussed in Benjamin H. D. Buchloh's »Conceptual Art 1962–1969: From the Aesthetic of Administration to the Critique of Institutions,« *October* 55 (Winter 1990), although Hilla Becher and Hanne Darboven are mentioned in passing. More recently, Ann Goldstein and Anne Rorimer, *Reconsidering the Object of Art 1965–1975* (Cambridge, MA/London: MIT Press, 1995) included only eight women out of a total of fifty-six artists. More recently, however, this seems to have changed. For example, Peter Wollen included numerous women artists in the North American section of the *Global Conceptualism* exhibition.

is the legitimacy of debate about what is legitimate and what is illegitimate.«[25] It is the very
publicness of art, art's traditional reliance on a public sphere for its legibility and value, that
makes art such a rich terrain for feminist critique. Hence Ukeles's performance of maintenance
activities, in full view of the museum and its visitors, opens public space to the pressures of
what it traditionally excludes, or renders invisible. The work of Chicago, Kelly, and Rosler does
this, too, each at the level of explicit content (although Kelly and Rosler do considerably more
work at the level of form, as well). But when Ukeles renames domestic labor »maintenance,«
she uses ideas and processes usually deemed »private« to open institutions and ideas usually
deemed »public.« This gesture is in obvious sympathy with the 1970s feminist slogan »the per-
sonal is political,« but, more incisively, it supports political philosopher Carole Pateman's con-
tention that »the public sphere is always assumed to throw light onto the private sphere, rather
than vice versa. On the contrary, an understanding of modern patriarchy requires that the
employment contract is illuminated by the structure of domestic relations.«[26] In other words,
one legacy of feminist criticism is to establish that it is the private sphere that can help us to
rearticulate the public sphere, as opposed to the other way around. Ukeles's exposure of this
problematic animates the content of labor in both *The Dinner Party* and the *Post Partum
Document*, pulling these works away from their more familiar interpretations.

To position this work as negotiating the terrain of public and private is to establish its links
to, as opposed to its separation from, other postwar art practices. Chicago's early sculptural
activity—in works like *Pasadena Lifesavers* (1969–70)—took the form of repetitive modular
units fabricated from industrial materials, objects clearly in dialogue with Minimalism and its
West Coast variant, »finish fetish.«[27] Chicago's repetitive formal structure, her use of the triangu-
lar shaped table, her fetishism of surface and texture, suggests that The *Dinner Party* continued
her dialogue with Minimalism. However, by the mid-1970s, Chicago had imported explicit con-
tent into these otherwise generic structures. Specifically sexed bodies are offered as opposed to
the nonspecific or universal body posited by Minimalism's understanding of phenomenology,
and the »private« nature of genitalia, especially the vagina, is rendered spectacularly public.
Likewise, historically under-recognized forms of domestic and decorative craft replace the lure
(and perhaps just barely veiled decorative aspects) of industrial production. Minimalism also
asked for a consideration of the logic of repetition; consider Donald Judd's oft-quoted »one thing
after another.« Reading *The Dinner Party* through a hermeneutics of maintenance suggests that
the logic of repetition is not exclusively bound to industrial production but exists as well—
although with vastly different effects—in the perpetual labors of cooking, eating, and cleaning
up: the women's work that is never done; work that is conspicuously absent in *The Dinner
Party*, effaced as it was by its Minimalist counterparts.[28] And if Minimalism asked its viewers
to distinguish what in the room was not sculpture, what in the room constituted institutional

25 Rosalyn Deutsche, *Evictions: Art and Spatial Politics* (Cambridge, MA/London: MIT Press, 1996), 273.

26 Pateman, *The Sexual Contract*, 144.

27 For an account of Chicago's early work and *The Dinner Party*'s fetishism of surface see Laura Meyer, »From Finish
 Fetishism to Feminism: Judy Chicago's Dinner Party in California Art History,« in *Sexual Politics: Judy Chicago's Dinner
 Party in Feminist Art History*, ed. Amelia Jones (Los Angeles: UCLA and Armand Hammer Museum, Los Angeles:
 University of California Press, 1996)

space, then *The Dinner Party* potentially asked viewers to articulate what in the room existed in the realm of the private and what belonged in the realm of the public.[29]

By tweaking and pinching Minimalism's suppression of the particularity of gendered bodies, *The Dinner Party* suggested that the (impossible) idea of a generic body helped to enable the historical bourgeois public sphere as a site of (fictional) disinterest, a site bound by the terms of patriarchy. Kelly's *Post Partum Document* similarly critiqued the terms of Conceptual art. Kelly's early work, done in Britain during the 1970s, was collaborative in nature and focused largely on the struggle for women's equality in the workplace. Two works stand out: the co-curated exhibition *Women and Work* (1975) and the collaboratively made film *Nightcleaners* (1975), which documented the organizing of a women's cleaning union but refused the traditional methods of agitprop or documentary, opting for Brechtian strategies of distanciation.[30] *Women and Work* depicted two years of research into the sexual division of labor in a metal-box factory. By conceiving of the exhibition as the art work itself, *Women and Work* questioned both the autonomy of the art object and the fiction of the disinterested gallery space. The show's refusal of visuality, its negation of the art object as a commodity, and its challenge to the traditional role of the gallery within the distribution system all partook of Conceptual art's assault on art.

It would be *Post Partum Document*, however, that would launch a more thorough critique of Conceptual art. Following on Minimalism's investigation of the public quality of art, much Conceptual art sought to replace a spatial and visual experience with a linguistic one, or what has been called »the work as analytic proposition.«[31] This meant that the art object could be radically de-skilled, potentially democratizing art's production. However, Frazer Ward has argued that while Conceptual art »sought to demystify aesthetic experience and mastery ('Anybody can do that'), [it] maintained the abstraction of content crucial to high Modernist art,« hence, »if Modernist painting was just about painting, Conceptual art was just about art.«[32] Just as Chicago exposed Minimalism's abstract viewer, similarly the explicit content of the *Post Partum Document* complicated Conceptual art's hermeticism.[33]

28 *The Dinner Party*, it should be noted, is always exhibited accompanied by documentary photographs of the massive groups and collectives of women who worked on the project. In this regard, the labor of making *The Dinner Party* is always registered, but in a peripheral, supporting role. *The Dinner Party* effaces the marks of labor within its boundaries, and in so doing presents itself like a traditional museum-oriented art object: the result of creative genius as opposed to manual labor (a distinction that perpetuates the power relations between the artist and those who work in his or her atelier), and, furthermore, the result of *artistic* labor only, not the maintenance labor that supports such labor.

29 For an account of Minimalism that argues that the sculptures pressured the terms of what is and is not sculpture, see Rosalind Krauss, »Sculpture in the Expanded Field,« in *The Originality and the Avant-Garde and Other Modernist Myths* (Cambridge, MA/London: MIT Press, 1985).

30 The exhibition *Women and Work* was curated by Margaret Harrison, Kay Hunt, and Mary Kelly; *Nightcleaners* was made by the Berwick Street Film Collective: Mark Karlin, Kelly, James Scott, and Humphry Trevelyn. For the best account of Kelly's early practice, see: *Social Process/Collaborative Action: Mary Kelly 1970–75*, ed. Judith Matsai, exh. cat., (Vancouver: Charles H. Scott Gallery, Emily Carr Institute of Art and Design, 1997).

31 Buchloh, »Conceptual Art 1962–1969,« 107.

32 Frazer Ward, »Some Relations between Conceptual and Performance Art,« in *Art Journal* 56, no. 4 (Winter 1997).

33 In this light, Kelly's *PPD* can be seen as a direct attack against the Conceptual art of someone like Joseph Kosuth, for instance, but not, say, the work of Hans Haacke. However, Kelly's work also does serve to problematize the dominant reception of Conceptual art as defined by male artists. For more on the historical context of the *Post Partum Document*, see Juli Carson, »(Re)Viewing Mary Kelly's *Post Partum Document*,« in *Documents* 13 (Fall 1998).

The *Document*'s numerous graphs and charts, in their standardized frames (a repetition that rhymes with Chicago's), represent the labor of child care, labor normally obscured in Western capitalist culture. One effect of the category of the mother as essential and biological is to naturalize this labor, placing it outside of social conditions. (It is telling that the *PPD* emerges around the time of the idea of the »working mother,« as if mothering weren't already a form of work.) Kelly's refusal to image the mother impedes the naturalization of the labor of motherhood (in Gatens's words, »cross referenced with the private«). By submitting this labor to the public and social languages of work and science, the *Document* countermands Conceptual art's maintenance of abstract relations between public and private realms, revealing its continuation of a modernist paradigm of art for art's sake. (Indeed, if one of the primary responses to modernist painting is »My kid could do that« or »What is that crap on the walls?« then Kelly's inclusion of her son's soiled diapers could be seen as a joke at the expense of both Conceptual art and modernist painting.) Kelly's inclusion of maintenance labor also functions as an address to the institution of the museum. She has said of the work, »As an installation within a traditional gallery space, the work subscribes to certain modes of presentation; the framing, for example, parodies a familiar type of museum display in so far as it allows my archaeology of the everyday to slip unannounced into the great hall and ask impertinent questions of its keepers.«[34] This »archaeology of the everyday« permitted Kelly to represent two forms of labor—artistic and domestic—both of which debunk the myths of nonwork that surround both forms of re-production (artist as genius, mother as natural). *PPD* stages the relations between artistic and human creation as analogous, and by doing so interrogates the boundaries between public and private realms of experience. And if one premise of Conceptual art is that »anyone can do it,« then Kelly's work suggests that the same is true of the labor of mothering, for to de-naturalize such labor is to make it non-gender-specific.

While Chicago and Kelly were extensively engaged with the public discursive fields of Minimalism and Conceptual art, Ukeles's explicit address of the museum makes her work an early instance of institutional critique.[35] By taking the normally hidden labor of the private sphere and submitting it to public scrutiny in the institutions of art, *Maintenance Art* explored the fictional quality of the distinction between public and private. The performances demonstrated that the work of maintenance is neither exclusively public nor private; it is the realm of human activities that serves to bind the two. Ukeles's use of performance—her insistence that her »private« body perform »private« activities in public space—seems to suggest that maintenance is a key component of subjectivity. Yet it is one that often goes unrecognized, and instead is naturalized through repetition into the status of »habit,« as opposed to being constitutive of identity. So one effect of Ukeles's performances is to show how institutions such as the museum unconsciously help to maintain »the category of artistic individuality that emblematizes bourgeois subjectivity« through its suppression of its dependence on the labors that keep the white cube clean.[36]

34 Mary Kelly, *Post Partum Document* (London: Routledge & Kegan Paul, 1985), xvi.

35 I do not want to place these artists so firmly within specific categories that their work is seen to be either only an instance of that »style« of work, nor do I want to suggest that these »styles« are in any way internally coherent. Rather, I want to emphasize the ways in which these works are in conscious and explicit dialogue with the predominant movements of critical art of their period.

36 Frazer Ward, »The Haunted Museum: Institutional Critique and Publicity,« in *October* 73 (Summer 1995): 83.

However, when the bonding between public and private realms is exposed, or when an identity delineated by maintenance, as opposed to artistic expression, is foregrounded, the »proper« functioning of the public institution is compromised. Ukeles's performances dramatize that when maintenance is put front and center, made visible, given equal value with art objects, the museum chokes and sputters. For instance, *The Keeping of the Keys* wreaked havoc on the museum's normal workday. The piece so infuriated the curators, who felt that their office and floor should be exempt, that when Ukeles announced that their office was to become a piece of »maintenance art,« all but one curator ran out of the office, fleeing both the artist and their own work. The work stoppage that resulted from the systematic privileging of maintenance work over other forms of work is a vivid instance of Carole Pateman's argument that it is absolutely structural to patriarchy and capitalism that the labor of maintenance remain *invisible*. When made *visible*, the maintenance work that makes other work possible arrests and stymies the very labor it is designed to maintain.

This work stoppage was not isolated. In *Transfer: The Maintenance of the Art Object*, Ukeles selected a female mummy housed in a glass case from the museum's collection. Traditionally, it was the janitor's job to keep this case clean. In a ceremony staged for the camera, the janitor relinquished his rag and cleaning fluid to Ukeles, who then cleaned the case as a »Maintenance Artist,« as opposed to a maintenance person, making what, she called a »dust painting.« After the mummy case was cleaned she stamped both it and the cleaning rag with a rubber stamp certifying their new identities as »Maintenance Art Works.« The stamped rag and the cleaning fluid were then offered to the museum conservator, in the same ceremonial manner; for the cleaned case, now a work of »Maintenance Art,« could only be cleaned (or maintained) by the conservator.

The photographs of *Transfer* are accompanied by a hand-drawn diagram that resembles a low-tech flow chart and details the ramifications of the transfer, mapping how one job (cleaning) had been made the province of three different professionals (janitor, artist, conservator). The goofiness of the chart is a send-up of the clinical »aesthetic of administration« put forth by many conceptual artists and practitioners of institutional critique, although here the diagram mimes managerial concerns with the division of labor, as well.[37] This performance highlights the division of labor that supports the aura of the artist's signature, an aura the museum is dependent on for its legitimacy (and which it in turn legitimates), but in *Transfer*, anyone can use the maintenance art stamp, compromising the value of the artist's signature as a guarantor of art. More importantly, though, by insisting that everyone clean the mummy case, the performance intimates that anyone can perform maintenance. Once again the public exposure of maintenance gums up the work of the museum, complicating the smooth, seamless, efficient functioning of the institution.

Ukeles's *Maintenance Art* performances combine slapstick humor and serious critique. This aesthetic mixture (Karl Marx meets the Marx Brothers) is also found in the works of Martha Rosler. Rosler is perhaps best known for her two influential conceptual pieces *The Bowery in two inadequate descriptive systems* (1974–75) and *Vital Statistics of a Citizen, Simply Obtained* (1977), both of which exposed the limits of representation and imported charged

[37] The phrase »aesthetic of administration« is taken from Benjamin H. D. Buchloh's definitive »Conceptual Art 1962–1969.«

political content into the field of Conceptual art. Her early collages and video works are less familiar. Many of these works focused on various aspects of cooking: the disparity between starvation and gourmet meals; the cultural value placed on cooking, and the complicated hierarchies of who cooks and who serves what food. Several works transpose the language of cooking and the language of art, forming a composite that alludes to the similarity between the terms »artwork« and »housework.« In all of these early works—be they videos, film scripts, or postcard pieces—Rosler frames the conviviality of food as a bodily necessity and pleasure that binds all human beings. Yet lest such commonality give rise to humanist myths (as is the case with Chicago's work) she also casts the production of food as a form of maintenance labor, and hence subject to the inequities of race, class, and gender, that cannot be merely swept away under the guise of things »private« or »domestic.« Similar to Ukeles's performances in both their rejection of traditional artistic media and their focus on various aspects of maintenance labor, video works such as *Semiotics of the Kitchen* and *Domination and the Everyday* turn a critical eye toward the relations between public and private that shape our daily lives.

Both videos employ various strategies of distanciation, yet, as in Ukeles's performances, such strategies are combined with a sometimes caustic, sometimes slapstick sense of humor. In *Semiotics of the Kitchen*, Rosler stands in a kitchen and names various cooking utensils in alphabetical order and then mimes their uses (»bowl,« she declares, and stirs an imaginary substance). Rosler »performs« the role of cook as if the stage directions were written by Bertolt Brecht; straight-laced and purged of emotion, she discourages any identification on the part of the viewer. (However, in the background we can see a large book whose binding reads »MOTHER,« suggesting a possible root cause for the character's bizarre behavior.) The tape also lacks a plot, offering a list instead of a story, further blocking »normative« identification. A broadly drawn spoof on television cooking shows, the tape further discourages identification in that there is nothing to cook, no recipe to complete, we are not asked to follow along with her activities. Yet Rosler's deadpan delivery is held in humorous relation to her slapstick-like performance of nonexistent activities (recalling Charlie Chaplin's *Gold Rush*, Rosler ladles an imaginary liquid and then tosses it over her shoulder; instead of »slicing« or »cutting« with the knife, she aggressively stabs at the air). The exaggerated sense of physical labor means that her everyday kitchen gestures border on the calisthenic. The work's humor and deliberate foiling of the maintenance labor of cooking (if the kitchen had any actual food in it the set would have resembled the aftermath of a food fight) recalls Ukeles's slapstick aesthetic. Indeed, to think of the two works in tandem is to heighten the way in which the works are designed in part to provoke an extremely ambivalent response on the part of the viewer. Should we giggle or shudder at the trapped quality of Rosler's slightly maniacal home cook? Do we laugh knowingly at Ukeles's »floor paintings,« with their explicit evocation of the grand painterly gestures of Jackson Pollock, or do we feel a tinge of shame at the public display of a woman who cleans up after us? Responses are rendered ambivalent, in part because both Rosler and Ukeles have combined an aesthetic of identification (traditionally associated with second-wave feminism) with one of distanciation (usually affiliated with poststructuralist feminism); and they have done so, in large measure, by showing us the fault line between things considered private and things considered public.

Rosler deals with this problematic even more rigorously in *Domination and the Everyday*. Self-described as an »artist-mother's 'This is Your Life,'«[38] the tape begins with an image of Chilean dictator Augusto Pinochet. The image track quickly becomes layered, as a steady stream of disparate pictures—family snapshots, mass-media advertising, photographs of political leaders and artists—fills the screen. Scrolling along the bottom of the screen is a dense theoretical text analyzing the problem of class domination and the relation between those who make culture and those with political power, arguing that »the controlling class also controls culture.« Deploying a classic strategy of filmic distanciation, the sound and image track are separate. Accompanying this already dense visual field is a similarly doubled soundtrack, as we hear, simultaneously, the real-time conversation between Rosler and her young son as she readies him for bed, and a radio interview with the famous art dealer Irving Blum.

Here the everyday labor of mothering, of feeding, bedtime stories, and cleaning, is laid down next to humanist art discourse, Marxist analysis, and the cruel facts of political domination; their polyvalence renders them, if not entirely equivalent, at least impossible to hierarchize. As one track among many, it is hard to privilege the everyday labor of Rosler's mothering, as hard as it is to keep any one of the tracks in focus above the others, as each interrupts, overlaps, synchronizes, and seems incommensurate with the others. To this end, *Domination and the Everyday* does something slightly different from the *Maintenance Art* performances. Rosler does not isolate the labor in order to show it, nor does she engage the literal public spaces of the museum. Rather, by placing maintenance labor as one competing factor among many, one ingredient among many that blend together to form the everyday, she shows it to be as structuring of our lives as other, seemingly invisible structures—political domination, for instance. For Rosler, the question is how to make the connection between the brutal regime of Pinochet and the ideology of first world bedtime stories; how to understand the relays between Irving Blum's blather about the genius of Jasper Johns and the laconic address of mother to child, as she slowly persuades the boy to get ready for bed. What do all these things have to do with one another? The tape insinuates that they are related in our inability not only to recognize them (they are too layered; they compete too steadily for our individuated attention), but further, to draw any meaningful connections *between* them. A sentence scrolls by: »We understand that we have no control over big events; we do not understand HOW and WHY the 'small' events that make up our own lives are controlled as well.«

Domination and the Everyday proposes that the public sphere is more than simply the space of the traditional institutions of the bourgeois public sphere (e.g., the museum). Instead, Rosler's work images a public sphere reorganized by, and shot through with, the effects of television (hence her use of video). Eschewing both the traditional venues and mediums of »art,« she turned instead to mediums not sanctioned by the art establishment (video, postcards, and performance works), mediums that presented difficulty in terms of distribution—showing distribution to be as important an element in the art process as consumption or production.[39] While Chicago, Kelly, and Ukeles are explicit in their address of more traditionally defined public

[38] The tape is called this in the descriptive list of Rosler's works found in *Martha Rosler: Positions in the Life World*, ed. Catherine de Zegher, exh. cat. (Birmingham: Ikon Gallery, Vienna: Generali Foundation, 1998).

Martha Rosler, *Domination and the Everyday*
(1978), video still

space, Rosler's work is an early instanciation of the changing parameters of such space, the very
despatialization of public space. However, while notions of what constitutes the public may shift,
the society of the spectacle hardly operates without the structural role of maintenance labor.
And Rosler's works make clear that we not only have to value that labor as such, but that one
way we might be able to do that is to articulate the relations among and between different forms
of dailiness: the everyday for her being an ineluctable mixture of politics, culture, and mainte-
nance activities. (This is one way Rosler refuses a fetishization of the everyday as a *retreat* from
politics.) To perform this articulation is to be willing to tear away at the layers and veils of ide-
ology that not only separate people from one another but also render various aspects of daily
life radically disjointed. And it is here that the function of maintenance as an activity that forms
a bond between public and private realms becomes so important. Rosler's work refutes the either
unknowing or unwilling acquiescence of people to systems of domination, be they ideological,
cultural, or political. Yet such refusals do not operate strictly in the negative, as *Domination
and the Everyday* ends on a decidedly utopian note:

> It is in the marketplace alone that we are replaceable, because interchangeable, and until we
> take control we will always be owned by the culture that imagines us to be replaceable. The
> truth, of course, is that NO ONE can be replaced ... but there will always be more of us, more
> and more of us, willing to struggle to take control of our lives, our culture, our world ... which
> to be fully human, we must do and we will.[40]

My work is a sketch, a line of thinking, a possibility.[41]
Martha Rosler

[39] This is perhaps why *Vital Statistics* and *The Bowery* are her most well-known works, in that each could be disseminated
more easily in the form of photography, and hence traveled better through the distribution network of art magazines,
etc. (For instance, *Vital Statistics* is usually represented as a photograph, while the video is not often shown.)

[40] Rosler, in de Zegher, *Martha Rosler: Positions in the Life World*, 31.

[41] Benjamin H. D. Buchloh, »A Conversation with Martha Rosler,« in de Zegher, *Martha Rosler: Positions in the Life World*, 31.

I have been arguing that the aspect that binds these works together is their concern with the problems of labor and political economy and their address to the public institutions of art. By importing explicitly domestic or private content (Chicago and Kelly) or by substituting the notion of domestic labor with maintenance labor (Ukeles), or by insisting on the equivalence between maintenance labor and other forms of domination (Rosler), all four artists explore the interpenetration between public and private institutions. This is notable, for in each instance the various institutions of art have wanted precisely to suppress the public address of the works. This is why, for instance, *The Dinner Party* is accused of being too kitschy, for Chicago has smuggled the decorative and the domestic into the modernist museum.[42] So, too, the familiar disparagement of the *PPD*, that it »should be a book,« is a desire to deny its place in the public space of the museum, to suppress the non-naturalness of motherhood as a legitimate public discussion. Rosler's work has received the least »proper« art world attention (she was only recently the subject of a European-initiated museum retrospective). Her explicit desire to envision an art practice that addressed a more diffuse notion of the public sphere and a more expansive notion of art has meant that many of her early video works on food and cooking and her postcard pieces that deal with domestic labor remain difficult to see. Finally, and perhaps most telling of all, the Wadsworth Athenaeum kept no records of Ukeles's *Maintenance Art Performances*, recalling Miwon Kwon's observation that when the work of maintenance is well accomplished it goes unseen.[43]

Another aspect that binds these works is that each participates in what Fredric Jameson calls the »laboratory situation« of art.[44] All four works submit various »givens« about the way the world works to a type of laboratory experimentation. For instance, the body and perception are questioned by Minimalism; the status of the art object is queried by Conceptual art; the medium of video places a strain on both art institutions (in terms of distribution) and the viewer (in terms of expectation); and the regimes of power embedded in the museum are articulated by institutional critique. Yet I would contend that these artists add yet another layer to these »laboratory experiments,« for embodied in each work is a proposition about how the world might be *differently* organized. Woven into the fabric of each work is the utopian question, »What if the world worked like this?« Chicago offers us the old parlor game of the ideal dinner party, and suggests that the museum could be a site for conviviality, social exchange, and the pleasures of the flesh. Kelly's work intimates the desire for a culture that would bestow equal value on the work of mothering and the labor of the artist; so, too, the work's very existence points toward a different model of the »working mother.« Rosler images a polyvalent and dialectical world where the demands of work and pleasure, and the seeming separation between culture and domination,

42 For more on the charge of kitsch launched against *The Dinner Party*, see Amelia Jones's »The 'Sexual Politics' of *The Dinner Party*: A Critical Context,« in *Sexual Politics: Judy Chicago's Dinner Party in Feminist Art History*.

43 Conversation with the artist, summer 1997. See Miwon Kwon, »In Appreciation of Invisible Work: Mierle Laderman Ukeles and the Maintenance of the White Cube,« in *Documents* 10 (Fall 1997).

44 Fredric Jameson, »Periodizing the 1960s,« in *The Sixties Without Apology* (Minneapolis: University of Minnesota Press, 1984), 79. Additionally, Martha Rosler has said of her own work: »Everything I have ever done I've thought of 'as if': Every single thing I have offered to the public has been offered as a suggestion of a work ... which is that my work is a sketch, a line of thinking, a possibility,« In »A Conversation with Martha Rosler,« in de Zegher, *Martha Rosler: Positions in the Life World*, 31.

are held in a constant tensile relation to one another. Ukeles's work, again, may be the most explicit in its utopian dimension, its literalness a demand beyond »equal time equal pay« or the »personal is political,« for hers is a world where maintenance labor is equal in value to artistic labor—a proposition that would require a radically different organization of the public and private spheres.

Feminism has long operated with the power (and limitations) of utopian thought. It is telling, then, that these artists have dovetailed the »what if« potential of both art and feminism. Yet they have not collapsed the distinction between art and life; rather, they have used art as a form of legitimated public discourse, a conduit through which to enter ideas into public discussion. So while all of the works expose the porosity between public and private spheres, none calls for the dismantling of these formations. Fictional as the division might be, the myth of a private sphere is too dear to relinquish,[45] and the public sphere as a site of discourse and debate is too important a fiction for democracy to disavow. Instead, these pieces have articulated something similar to the utopian thought of feminists like Moira Gatens, and, more recently, Drucilla Cornell. As Gatens argues, »To effect the total insertion of women into capitalist society would involve the acknowledgment of the 'blind spot' of traditional socio-political theorizing: that the reproduction of the species, sexual relations and domestic work are performed under socially constructed conditions, not natural ones, and that these tasks are socially and economically necessary.«[46] She suggests a new model of the body politic, one that would be able to account for the heterogeneity of its subjects and their asymmetrical relations to reproduction, sexuality, and subjectivity.

Such utopian language is vague, and for some time now such vagueness has produced frustration or dismissal. However, this is a utopian language without the problematic proscriptive nature of previous utopian thought. Similarly, it is not a theoretical language that ends with a description of a system or an ideology. Instead, it offers speculation. At the end of *Feminism and Philosophy*, Gatens calls for representations, both symbolic and factual, of future conceptions of sociopolitical and ethical life. And in *At the Heart of Freedom*, Drucilla Cornell writes, »There is a necessary aesthetic dimension to a feminist practice of freedom. Feminism is invariably a symbolic project.«[47] It is within the tradition of art as a laboratory experiment that Chicago, Kelly, Rosler, and Ukeles engage in speculative feminist utopian thought, each attempting to rearticulate the terms of public and private in ways that might fashion new possibilities for both spheres and the labor they entail. But this is not a call for a utopian field in which all parties agree on the terms of the discourse, decidedly not. While all four artists are bound by their interest in labor, their address to questions of public and private, and their pointed complications of the (now) standard narratives of postwar advanced art practice, they clearly differ in

45 For more on the importance of privacy, see Drucilla Cornell, *At the Heart of Freedom: Feminism, Sex, and Equality* (Princeton, NJ: Princeton University Press, 1998). Cornell despatializes privacy by insisting on the idea of an imaginary domain. The imaginary domain is a site (both imagined and actualized), where persons are free to articulate their desires with the historical protections of the idea of »privacy.« By despatializing privacy she is able to unhinge it from notions of private property, notions which have been legally disadvantageous for women (with regard to domestic violence, for instance).

46 Gatens, *Feminism and Philosophy*, 129.

47 Cornell, *At the Heart of Freedom*, 24.

contentious and important ways. While this essay has valorized a moment of obscured affinity, this is not to say that such affinities should be privileged as such. Difference is crucial for utopian thought, in that utopia (like democracy) has the potential to offer discourses marked precisely by disagreement and contestation. For some time feminism has labored under equally false ideals of harmony or superiority. What seems increasingly necessary in our putatively »postfeminist« age is a feminism vibrant enough to encourage dissension and conflict without closing off considerations of points of contact, moments of unexpected convergence. That 1970s art work informed by feminism is currently a site of intellectual energy is perhaps due to the problems of labor that shape our current public sphere: from the »end« of the welfare mother to home officing; from the new threats to privacy made possible by the ever-expanding role of the Internet in the lives of people in developed nations to the multinational corporate reorganization of public space. These issues seem to run through the fabric of our daily lives with astounding thoroughness. If the politics of the 1970s were marked by various battles for equality, and the politics of the 1980s were shaped by struggles over the politics of representation under the Reagan/Thatcher era, where the spectacle reigned supreme, then the core of contemporary politics may be shaped largely by the reciprocity and contested relations between the public and private spheres and the forms of labor that support them.

Lygia Clark, *Planos em superfície
modulada n°1* (1957)

Ricardo Basbaum

Within the Organic Line and After

When the Brazilian artist Lygia Clark invented the *organic line* in 1954, she had no way of suspecting this gesture would prove to be decisive for the development of contemporary art and thought. After all, several of the trends of the post World War II period through to the 1960s were intent on finding an escape from the linearity of dialectics. The *organic line* is a line that has not been drafted or carved by anyone, but results from the contact of two different surfaces (planes, things, objects, bodies, or even concepts): it announces a way of thinking beyond the logic of true or false, without awaiting a synthesis of previous counterparts to evolve—it points to a way of thinking »without contradiction, without dialectics, ... thought that accepts divergence; affirmative thought whose instrument is disjunction; thought of the multiple. ... We must think problematically rather than question and answer dialectically.«[1] The *organic line* does not have the touch of human hands, thus revealing a process of creation through another mind-body articulation—everyone familiar with Lygia Clark's work from the 1960s and 1970s understands the radical meaning of such a gesture—the creation of the *organic line* should not be underestimated. If we follow her writings in which she reveals how she arrived at this discovery, it's interesting to see the artist's incredible lucidity—highly aware of modern art's developments—appropriating small events around her (a Duchampian gesture, although not assumed as such, in which she escaped the object in favor of the »event« quite early on) to establish a continuity between the artwork and the real world, between art and life.

Lygia Clark liked to exemplify the organic line as the one we can see »between the window and the window-frame or between tiles on the floor«[2]—she states that it first appeared when she was observing the line that formed where a collage touched the passepartout paper, in the frame. This was in 1954—»I set aside this research for two years because I did not know how to deal with this space set free«[3]—and then in 1956, when she found the relation between this line and

1 Michel Foucault, »Theatrum philosoficum,« (1975) in *Language, Counter-Memory, Practice: Selected Essays and Interviews* (Oxford: Blackwell, 1977), 185–86.

2 Guy Brett, »Lygia Clark, the borderline between art and life,« in *Third Text*, no. 1 (Autumn 1987): 67.

3 Lygia Clark, »Lygia Clark e o espaço concreto expressional,« in *Lygia Clark*, exh. cat. (Barcelona: Fundació Antoni Tàpies, Paris: Réunion des Musées Nationaux, Marseille: MAC, Galeries Contemporaines des Musées de Marseille, Porto: Fundação de Serralves, Brussels: Société des Expositions du Palais des Beaux-Arts, 1998), 83. Originally published in *Jornal do Brasil*, 2 July 1959. (Own translation)

the adjoining lines encountered in doors, floors, and windows, she created the designation »organic line«: »it was real, existed in itself, organizing the space. It was a line-space.« Clark was particularly aware of how these lines acted »to modulate all of a surface,« and stated that her major plastic problem was then »simply the valuation or devaluation of this line.«[4] A short while later, in 1958, the art critic Ferreira Gullar had already observed that »little by little, the organic line ... becomes the structural determinant of the picture.«[5] Because »it is a limit between bits of space, ... it is space,« Gullar goes on, the artist began making it manifest outside of the painting's surface, as an »external line ... between the painting and the outside space.« Lygia Clark had managed in just a few short years to transform an apparently formal problem within the picture's protected surface into a matter that questions the very nature of the artwork in relation to real space: with Clark, contemporary art is necessarily an investigation of the art field's borders in terms of its relationship to the continuity of mind-body, in which the senses—all, not only the visual—contribute to producing a way of thinking that is ultimately the production of a body: the production of life-forms.

In order to make Lygia Clark's first steps more precise, in terms of actual artworks, it is important to note that her process of »discovering« the organic line,[6] playing with it within the paintings' surface, and then shifting it progressively to the borderline between art object and real space, can be traced in terms of a very clear set of works—such development is described clearly by Ferreira Gullar in his famous article, quoted above: more than a sort of classic piece of art criticism in terms of the Brazilian historiography, Gullar's text is also exemplary in the way it depicts Clark's investigation as entirely linear step-by-step research—the contemporary reader is granted a reading that affords the »pleasure« of having closely followed the artist in her achievement; and is left with at least one question: was Lygia Clark's investigative method really so linear? Art, viewed from an »after-modernism-perspective,« is a matter of moving in several directions simultaneously and confronting several impasses—in fact, closer to a non-linear and chaotic process. But Gullar describes a transparent and direct accomplishment: (1) breaking the frame; (2) using the organic line to modulate the surface; (3) getting from the plane to the space, having the organic line as the border in between »real« and »fictional« space.[7] Interesting is to perceive, some decades later, how both—the artist and the writer—were immersed in the modernist credo, in the sense of having linear project development as the »norm« or standard mode of progress. Yet art should not be naturalized as a project-oriented task, nor should Clark and Gullar's testimonies of their procedures be taken as the objective description of a process, which we can easily comprehend as much more complex than merely following a straight line from dark to light. Nevertheless, their testimonies demonstrate the crucial role that both artist and

4 Lygia Clark, »Conferência pronunciada na escola Nacional de Arquitetura em Belo Horizonte em 1956,« in *Lygia Clark*, 1998, 72. Originally published in *Diário de Minas*, 27 January 1957. (Own translation)

5 Ferreira Gullar, »Lygia Clark – uma experiência radical,« in *Etapas da arte contemporânea: do cubismo à arte neoconcreta* (Rio de Janeiro: Editora Revan, 1988), 278. Originally published in 1958. (Own translation)

6 The artist always referred to this gesture as »discovery,« rather than »invention« or »creation.«

7 Two other important writings from Ferreira Gullar, where he discusses the passage from neoplasticism to neoconcrete art—from Mondrian's »fictional« space to the neoconcrete non-object installed into the »real« world, are the »Neoconcrete manifesto« (1959) and the »Theory of the Non-object« (1960). They are reprinted in Gullar, »Etapas da arte,« 283–88 and 289–301. An English version of the »Neoconcrete manifesto« was published in *October* 69 (Summer 1994): 91–95.

writer played in questioning art's conditions in their time and in promoting solutions that offered new ways to move out of the crisis of modernism in the 1950s.

Three series of works mark the achievement of the organic line and its further development into pieces that unfold into the real space: the *Quebra da moldura* (Break of the Frame) series, from 1954, depicts the progressive integration of the painting with its frame—two of the individual paintings are titled *Descoberta da linha orgânica* (The discovery of the organic line). Like in the other examples from this series, we see a sort of central core where a certain event takes place (through geometric forms or color surfaces)—it is important to say that the event is not restricted to the center, but slides to areas alongside the paintings' borders. Their specificity resides precisely in the fact that the paintings' dynamics, in its entirety, takes part in the work's surface as a whole, making it a painting that is becoming an object as well. There is a borderline inside, which operates as an internal limit that does not prevent things from crossing but modulates the internal space. In the two series that follow, *Superfícies moduladas* (Modulated surfaces; 1955–56) and *Planos em superfícies moduladas* (Planes in modulated surfaces; 1956–58), the surfaces become more solid and concrete, as the canvas is abandoned in favor of woodcuts that are mounted over wood: the cut pieces—initially colored and then reduced to black and white—are displayed side by side, separated by organic lines (or space lines), which take more and more of a structural role in the works. For Ferreira Gullar, it is the painting *Planos em superfície modulada nº1* (1957) that indicates the leap forward: the two juxtaposed wood plates leave between them »a half centimeter separation that constitutes a line of void, of empty space, which cuts the surface in an irregular, diagonal mode«—the organic line—but »the difference is that now the line is left there, created there, to irrigate the painting's surface with real space.«[8]

Klein x Clark

In the 1950s, Yves Klein was another artist contributing with work around the notion of the void, the emptiness. It is very well known that he developed a quite consistent and coherent body of work in just a few years, which departed from monochrome paintings to reach the blue as »pure color,« as well as the immaterial as a realm and concrete dimension. Both Klein and Clark are among those artists who successfully dealt with the heritage of classical modernism, in the sense that they managed to confront the crises following the post-war/post-avant-garde period, and discover a productive way out of a few of its dead ends. Their work functions as a true gateway opening to large passages throughout the following two decades, providing references that disperse to almost all of the subsequently emerging trends and movements—Conceptual art, performance, Happenings, earth-works, bodyart, experimentalism, etc; the names Jasper Johns, Robert Rauschenberg, and Piero Manzoni can be mentioned in this context. Truly remarkable is that they inhabit a sort of turning point from where multiple lines of flight open up, not only pointing to a future yet to come, but more precisely, announcing art's present state as an

[8] Ferreira Gullar, »A trajetória de Lygia Clark,« in *Lygia Clark*, 1998, 62.

Lygia Clark, *Descoberta da linha orgânica* (1954)

expanded territory of investigation, invention, and resistance.[9] They most certainly experience another use of history, in which »the dilated present reveals a change from the—modern—habitus of organizing multiple representations of the same phenomena as evolution and history to the—post-modern—habitus of treating them as variations available simultaneously.«[10]

However, although Klein and Clark reveal certain parallel preoccupations with the presence, operation, and meaning of the empty space—and in relation to their respective art and cultural contexts play the role of »filtering« (establishing breaks, threading links, producing lines of flight) certain avant-garde practices in order to keep investigation updated, pointing to open up possibilities—they also demonstrate positions that emphatically differ one from the other. Confronted directly, their strategies unfold in opposite sorts of ways—the mystical and transcendent Yves Klein and the organic and immanent Lygia Clark. Around the same time—the 1950s— Klein was also experimenting with the plane and the surface, but in terms of the monochrome, since for him it was a matter of obtaining maximum intensity: »it is through color that I have little by little become acquainted with the Immaterial.«[11] But his self-declared engagement with monochromatism led him to reject juxtaposition and the line—the same operation that was productive for Clark, Klein strongly rejected: »I precisely and categorically refuse to create on one surface even the interplay of two colors. ... two colors juxtaposed on one canvas prevent [the observer] from entering into the sensitivity, the dominance, the purpose of the picture. ... one can no longer plunge into the sensibility of pure color, relieved from all outside contamination.« This rejection of internal borders or limits indicates that for him there was no possibility for lines and divisions (that is, the recognition of difference) to somehow become productive within his art system; his »leap into the void« not only points to the absence of any ground whatsoever

9 Some of the issues pointed out here are resumed in my essay »Quatro características da arte nas Sociedades de Controle« (Four Characteristics of Art in the Control Society) from 1992. Published in Ricardo Basbaum, *Além da pureza visual* (Porto Alegre: Editora Zouk, 2006).

10 Hans-Ulrich Gumbrecht, »Cascatas de modernidade,« in *Modernização dos Sentidos* (São Paulo: Editora 34, 1998), 22–23.

11 Yves Klein, »Sorbonne Lecture,« in *Art in Theory 1900–1990: An Anthology of Changing Ideas*, ed. Charles Harrison and Paul Wood (Oxford: Blackwell, 1992), 803–805. The subsequent quotes from Klein are extracted from this text.

(otherwise his body would be facing too literally a »borderline shock«), it also dismisses the existence of any line: »I felt more and more that the lines and all their consequences, the contours, the forms, the perspectives, the compositions, became exactly like the bars on the window of a prison.« Here, the line has no function of mediating the encounter of two different contacting entities exactly because there is no perspective of such meeting, as far as the aim is to move to a space where »in the realm of the blue air more than anywhere else one feels that the world is accessible to the most unlimited reverie. It is then that a reverie assumes true depth«—for »blue has no dimensions, it is beyond dimensions.«

Immediately« obvious is that both artists relied on the current image of the »window« as a metaphor for art's condition. Assuming that the modern era's start is marked by the Renaissance's perspective devices, which permitted a break with Plato's mimesis and the initiation of development and progress in terms of artificial means,[12] the »window« is the classic referential image for Western art, present from Leonardo Da Vinci to Marcel Duchamp: how to deal with the passages from art to life (and vice-versa) that indicate the autonomy of the art object and its connectedness with the real? Although during the development of perspective, painting was compared to a »window« opened to the outside, for Clark (who had her production departing from constructivist tradition), the »window« was the source of the organic line—not a matter of looking through, but of being aware of the limits between the frame and the architecture/world; but Yves Klein kept his eyes attached to the window's surface, anxious to enter its still metaphysical depth, perceived as some sort of protection from the impurity of the world. However, what is interesting to extract from the Clark-Klein confrontation—*between* versus *beyond*—is how both faced a similar problem at the same time but got different responses and pointed to diverse practices.

Art & life, silence, membranes

Somehow, Jasper Johns, Robert Rauschenberg, and Piero Manzoni also touch on a similar problem having to do with »emptiness, borders and lines«—to remain with dematerialization (in all its different inflections), which proved decisive for Conceptualism and Conceptual art, and was accepted as one of its brands. Both Johns and Rauschenberg were taken into John Cage's philosophy, performed, via Zen, in the border between art and life: two of his written pieces make this point absolutely clear.[13] The two texts, it is important to mention, were conceived according to Cage's compositional methods, which accept the presence of empty spaces among the blocks of writing (these become silences in the moment of the reading performance). For »Jasper Johns: Stories and Ideas,« he writes, »I decided for the plan to make use ... of my Cartridge Music,« which is composed of »a series of materials with usage instructions«—

12 The philosopher Gerd Bornheim indicates how, since Renaissance, the concept of »imitation« (from Plato's mimesis) is replaced by the concept of »copy.« The latter is conceived of as artificial imitation, as it is produced by the means of a tool developed by human ingenuity, which progressively replaces God as source of knowledge. See Gerd Bornheim, *Páginas de Filosofia da Arte* (Rio de Janeiro: Uapê, 1998), 117–30.

13 See John Cage, »On Robert Rauschenberg, artist, and his work,« (1961) in *Silence* (Hanover, NH: Wesleyan University Press, 1973), 98–108, and »Jasper Johns: stories and ideas,« in *A Year from Monday: New Lectures and Writings* (Hanover, NH: Wesleyan University Press, 1967), 73–84. The subsequent quotes are extracted from both sources.

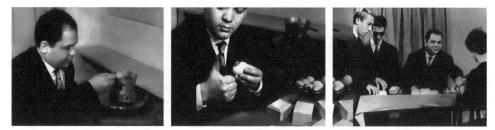

Piero Manzoni, *Consumption of dynamic art by the art devouring public* (1960)

through various operations; Cage arrives first at the structure and content of the text, and only then starts the proper writing. »The empty spaces are consequence of the same method. In the oral presentation ... the spaces correspond to silence.« For the reader/listener, the pieces on Johns and Rauschenberg invest in a mix of Cage's comments, quotes from the artists, and several daily episodes from moments when they meet, talk, work, or just perform life in its intensity (common, vivid unimportant instants): »There is Rauschenberg, between him and what he picks up to use, the quality of encounter. ... But now we must have gotten the message. It couldn't have been more explicit. Do you understand this idea? Painting relates to both art and life. Neither can be made. (I try to act in that gap between the two.) The nothingness in between is where for no reason at all every practical thing that one actually takes the time to do so stirs up the dregs that they're no longer sitting as we thought on the bottom.« Here it is necessary to recall Rauschenberg's decisive erasure gesture made in1953, as a moment that indicates a change in the perception of history (space-time), showing that linear progress was no longer operative, and that the productive act should be interventionist—opening spaces between existing things, »additive subtraction,« according to Cage, who writes: »The relationship between the object and the event, can the two be separated? Is one a detail of the other? What is meeting? Air?«

The Manzoni situation can be interpreted as a conflict involving, on the one hand, a taste for the absolute *beyond* infinite purity (similar to Klein's) and, on the other, a finite preoccupation with the body in all its proper immanent limits—clearly, not an easy dissention to administrate. His basic statement began with a reaction opposing the saturation of the painting's surface (like Rauschenberg), claiming its liberation: »A surface with limitless possibilities has been reduced to a sort of receptacle. ... Why not empty the receptacle, liberate this surface? Why not try to make the limitless sense of total space, of a pure and absolute light, appear instead?«[14] and, in search of purity, he also pointed to a difficulty (again, like Klein) to administrate conflicting pairs of objects or events (continuous or not): »two matched colors, or two tones of the

[14] Piero Manzoni, »Free Dimension,« in Harrison, Wood, *Art in Theory*, 709–11. All the subsequent quotes come form this source as well as from Piero Manzoni, »Some realizations... Some experimentations... Some projects...,« 1962, http://home.sprynet.com/~mindweb/page14.htm.

same color are already an alien element in the concept of a single, limitless, totally dynamic surface«—for Manzoni, if »infinity is strictly monochromatic,« it is »colorless.« Also the lines need to escape formal practice through the absoluteness »beyond all pictorial phenomena,« and in Manzoni's system »it can only be drawn, however long, to the infinite, beyond all problems of composition or of dimensions,« as »there are no dimensions on total space.« But what is of particular importance for Piero Manzoni, pointing to a significant shift suitable for his proposal as compared to the mystical Yves Klein, is the emphasis on »total freedom« as the result of »pure matter … transformed into pure energy«—this shift is so important that subsequently »the entire artistic problematic is surpassed«: this leads Manzoni to locate his practice in the region of becoming (»the transformation must be total«), which indicates that his project is not completely subsumed under a transcendental and perennial goal. As he states, »a colorless surface … simply 'is'. … the total being … is pure becoming.« Because he considers existence to be a value in and of itself, Manzoni can easily move from the *Achromes* to the other series of works that deal directly with the limits of the body and its fluids—the formal problem is solved when »the surface only retains its value as a vehicle«: and he can then open the perspective of directly involving the concrete, biological, mechanical, impersonal, and non-subjective body (»there is nothing to explain: just be, and live«). The *Bodies of Air* is a key-piece for the artist's leap, as it comprises »the membrane and the base« (in Manzoni's words), as a receptacle »that one can let down or fill at leisure«: the piece is his first to deal with the problem of designing some container object to involve organic fluids (breath, shit, blood), which shouldn't be seen as a »form« versus »formless« confrontation, but a much more intriguing problem of re-conceptualization of formal vocabulary, by means of experimenting with new uses for the issues of »line« and »surface« (Manzoni reminds us: »all intervention destined to give them [the pneumatic sculptures] a form, even formlessness, is illegitimate and illogical«). His conceptual operation renews comprehension of the surface as »vehicle« and the line as »membrane«—both were used and experienced in a variety of modes in the few years of the artist's intense existence (he died in 1963 at the age of twenty-nine): the proposition *The consumption of dynamic art by the art devouring people* (1960) invests in distributing the artwork through the spectator's body through a viral contamination-like strategy—Manzoni imprinted his thumb into a number of hard-boiled eggs and »the public was able to make contact with these works by swallowing the entire exhibition in 70 minutes;« the *Living sculptures* (1961) had the body's skin as a dynamic surface, which, as an active membrane, would be touched by his signature providing its transformation into an art piece, a bio-sculpture ready (perhaps) to produce a modification of the environment in the recognition of the subject's permeable condition in terms of inside/outside exchange. This operation continued with the *Magic Base* (1961) series, where a wooden plinth would mediate the transformation of ordinary bodies into living sculptures—with the most ambitious piece being the *Socle du Monde* (1962), where the whole planet was meant to be displayed at the base, conceived as a platform for transformation. It is remarkable to see how Piero Manzoni creates a shift from a preoccupation with the absoluteness of pure space to the gesture of working on structures for mediation—membranes, vehicles—that locate his artistic program within the issue of thinking about the space between things: How to open that space? How is this space produced? What kind of operation is it possible to develop there?

Dematerialization and discourse

In gaining access to the empty space through this matrix, the operative possibilities of »dematerialization« are foregrounded; not as an alternative to escape from the art object, leaving it behind, but as a set of tools that point to the need to consider the contact zones or interfaces (internal or external) as one of the constitutive layers of any artwork, not necessarily more or less important than its other traces but fundamental for its functioning, operation, and existence. Note that in the situations indicated above, the lines of contact or empty spaces had to be extracted or built between given structures or events, by means of complex operations, simultaneously plastic and discursive. Historically, Conceptual art has usually been considered a moment in contemporary art when artists decided to strategically emphasize the discursive component of their practices, making it preeminent in exhibitions and related areas (text, magazine, newspaper, outdoors, public spaces, etc)—dematerialization was generally adopted (even if not all artists accepted the term) as a consequence of the decision to escape aestheticism and formalism, of not wanting to play with art only visually. Terry Atkinson, for instance, one of the main protagonists of the period, commented on »theory-objects« and a »technique of content-isolation,« and also on relating to objects by »reading-looking« at them:[15] for him and his group it was fundamental to produce an inversion of the established order—not the visual, but the discursive layer as »first-order information«—to develop a discussion engaged in the art field's *word architecture* characteristic. Such a diagnosis, however, reveals a presupposition that a hierarchical structure in fact exists, one which would envelop the discursive dimension of art as secondary or alien to the art work and practice: therefore, many voices from the period promptly echoed the observation (and demand from the time) that artists were thus »working with what, in the visual art context, is traditionally recognized as the medium of the art-critic and art-historian,«[16] that »conceptual artists take over the role of the critic in terms of framing their own propositions, ideas, and concepts,«[17] and that »this art both annexes the functions of the critic, and makes the middleman unnecessary.«[18]

Now, forty years later, it is very clear that the conceptual artists were fighting against the role of visual-formal-artist imposed on them by a specific (rich, powerful, and dominant) art system (comprising mainly the U.S./European axis)—where »a new kind of patronage« emerged, one that purchased art »at record rates,« due to the fact that the »circumstances were favorable, as the 1960s were boom years in economic terms and the future promised endless growth.«[19]

15 Terry Atkinson, »Concerning the article denominated 'The dematerialization of art,'« in *Conceptual Art: A Critical Anthology*, ed. Alexander Alberro and Blake Stimson (Cambridge, MA/London: MIT Press, 1999), 52–85.
16 Atkinson, »Concerning the article,« 54–55.
17 Ursula Meyer, »Introduction,« in *Conceptual Art* (New York: Dutton,1972), viii.
18 Joseph Kosuth, »Introductory Note to Art-Language by the American Editor,« in *Art After Philosophy and After: Collected Writings, 1966–1990* (Cambridge, MA/London: MIT Press, 1991), 39.
19 Alexander Alberro, »The contradictions of conceptual art,« in *Conceptual Art and the Politics of Publicity* (Cambridge, MA/London: MIT Press, 2003), 1–24. Although the author warns that his description has »a New York bias,« it is possible to take it as a valid account for the big change from modernism to contemporary art, when New York took the place of Paris as the world's art capital—dramatic changes affect the status and the image of the artist, the art critic, the gallerist, as well as all the other roles characteristic of the art circuit.

In this new scenario, characterized as the beginning of a new and very aggressive relation-
ship of capital and culture intrinsic to the »society of control« described by Gilles Deleuze,[20]
»the entrepreneurial, innovative and often historically naïve dealer replaced the highly specialized
art critic as the central conduit between artists and their audience. ... the critic ... was no longer
the primary arbiter of artistic success«:[21] then, as Joseph Kosuth correctly insists, facing this new
dynamic and its effects, artists should not forget their »responsibility ... to defend [the meaning
of the work] against the theoretical encroachment of others«[22]—the market will generally ignore
what is not directly marketable and will stick to what is most profitable from labor, eliminating
subtleties of any kind. In such terms, the conceptual artists assumed a decisive gesture by taking
writing as a primary tool for their practices—the strategy proved efficient: a new production
emerged, questioning the limits of the art object and practice; artists negotiated their presence
in the art circuit from a more active behavior that intersected the roles of artist, writer, and
curator; art production spread to a whole variety of media, chosen according to the needs of
each particular proposition; artists' statements became part of the daily art management, making
its presence concrete, as first or second order information. This observation (clearly an over-sim-
plified survey of Conceptual art's influence on the present) is meant to point out some strategic
aspects in recent art that involved the presence of the discursive field as an invisible, dematerial-
ized layer.

Théorie des énoncés

Nevertheless, since modernism, discourse constitutes art practice as one of its principal
operators. It can be said that »modern art is founded precisely from the possibility of objects
that intend to be pure and completely visible, encountering a field of discourse that finds its
proper location via these objects crossing of it.« Moreover, »to be more precise: at the moment
when the modern art making process was founded, there is the presence of a particular assem-
blage of image and language, the visible and the enunciable«; both modes of »meaning produc-
tion configured themselves as autonomous entities, with their own structure, materiality, and
fields of action constituted by differentiated strategies and practices—and it would be the partic-
ular mode of production of such assemblages, the attrition and friction born from the contact
between both fields, that makes it possible to affirm the existence of a particular territory for
the plastic/visual arts. Modern art, then, will be identified as a hybrid territory, where objects
and meanings interweave.«[23] Thus, Conceptual art—in its proper project of playing with words
and images—can be taken as just a particular moment of a broader and constitutive conceptual

20 Gilles Deleuze, »Postscript on the Societies of Control,« in *October* 59 (Winter 1992): 3–7.

21 Alberro, »The contradictions of conceptual art,« 9. Later, in the 1990s, the curator had the function of the most powerful
 role in terms of the standard commercial art world. For one interesting critique on the hypertrophy of the curator's role,
 see Olu Oguibe, »The Curatorial Burden,« paper delivered at *SITAC—International Symposium on Contemporary Art
 Theory*, Mexico City, 2002.

22 Kosuth, »History for,« in *Art After Philosophy and After*, 240.

23 Short extracts from my essay »Migração das palavras para a imagem« (Migration of the words to image), published
 in *Gávea*, issue 13 (1995): 373–95. Reprinted in Basbaum, *Além da pureza visual*.

condition of modern art, given that the condition of the art territory is one of articulation of the visible and enunciated matters since the break with the principles of representation carried by modern times. There should be a conceptualism condition in art, of which Conceptual art is just a particular and important case. It is important to know that we are *not* speaking in Joseph Kosuth's terms, nor quoting from his famous »Art After Philosophy« article:[24] when we emphasize a conceptual condition of modern and contemporary art, we are not entering the terrain of analytical philosophy, but taking as reference the »théorie des énoncés« (theory of enouncement) proposed by Michel Foucault throughout his work. The major writings where he develops propositions along these lines were produced during the 1960s and 1970s,[25] for example, »This is not a Pipe« (1968) explores Magritte's seminal painting/statement as the actual departure point for the banishing of a hierarchy in a relationship between »enouncements« and »visibilities« (which legitimizes the representation regime)—for Foucault, Magritte demonstrates that representation is no longer productive, and therefore words and images are subsequently heterogeneous practices that cannot be reduced to each other's terms (Deleuze indicates that for Foucault knowledge is »bi-form,« traversed by »the discursive practices of statements, or the non-discursive practices of visibility«[26]). In this new regime, »it is in vain that we say what we see; what we see never resides in what we say. And it is in vain that we attempt to show, by the use of images, metaphors, or similes, what we are saying; the space where they achieve their splendour is not that deployed by our eyes but that defined by the sequential elements or syntax«[27]—here, words and images have nothing in common, are indeed different matters, without any region or territory where they could share a more stable and regular relationship. Looking at Michel Foucault's *théorie des énoncés*, three basic aspects of the relationship between discourse and images can be emphasized: enouncement and visibility are in »reciprocal presupposition«; consist of »heterogeneous forms« that have nothing in common; and are in permanent state of »heterogeneity of the two forms« and can therefore only operate in a situation of »mutual presupposition between the two, a mutual grappling and capture«.[28]

What is most remarkable about Foucault's theory is that, when it establishes the absolute otherness of the matters that constitute the discursive and visible dimensions, it brings forth the *in-between* space—contact zone, interface—as the principal site (or non-site) where productive events are generated, created, triggered. In fact, this model takes both images and words at the same level, indicating that if meaning (of any kind) is to be produced, it will be the result of a conflictive and disjunctive operation of (never peaceful) contact of these two matters[29]—the borderline is no longer what sets things apart in a sterile and anesthetized environment, but the hotspot where processes become productive.

24 Reprinted in Kosuth, »Introductory Note to Art-Language,« 13–32.
25 See from Michel Foucault, *The Order of Things: An Archaeology of the Human Sciences* (first published in French, 1966), *Archaeology of Knowledge* (first published in French, 1969), *The Discourse in Language* (first published in French, 1971), *This is not a pipe* (first published in French, 1973).
26 Gilles Deleuze, *Foucault*, trans. Sean Hand (Minneapolis: University of Minnesota Press, 1988), 51.
27 Michel Foucault, quoted by Deleuze, ibid., 66.
28 Michel Foucault, *This is not a pipe*, quoted by Deleuze, ibid, 66, 67–8.
29 Of course, Foucault's model does not propose any neutral or ideal situation, but indicates that at any moment these two layers are involved in a dynamic that is worth revealing, through his archeological approach.

Gilles Deleuze, *Foucault's Diagram* (1986)

Seen through Foucault's *théorie des énoncés*, Conceptual art's efforts to justify its shifting of »dematerialized« written pieces as exhibits in exhibition spaces seem somehow unnecessary— although we have a sense of heroism in those gestures—for the shift from visual to verbal and vice-versa can be assumed as part of the investigation. The development of Conceptual art and Michel Foucault's investigations are, in fact, contemporaneous, and if we take their works as parallel and complementary research—aiming at the production of new forms of thinking (Foucault's theories are quite strongly influenced by topological models that emphasize structural- ism and offer other possibilities for conceiving thought in space[30])—one productive gesture today would be to build the terrain for the confrontation of both bodies of work. There is a certain philosophical naïveté in Conceptual art regarding this framework structure, as it is constructed primarily in terms of Anglo-American analytical philosophy and linguistic theory— perhaps, if it had escaped its self-referential modernist impulse during the 1970s, it would have been able to encounter other philosophical practices capable of reversing its direction (in a certain sense, the »post-conceptual generation« assumed such a meeting[31]).

Organic line, again

This essay has not adopted a historical perspective, its premises unfold in the contemporary time-space of the present, which indicates equal access to events that although chronologically disparate, when linked, establish certain productive connections: it's more interesting to develop some »plastic force from the present ... and transform the past« than to be blocked by the

30 See Jeanne Granon-Lafont, *La Topologie Ordinaire de Jacques Lacan* (Paris: Point Hors Ligne, 1985).

31 Alexander Alberro identifies three groups of post-conceptual artists: Mike Bidlo, John Knight, Louise Lawler, Sherrie Levine, Allan McCollum, and Richard Prince (identified by »exploration of structure« and »critique of authenticity«), Victor Burgin, Jenny Holzer, Barbara Kruger, and Mary Kelly (addressing the »construction of the subject through various overdetermining forms«), and Fred Lonidier, Martha Rosler, Allan Sekula, and Phil Steinmetz (who share the implication that »self-determination and communication ... is still a historical option and artistic possibility«). Alexander Alberro, »Reconsidering conceptual art, 1966–1977,« in Alberro, Stimson, *Conceptual Art: A Critical Anthology*, xxviii–xxx.

»hypertrophy of historical meaning.«[32] Lygia Clark's organic line has been introduced to indicate the importance of its discovery in the mid-1950s, pointing out that her investigation had already produced certain possibilities for exploring empty or invisible space, which proved fundamental for Conceptual art's development—her contemporaries, Klein, Manzoni, Johns, and Rauschenberg have already been recognized as decisively influential, but Clark's contribution must also be considered in this matrix. By encountering the complex achievements of Foucault, who considers both discursive and non-discursive practices and processes, and extracts from them the disjunctive operation[33] of confronting the heterogeneous matters of visuality and enouncement, the organic line finds the correct resonance to become an accurate political tool. Nonetheless, it is necessary to clarify that the operation of disjunctive confrontation is not simply processed through the given dimensions of word and image—on the contrary, it has to be produced through concrete engagement. Therefore, the organic line is not just a given, as part of the world, but must be produced and activated by an intervention, a gesture that opens things and produces a new flow of problems, situations, and events.

Because her work was directly invested in the body, Clark's investigation has attracted great interest as a fundamental reference. In an age of globalization and biopolitics, »'life' and 'living being' are at the heart of new political battles and new economic strategies«[34]—developing resistance now involves »the production and reproduction of life itself,« that is, the creation of new forms of »intelligence, affect, cooperation and desire.«[35] Indeed, Lygia Clark's final development—from 1968 until her death in 1988, she spent time in Paris and Rio de Janeiro—led her to more radical propositions, located at the borderline between art and therapy, notably the *Estruturação do Self* (Structuring of the Self), started in 1976.[36] This activity, which Suely Rolnik locates in a »new territory, which does not consider the borderlines of art, and of clinic«[37] (but certainly is produced from the contact zone between them)—reveals perceptive, sensorial, and political layers indicating how the artist also worked out several recent issues in contemporary art: likewise, a kind of organic conceptualism is present, investing in regions of discourse and visibility, and employing practices of appropriation. Rolnik points out how Clark involves the participant through Relational Objects »in two regimes of sensorial exercise—to connect with

32 Peter Pául Pelbart, »Deleuze, um pensador intempestivo,« in *Nietzsche e Deleuze — intensidade e paixão*, ed. Daniel Lins, Sylvio de Sousa, Gadelha Costa, and Alexandre Veras (Rio de Janeiro: Relume Dumará, 1999), 65.

33 In the *Anti-Oedipus* (1972), Deleuze and Guattari call the energy of disjunction »divine«: »The sole thing that is divine is the nature of an energy of disjunctions.« Gilles Delueze and Felix Guattari, *Anti-Oedipus: Capitalism and Schizophrenia* (Minneapolis: University of Minnesota Press, 1983), 13.

34 Maurizio Lazzarato, »From biopower to biopolitics,« accessed at http://www.generation-online.org/c/fcbiopolitics.htm. Originally published in *Pli—The Warwick Journal of Philosophy: Foucault: Madness/Sexuality/Biopolitics*, vol. 13 (2002): 100–11.

35 Peter Pál Pelbart, »Império e biopotência,« in *Vida Capital—ensaios de biopolítica* (São Paulo: Iluminuras, 2003), 83.

36 See notes 2 and 3 for references, and also the catalogue *Lygia Clark, de l'oeuvre à l'événement: Nous sommes le moule, à vous de donner le souffle*, ed. Suely Rolnik and Corinne Diserens (Nantes: Musée de Beaux-Arts de Nantes, 2005).

37 Suely Rolnik, »D'une cure pour temps dénués de poésie,« in Rolnik, Diserens, *Lygia Clark*, 13–26. The following quotes are from the same source.

38 Notion developed by Suely Rolnik in a number of her writings (»corpo vibrátil,« in the original), to refer to a permeable and membranous body that »absorbs the forces that affect it, making them into elements of its texture, the marks of sensations that will compose its memory.« Rolnik, ibid., 16.

the world as diagram of forces or as cartography of forms,« establishing a »paradox between micro- and macro-sensoriality«: the »micro-perception« leads to the »resonant body,«[38] and the »macro-perception« to »objectification of things, separating them from the body«—what is important is to »establish a free micro and macrosensorial communication flux between the bodies,« that will originate the »becomings of the self and of the world.« For Rolnik, the importance of bringing Lygia Clark's experiences back to the art field is decisive to »reactivate, today, art's political potential«—here, the activation would succeed through a concrete and dynamic relationship of the dematerialized layers and the body in its limits.

It is interesting to think of the organic line as a construction progressively gaining »thickness,« as it involves more and more spaces, issues, elements, and concepts, becoming a »membrane«—an active and autonomous structure functioning as the region of contact between neighboring territories of various kinds. Therefore, in order to operate effectively in the connection between art and life and all its mediations and contact zones with art and politics, systems and circuits, artists—and writers—should make the borders active, playing and experimenting with all of the passageways between them.

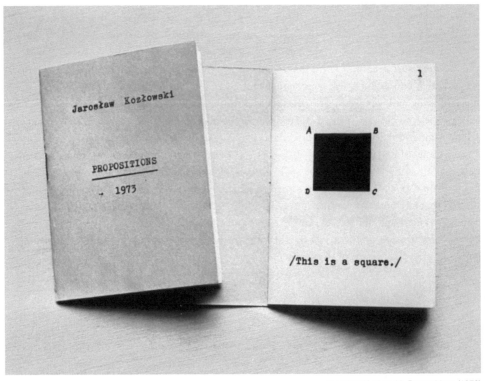

Jarosław Kozłowski, *Propositions* (1973)

Luiza Nader

Language, Reality, Irony:
The Art Books of Jarosław Kozłowski

In its reflections on Conceptual art practices, art history has neglected the issue of the subject, and the ensuing questions of desire, absence, and doubt, by treating Conceptual art as a strict, anti-emotional critique of visuality and aesthetics. The question of subjectivity points to an emerging peripheral field in the study of Conceptualism, which is usually associated with analytical procedures and conscious intellectual operations.[1] Apart from well-known notions such as »dematerialization of the object« (Lippard), »critique of the institution« (Buchloh), »uncompromising stance« (Ludwiński), and their derivatives, the Conceptualism dictionary created by art historians and critics has not allowed any other entries. This is surprising since the attitude, criticism, and disposition towards objects are inevitably regulated by the subject's condition, which, in Conceptual art—more than in any other area—expresses itself through language. It is through language that subjects most clearly reveal their meta-stable position and doubt; they are fragmented and dispersed. The conceptual vocabulary is, therefore, incomplete, half-open, full of marginal notes and cross outs. It resembles Richard Rorty's final vocabulary,[2] whereby in Conceptual art, philosophy serves as the »vanishing mediator.«[3]

The figure of »liberal ironist,« as described by Rorty, meets three basic conditions: she treats her final vocabulary as contingent (because the ironist has been influenced by other vocabularies as well); she is constantly dubious about her own vocabulary; she does not choose between vocabularies within a neutral meta-vocabulary, but in »playing the new off against the old.« She is a nominalist and historicist, and she is aware of the contingency not only of the language

1 Briony Fer, »Hanne Darboven: Seriality and the Time of Solitude,« in *Conceptual Art: Theory, Myth and Practice*, ed. Michael Corris (Cambridge/New York: Cambridge Univ. Press, 2004), 223–33.

2 Final Vocabulary is a set of words we use to motivate our lives: actions, beliefs, doubts, and hopes. »It is 'final' in the sense that if doubt is cast on the worth of these words, their use has no noncircular argumentative recourse. Those words are as far as one can go with words; beyond them there is only helpless passivity or a resort to force.« See Richard Rorty, *Contingency, Irony and Solidarity* (Cambridge/New York: Cambridge Univ. Press, 1989), 73.

3 Osborne takes the *vanishing mediator* metaphor from Max Weber. The vanishing mediator according to Osborne (after Jameson) is a catalytic link that enables the exchange of energy between two discrete expressions, serving as a sort of overall structure within which changes take place and can be removed when no longer needed. Peter Osborne, »Conceptual Art and/as Philosophy,« in *Rewriting Conceptual Art*, ed. Michael Newman and Jon Bird (London: Reaktion Books, 1999), 64–65.

she uses but also of her consciousness. At the same time, she has a feeling of constant uprooted-ness. The ironist »spends her time worrying about the possibility that she has been initiated into the wrong tribe, taught to play the wrong language game. She worries that the process of social-ization, which turned her into a human being by giving her a language, may have given her the wrong language, and so turned her into the wrong kind of human being.«[4]

Jarosław Kozłowski is not a philosopher, nor does he believe in philosophy in its post-Kantian form. He is a liberal ironist. Yet he needs philosophy and he uses it as a kind of symbolic weapon, a sharp tool. Similar to Wittgenstein, Kozłowski seems to believe that philosophy »is a battle against the bewitchment of our mind by the means of our language.«[5] The question of language can be perceived as central to the artist's work, particularly to his art books written and created from the early 1970s. This question, together with the relationship between Conceptu-alism and philosophy, lies at the heart of all reflections on Conceptual art. Kozłowski—the liberal ironist—treats language as an autonomous base from which one does not look for the truth, but instead, for freedom. His reflections on language, on its relation to the world, and on the condition of the subject imprisoned within the language and language games, force us to regard Conceptualism from a subjective perspective, with doubt and distance. By incorporat-ing terms such as absurdity, paradox, solipsism, symmetry, and chance, narration, freedom, and absence into his final vocabulary, the artist deconstructs these notions, including the notion of Conceptual art.

Kozłowski's books were created in the library: But it wasn't the PWSSP (State College of Visual Arts) Library where Kozłowski was relegated to become chief librarian after the militia's intervention at the first NET exhibition,[6] but a library meant as a thesaurus of readings, an intellectual map of conscious and unconscious references, the figure of a specific kind of knowl-edge and discourse. His books refer critically to other artists' propositions and, primarily, rede-fine the artistic field by opening it and incorporating it into a wider philosophic discourse. Having re-evaluated the modernist categories (ethos of skills, notion of autonomy of the work of art, homogeneity of the medium), they burst the traditional notion of the artist and of cre-ation by placing artistic practice within the discussion of the possibilities and impossibilities of metaphysics rather than within aesthetic discourse.

An important component in Kozłowski's final vocabulary is the concept of play or games, played out on the pages of his books, whose rules are not only uncovered, but also, in a sense, co-established and redefined by the reader and his or her own collection of books. Language games, games of conventions, meanings, or lack of meanings not only affect how fast or slow the book is read, but also become their sole rhetoric. The notion of the game does not leave hope for a reality beyond itself that could be re-entered, nor does it serve as a referential base. It is the game itself that is treated as reality. The kind of game initiated by Kozłowski engages presence and non-presence, triggers a wandering sequence of meanings and inquiries into lan-guage, erudition, and distrust. It is an aimless game though something is always at stake: things

4 Rorty, *Contingency, Irony and Solidarity*, 74–75.

5 See Ludwig Wittgenstein, *Philosophical Investigations* (Oxford: Basil Blackwell, 1997), par. 109.

6 See Jarosław Kozłowski and Jan Kasprzycki, »Alternatywna rzeczywistość. Akumulatory 2,« in *Arteon*, no. 3, 2000: 39.

7 Edited by Jarosław Kozłowski (Poznań, 1972).

are won and lost. What Kozłowski bids is the subject's own self—the self on the verge of insanity, fighting to recapture the lost bond between language and the world.

In *Deka-log*,[7] Kozłowski makes specific use of the numbers from one to ten. Every subsequent page depicts a multiplication of signs according to their numerical value; a single one being followed by two twos and three threes, etc. The abstract/symbolic value of numbers is hereby confronted with concrete graphic depiction. The multiplication of signs, analogous to their numeric value, creates the following paradox: only a one (1) has its corresponding value. In the subsequent example of the two twos, which are represented by the corresponding number of signs, they add together to become four in abstract value, and so on. The artist is playing with the abstract numerical value and its visual representation, with the idea and its materialization, and eventually with *signifiant* and *signifié*.

Jarosław Kozłowski describes *A, B*,[8] one of his first art books, as a simple game with relativism. The first page displays the two title letters situated symmetrically against a vertical line between them. On the subsequent pages, the picture is turned 180 degrees counter-clockwise; the reader observes a constant shift in the angle of the whole picture within the page frame so that the dividing line becomes longer towards the diagonal position, and the letters almost disappear in the extreme position when the picture reaches ninety degrees. Then, at larger angles, the letters again come into the frame and the image appears »as if on the opposite side of the mirror.« The operation is repeated in a manner similar to musical imitation »in contrario motu«: above ninety degrees, the letters are slowly rotated upside down until the angle reaches 180 degrees with the initial image turned upside down and the title page reversed.

The book thereby has no specified direction of reading/viewing: both directions are equally relevant. The forward-backward relation has no application in this case. The reader is, instead, an observer of a clock reflected in a mirror.[9] However, there is no clear indication as to which part is original and which the reflection. The reader's impression of the original or the reverse depends purely on his or her choice of reading direction. The reader is the point of reference for the book, in other words: the two ways of reading/viewing the book are of equal value depending on the reader's consciousness. *A, B* is therefore a theorem on relativism. It does not, however, relate to an abstract, disconnected situation. The repetition of the front page, seen as a kind of »retrograde imitation,« suggests that it is not just a quotation or a meta-statement, but rather, an operation in reality: in his book, the author is using first degree language. It is up to the reader to gradually distinguish the rules of the game and find the meaning. As the artist seems to suggest, it is not just the rules that are relativized but also the reader's knowledge and beliefs cease to have any universal character; they become dependent on our individual identity constantly revised by ever evolving history and culture.

8 Jarosław Kozłowski Edition, 1971. In the case of *A, B*, *Grammar*, and *Language*, the following institutions have been given as publishers: ZPAP (Union of Polish Artists and Designers) in Poznań, Galeria Akumulatory, Galeria Foksal PSP. Appearing under an official institution label was a deliberate measure to mislead censorship. In fact, the true editor of all the books was Kozłowski himself. *A, B* was distributed within NET (an informal society). During the inauguration exhibition of NET in the author's private apartment, militia and SB (secret service) agents intervened and two thirds of the issue was confiscated and never returned.

9 Here, I refer to Kozłowski's work from the 1980s. See Piotr Piotrowski, »Meblowanie pokoju. O sztuce Jarosława Kozłowskiego,« in *Jarosław Kozłowski. Przestrzenie czasu* (Poznań: Muzeum Narodowe w Poznaniu 1997), 10.

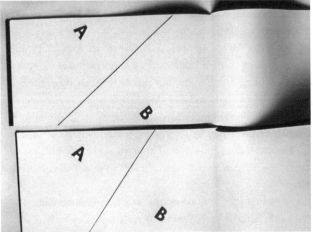

Jarosław Kozłowski, *A, B* (1971)

Deceitful symmetry, duality, and mirror reality also determine the parameters of *Propositions*.[10] This book focuses on the issue of meta-linguistic statements and the reality referred to as the process of increasing and decreasing these statements. The point of departure is a black quadrangle, an equilateral figure named »square«: */This is a square/*. As the form of writing seems to imply, it is not a set linguistic utterance, but instead, an idea, assumption, or even presumption. The next sentence is formulated in first degree language: *The square is black*, followed by an example of meta-language: *The proposition »The square is black« is true*. Subsequent pages develop the number of meta levels up to a fourfold-meta-linguistic option: *»The proposition ///I ascertain: 'It is true that the proposition »The square is black« is true'// is true.«* In the case of meta-linguistic utterances, especially in those of spectacular multiplication, language ceases to refer to an external reality, becoming a reality of its own, in which the categories of true and false have no references. At this point, it almost goes unnoticed just one page later, that instead of further multiplying the alterations, Kozłowski introduces a slight correction: *true* is replaced by *false*: *The proposition // I ascertain: 'It is true that the proposition »The square is black« is true'// is false*. The meta-linguistic statement remains true because this »slight« change of meaning, at that level, does not affect the rules of language. A gradual process of reduction is then applied, with the word *true* being replaced by *false* in the following meta-statements, in accordance with the meaning of the sentence as stated previously. The last two sentences read: *The proposition »The square is black« is false* (meta-language) and *The square is not black* (language) as the final statement. The paradox is revealed only in the last statement, which, as mentioned above, is not purely linguistic, but instead, a sphere of a priori presumptions; when */This is not a square/* is placed under the black rectangular figure it clearly defies basic language conventions and common sense. Significantly, the black square appears only with the extreme statements and is omitted when a sentence is marked as language or meta-language.

10 Edited by International Artist's Co-operation, Central Office, Klaus Groh, Roter Steinweg 2a, 2901 Friedrichsfehn, 1973.

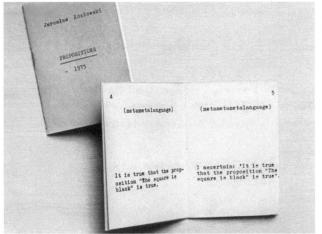

Jarosław Kozłowski,
Propositions (1973)

If we presume that the black square represents reality, we could also say Kozłowski ascertains—as did Wittgenstein in his *Philosophical Investigations*, and Rorty, inspired by Wittgenstein's thought, in constructing his »liberal utopia« that truth, which is formulated in language, does not exist in an external reality. In other words, where the sentences do not exist, there is no truth, sentences are elements of human languages, and human languages are human creations. Truth, which like sentences cannot function outside of the human mind, is thereby something that is not found, but constructed.[11] Kozłowski seems to present a stance similar to Rorty: an external world exists, but it does not speak even so abstract an entity as a geometrical figure is a construct of the human mind. In keeping with Rorty, language is not »a third thing intervening between self and reality.«[12] We may then suppose that Kozłowski, like Austin, claims that true and false are not relations but estimations relating to the critique of an utterance. Mounting meta-statements refer to the black square, which is, however, not only an abstract geometrical figure, but also a specific figure from art history, a symbol of suprematist utopia: the black square on white canvas by Malevich. Kozłowski does not strive to reach the truth or dissolve in the absolute. He is not interested in the *doxa*, but rather, in tracing paradoxes, antinomies, and ambivalences.

In *Exercise of Aesthetics*,[13] the aesthetic deliberations are reduced to the most elementary level: color is what remains of aesthetics, whereas the desiccated language of logic is applied to address the problem. The book is therefore a catalogue of prepared aesthetic value—color. Successive pages bear crayon drawn »samples« of colors: white, yellow, orange, red, brown, light green, dark green, blue, navy, and black. These are marked with a letter and a corresponding number from K1 to K10 accordingly. The samples are accompanied by the sentence: NEITHER *beautiful* NOR *ugly* in four languages: Polish, English, German, and French. On the final pages, using basic logical applications of preference, equality, negation, and conjunction, the author infers:

[11] Rorty *Contingency, Irony and Solidarity*, 3.

[12] Ibid., 14.

[13] Edited by Galeria Foksal PSP, 1976.

- A state which is neither beautiful nor ugly is indifferent »in itself«:

 (pP ~ p) & ~ (~pPp)

 Two states, none of which is preferred to the other, are indifferent »between themselves«: ~ (pPq) & ~ (qPp)

- Unconditional indifference, which satisfies these two conditions (1) and (2), may be defined by the notion of (value-) equality E. That the state p is value-equal to the state q shall mean that under no circumstances is the state p & ~ q preferred to the state ~ p & q or vice versa.

- If a state and its contradictory state are value-equal, this state (and its contradictory) has zero-value.

- A sample E—tautology:

 (pE ~ p) & (qE ~ q) -> (pEq)

By substituting p and q variables with K_1, K_2, K_3... K_{10}, Kozłowski draws the logical conclusion that all colors are equal both »in themselves« and are indifferent »in relation to each other.« In the face of logic, they are all equal, which means they have a zero value. It is therefore impossible to judge whether one is »beautiful« or »ugly« because aesthetic norms prove irrelevant. An aesthetic judgment of even such a basic quality as color (we could also use form rather than color) appears impossible.

The juxtaposition of aesthetics with inadequate unemotional logical operations proves that the system of aesthetic evaluation is useless. Our preferences seem to be a matter of contingency and not acknowledged facts. Belief in the existence of beauty or an absolute, which is related to aesthetics, together with belief in the idea of rationality and taste can be treated solely as a matter of individual preferences. It is worth noting, however, that it is the artist himself who proclaims the aesthetic equality of colors. In the same way as the choice of the language of logics, which will be off-putting for a majority of readers, the choice of the neutral state, which is ironical, appears just as arbitrary as aesthetic preferences. In the world of contingency, both aesthetics and the language of description are solely a matter of individual tastes and strategies, the rules of the games we play.

A drawing and an accompanying text »In the Sitting Room« from a popular handbook by E.F. Candlin, *Present English for Foreign Students*, became the basis for artistic operations in *Lesson*.[14] An imaginary, model situation depicted in the text and drawing was »made real« by Kozłowski: the drawing was replaced by an arranged photograph (in the photo, Kozłowski's parents are Mrs. and Mr. Brown) and the originally continuous text was split into columns. The artist had typed the text, though not entirely, as it was cut at the end of the page. One could say that its length was determined, at least to some extent, by accident. On each page, the subsequent sentence from a column is confronted with the photograph and subjected to a very specific analysis. First, the sentence is fragmented into a complete set of letters used. Second, the letters are arranged continuously in the order in which they appear in the sentence. Further, the letters

14 1972, edited by Beau Geste Press, 1975.

are organized into sounds, as in the process of learning to read. Then these sequences are formed into words, i.e., linguistic expressions with a specified meaning. Quotation marks, which distinguish particular words, suggest that these words are treated here as separate elements with no common context. The next step is to bind the words into a sentence, but, once again, quotation marks separating particular sentences make them meta-utterances. Only in the consecutive step, where the sentence begins with a capital letter and ends with a period, with no quotation mark limitations, does it become an utterance of first degree language, natural language. Going still further, by using standardized phonetic symbols, the sentence is »transcribed« into sound and speech. Finally, by setting ellipses, usually used to mark omitted text or blanks, the sentence is represented as a thought.

The exercises enclosed at the end of the book refer to the main problems that *Lesson* investigates: the interrelations between text, speech (sound), thought, photography, drawing, and, last but not least, reality. How is text related to photography? What is the relationship between speech and text? Between thought and photography? Text and reality? and, finally, how is an artistic expression (*Lesson* in this case) related to reality? Various modes of representation are thereby confronted ranging from thought, speech, and text to different means of visual expression. The language of Candlin's textbook is natural, but, at the same time, extracted to serve not so much communication, but the purpose of learning and exercising English words, pronouns, and conjugation. Kozłowski ironically appropriates the obsessive language of textbook description and exposes it to his own exercises. This artistic realization stems from the sampled language but also from an imaginary situation (text) and its visual representation (drawing). They become a pattern for the real intimate situation, which is then captured in the photograph depicting Kozłowski's parents in their apartment. The artist will enact a similar critique of the *mimesis* category several years later in *Still Life with Wind and Guitar*.[15] The representation both visual (drawing) and linguistic (text), becomes, in a way, a matrix for the real situation, which is then re-represented (photography, language, and thought).

It seems obvious that Kozłowski asks and reshapes the question that is present in Wittgenstein's *Tractatus Logico-Philosophicus*: how is thought related to the world? The issue of language, however, is closely bound with this question because as Boguslaw Wolniewicz observes, in his »early« philosophy Wittgenstein identified »thinking with any reasonable use of symbols—'language'—resulting in questioning the relationship between thoughts and the world, as transformed into the question of the relation of language and the reality it conveys.«[16] Wittgenstein, however, had his own specific way of understanding thought and language far from linguistics or psychology. As Wolniewicz points out, Wittgenstein considered thought a carrier of logical value, as something to be judged true or false. He conceived of language as everything that imitates the »logical world order« and that carries intentionality. Therefore, he saw the distinction between language and thought as fluent—thought was almost considered

15 See Piotrowski, »Meblowanie pokoju,« 10.

16 Bogusław Wolniewicz, *Rzeczy i fakty. Wstęp do pierwszej filozofii Wittgensteina* (Warsaw: PWN, 1968), 22. I refer to this publication not only because of the originality of the thesis proposed, but because it was one of the publications »concerning Wittgenstein« that Kozłowski read at the end of the 1960s. He pointed that out during one of our conversations. Script in the possession of the author.

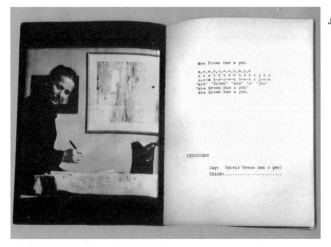

Jarosław Kozłowski, *Lesson* (1972)

a form of language. Another major question in *Tractatus…*, analogous to questioning the nature of thought, is that of a statement's meaning.[17]

In his allusions to Wittgenstein, Kozłowski, however, stays away from those questions posed by the author of *Tractatus*…. First, he undermines the identification of language and thought: thought is not represented through language, but instead, by the graphic sign referring to pre- or extra-linguistic reality. Second, and more importantly, Kozłowski questions the transparency of language with respect to the world, as assumed by Wittgenstein, and the correlation that occurs between language and reality. For Kozłowski, language is not a phenomenon spread out above the world homogenously, but instead, it is one possible form of representation, which may also, similar to photography or drawing, contain fault. If he considers language a reflection, then it is cast by a distorting mirror. In this sense, one could say that Kozłowski considers language, photography, and drawing as equivalents. He does not claim, however, that any of these means provides us with direct access to experience. It is possible to state, however, that he takes a stance against Wittgenstein's assertions (from the period of *Tractatus?*), and those of Austin stating that there is no better access to phenomena in their metaphysical dimension than through language.[18] Kozłowski calls into question the unmediated access to experience, the very notion of such an access, sheer experience, and, finally, metaphysics in general. In his *Tractatus…*, Wittgenstein related the meaning of linguistic expressions with experience and eliminated, as useless, all utterances that cannot be verified empirically. Kozłowski reversed the situation by relating experience to linguistic expression. Rather than the language being »applied« to the fact, the fact was verified within the linguistic sphere. In the reality Kozłowski created, an endless play of mirror reflections takes place, and no question of the basis, truth, or means of perception is ever raised. Representation depicts a reality that is only an imitation, a repetition of yet another representation. Priority is void of meaning here.

A description on the initial page of *Language*[19] resembles a set of game rules:

17 See ibid., 23–25.

18 Bogdan Chwedończuk, »Wstęp. Myśl Johna Langshawa Austina,« in *Mówienie i poznawanie. Rozprawy i wykłady filozoficzne* (Warsawa: PWN, 1993), xlvii.

the Latin alphabet is the basis of l a n g u a g e

l a n g u a g e consists of words which are assembled by combining all the letters
of the alphabet

the number of letters in a single word is limited by the number of letters in the alphabet

within a single word a specific letter may appear only once

The artist uses the alphabet as a finite set of elements and subjects it to combinatory trans-
formations. The letters are successively combined into sets of 2, 3, and 4, and their permutations
run through the book's forty-four pages. The very last word/set, which closes the book, is »idea.«
As his artistic method, Kozłowski applies the theory of combinations, also used in the theory of
probability. It can be assumed that Kozłowski views particular resulting sets, which only in some
cases form meaningful words, primarily as elements, things, or objects, having a corresponding
sound. The compositions of letters on a given page are just as likely to appear as a set of signs
that »dismiss *signifié*.« Kozłowski calls into doubt the function of ideas in artistic realization and
the dematerialization of the object—the dichotomy of concept and object—much emphasized by
conceptual artists. An idea exists as an object, a word on a page, or a text. Dematerialization of
the object understood in this way is impossible. In the game created by Kozłowski, the signifier
is always present, whereas, the signified may, at times, be missing; in other words, the plan of
what is to be expressed may not have any meaning at all. The artist said in a conversation with
Jerzy Ludwiński in 1993:

> From today's perspective I would not put a clear division between the object and the idea.
> I view it rather as a continuous »change of places,« incessant translocation. Objects can
> be good carriers for ideas, just as ideas can be objectified. Every shift of this kind produces
> temporary chaos and confusion, which is one of the most interesting moments of demystifica-
> tion of objects or ideas. A certain gap, which allows us to see what is usually concealed,
> inaccessible, or disguised, appears and brings new meanings to objects and ideas.
> Otherwise, a chair would always remain a chair and never become anything else but
> being a chair as a chair. And yet it sometimes happens to be the Eiffel Tower.[20]

This kind of thinking, however, which eliminates the opposition between concept and object,
and searches for what is hidden (this hidden element may not be the truth, but non-presence),
can be sensed in the artist's earlier works. In the case of Kozłowski's books, the object became
a perfect carrier for ideas, while the idea itself in *Language* among others expressed as word,
gesture, sound, or visual sign was reified. Even when the sign disappears, the whiteness of the
page remains. In other instances, the idea becomes an unattainable dimension of reality, as far
away as the things and phenomena hidden behind the membrane of language.

Kolor (Color)[21] is a record of a conversation about the color of a book's hardcover. The
conversation took place among three characters identified by the seemingly abstract letters:

19 Edited by Jarosław Kozłowski, Poznań, 1972.
20 »Jarosław Kozłowski—Jerzy Ludwiński. Rozmowa,« in *Rzeczy i przestrzenie/Things and spaces* (Łódź: Muzeum
 Sztuki, 1994), 67.
21 Edited by DESA, Galeria Pawilon, Kraków, 1978.

I, J, K. At the end of the book we find out that the participants in the discussion were Kinga Kozłowska (K), Jarosław Kozłowski (J), and Iwona Malińska (I), and that it was taped on 4 January 1978. A starting point for the »investigations« presented in the book was an ordinary, private situation. The conversation is open to readers holding the book in their hands; its color is the subject of the (actual) discussion.

Subject, style, and the specific pace of the conversation lead to the problems elaborated upon in Wittgenstein's so-called »late« philosophy in *Philosophical Investigations*, in which the word is treated as a means of communication and not as a carrier of truth. Formalized languages no longer have precedence in the description of the world. Moreover, the very notion of the possibility of linguistic transparency in relation to reality is dismissed. Language is ascribed countless functions and forms, which Wittgenstein calls »language-games«: »Here, the term 'language-game' is meant to bring into prominence the fact that the *speaking* of language is part of an activity, or of a form of life« as Wittgenstein wrote.[22] His late philosophy rejects metaphysics and becomes, as Wolniewicz writes, »a therapeutic philosophy«: it strives not so much to disentangle philosophical issues, as to find cures for them.[23]

Wittgenstein's famous deliberations on colors are, among other things, a critique of a so-called mentalistic, associational theory, according to which the meanings of words correspond when they evoke an identical »inner image« in the mind. Being an instrumentalist, Wittgenstein, as Wolniewicz puts it, claimed that: »two words have the same meaning ... when they are used in the same way,« whereas, »the linguistic consent is formed by consistence of definitions and also consistence of judgment.«[24]

Clearly referring to Wittgenstein's considerations, in *Kolor,* Kozłowski initiates his »investigations« *à rebours*: beginning with the phenomenon (color) rather than its denomination or application.[25] The interlocutors do not find any agreement in either the definitions or evaluation. K is the representative of the associational theory, whereas I claims: »the cover is what I perceive at a certain moment,« i.e., it is black in darkness, it gains color in light. I reveals the extreme form of subjective idealism. Undermining both K's and I's convictions, J acts as a moderator, and points to the fact that all participants are only playing language-games. According to him, truth lies beyond the reach of the game or, in other words, the game is the only reality, which is contained in the contingency of the language one uses. Kozłowski proves that everybody possesses an individual table of colors, uses different names to describe them, and has his or her own ways of using them. »It is almost as if we detached the color-*impression* from the object,

22 Wittgenstein, *Philosophical Investigations*, par. 23.

23 Bogusław Wolniewicz, »Wstęp,« in Ludwig Wittgenstein, *Dociekania filozoficzne* (Warsaw: PWN, 1972), xv.

24 Ibid., xxii–xxiii.

25 See Wittgenstein, *Philosophical Investigations*. See especially par. 273 and 274: »What am I to say about the word »red«? — that it means something »confronting us all« and that everyone should really have another word, besides this one, to mean his *own* sensation of red? Or is it like this: the word »red« means something known to everyone; and in addition, for each person, it means something known only to him? (Or perhaps rather; it *refers* to something known only to him.) Of course, saying that the word 'red' 'refers to', instead of 'means', something private does not help us in the least to grasp its function; but it is the more psychologically apt expression for a particular experience in doing philosophy. It is as if when I uttered the word I cast a sidelong glance at the private sensation, as it were, in order to say to myself: I know all right what I mean by it.«

like a membrane. (This ought to arouse our suspicions)« notes Wittgenstein.[26] In this case, should we not consider that the language we use to denominate color is yet another membrane separating us from the surrounding reality—Kozłowski seems to ask.

The point of Kozłowski's realization is not limited to the titular color or to the problem of language-games alone. Meaning originates in the conversation itself; in its pace, in the accelerations and relaxations, in the very act of conversation that takes place among the participants and, finally, in the process of reading the book, which includes the reader in the discussion. The meaning is constituted in the contribution to the language-game Kozłowski has initiated. Conversation and communication assures the sanity of participants—including the reader—and »understanding others gives hope for understanding themselves.«[27]

The concept of the subject, as it is developed in *Kolor,* is basically solipsistic. According to this concept, the objects of the external world are part of consciousness and of direct, individual experience. When pointing at a color and naming their impressions, the interlocutors are »pointing at themselves« reaching not with a hand but with their »attention.«[28] The possibility of the exchange of words between the interlocutors guarantees that the subject, created by Kozłowski, though confined in its solipsism, is not driven insane: »the self,« although exceedingly subjective, does not make communication impossible.

In *Grammar,*[29] the subject's world is locked in a game of combinations with being. This book is a catalogue of the verb *to be,* which was conjugated in English through all the tenses every day from 4 January until 2 March 1973. The list was organized into four sections with subsequent lines added daily:

I. The simple present tense, the simple past tense, the simple future tense
 (What was, it was
 what will be it will be)
II. The present continuous tense, the past continuous tense, the future continuous
 (what was being, it was being
 what will be being, it will be being)
III. The present perfect tense, the past perfect tense, the future perfect tense
 (what had been, it had been
 what will have been, it will have been)
 The present perfect continuous tense, the past perfect continuous tense,
 the future prefect continuous tense
 (what had been being, it had been being
 what will have been being, it will have been being)

At the end of the book, there are exercises in which the author recommends practicing the combinations of conjugation in sixty different variants. These compositions are the result of applying combinatory procedures as earlier in *Language.* The obsessive, even compulsive, listing

26 See ibid., par 276.
27 Wolniewicz, »Wstęp,« xxiv, Wittgenstein, *Philosophical Investigations*, par. 504.
28 See Wittgenstein, *Philosophical Investigations*, par: 275.
29 Edited by Jarosław Kozłowski, Poznań, 1973.

in *Grammar* can be seen as the author's »intimate diary«[30] on the one hand, and an »exercise in being,« affecting both the reader and the author, on the other. »Being« is permuted through a complete list of tenses, but it is also repeated diligently for a number of days and, finally, it is transformed in the exercise section. Though emotionally blank, this repetitiveness serves as a kind of therapy. The author's everyday treatment of »being,« and of himself, gains an existential quality in the act of writing. The primary rule is repetition. The vanishing meaning is gradually concealed in the repetitive act of writing. Multiplication, composition, and arrangement become the message.

As Briony Fer writes in her article on Hanne Darboven, »...to repeat is to evacuate the meaning something once might have had.«[31] Referring to Mel Bochner's famous text »Serial Art, Systems, Solipsism«, Fer notes that Bochner does not associate serialism with the formal arrangement of space, but with solipsism understood as a specific kind of surplus—the excess of the *self*. A subject that has lost its bond with the outside world and with meaning, one that functions solely self referentially, is solipsistic. In repetitiveness and accumulation, the sign is separated from its reference. Repeatability becomes a »place« for detachment from the self, as Fer writes.[32] A similar situation can be found in *Grammar*, where in the amassment of tenses, conjugations, and permutations, being is fragmented and becomes only a shadow of its meaning. Despite the passage of time, being is in a position where, as in Beckett's play, the time always remains the usual.[33] Being, always referred to in the third person, indicates a sphere of what has been detached from the »self,« which left it scattered and intelligible. But the »self« is present in the text's structure as a compulsive manner of recording, repeating, rewriting, as the language contained not in the sign but in the action or habit. Yet, does the multiplication of the verb mean the sign's restoration or does it mean its regression? Further, does repetition imply a question of presence or, quite contrarily, of absence?

Absence, as a central issue of both philosophy and art, was undertaken in »*REALITY.*«[34] As the author explained in »Prolegomena to '*REALITY*'«[35] the book is based on Kant's *The Critique of Pure Reason*, being a »precise reproduction of the third subsection of 'Transcendental Doctrine of The Faculty of Judgement or, Analytic of Principles' from 'The System of Principles.' The full title of this subsection is: 'Of the Ground of the Division of all Objects into Phenomena and Noumena.'« Contrary to the author's statement, the reader will not find an exact copy of Kant's work here. One will not encounter, as in Borges's story, the author writing a contemporary *Don Quixote*. »REALITY« is a re-creation of a specific group of symbols used in Kant's text. Words aside, the reader finds all the punctuation marks in their original arrangement.

30 Kozłowski's statement from a conversation with the author. Script in possession of the author.
31 Fer, »Hanne Darboven,« 223.
32 Ibid., 223–33.
33 This citation was used by Kozłowski in the text »Collages« from 1968 published in the periodical *Odra* as a conversation between the artist and critic at Galeria pod Monà Lisà. See Kozłowski, »Collages,« in *Odra*, no. 11 (1968): 69–72.
34 First edited by Jarosław Kozłowski, Poznań, 1972.
35 Jarosław Kozłowski, »Prolegomena do '*REALITY,*'« in *Zeszyty Artystyczne*, no. 9 (1996): 68–73.

Jarosław Kozłowski, »REALITY« (1972)

Clues expressed in his »Prolegomena to 'REALITY'« suggest possible interpretations
in which the essential question is that of the language as reality rather than of the language in
relation to reality. Surprisingly, the question posed in this manner refers to writing and not to
language, to the trace of non-presence and not to reality.

Assuming, after Wittgenstein, that »language being a symbolic construct imitates the logical
form of reality,« Kozłowski continues: »as a certain cliché, which has a logical and syntactic
structure superimposed on and constantly confronted with reality, language is a symbolic that
is to say, meaningful construct, and a projection of reality that cannot be and is not a reality in
itself. The same applies to expressions of language—names.« However, there are elements which
neither describe nor imitate reality:

> what escapes confrontation with the extra-linguistic reality ... is, in writing, punctuation: dot,
> comma, colon, semicolon, dash, brackets, quotation marks, question mark, interjection, dots.
> Described as punctuation marks, these signs denote nothing other than themselves. They
> do not have any extensions in the extra-linguistic reality; they do not serve as models of any
> element in that reality. They do not have any designates but are not empty; they seem simply
> indifferent to the extra-linguistic reality. In this sense, . , : ; - () / / » » ? ! ... are the only real
> subjects of Kozłowski's »REALITY.«

In his »Prolegomena,« Kozłowski refers in a deceitful manner to Kant's *Critique...*,
Wittgenstein's *Tractatus...*, Carnap's *Meaning and Necessity*, Russell's *An Inquiry into
Meaning and Truth*, and, finally, to Grodziński's *Język, metajęzyk, rzeczywistość* (Language,
Meta-language, Reality) and grants priority to what is written and not what is spoken. Kant's
language is literally deconstructed; what is left of it, is only that which, at the same time, is lin-
guistic and indicates the linguistic trap, that which is something and, at the same time, nothing—
the punctuation marks. Punctuation marks in »*REALITY*,« diligently copied from Kant's
Critique...—the work which re-addresses the issues of being and presence—look like a misprint,
or a printer's silly joke. The marks left by Kozłowski together with the primary whiteness of the
page create a reality in the text's margins, and indicate a certain break or gap. They hint at yet

another mistake, or rather, at a »provocative result of orthographic fault«: a category referring to the difference in writing that takes revenge on speech: Jacques Derrida's *différance.* »In constituting itself, in dividing itself dynamically, ... is what might be called spacing, the becoming-space of time or the becoming-time of space (temporization).«[36] In »*REALITY,*« the page is being temporized—in reading between the signs only time remains. As in his other realizations, Kozłowski incorporates time to function as an arduous day by day author's effort, and as the reader's concentrated activity, in which reading is equalized to visual perception. Through signs, time is both spatialized and visualized, and a page serves as the clock's face. Punctuation marks are both linguistic and non-linguistic elements. They provide a door to an essentially extra-linguistic experience: a door to non-presence. Non-presence rejects language in its denominational shape and its functions, such as naming or reference. In other words, it dismisses the appointing power of language.[37] The marks Kozłowski leaves are bundled traces: they do not refer back to any meaning or truth, but rather, they point to a gap or an abyss. Disregarded by the metaphysics of presence, the script becomes the only reality where, as Rorty would like to see it, the postulates of truth and reality are not brought forth, but instead, those of metaphor and auto-creation.[38] As Krzysztof Matuszewski observes, any script not seeking the Truth is profane and it can only serve to satisfy an erudite's ambitions. In depriving Kant of speech, Kozłowski reveals the erudite's doubts concerning the possibility and impossibility of metaphysics at the core of *The Critique of Practical Reason.* How are metaphysics and all of Western philosophy possible, if its vocabulary remains helpless in the face of non-presence? How can metaphysics be impossible, if its categories are applied to the natural world? And how is non-presence possible if presence (truth, values) constitute our desires? The artist leaves punctuation marks—a certain script below which »there is the unknown, the source of constantly stimulated desire, which is accompanied by philosophical omissions [concerning the relation between desire and the unknown] of a clearly traumatic character.«[39] Kozłowski's signs do not allude to the phrases that had once stood between them. Instead, they indicate that the presence restored in Kant's work may have always been an illusion.

Kozłowski's art books do not build into any closed system; they turn more »from theory to narration.«[40] Kozłowski suspends the problem of truth, regarded both as *aletheia* and as *adequatio,* between *Tractatus Logico-Philosophicus* and *Philosophical Investigations;* between the treating of language as a metaphysical subject and accepting its contingency. The spectacular choice of readings may refer to the gap between Wittgenstein's early and late philosophy; a gap that embraces, on the one hand, philosophers associated with the Lvov-Warsaw circle, such as Kazimierz Twardowski, Kazimierz Ajdukiewicz, Alfred Tarski, and Jan Łukasiewicz (all of whom frequently provide a point of reference for Kozłowski), and Alfred J. Ayer, John L. Austin, Jacques Derrida, and Richard Rorty, on the other; a gap which finally gives an order to define

36 Jacques Derrida, »Différance,« in *Margins of Philosophy* (Chicago: Univ. of Chicago Press, 1982), 13.

37 See Krzysztof Matuszewski, »Erudyta w świecie profanum,« in *Derridiana* (Kraków: Inter esse, 1994), 232.

38 Rorty, *Contingency, Irony and Solidarity,* 40.

39 Matuszewski, »Erudyta w świecie profanum,« 241, 248.

40 See Rorty, *Contingency, Irony and Solidarity,* 2.

41 Ibid., 27.

the truth as a »mobile army of metaphors.«[41] In an attempt to escape the labyrinth of language games, Kozłowski abandons philosophy and turns to artistic narration, to the visuality of the word and »beneath the scripture.« The pace and the logic of the pages' layout in his art books become the perfect means for the artist to reflect on the extra-linguistic sphere where the aesthetic experience proves helpless. Kozłowski's books strike us with their modesty and intriguing layout. Their rawness suggests a resignation, on the part of the author, from aesthetic pleasure but not from visual experience. Kozłowski's books are both to be read and watched; reading and watching become equally relevant methods of approach. The choice of book as medium is a negation of the traditional artistic discourse and of general rules of exposition and distribution of an art work. The book is an object that excludes the avant-garde category of originality (they are always printed in at least one hundred copies). What is more, it combines the visual with the textual, and the process of reading demands from the viewer/reader a certain type of intimacy. Kozłowski's books are an encounter and they demand returns—they refer to other readings and other discourses; they are both intriguing and alluring though, at the same time, repelling. They are driven by a dialectic of incessant covering and uncovering of the rules and of a shimmering meaning.

In the hands of Kozłowski, the book reveals the visual aspect of the text and it becomes a perfect vehicle for addressing questions of language—an issue crucial to both philosophy and art of the twentieth century. In contrast to other conceptual artists such as Sol LeWitt, Joseph Kosuth, or Włodzimierz Borowski, Kozłowski does not use language as a remedy for an objectification of the art world. Quite to the contrary, he exposes and uses the materiality of language and stresses its processuality. Consequently, in Kozłowski's books, time has the same importance as drawing or text. The organizing principle for the narration and the pace of reading is contained not in the text itself, but primarily in the logic of the page; the text is always composed with reference to the page's inner structure, the whiteness of the page is just as meaningful as the sign. Visuality, objectivity, and processuality,[42] the graphic sign, language understood as a set of elements on a page, color, book, time of writing, time of reading—all of these enable the artist to move along the margins of meaning and introduce the extra-linguistic dimension into the text. Kozłowski questions the innocence and transparency of language, just as he questions the innocence of any kind of representation. He reveals the preconceptions contained in the very structure of representation (its metaphysical nature) and proves, in opposition to Wittgenstein, Austin, and the conceptual orthodoxy—that language is not a privileged space for communication with the world. Kozłowski would surely agree with Rorty's idea that languages are made and not found. For this reason, language is not considered a space for investigating truth, but rather, a space for reflection on freedom, meant as admitting one's contingency and respecting final vocabularies of others. In his interpretation of Nietzsche and referring to Wittgenstein's famous statement, Rorty notes that in order »to create one's mind, one needs to create an own language, not allow our mind to be limited by the vocabulary other human beings have created

41 »Processuality« and a specific spatiality of Kozłowski's books is acknowledged through the fact that some of them were also presented as performances (*Lesson*, Akumulatory 2, March 1976) or written out in the exhibition space (*ćwiczenie z Estetyki/Exercise of Aesthetics*, Galeria Foksal PSP, 1976).

43 Rorty, *Contingency, Irony and Solidarity*, 51.

earlier.«[43] The subject present in Kozłowski's books is an ironic one, in a parallel sense to Rorty's definition: a subject indicting language, disbelieving any extra-temporal order, using every available language incessantly attempts to describe his or her self, the world and every being anew. Slightly reinterpreting Bloom's figure of the »strong poet,« Rorty observes that Wittgenstein and Heidegger both seem to have concluded their work on an attempt to find respectful conditions under which it was possible to surrender philosophy to poetry. Kozłowski incorporates philosophy into his considerations precisely because it is in a redefined creative space that he sees a chance to disclose intuitions philosophy failed to address.

Having engaged philosophy into artistic creation, Kozłowski reformulated the existential rules applying to the cultural fields of artistic and philosophical discourse. The artist did not easily succumb to political activism, nor did he become a philosopher or (more of) an outsider. Transferring basic philosophical issues into the realm of visual arts, he escaped aesthetics and raised questions of an epistemological and ontological character, as well as a criticism of reality. Peter Osborne observes that in the case of Western-European and U.S. artists, philosophy was often used in the field of artistic production as a means of usurping power by the ascending generation of artists, as an instrument suitable for relating to the artwork's crisis of ontology, and finally, as a way of gaining social control over the reception of their works.[44]

Philosophy, especially positivistic and linguistic sorts, granted some authority to a »newly recognized« Conceptual art. In a few instances (such as Art & Language), philosophy was regarded as not only a way of redefining the artistic field, but, much more than that, as a way of bringing hope for social and political transformation. In Poland of the 1970s, the combination of philosophic and artistic discourses acquired separate meanings decided on by the political context and the space where Polish art existed after 1945. This space—described by Andrzej Turowski as a space of »ideosis,« where political power took over control of individual choices,[45] exerted a stifling pressure on Polish postwar culture and defined artistic attitudes and values. Kozłowski managed to escape these ideosis-generated artistic paradigms by using philosophy as his strategy. First, Kozłowski did not have a particular artistic tradition as a point of direct reference, but instead, a philosophical context, which was free from the rule of »ideosis« dominant in the artistic field. Second, choosing language as a medium, the artist not only negated painting and other traditional artistic media but liberated his realizations from the haunting dichotomy in Polish art of realism and abstraction. Language as an artistic medium was not seen as either abstract or realistic. The artist simply suspended any and all categorization.

By exposing his art to philosophical discourse, Kozłowski, while not necessarily taking control over the reception of his works, instead directed the recipient to a field of reference previ-

44 Osborne, »Conceptual Art and/as Philosophy,« 49–51.

45 See Andrzej Turowski, »Krzysztof Wodiczko and Polish Art of the 1970s,« in *Primary Documents: A Sourcebook for Eastern and Central European Art Since the 1950s*, ed. Laura Hoptman and Tomas Pospiszyl (Cambridge, MA/London: MIT Press), 154.

46 Ibid., 155–56.

47 As Andrzej Turowski writes, in the early 1970s, just like in the post-Stalinist period, the artwork was almost totally deprived of its social and artistic identity, whereas the artist's role in society was no longer questioned. Ibid., 158.

48 I use the distinction between the subject and the »self« after Michel Foucault. See also Michał Paweł Markowski's paper »Literatura, prawda, podmiotowość« presented at the Polish-French symposium *Światy Foucaulta* (Foucault's

ously alien to the »fine arts.« Having done that, he re-formulated not only the conditions of cre-
ation but also of reception. He deconstructed the notional structure within which art in Poland
was created, exhibited, and received. Kozłowski's books, like the artistic publications of other
conceptual artists in Poland, managed to avoid institutional supervision by breaking out of tradi-
tional systems of distribution. These works could be perceived as neither literature nor fine arts.
Andrzej Turowski[46] observes that from the second half of the 1950s, the official cultural policy
was all about stimulating, limiting, or appropriating existing or emerging means of representa-
tion. Policy was laden with the sanctioned ideology, nonetheless; no defined artistic forms were
imposed. In his philosophical critique of the notion of representation, using language games,
contingency, and absence, Kozłowski indicted any form of representation, leaving nothing to
appropriate. Philosophy, applied by Kozłowski, granted the artistic work some of its authority
and enabled it to regain social and artistic identity[47]—the conceptual artistic fact became an
evaluative statement, a statement on transcendental notions, and on both the reality of art and
the external world. This explains how Kozłowski's conceptual works, of which his books are
the finest and most interesting examples, were not so much self-referential in the formalistic
sense, but rather, auto-reflective, and provided a critical examination of both inner and outer
conditions of artistic practice.

Taking Wittgenstein's or Twardowski's thought as a starting point for his artistic practice,
Kozłowski always concentrated on contemporaneity and on applying even the most intricate
deliberations to private and intimate situations (even if they were deeply hidden or coded). The
subject—understood as the authorial »self«—is never eliminated from the work, though it does
not have much in common with the figure of the author. Its function is primarily to reveal, in
the plurality of languages, opinions, preferences, incidents, and historical conditions, the funda-
mental questions relating to freedom. And so, speaking on behalf of itself, the »self« evolves from
a silent being to a discursive one and replaces the subject.[48] Philosophically engaged Conceptu-
alism became for Jarosław Kozłowski the only possible form of social action and involvement.
It was a territory of equal aesthetic and ethical choices, of permanent negotiation of meanings,
and of recurring attempts to describe reality. Last, but not least, for him, Conceptualism became
the language of the subject explaining true discourses.

Translated from the Polish by Mikolaj Palosz.

Adrian Piper, *Catalysis III* (1970)

Isabelle Graw

Conceptual Expression
On Conceptual Gestures in Allegedly Expressive Painting,
Traces of Expression in Proto-Conceptual Works,
and the Significance of Artistic Procedures

Ideas with emotions?

To seek a universally valid definition of »Conceptual art« is futile, just as the attempt to unambiguously determine so-called »neo-expressive« or »wild« painting will ultimately remain unsuccessful. The fuzziness of the notion was in a way constitutive for Conceptual art, igniting numerous controversies and rivalries over dates and founding acts.[1] While numerous artists claimed to have decisively initiated Conceptual art, others—art historians as well as artists— disputed their right to this history in order to establish alternative historiographies. Embattled as »Conceptual art« may be, it is, in the end, an art-historical categorization with positive con- notations, endowed with the aura of being not only progressive but also *critical of the market.* Following the logic of modernism, the conceptual approach was claimed to be superior, casting doubt, it is claimed to this day, on the traditional status of the artwork as commodity.[2] Accord- ingly, a great number of art-historical studies were devoted to Conceptual art, especially in the 1990s. The opposite is true for what is called neo-expressionism. Here, too, one encounters ges- tures of superiority, pathos, and demonstrations of excessive confidence; but by the early 1980s, they had ceased to give rise to belief in the possibility of a progressive position. So far, only *one* inquiry into this phenomenon, unfortunately in a very descriptive style, has been presented; the mere contrast of this paucity of publications with the wealth of literature on »Conceptual art« speaks volumes.[3] Is a dissertation on the subject of »neo-expressionism« destined to be a bad career move for an art historian? It would seem so. The reason why this subject is unattractive has to do with the pejorative aspect of the label »neo-expressionism,« for this term, coined in the early 1980s, is invariably used in a deprecating sense. It was intended to disparage painting that appeared to be »figurative,« »expressive,« or »gestural,« which at the time had been particularly promoted by European traders and curators in close association with their U.S.

1 See Sabeth Buchmann, »Conceptual Art,« in *DuMonts Begriffslexikon zur zeitgenössischen Kunst*, ed. Hubertus Butin (Cologne: DuMont, 2002).

2 See Tony Godfrey, »What is Conceptual Art,« in *Conceptual Art* (London: Phaidon Press, 1998), 4–16.

3 See Nina Ehresmann, *Paint Misbehavin': Neoexpressionismus und die Rezeption und Produktion figurativer, expressiver Malerei in New York zwischen 1977 und 1989* (Frankfurt: Lang, 2005).

colleagues, and had initially seen rapid market success.[4] Yet despite the negative connotations of the term, some advocates of such painting also employed it, in order to wax enthusiastic about a »neo-expressionist movement,« which they saw dawning in a wide spectrum of phenomena, ranging from the Cologne »Mülheimer Freiheit« across the Italian »Transavantguardia« (Chia, Clemente) and the late works of Frank Stella to paintings by Büttner, Schnabel, or Fetting.[5]

So, while conceptual practices gained status, becoming a favorite area of research among critics and historians with a socio- and market-critical perspective, advocates of »neo-expressionism« were frequently the same players who had helped to achieve the style's acceptance on the art market.[6] That is not to say, however, that the symbolic capital accumulated over the course of years by Conceptual art had not at some point been transformed into cultural and economic capital. At least since the Paris exhibition *L'art conceptuel: Une perspective* (1989/1990), a second phase of the European reception was initiated and sustained by a resurgent interest in conceptual and institution-critical approaches, which also included younger artists. With it, however, came a discussion that has continued to this day about the connection between a number of production-aesthetic premises associated with Conceptual art (strategic planning, the imperative of communication, self-management), and a post-Fordist regime's profile of demands. The spectrum of such considerations ranged from Ian Burn's early diagnosis of the 1960s' »official styles'« imitation of the »American Corporate Way of Life,«[7] to Benjamin Buchloh's succinct formulation of an »administrative aesthetic« that smoothly adapts to, even mimetically reproduces, the logic of the administrated world: raising the question of whether such an »administrative aesthetic« also mirrored the expansion of the service sector in post-Fordist society.[8] The only problem with arguments of this kind is their tendency to totalize; what was once at stake in these practices is now of much less importance than the fact that general social developments, or neoliberal virtues, can indeed be discerned in some of these practices' production-aesthetic premises. At this point I would suggest a different argument in order to recognize as one of their achievements that they have made visible and palpable the development of artistic competences that continue to be in demand today. »Conceptual art« of the 1960s cannot be made responsible for today's tendency to demand of artists that they manage themselves, operate strategically, network incessantly, or pander to the »corporate logic« of institutions by offering consulting or animation services or various suggestions for improving architecture or interactivity. But if this image of the artist, owing as it were to an overly simplifying reception of Conceptual art, is by now predominant, and if, moreover, there can be no doubt that this image of the artist correlates with the »entre-

4 See a by now canonical text by Benjamin Buchloh, who takes the term »neoexpressionism« to denote mostly the variant of such painting originating in Germany, which he condemns as reactionary. Benjamin H. D. Buchloh, »Figures of Authority, Ciphers of Regression,« in *Art After Modernism. Rethinking Representation*, ed. Brian Wallis (New York: The New Museum of Contemporary Art, 1984), 107–37.

5 See Robert Rosenblum, »Gedanken zu den Quellen des Zeitgeistes,« in *Zeitgeist*, exh. cat. (Berlin: Frölich und Kaufmann, 1982), 11–14, here 11.

6 See Christos M. Joachimides, »A New Spirit in Painting,« in *A New Spirit in Painting*, exh. cat. (London: Royal Academy of Arts, 1981), 14–16.

7 See Ian Burn, »The Sixties: Crisis and Aftermath (or the Memoirs of an Ex-Conceptual Artist),« in *Conceptual Art: A Critical Anthology*, ed. Alexander Alberro and Blake Stimson (Cambridge, MA/London: MIT Press, 1999), 329–408.

8 See Benjamin H. D. Buchloh, »From the Aesthetic of Administration to Institutional Critique,« in *L'art conceptuel: Une perspective*, exh. cat. (Paris: Musée d'Art Moderne de la Ville de Paris, 1989), 41–53.

preneurial self« demanded by the labor market, wouldn't it make sense to adopt different pro-
duction-aesthetic premises and hence favor a kind of painting that *conceptualizes* expression?
This question will be the focus of the following inquiry. It requires, however, a little detour. At
first it will be necessary to trace, render plausible, and dissolve the classical frontline between
supposedly conceptual and expressive practices at specific historical junctures. Rather than
polarizing them in the usual manner, I will seek to demonstrate that expression can be conceptu-
alized also in seemingly expressive painterly gestures without permitting conclusions as to any
authentic emotional state, just as works resulting from thorough conceptual planning can ex-
hibit a sort of »residual expression.« This is not to imply, however, an abrogation at once of
all differences between »expression« and »conception.« They continue to exist, and have their
foundation not least in the economic dimension and at the level of procedure. Both »expres-
sion« and »conception« represent specific notions regarding artistic procedures, which in turn
are conjoined to processes of value-formation and relations to the market. Yet these relations to
market conditions may, upon closer scrutiny, turn out to be different from what is traditionally
claimed. Based on such a »refined« understanding of conceptual and expressive practices, I will
consistently argue for different canonizations and art-historical categorizations. This revision of
the canon, however, meets its limits in the fact that it, too, is beholden to a belief in the signifi-
cance of artistic procedures, and thus operates on the implicit assumption that artistic proce-
dures do have a significance that transcends them. But can one make that assumption today?
Can an artist who avails him- or herself of artistic procedures of the 1960s or 1980s, even if
refined and adapted to a changed situation, still count on an inherent power to disrupt the
sociopolitical status quo? The significance and expressive force of artistic procedures will them-
selves be at stake at the end of this inquiry. It is possible that artistic forms of critical interven-
tion—an intervention, however, which I believe must always reflect also upon its own
involvement in the present situation—are found on an entirely different plane today.

Frontlines

Conceptual and expressive-painterly practices are traditionally—most recently, during the
early 1980s—irreconcilable opponents. It cannot be stressed often enough how much each side
felt to be on the defensive, and regarded the other side as threatening. Just as the advocates of
a »New Spirit in Painting« construed a radical break with the allegedly so »un-sensual« practices
of the 1970s, whose putative predominance had at that time finally come to an end, its oppo-
nents projected the phantasm of an omnipresent »neo-expressive« painting, which, though glut-
ting the market from all sides, was otherwise »regressive« or »obsolete«—at the time, synonyms
for »not worth talking about.« The historical vicissitudes of the notion of the obsolete led in the
1990s to a sort of rehabilitation: The journal *October* devoted an entire issue to it (*October* 100
[June 2002]: »A Special Issue on Obsolescence«), and by then thought quite highly of artistic
procedures that turned toward the abject and the rejected, that is, the seemingly obsolete. In the
early 1980s, however, the »camps« were still facing each other irreconcilably: the one side, in a
finalizing way, decreed the end of painting[9], a closing of the books, which in some ways is also
conservative, while the other side conjured up with great pathos a comeback of painting, as

though the latter were an insuppressible anthropological constant. Instead of distinguishing different pictorial practices, painting was called upon as a given institution endowed with an »essence.« The notion that there is a painting »as such« is the epitome of what Bourdieu has aptly described as »illusio.« In reality, there are only the different ways of employing it, and these different pictorial practices can be distinguished—and their relative merits assessed.

Both sides thus displayed a tendency to make totalizing claims, manifesting a strong underlying desire for expressive force. In a foreshortening perspective, entire decades were stripped of any ambivalence and rendered as devoted to »one« artistic style, whose predominance one was now determined to break. In such overstated representations, ignored was that some conceptual artists were advocates of pictorial practice, and that some allegedly »neo-expressive« painters used conceptual and institution-critical approaches. Thus, for instance, a painter such as Julian Schnabel, reputed to be a prototypically neo-expressive painter, could be understood as a conceptual artist, especially since he always thematized and over-dramatized framing by delivering his paintings with their massive frames. The frame was declared a part of his pictorial concept, and seemed so overdone and kitschy that it conjured up, and at the same time cast doubt upon, the status and value of painting. A penchant for simple systems and platitudinous commonplaces can also be read in the reduction of his formal vocabulary, and one could go so far as to call a painting like L'heroïne (1989) a linguistic proposition, since it literally feeds off the weight of this word, written in white paint on black ground. The place of visual information has been taken by a linguistic proposition, which, while maintaining the pictorial format, now merely has an instrumental relation to its medium: painting functions for it as a carrier, not unlike a sheet of paper. In turn, one might find signs of »expressive painting« also in the works of a prototypical conceptual artist such as Adrian Piper, for instance, when (as in Catalysis, 1970), wearing a T-shirt printed »Wet Paint,« she stylizes herself as a painting walking down the street, the paint still wet. Any bodily movement is thus transmuted into a painterly gesture, provoking reactions from passersby. This work engages, so to speak, in »expressology« by calling upon bystanders' racially motivated fears of contact, translating them into the code of painting, and thus rendering them visible.

Now, the traditional front between conceptual and expressive-painterly practices has in my view to do also with their divergent economic potentials. For they present widely different prospects regarding the maximization of profits. Even the works of the most legendary conceptual artists, such as Dan Graham or Lawrence Weiner, failed to generate increases in prices comparable to the speculation gains that were to be expected, for instance, upon buying a painting by Julian Schnabel in the early 1980s. This de-facto gulf is explained by the traditionally high credit oil painting has among investors. There is simply a greater readiness to spend more money on this format, for it has historically proven to be the ideal carrier of massive appreciation. It would be mistaken, however, to explain the comparably lower prices fetched even by the most well-known works of »Conceptual art« with the notion that the latter were by design incongruous to the commodity form, or even critical of the market. It has been shown in the meantime

9 See Douglas Crimp, »The End of Painting,« in On the Museum's Ruins (Cambridge, MA/London: MIT Press, 1993), 84–106. At the end of this polemic against the »resurrection of painting,« he simply decrees that painting has come to an end.
10 See Alexander Alberro, Conceptual Art and the Politics of Publicity (Cambridge, MA/London: MIT Press, 2003).

that this notion is a myth. In his study of the »publicity politics« of »Conceptual art,« Alexander
Alberro has given exemplary demonstration that this artistic style did not at all, as is often
claimed, intend to abolish the status of the art object as commodity.[10] Quite to the contrary:
according to him, the central agents of Conceptual art, particularly Seth Siegelaub, deployed
ingeniously devised marketing and advertising strategies. Yet if one has to assume, following
Alberro, that »Conceptual art's« mastery of the clever sales pitch is commensurate with, let's say,
painter Julian Schnabel's perfect pandering and his bare-chested self-staging, to the art world's
desire for the violent bravado of a »celebrity painter«: does a softening of programmatic differ-
ences necessarily follow? In my view, that would be a little hasty, and moreover, neglectful of
what was at stake in the respective formations.

In the early 1980s, there certainly were reasons why painting was regarded as hopelessly
contaminated—especially when it gave the impression of being figurative, expressive, or gestural.
It had not been envisioned as a medium of »Conceptual art« even in the 1960s, as it was con-
sidered incapable of challenging the myth of »high art,« and it was admitted in the early 1980s
only as an exception, even within the paradigm of »appropriation art«: Jack Goldstein or Troy
Brauntuch were susceptible to integration within the »Pictures« artists' group pushed by critic
Douglas Crimp only because their paintings were based on templates from various media and
displayed no brushwork legible as »vigorous« or »expressive.«[11] The skepticism toward pictorial
practices among leading U.S.-American art theorists was so pronounced that artist Thomas
Lawson, in his legendary »Last Exit Painting,« felt compelled to distance himself from the
»pseudo-expressionists« (among whom he counted Schnabel, Fetting, Clemente, and others)
before launching a sort of vindication of his own painting as well as that of his friend David
Salle, which, he claimed, was »critically subversive.«[12] Today, »Last Exit Painting« reads like
an insistent plea addressed to the theorists around the journal *October*, imploring them, as it
were, to finally take cognizance of this style of painting based on originals from popular culture,
and to induct it into the canon of critical appropriation, as it alone was capable, according to
Lawson, of attacking the center of the market, and critically undermining its power. To my
knowledge, there has been no such critical acceptance to this day—quite to the contrary, the
distinction was now made between »good« and »bad« appropriation, with the reservation that
the act of appropriation alone did not guarantee that a work was »critical,« a distinction that
rendered any art-critical appreciation of Salle impossible and excluded him from the canon.[13]
One can recognize that this polarization extends to the present from a remark made by Michael
Asher, one of »institutional critique's« founding figures. He recently indicated that something
like »conceptual painting« was to his mind entirely inconceivable—a *contradictio in adiecto*,
as it were. His unqualified expression of this conviction in a film by Stefan Römer (*Conceptual
Paradise*, 2005) is the more striking given that, in his personal vicinity, in Los Angeles, he could
very well have encountered examples of conceptual painting. One need only think of the diligence
with which Ed Ruscha premeditated and planned the paintings of his *Stains* series (1969)—
paintings made approximately at the same time as his famous conceptual photograph series

11 See Douglas Crimp, »Pictures,« in Wallis, *Art After Modernism*, 175–87.
12 See Thomas Lawson, »Last Exit: Painting,« in Wallis, *Art After Modernism*, 153–64.
13 See Douglas Crimp, »Appropriating Appropriation,« in *On the Museum Ruins*, 126–37.

(*Thirty-four Parking Lots*, 1967 and *Nine Swimming Pools*, 1968). Or of Baldessari solemnly burning the paintings he had made so far in the *Cremation Project* (1970)—an act which at the same time created a lasting monument to painting. His famous series *The commissioned paintings of 1967–70* is an example of conceptual painting that submits to an external experimental set-up. It is based on photographs Baldessari made of friends pointing at something. According to Baldessari, that is the quintessential conceptual gesture of pointing something out. In fact, however, the customary reproach against Conceptual art, that it is »instructional,« »cerebral,« or »didactic,« is taken up here and canceled immediately by Baldessari's transposing this gesture into the register of painting. A hobby painter was commissioned with the photorealistic execution, which at first glance seems to avoid personal expression but, upon consideration, shifts it to the plane of conception. For conceiving something, which is to say, planning or drafting it, always also means having to select: to decide in favor of one or another idea, one or another photograph. Even selection thus expresses a personal predilection. A few years later, an artist such as Martin Kippenberger, who was at first mistakenly categorized as a »young savage,« employed a similar procedure of delegating pictorial competence. The *Lieber Maler male mir* series (1981) was commissioned from a poster designer, who realized, again with photographic realism, the seemingly banal motifs—a street scene outside the Düsseldorf artist and musician hangout »Ratinger Hof,« a still life with a package of pasta, a grotesque little dog, rounded off with Kippenberger staging himself with much pathos on a dilapidated sofa. Manifest here, among other things, is a system of personal preferences—ranging from bars to pasta. That such a thing as »conceptual« painting—that is to say, a simple pictorial transposition of a concept that is as »simple-minded« as possible—has existed for a long time, at least since Warhol's principle »painting by numbers,« is thus a fact of history that would seem inevitable.

The most prominent example would be the Art & Language group, whose artists turned against the radically linguistic consensus among their colleagues already in the late 1970s and put painting back on the agenda—a painting, however, that would implement certain plans as a point of program, and could in fact consist in the mere announcement of such plans: »We shall make a painting in 1995 and call it hostage,« one painting read. Paintings such as *Portrait of Lenin by V. Charangovitch (1970) in the style of Jackson Pollock* (1980) also virtually forced the union of what one would assume were irreconcilable opposites, such as Socialist Realism and Abstract Expressionism. It would seem as though the experimental set-up had indicated that such a plan, as shallow as it is absurd, was to be implemented by all means in painting.

One could give this screw another turn and offer evidence that a conceptual trait is inscribed even in the famous »asparagus painting,« *Spargelfeld—dithyrambisch* (1966), by Markus Lüpertz, denounced to this day as a »Malerfürst« (»prince of painters«), by virtue of its serial and systematic character.[14] Again, there is a phenomenon of interference between his monumental painting *Westwall* (1968) and the performance by the same name, during which Lüpertz assumed various poses next to rock formations, interacting with them, and huddling against them in a mimetic manner reminiscent of VALIE EXPORT's body figurations. His early works

14 See Isabelle Graw, »Ein Bild von einem Mann. Für einen früheren Markus Lüpertz,« in *Texte zur Kunst*, no. 51 (September 2003): 74–83.

Martin Kippenberger, painting from the
Lieber Maler male mir series (1981)

would thus have to be read also against the backdrop of his performative fluxus activities—after all, Lüpertz participated in a legendary junkyard happening by Wolf Vostell in 1965. And there is indeed a kind of familial likeness between the »instructions« of fluxus performances and the plans typical of »Conceptual art.« Such unexpected genealogies can be taken even further in the case of Jörg Immendorff's early oeuvre, which, to my mind, has yet to be accepted into the canon of institutional critique.[15] One need only think of his participatory actions with middle school students, who were asked to evaluate his artistic performance, or of his suggestion for an alternative Lidl Academy, including a charter and room plans. One can find here elements of an »administrative aesthetic« as well as conceptual procedures and »teamwork.«

Market analysis

»Neo-expressionism« was first and foremost a polemic term, intended to fend off and combat the works branded with it. As with any label, no allowance was made for differences between the pictorial practices subsumed, or rather, lumped together under the term »neo-expressionism«; as though the procedures of artists as different as Lüpertz, Clemente, Kippenberger, Baselitz, Dahn, Immendorff, Salle, Schnabel, Dokoupil, Fetting, or Büttner were basically one and the same thing: neo-expressive painting, and hence painting that was, per se, not to be taken seriously. As is often the case, the origin of this designation is undocumented—yet it seems peculiar to me in that it connotes also the success on the market of the artists associated with it. For the word »neo-expressionism« was pronounced always in a tone that left no doubt regarding one's desire that this phenomenon, a product of the market and the media, soon come to an end.[16]

15 See Isabelle Graw, »Jenseits der Institutionskritik. Ein Vortrag im Los Angeles County Museum of Art,« in *Texte zur Kunst,* no. 59 (September 2005): 41–53, here 48.

16 In the »Postscript« to his »Figures of Authority, Ciphers of Regression,« Buchloh gives the almost desperate diagnosis that his worst fears had come to pass: This painting had indeed vanquished »museums and ... the art marketplace« in an unparalleled fashion, had »[aggressively asserted] its reactionary political affiliations and its defense of a notion of culture that is right-wing, sexist and elitist,« and had served as the »willfully ignorant« smoke screen for the conservatism and aggressive policies of the Reagan administration.

Markus Lüpertz, *Spargelfeld—dithyrambisch* (1966)

The manner in which the term »neo-expressionism« was used thus already included the animus against a formation that at a certain point in time indeed dominated the market.

From today's perspective, however, the situation appears somewhat different: Could not the potential of certain painterly approaches of the early 1980s lie precisely in the fact that they accepted the market as an objective institutional power and defined their relationship to it, instead of falling into the naïve belief that one could elude it? That is indeed the case with artists such as Martin Kippenberger, who even made an outright exhibition of the market's arbitrary value-assignments with his *Preisbilder* series, which plays on the double meaning of »prize« and »price.« Yet here, too, differentiation is in order: now between those painters, such as representatives of the so-called Transavantguardia (Sandro Chia or Francesco Clemente), who in their naïve belief in painting and implementation of univocal narrative, produced gestures that tend to conform to the market; and those who, such as Kippenberger, behaved on the one hand in a manner conforming to the market by networking indefatigably, but on the other, irritated this market with inflationary production, silly antics, and a behavior felt to be impertinent, which at first earned him institutional rejection. In turn, a high degree of reflection upon the market is to be found also among conceptual artists. For instance, Ian Burn wrote an illuminating text in 1975 that takes an astonishingly disillusioned look at the market.[17] In spite of the recession incipient at the time, he diagnoses a definitional power of the market heightened to the point where it determines what will be regarded as having aesthetic value. The present-day tendency for economic criteria to replace aesthetic ones could already be anticipated thirty years ago. According to Burn, the grasp of the market went so far as to seize the sphere of production. For Burn, works of art are commodities from the beginning—that is to say, conforming to the commodity-form already on the plane of conception. In other words, the market cannot be kept out of the design phase of a proto-conceptual work. The notion that conceptual practices were and continue to be highly conscious of the laws of the market is supported also by the practice

17 See Ian Burn, »The Art Market: Affluence and Degradation,« in Alberro, Stimson, *Conceptual Art: A Critical Anthology*, 320–33.

of »certificates,« now highly popular again, for instance among young post-conceptual artists such as Jan Timme or David Lieske. Traditionally, certificates represent an attempt at self-empowerment, at gaining control over distribution and decentralizing it, bypassing the galleries. By employing certificates or the famed »contracts,« artists intend to have a say about the circumstances of the future existence of their works. By now, however, the certificate has been transformed into a sort of fetish that is perfectly compatible with the gallery system, especially since it delivers proof of originality or authenticity as desired by the collector even in instances where the work does not take the form of a singular object, exists only as an instruction, or exists in multiple editions. It is nowadays seen as the tribute that an artist invested in »conception« is willing to pay to market demands. The high degree of reflection upon the market, past and present, among conceptual artists, is conversely matched by painters within the formats of »wild« or »neo-expressive« painting who hampered the market's grasp; whether elevating the ostentatious lack of complexity to a principle, like Oehlen, Kippenberger, and Büttner in their early painting; or, like the artist Jutta Koether, took the principle of »Bad Painting« literally, painting images that went beyond the approved »Bad Painting,« that were dismissed as simply bad painting and ignored by the market for years. Still, stereotypes—such as the notion that »neo-expressionism« is a pure market phenomenon while Conceptual art stands outside the market—have persisted to this day. As is well known, stereotypes are tenacious. Yet there is another deployment of both artistic styles, located on the level of procedure. There is good reason, after all, for two fundamental figures to be advocated, distinguished even simply by their titles: »expression« on the one hand, »conception« on the other. These production-aesthetic ideas are closely associated with fundamental notions of procedure as well as notions of subjectivity and art that could not be more different. They are, to put it starkly, worlds apart.

What expression expresses

While »expression« is a central category of idealist aesthetics, reactivated at first by German Romanticism and later by Expressionism and »neo-expressionism,« and always remains tied to the subject, the importance of this subject was to be curbed in »Conceptual art.« Ideas, concepts, or systems were to ensure that, ideally, the subject would play virtually no role. The artistic subject thus submitted to an external specification, and it was held that subjectivity would, in this way, cease to play any role in artistic production.[18] While Conceptual art hence pretended to have left behind the paradigm of expression, »wild« or »neo-expressive« painting put expression back on the agenda. The curators of the propagandistic *Zeitgeist* exhibition went so far as to elevate »expressive force« to the status of a criterion: the more vehemently and immediately the artist's passions forced their way into the painting, the greater, they thought, the artistic accomplishment, as though the significance of a work of art depended on the emotional input. In fact, the *Zeitgeist* program regressed even behind Adorno's dictum that »valid art« had to move between »unassuaged and inconsolable expressivity« and the »expressionlessness of construc-

18 See Sol LeWitt, »Paragraphs on Conceptual Art« (1967), in *Open Systems. Rethinking Art c.1970*, ed. Donna De Salvo, exh. cat. (London: Tate Modern, 2005), 180–81.

tion.«[19] This momentum of construction, which can be found even in the seemingly most impetuous paintings of K. H. Hödicke, which are, after all, based on a systematic compositional principle, was simply suppressed. Instead, a Romantic expressive pathos was reactivated that was characteristic most recently of the second half of the eighteenth century, when it had been held that art is destined to express emotions. The idea of this expression harbored by the advocates of »neo-expressionism« remained tied to a subject, whose constitutive substantiality was presupposed, as was the notion that its emotions and passions are immediately transposed into and articulated in images. That painting is a complex and highly mediate language with its own laws, not a one-to-one translation of an emotional state, was assiduously overlooked. Ignored was especially the fact that this postulate of a unified subject »immediately« expressing its emotions, its state of mind, had proven to be highly questionable also in the process of postmodern and poststructuralist critiques of the subject. Texts or images can thus no longer be understood as revelations of subjective expression, but rather, stand for the opening of a space in which the subject effects its own disappearance. At most, it leaves traces, traces that should, however, not be confused with authentic testimony as to its essential mental-emotional state. Yet regressive views fell back to this short-circuited notion and Buchloh was rightly shocked that brushwork or impasto effects were again felt to be »painterly« or »expressive,« when one should have known since Ryman and Richter, at the latest, that pictorial signs are not transparent. He was fundamentally right, and yet there were artists, in fact within the formation that Buchloh attacked, who mobilized these signs for expressivity with full knowledge of their status as signs. Then, expression no longer intends to refer to something originary or authentic, but instead, is exhibited as the effect of a specific procedure. Thus, early paintings by Kippenberger frequently contain »worms of paint,« squeezed directly from the tube, which form unsightly blobs on the canvas. They must be read as exaggerated signs for an immediacy that does not pose as authentic utterance or ex-pression. They thus stand less for the impulsive gestures of an artist than for his or her interest in a pictorial vocabulary that creates the impression of »immediacy« in order to demonstrate the fact that it is mediate. The problem, however, was that neither the advocates of neo-expression nor its opponents were capable of registering such conceptualizations of expression; they were either too busy to put an end to the »paltry, cerebral, abstract styles« (Rosenblum) of the 1970s, or allergic to any signs of »expression« or »figuration,« which were immediately accused of being reactionary. Indeed, the advocates of the *Zeitgeist* show could hardly conceal their satisfaction that, according to them, the time of avant-garde experiments was finally over for good. This mentality of an »end for good,« this condemnation of all conceptual achievements, is reminiscent of the cyclically recurrent longing for a »zero hour,« which can again be heard of late. Especially young painters desire that unhampered »expression« or »regression,« and ignorance of all post-conceptual insight be permissible again. There is always a conservative tilt to such anti-intellectual impulses, and they must be taken with a grain of salt.

Although major representatives of »Conceptual art« had in turn taken punches at »Abstract Expressionism,« they owed as much to this opponent, who was constitutive of their own posi-

19 Theodor W. Adorno, *Aesthetic Theory*, ed. Gretel Adorno and Rolf Tiedemann (Minneapolis: Univ. of Minnesota Press, 1996), 43.

tion. For instance, their preference for intuitive procedures or irrational systems presents an unintended affinity to the production-aesthetic premises of Abstract Expressionism.

Sol LeWitt's famous »Paragraphs on Conceptual Art« (1967) already evince the endeavor to discard »expression« as though it were an irritating insect at last to be got rid of. The »Conceptual art,« whose side he took right at the beginning of the text, addresses, according to LeWitt, the mind rather than the senses, and is hence, as he emphasized soon after during an interview, more »complex« than Abstract Expressionism.[20] Thus insinuating that the latter is sub-complex and rather dim-witted made distancing oneself the more effective. For Abstract Expressionism was to stand for the sort of art that remained characterized by »rational decisions,« whereas Conceptual art, as LeWitt understood it, based its endeavor on the irrational and the insanity of systems. This text must be read, and taken seriously as a manifesto for different notions of art and the subject; it is, of course, *not* to be confused with a description of the true method of »Conceptual art,« let alone of Abstract Expressionism. For Pollock's procedure, the attempt to systematically bring forth »immediacy« through a specific experimental set-up (»dripping«) is, in fact, not so alien to LeWitt's production-aesthetic systematics. Yet the problem for LeWitt lay in the fact that this painting aimed at what he called the »emotional kick,« whereas his other artwork was intended to be »emotionally dry.« Still, upon closer look at LeWitt's modular systems, such »emotional dryness« is not evident. A spectator standing before such an object (for instance, *Modular Structure [floor]*, 1966) can very well experience rapture over a structure as systematic as it is irrational, that is to say, experience a sort of aesthetic kick. Series and systems do not preclude emotionality, as LeWitt would today be the first one to concede, especially since his pictorial wall works operate with the expressive values of color. Expression is being staged in these wall works. But in the »Paragraphs,« he still saw the fundamental choice of a system, which then made decisions, as guaranteeing avoidance of subjectivity and personal expression. Still, such systems are, equally, results of a personal selection, which may display personal preference, or resonate with existential necessities, such as, »obligation to report.« Therefore, artists can even stand in libidinous relations to their systems. An example would be Hanne Darboven's early cross-sum calculations and writing systems. Her method of integrating to-do lists and excerpts from her reading into her diagrammatic drawings can also be interpreted as a means of coming to terms with the repressive-inclusive milieus of »school« and »family.«[21] Some of her diagrammatic works and notebooks seem like reports, manifesting the compulsion to justify to her parents that her actions are meaningful. Expression becomes here the effect of a systematic procedure, just as subjectivity becomes discernible in LeWitt as the effect of an industrial procedure. LeWitt's obsessive variations on the cube are expressive also of his personal enthusiasm for this form—an enthusiasm in turn supported by a consensus. After all, the cube was part of the preferred formal vocabulary of the 1960s, due to a number of its implications (anti-hierarchical, serial, industrially standardized). The cube was in a sense

20 See Patricia Norvell, *Recording Conceptual Art. Early Interviews with Barry, Huebler, Kaltenbach, LeWitt, Morris, Oppenheim, Siegelaub, Smithson, Weiner*, ed. Alexander Alberro and Patricia Norvell (Berkeley/Los Angeles, CA: Univ. of California Press, 2001), interview with Sol LeWitt, 12 June 1969, 114–23.

21 See Isabelle Graw, »Am richtigen Ort, zur richtigen Zeit, Hanne Darboven,« in *Die bessere Hälfte. Künstlerinnen des 20. und 21. Jahrhunderts* (Cologne: DuMont, 2003), 115–23.

representative of an industrial procedure that could create subjectivity without reference to an authentic mental-emotional state. What was expressed in it did not have its causal origin in the artistic subject, in fact, it was disengaged from the subject. Varying Adorno, one could say that, according to this understanding of expression, it is not the artist but the circumstances that are expressed. The problem with this argument is only that the particular is now expected to vouch automatically, as it were, for the universal. This reversal of the subjective fraction in the work of art into objectivity (»The share of subjectivity in the artwork is itself a piece of objectivity«) had already seemed a little magical in Adorno's *Aesthetic Theory*, but his exhortation not to confuse expression with an image of the subject still seems interesting.[22] In fact, the subjective, mental-emotional states appear less often than the external constraints, and are negotiated in works of art in specific ways,—whether they are said to be »expressive« or »conceptual.«

Conceptualized gestures, residual expression, and expressology

So far, art history has failed to consider the possibility that the expressive »scrawlings« of Julian Schnabel might in truth be a form of conceptualization of expression. Instead, Schnabel stands as the epitome of the »neo-expressive« artist, and his early market success and pathos-laden self-exhibition in the lifestyle press made him the more suspicious. Yet even simple biographical details should raise doubts: in the 1970s Schnabel passed through the Whitney Independent Studies Program, where training was strictly oriented on the conceptual, in institution-critique terms. That would argue at least for a certain familiarity with conceptual strategies. The latter then also appear in his oeuvre, for instance, in a drawing containing a sentence that Lawrence Weiner might have written: »what to do with a corner« (1978). The essence of this work is a plan, a concept whose execution seems secondary. On occasion, he also painted maps over with shapeless brown spots, as though forcing signs of gesture upon the conceptual artists' »mapping.« In turn, many representatives of »Conceptual art« passed through an abstract-expressionist education, which explains their vehement disavowal of the expressive paradigm as well as their fascination with the production of expression. One could say of some works that they present a sort of »typology of expression,« or engage in »expressology.« Thus, just as Schnabel conceptualizes expression, even the seemingly most inexpressive works cannot render »Conceptual art« devoid of expression. Let us take one of Douglas Huebler's *Variation Pieces* (*Variable Piece #34*, 1970), for which he ostensibly photographed forty people at the very moment of telling them that they had a pretty face. The interest for him was thus in the facial expression, that is to say, in the question of what effects a compliment would have on the latter; a sort of phenomenology of expression under the conditions of a celebrity culture characterized by a generalization of the standards of the Culture Industry in which vacuous compliments are liberally dispensed. Baldessari also conducted a similar form of expressology in *The Back of All Trucks Passed While Driving From Los Angeles to Santa Barbara, California, Sunday 20 January, 1963*, which is about the physiognomies of trucks photographed from behind. These trucks appear here like different types that are members of one genus, each

22 See Adorno, *Aesthetic Theory*, 41.

Julian Schnabel, *Drawing for »What to Do with a Corner in Madrid«* (1978)

type having a typical »facial expression.« Only, expression here must in no way be read as an indication of the most individual or personal. What becomes discernible in it is rather the outward appearance that conveys something—comparable to the painterly gesture that stages expression and thus attests less to vigorous mood swings or authentic emotions than to the radical insubstantiality of being. This »residual expression« may very well coincide with a system; thus in the serial »raster drawings« by Jutta Koether (*10. Dezember 2000–6. Mai 2002*, 2002), which combine a strict, experimental set-up in the manner of Hanne Darboven (every day one sheet is filled with boxes drawn with crayons) with signs of expressivity (more or less vigorous strokes, greater or lesser indentation of the paper). In other words, what is present is a conceptual series in which the individual's day-to-day mood swings are also rendered justice. The primal scene of all these procedures that conceptualize expression is, to my mind, to be found in »écriture automatique,« which according to Breton required certain provisions for the stream of the unconscious to be produced systematically. Fundamentally, irrationality was here, too, due to a system, as it was later in »Conceptual art,« or in Kippenberger's approach to painting, always acceding to it from the outside by implementing conceptual projects that sounded absurd. Asked how he came by his motifs, he noted, for instance, that the motif of the »egg sunny side up« had not yet received fair treatment in the history of art. He had wanted to take care of the matter.[23]

Keep to yourself

Adorno's phrase of the »*valeurs* of expression,« an allergic defensive reaction against that which was for him a »form of expression,« hints at the fact that expression has a value, and pays off.[24] A gallery owner recently told me an anecdote that is illuminating in this context: the more signs for a »face« or allusive traces of facial expression can be recognized in an otherwise

23 See Martin Kippenberger and Daniel Baumann in conversation: »Completing Picasso,« in *Martin Kippenberger*,
 ed. Doris Krystof and Jessica Morgan, exh. cat. (London: Tate Modern, 2006), 59–65, here 63.
24 See Adorno, *Aesthetic Theory*, 32, where »Ausdrucksvaleurs« is rendered as »nuanced expression.«

abstract painting, the better it sells. This means that there is something comforting and reassuring to residua of expression, that they instill confidence. Is that the case irrespective of whether they suggest authenticity or exhibit the fact that they are staged? Are the sales opportunities of an expression that seems to refer to the mental-emotional state of the artistic subject greater than those of an expression that is an effect explicitly owed to an external, experimental set-up, appearing only as »residual expression«? These dividing lines are at times blurry. Especially on the plain of reception it can happen that even the »residual expression« is (posthumously, as in the case of Kippenberger) romanticized into evidence of the inspired artist's genius and his or her authentic mental-emotional state. And a putatively »regressive« gesture that, upon closer scrutiny, turns out to be »prearranged regression,« can be considered authentically regressive, and hence regarded with undeserved skepticism, as in the case of Jutta Koether's project. From the perspective of production aesthetics, it seems therefore virtually impossible to gain control over the expressive paradigm. It is certain, in any case, that the present image of the artist is characterized more by conceptual ideals—that is to say, that conceptual norms are currently doing well on the market, and pay off. It is, as it were, part of the job profile of artists that they first have a project, a plan, a concept to show, which is then implemented as though unpredictable and chance events played no role. It is expected, moreover, that artists trade in information, that communication supplant production, or that they practice teamwork. Those artists who conceptualize »expression« equally find themselves exposed to this set of requirements: it is demanded of them that they be ready to provide elucidation about the conception of their work, and network and self-promote. Yet even if certain characteristic aspects of »Conceptual art« nowadays coincide with the neoliberal set of requirements, that to my mind does not at all mean that the insights of Conceptual art and institutional critique ought to be jettisoned—quite to the contrary, there is no alternative to them. Precisely because it is tempting to repress these lessons, their internalization should be insisted upon; the more so since the painter invested in »expression« equally mobilizes a resource that is in demand under the neoliberal regime—a resource in which his or her life, which is at work, as it were, within expression, is disposed of. Whether they remain beholden to the conceptual mode or the expressive paradigm—in both

Douglas Huebler, *Variable Piece #34* (1970), detail

cases, artists make available precisely the emotional and cognitive capabilities that capitalism demands in its current, spectacular phase. Capitalism wants all of us, body and soul—our entire lives. For this reason alone, it is insufficient to specialize exclusively in artistic procedures like »conception« or »expression,« as though that meant being on the safe side. For procedure alone cannot guarantee »resistance« or »critical stance,« hopelessly involved as it is in current requirement profiles. In my opinion, possible ways of escaping present-day interpellations are located on a different plane. The decisive point is how artists act *in general*—and not only on the plane of their artistic procedure—that is, whether they readily make all their cognitive and emotional capabilities available, as is demanded of them with the bio-political turn, or selectively refuse these interpellations, without, of course, ever being able to step fully outside them. Artistic procedure may be imbued with »life,« but in the end, what counts is how a life is lived.

Translated from the German by Gerrit Jackson.

Dan Graham, *Cinema* (1981), model, exterior view

Gregor Stemmrich

Heterotopias of the Cinematographic
Institutional Critique and Cinema in the Art
of Michael Asher and Dan Graham

There is no self-evident historical or conceptual connection between the art practice which
had its beginnings in the late 1960s and is now known as »institutional critique« and cinema
as an institution nor is there one that can be seen as included from the outset in the concept of
institutional critique. The connection became evident relatively late, in the early 1980s. To no
small extent, this can be attributed to the concept of institutional critique and a set of problems
associated with it. Nevertheless, institutional critique represents a critical ambition and a preoc-
cupation that must be taken into consideration in any effort to illuminate the relationships that
have evolved between art and cinema.

Recalling several aspects of art's development in the second half of the twentieth century
may make this clearer. The atmosphere of departure, mercurial anarchism, and simultaneous
radical theoretical ambition (which could manifest both formally and politically) with which
artists and independent filmmakers had made films from the 1950s to the early 1970s were no
longer noticeable in the early 1980s. Instead, the art scene was flooded by a wave of so-called
Neue Wilde (new wild or neo-Fauve) painting, cited as the expression of a »hunger for pictures.«
This slogan not only implied a rejection of the entire development of so-called Minimalist and
Conceptual art (including so-called institutional critique); it also carried the furtively uncanny
connotation that moving pictures were not the sort of pictures that could satisfy this »hunger
for pictures.« Paintings were courted as marketable objects, which due to their traditional tech-
nique and expressive painterly gesture could be considered an authentic externalization of a cre-
ative individual. Every film image seemed to pale in comparison to this claim, which was often
exalted, even when presented as mere pastiche.

At the same time, however, there was subliminal competition with the visual power of cine-
matic images and an unacknowledged need to borrow from them. For example, Markus Lüpertz
was not ashamed to declare that the symbolically dense configurations at the center of his paint-
ings were oriented on the archetypical logos from film studios—Warner, Columbia, Twentieth
Century Fox, and so on—in the title sequences of Hollywood films.[1] This same strategy of
address appears in different forms in various media, but is nevertheless still palpable as the

1 See Siegfried Gohr, »Deutsche Motive,« in *Markus Lüpertz: Deutsche Motive*, ed. idem (Stuttgart: Cantz, 1993).

dominant factor. There was an underlying suggestion that the art world is somehow like the movies. In fact, a whole series of star artists of the 1980s (Robert Longo, Julian Schnabel, Cindy Sherman) felt prompted to make feature films, preferring the classic production site Hollywood above all. »Hollywood« could be seen as an extension of the art scene, nourishing the idea that an artist is able to reach a mass audience by choosing the right strategy of address. At the same time, Hollywood presented a challenge, because its visual world had an ambivalent relationship with the visual world of painting, a situation that left a variety of options open.

And while Neo-expressionism seemed to dominate the art market, photographs were bought and sold there at prices previously reserved for paintings and sculptures; in turn, photography began to adopt the formats of painting, advertising, and the projected film image. Unlike painting and sculpture, photography had an affinity with Conceptualism, since Conceptual art had adopted photojournalism as a model. Artists such as Cindy Sherman and Jeff Wall utilized this legacy of Conceptualism to take a stance with regard to visual worlds that Conceptualism had excluded—in particular, the visual world of the cinema.

References to cinema in art have meanwhile become ubiquitous. A series of international exhibitions in the 1990s—some as historical retrospectives, others as cross sections of contemporary production—focus on this theme: from the large-scale exhibitions *Hall of Mirrors: Art and Film since 1945* in Los Angeles in 1996, and *Spellbound* in London in 1998, to a series of smaller exhibitions, such as, *Cinéma Cinéma* in Eindhoven and *Moving Images* in Leipzig. The majority of works shown were clearly based on a conceptual claim, although not one that would be associated with the concept of institutional critique. The artists did not work in and with the cinema as an institution in order to lay bare its functional conditions, but instead, seized its visual world as a pretext: which means that although the experiences of art and cinema overlapped, it was not necessarily in terms of the institutional structure, instead, this overlap was merely »visual.«

The concept of institutional critique and cinema

The concept of institutional critique was at the center of art critical discourse in the late 1960s and in the 1970s. It was characterized by two positions: first, a coming to terms with Peter Bürger's *Theory of the Avant-Garde*, which (following from Walter Benjamin) viewed the critique of institutions as an essential concern of the historical avant-gardes of the 1920s.[2] The other was marked by the sort of artistic approaches that had critically questioned art's institutional framework since the late 1960s. In fact, these two points of departure at the base of the concept were irreconcilable, since Bürger did not incorporate into his historical analysis—and may, in fact, not have been aware of—the artistic efforts to which art critics applied his theory of the avant-garde (artists, such as, Michael Asher, Daniel Buren, Dan Graham, Hans Haacke, and Lawrence Weiner, among others). Instead, he labeled all postwar artistic developments »neo-avant-garde,« with clearly pejorative intent. The term was meant to evoke the impression

2 Peter Bürger, *Theorie der Avantgarde* (Frankfurt: Suhrkamp, 1974); transl. Michael Shaw, *Theory of the Avant-Garde* (Minneapolis, MN: Univ. of Minnesota Press, 1984).

that their approach to the achievements—and, above all, to the failures—of the historical avant-garde was not entirely honest, and was also historically obsolete.

The American reception of Bürger's theory of the avant-garde associated it—even unwittingly—with Clement Greenberg's theory of modernism, and specifically in a way in which each theory emphasized the neuralgic points of the other achieving a connection on a higher reflective level. Greenberg had provided a fundamental distinction between two concepts of critique: criticism in the spirit of the Enlightenment was a critique from outside; and by contrast, Kant was the first »modernist,« because he was the first to subject critique's own means and procedures to a critique to demarcate its genuine area of competence. Greenberg considered this general principle of critique binding for modern art, but with the proviso that it only applied to the individual arts: each individual art in modernism had to lay bare, with its own means, the »essence of the medium«—that which was unique to it and to no other art.[3]

Greenberg could never have accepted Bürger's theory of the avant-garde, because it was based on the general principle of critique in the spirit of the Enlightenment—as a destructive critique »from the outside.« In the American reception of Bürger's theory, however the »critique of institutions« was recoined as »institutional critique.« Thus, it could no longer be understood as a »critique from the outside,« but only as a »critique from the inside« that ensured its own institutional basis and no longer referred to individual arts, but to the institutional status of art and the system of particular art institutions (museum, gallery, art journal, art market, and so on).

As a result, the suspicion remained that the art known as institutional critique ultimately remained captive to Greenberg's definition of modernism.[4] This suspicion was nourished by the circumstance that, again and again, merely the art institutions were subjected to institutional critique. Moreover, it became evident that these art institutions sought to employ institutional critique for their own legitimation. The artistic and critical confrontation with the general framework was presented as though borne by the institutions, as something desired and displayed, and thereby tended to become a form of confirmation.

The concept of institutional critique thus seemed to stand for art that could be understood using Freudian terms, that is, art that maintained a quasi-Oedipal relationship to its own institutions. But this would not hold for very long. Historians, whose primary concern was with demarcating a politically critical standpoint, soon preferred to speak again of a »critique of institutions,« whereby artistic positions that had thus far been geopolitically marginal—for example,

3 Clement Greenberg, »Modernist Painting,« in *The Collected Essays and Criticism*, ed. John O'Brian, vol. 4, *Modernism with a Vengeance, 1957–1969* (Chicago/London: Univ. of Chicago Press: 1993), 85–93, esp. 89.

4 Regarding this issue, in an interview Jeff Wall remarked: »On this level one could also argue with Greenberg that the art institution establishes its own legitimacy by concentrating on its own essence. But its essence is discursively: its own reflection on the forms of its relationship to other institutions and to itself. It would therefore be completely legitimate to say that in its examination of other institutions, art examines itself as an institution.« Wall combines this argument with a critique of Buren's position: »I believe that Buren's position has its limits. One of its most essential limitations is the idea that the art institution is so much more significant than the complex of institutions that makes up the social world.« See T. J. Clark, Claude Gintz, Serge Guilbaut, and Anne Wagner, »Repräsentation, Mißtrauen und kritische Transparenz: Eine Diskussion mit Jeff Wall« (1989), in *Jeff Wall: Szenarien im Bildraum der Wirklichkeit; Essays und Interviews*, ed. Gregor Stemmrich (Dresden: Verlag der Kunst, 1997), 225. [This interview has only been published in excerpts in English; these passages are my translations of quotations from the full interview as published in German—*Trans.*]

Latin American artists—were given more serious consideration. In contrast, art critics and theorists who tried to »go with the times« soon felt obliged to qualify the question of institutions' roles. In this way, so-called »Kontext-Kunst« (Context art) of the early 1990s in Germany,[5] inherited a discussion centered on terms like institutional critique and site specificity, yet no longer remained committed to this discourse. The value of Context art's message comprised primarily its being, or seeming to be, at odds with the demands of the 1980s booming art market, which was dependent on the »autonomous work« as a marketable product.

The question raised by Context art was not one of categorically distinguishing itself from institutional critique, but instead, how to transcend it and open to forms of practices and fields with which it had not previously been associated. Yet the term Context art refers more to a constellation of efforts than to a distinct thrust. Posed with a certain urgency at the historical intersection of institutional critique, which at least began as such a thrust, with a situation that could now only be understood as a constellation, was the question of possible forms for an artistic treatment of mass media and their supporting institutions: mass media could be understood as institutions that penetrate and determine the general awareness—unconsciously—to such an extent that they represent a kind of hypercontext preforming experiential dispositions.

Institutional critique began with the question of how the institutional framework of the gallery and the museum, the art market and the art journals preformed the experience of art, and it wanted to structurally break open these preconfigurations within the context of their functional conditions. That could only be achieved effectively if the broader cultural context was, at the same time, included in the analysis. As a result, a consequence of institutional critique's approach was an advance into the field of mass media. This was most easily achieved in print media and was indeed one of Conceptual art's strategies from the outset; most difficult were television and cinema, that is, if the demand of working in and with supporting institutions was adhered to.

The development of cable television initially brought hopes of television use that was not primarily commercial and the idea that users would actively participate in designing programs and a new form of medial public space. Dan Graham's *Project for a Local Cable TV* (1971) should be read in that context. Based on reciprocally reoriented subjective cameras, the project was only realized as an experiment, and was never shown on television. As part of the group exhibition *Via Los Angeles* at the Portland Center for Visual Arts in Oregon in 1976, Michael Asher, partly in response to Graham's 1975 work *Yesterday/Today*, had the opportunity to realize an artistic work (namely, *The Occurrence of Rolling the Television Program the Tenth of January 1976*) on commercial television.[6] That same year, Graham responded with *Production/ Reception (piece for two cable TV channels)*. This project also remained unrealized, however, in it, Graham presented his ideas on art's critical use of cable television, and simultaneously pointed to a fundamental—although vaguely formulated—commonality with Asher's approach:

5 Peter Weibel, ed., *Kontext Kunst: Kunst der 90er Jahre* (Cologne: DuMont, 1994).

6 See Michael Asher's description, written in collaboration with Benjamin H. D. Buchloh, in Michael Asher, *Writings, 1973–1983, on Works, 1969–1979*, ed. Benjamin H. D. Buchloh (Halifax: Press of the Nova Scotia College of Art and Design, 1983), 112–17.

7 Dan Graham, *Video, Architecture, Television: Writings on Video and Video Works, 1970–1978*, ed. Benjamin H. D. Buchloh (Halifax: Press of the Nova Scotia College of Art and Design 1979), 55.

Michael Asher, contribution to
Via Los Angeles, Portland Center
for Visual Arts, Oregon (1981)

»Both works involve a sense of the architectural properties of television.«[7] Asher's work comprised filming the events in the master control room of a television station for thirty minutes and then broadcasting the images on that station, interrupted only by the usual commercials.

The work was part of an art exhibition and was indicated as an artwork in the press, in television magazines, and even on television. By contrast, Graham, aimed to show situations typical for both production and reception—in principle, freed from the context of art—and thereby integrate different television channels. Two years later he received the opportunity to do so in another piece conceived and performed together with Dara Birnbaum—*Local Television News Program Analysis for Public Access Cable Television* (1978–79). In this project, the main interest was not—as it had been in Graham's 1971 project—to shift controversial standpoints in a public debate by means of employing a subjective camera, video feedback, and splitting the sound and image into a highly unconventional perspective, emphasizing the mediation of what was shown, but instead, to analyze the sheer conventionality and media sleekness of television news broadcasts, and make them transparent for viewers. In a similar spirit, as early as 1976, Michael Asher indicated in notes on his work that if he were to do another piece for television, he would record all the activities in the control room during a news show and broadcast them. His artistic interest focused on precisely those aspects of television that possess subliminal political and ideological meaning in their typified form. Crucial to this artistic approach was that absolutely no historicity was implied: the day's events reported on television, news production, its reception at home, and the critical perspective the artists proposed were all connected to an awareness of simultaneity or to a direct temporal link. At the same time, this simultaneity could be experienced as a latitude for action and behavior so that all the more critical attention was drawn to conventions, typical behavior schemas, and fixed expectations. However, this artistic strategy with reference to television had no immediate continuation after 1979.

Thus, it is all the more interesting that in the early 1980s both artists turned toward another cultural institution—the cinema—and in their art demonstrated that cinema could not feasibly be abstracted from its historicity as a medium and from its institutionalized form. The critical analysis of television could be read as remaining within the framework of the basic concepts of

presence and place—within an extension of these concepts (which had undergone diverse trans-
formations and extensions since Minimal art) that was appropriate to the medium and the insti-
tution. By contrast, the critical analysis of cinema brought with it a necessity to open up a
historical perspective; the implicit or explicit reference to something that only emerges in the
present because it concerns the past.

Cinema in the art of Michael Asher and Dan Graham

There is nothing shared by the works in which Asher and Graham come to terms with
cinema that make them seem directly comparable. Nevertheless, they are related discourses,
as is clear from their common pre-history—that is, the efforts of both artists to come to terms
with television. They place cinema as an institution, rather than film as a medium, at the center
of a set of questions concerning art's position in a cultural context. Because both works were
produced independently of each other within the same year (1981), neither can be seen as a
response to the other; instead, together they shed light on a certain historical moment in which
the demands and methods of institutional critique were applied to cinema. Asher kept to the
institutional context of the art museum, but in it he found connections to a broader socioeco-
nomic and historical context, which he then exposed through interventions. Graham, by con-
trast, sought opportunities to work outside the enclave of the museum by examining the
socioeconomic and historical context, but at the same time, commented on the art context.

Asher's contribution to the exhibition *Art in Los Angeles: The Museum as Site: Sixteen Projects*, Los Angeles County Museum of Arts (1981)

For the exhibition *Art in Los Angeles: The Museum as Site; Sixteen Projects* at the Los
Angeles County Museum of Art in 1981, Asher produced a work, that in keeping with his artistic
approach, related to the premises and general conditions of the exhibition. Yet this was connect-
ed to a particular challenge, since the subtitle of the exhibition, *The Museum as Site*, represented
a historical upheaval in reception of the artistic practice known as institutional critique. The late
1960s saw the emergence of artists such as Daniel Buren and Michael Asher who questioned the
institutional circumstances of art, the ideological motives concealed within these circumstances,
and the way in which those motives determined the meaning of the works exhibited. In the
1980s, however, institutions began to turn their artistic interventions into a kind of official insti-
tutional practice: exhibitions were conceived as playing fields for artistic interventions. The
exhibition *The Museum as Site* represented this historical upheaval. At the same time, it revealed
a new approach to the concept of site specificity. In the late 1960s and the 1970s, »site specific«
referred to works of Land art or Earth art, interventions in urban or suburban spaces, such as
those of Gordon Matta-Clark, and particular interventions in institutional contexts, for example,
those of Asher and Buren. This term did not stand for the harmonious integration of the artwork
and its surroundings but, quite the opposite, for critical interventionism. A subtitle like *The
Museum as Site*, by contrast, points to a concept of fencing in, of using site specificity in art
as a way for the museum to present itself.[8] Asher accepted the challenge by creating a work that

Michael Asher, contribution to
The Museum as Site, Los Angeles
County Museum (1981), detail

was, in fact, only a self-depiction of the museum, but one that, by operating under that premise, cast a critical light on forms of self-depiction.

His work consisted of three parts: a poster, a painting in the museum's collection, and the reconstruction of a sign in the museum's park. The poster was placed behind glass on a post in front of the museum's entrance where the museum normally announced its events. The poster had a full-size color reproduction of an advertisement for the film *The Kentuckian* of 1954 with Burt Lancaster alongside the same scene in a black-and-white production photograph. It also had a site map of the museum. The poster is described as part of Asher's contribution to the exhibition *The Museum as Site* and has textual, visual, and graphic indications of the work's other elements: the painting *The Kentuckian* by Thomas Hart Benton in the museum's gallery and the reconstruction of the sign in the museum's park. Thus, it reveals a twofold embedment: on the one hand, between the film *The Kentuckian* and Benton's eponymous painting; on the other, between the reconstruction of the sign in the museum's park and the poster, which is found on a post in an outdoor space.

Lancaster commissioned the painting from Benton and later donated it to the museum; it served as advertising for the film, though not in the usual commercial sense of giant painted posters, but rather, because as a traditional painting, it could claim to be art in a way that seemed to rub off on the film itself. The film's claim to be art is also evident in the fact that Lancaster was both director and star, as is clear from the title of both photographs. Evidently, this personal union was not only intended to guarantee total control over the product, but also to mark this product as an artist's work. Benton's painting was a kind of stamp with the word

8 Thus, the curator, Stephanie Barron, wrote in the exhibition catalogue: »the experience of encountering a scattering of unusual and sometimes jarring, sometimes playful works of art, or of viewing installations that employ non-art materials or unexpected motifs in nontraditional art spaces«; in *Art in Los Angeles: The Museum as Site: Sixteen Projects*, exh. cat. (Los Angeles: Los Angeles County Museum of Art, 1981), 9. See also Benjamin H. D. Buchloh, »Allegorical Procedures: Appropriation and Montage in Contemporary Art,« in this volume. In this context it should be noted that a work proposed by John Knight, who was originally supposed to take part in the exhibition, was rejected by the exhibition committee. See the documentation thereof in *Documenta 7*, exh. cat. (Kassel: Museum Fridericianum; Kassel: Diederichs 1982),1:284–85.

art that Lancaster applied to the film. He used the conventional status of the painting as an art-work to swap the roles usually attributed to painting and film: the traditional painting as commercial product asserted the film's claim to be »genuine art.«

By taking a painting in the museum's collection conceived as both art and advertising, and placing it at the entrance to the museum—thus relating it to common film advertising and production—Asher declared the museum a cinema. Hence, the roles of painting and film (photography) were swapped: the »film« Asher's poster refers to is Thomas Hart Benton's painting.

The immediate discursive context of Asher's work was defined by the revival of easel painting at the end of the 1970s, in connection with a reevaluation of photography and the appeal of Hollywood emerging in the art world. Asher was not simply content reacting to this situation; instead he proposed a historical perspective for understanding it. This becomes clearer in examining Benton's and Lancaster's relationships to the film industry.

Benton was fascinated by Hollywood and, in the late 1930s, commissioned by *Life* magazine, he captured its whole system of production in countless sketches and drawings and summarized them in a painting. This was the studio system of the 1930s and 1940s that produced films as though on an assembly line. Benton's depictions, however, emphasize the workers' total control over the product; he depicted the film industry in the way he once presented steelworks. Ultimately, however, *Life* magazine rejected Benton's »Hollywood,« because Benton's »producerism« conflicted with the »consumerism« that had developed along a broad front, and which *Life* magazine promoted through its journalism.[9]

After the war Lancaster appropriated Benton's producerism. He was the first Hollywood actor to grasp that time had run out for the studio system and by 1948 had already founded his own production company.[10] He sought to define his own role within the system. By claiming autonomy, he distinguished himself from the studio system and established his relationship to the sphere of art. Nevertheless, his goal was not to redeem his claim to art through avant-garde experiments. Indeed, in their forms and themes, his films professed their allegiance to traditional —sexist, nationalist, chauvinist—clichés. This was something he shared with Benton, whose painting offered a mannered, cartoon version of such clichés.

In the early 1980s, Benton experienced a revival in the United States, something no one had foreseen, but it was evidently connected to changes in the artistic climate as a whole. The wave of neo-expressionist painting that flooded the art market at the end of the 1970s was associated with a radical upsurge in the value attributed to regionalist and nationalist tendencies in art— that is, with a critical turn away from the claim to internationality and universality made by Minimalism and Conceptualism. At the same time, the postmodernism discussion led to a radical upsurge in the value attributed to eclectic practices that were seen as a critical turn away from modernism's strive for originality. Benton clearly fit this image. In Paris during the 1920s, he had experimented with all the stylistic forms of modernism, only to turn to Mannerism as his stylistic model and to profess regionalist themes.

9 See Erika Doss, *Benton, Pollock, and the Politics of Modernism: From Regionalism to Abstract Expressionism* (Chicago/London: Univ. of Chicago Press, 1991), esp. chap. 3, »Thomas Hart Benton in Hollywood: Regionalist Art and Corporate Patronage,« 147–228.

10 Tony Thomas, *Burt Lancaster* (New York: Pyramid Pubications 1975).

Thomas Hart Benton, *Dubbing in Sound* (1937)

After the war, his primary claim to fame was having been Jackson Pollock's teacher. However much Abstract Expressionism tried to distance itself critically from Benton's regionalist painting, it cannot be denied that the leading advocates had initially looked to him for direction. This is true of Barnett Newman as well, who, in 1938, appealed to Benton for support in his battle against the academics. In a *New York Times* article, he referred to Benton as »father of the mural art revival in this country,« describing a painting by Benton that is easily identifiable as *The Kentuckian*: »He had made the trip [east from Kansas City] through the hidden byways of the South, accompanied by his favorite pupil, Fitz, and his dog, Peter.«[11] Abstract Expressionism and its universality claim ultimately pushed Benton's regionalist painting into the shadows. Yet from the early 1980s onward—in the context of Serge Guilbaut's historical research[12]—it was attacked precisely for this claim to universality: its indeterminate content was said to be a renunciation of clearly fixed content, which had only served to foster an ideological appropriation by various forms of institutional and media-based dissemination. In this context, Benton's position seemed acceptable and quite topical.

Asher's work begins with this background—the question of institutional and mass media-based forms of dissemination—and allegorically adopts various pretexts that point to an overriding authoritarian discourse. The reinstallation of the sign makes this obvious. The crude, rustic design reminiscent of the Wild West, which has nothing to do with the written message, was obviously intended to contribute to a kind of Disneyland effect in the park's overall design—which also means, to contemplating cinematic experience. In the original design of the park, these signs stood at all the park's entrances. The numbers of the ordinances prominently placed on the signs are so large—they number in the ten thousands—that they evoke an impression of an anonymous superior power. These forms of mise-en-scène render directives, even those such as, »Dogs must be kept on a leash,« an anonymous threat.

11 »Barnett Newman: Interview with Thomas Hart Benton« (1938), in Barnett Newman, *Selected Writings and Interviews*, ed. John O'Neill (New York: Knopf 1990), 14–17.

12 Serge Guilbaut, »The New Adventures of the Avant-Garde in America: Greenberg, Pollock, or from Trotskyism to the New Liberalism of the 'Vital Center,'« in *October* 15 (Winter 1980): 61–78.

The idea that the museum as an institution mirrors the structures of the bourgeois family was nothing new: the maternal functions of caring for, rearing, and looking after »children« and the paternal functions of representing, regulating, and protecting the family. It is surely no coincidence that Asher chose a photograph advertising a film that makes these structures—and the associated dramaturgy—evident as clichés. It shows a family (a husband, a wife, and a boy with a dog on a leash) at the edge of a forest. Positioned in front of them are two men with rifles who clearly support the policy that »Dogs must be kept on a leash«—in the metaphorical sense as well. It is readily transparent that the whole scenario is Lancaster's self-dramatization. Yet the the question is also where Asher positions himself in this scenario.[13]

Dan Graham's *Cinema* (1981)

As he explained on one occasion, in his art he sought »the final incomprehensibility of that which the work shares with the institution.«[14] For his work, Asher calls upon the institution's full authority in order to draw attention to a set of problems inherent in this authority. His work is not a critique from outside with a claim to enlightenment; instead, it only exists because it was accepted by the institution, and yet does not represent a purist, modernist critique from the inside, which has the authority to demarcate only the institution's genuine area of competence. His work sublates both attitudes toward critique on a higher level. The »incomprehensibility of that which the work shares with the institution,« thus also comprehends the way in which art and cinema participate in each other as institutions.

Institutions have a dual character: they are concrete forms—buildings, equipment, modes of representation, regulations, patterns of behavior, social hierarchies, and so on—and at the same time, there is an abstract, overriding reason for existence, such as, »the care, rearing, and preservation of art.« Institutional critique refers to the space between an institution's abstract reason for existence and the concrete manner of its existence in order to reopen that space for critical awareness. In doing so, its goal is not to make concrete proposals for design conceivable or comprehensible separate from the proposal's status as an artwork. The work refers to itself as art in an institutionally relevant sense, and in the process, utilizes and critiques existing institutions. The resulting possibilities and forms of participating in the institution are overdetermined, or have an aspect of »incomprehensibility.«

Whereas Asher kept to the context of art institutions, in order to expose references to a broader cultural, historical, and institutional context, Graham developed proposals that transcend the context of art, with a view toward a broader cultural context: when realized, their understanding and functionality are not dependent on the art context, though they are proposed and presented as models in the art context.

Thus, Graham's guiding principles all but contradicted Asher's. Asher never declared a mere idea, a proposal, or a model to be a work of art. Only when the proposal has been accepted and

13 It should be noted in this context that in a later work Asher again used film advertising and production photographs; on this, see *Michael Asher*, exh. cat. (Brussels: Palais des Beaux-Arts de Bruxelles, 1995), documenting Asher's exhibition from 18 September to 10 November 1992.

14 Quoted in Birgit Pelzer, »Entropie,« in *Michael Asher*, exh. cat. (Bern: Kunsthalle Bern, 1992), 72.

Dan Graham, *Cinema* (1981),
model, exterior view

realized by the institution does the work exist. It is part of the institution. Graham, by contrast, developed artworks as models, conceived simultaneously as thought models and concrete models of experience, while leaving open the question of realization. Another aspect is that the model is not tied to one single site for its realization; instead, Graham refers to cultural standards and stereotypes, which he takes up as material, form, or situation, translating them into hybrid structures and psychologically undermining them.

This becomes rather obvious in his *Cinema*-model from 1981. The cinema is part of a modern office building, which has a mirror-glass façade and is located at an intersection. The screen is not a normal screen but a semitransparent, slightly curved projection screen of mirror glass, which is adapted to the building at the intersection. Like the projection screen, the side walls of the cinema are at the same height as the shop windows and, like the rest of the building's façade, are made of two-way mirror glass. Because this glass has the property that the side with more light at a given moment becomes a mirror, while the other side becomes transparent glass, there are changing conditions for experiencing Graham's *Cinema*. Two audiences—one inside the cinema and one on the street—relate to one another through the cinema's architectural structure in such a way that an evenly matched reciprocity of gazes can never occur.

Before and after screenings, when the interior of the cinema is illuminated, passersby on the street can observe the audience in the cinema without being seen by them. The audience in the cinema sees only itself on the side walls and on the projection screen. Because the rows of seats are situated in a quarter circle, they form an arena in the reflection: an imaginary self-contained form dominates.

During film screenings, the situation is reversed: under normal conditions, there is more light on the street than in the movie theater, so that passersby on the street see themselves and their surroundings mirrored on the cinema's side walls. The cinema audience, on the other hand, can look through the side walls and watch the cityscape and the passersby on the street. However, the situation with the projection screen is different. During brightly lit film sequences, the passersby on the street can look through and see the audience in the cinema.[15]

Graham's *Cinema* alludes to the modern corporate city, whose facades comprise two-way mirror glass since the late 1960s, which has typically been employed to actually permit only one viewing direction: out of the company building. By contrast, Graham's response is to employ two-way mirror glass to open up changing perspectives and cross them. The result is a form of intersubjective intimacy—even if only as a private notion.

On the psychological level, Graham's *Cinema* can be understood as a succession and dispositive of voyeuristic, narcissistic, and exhibitionist dispositions of experience. Yet at all times, both audiences are aware of the other, even if they cannot see it, and this knowledge ruptures the imaginary identification »from the inside«—the identification with the film's characters, with the camera, and also the identification with one's own mirror image. The viewers are never sure of their own position since at the same time they imagine it perceived by another position.

Graham related his *Cinema* to the metapsychological film theory that, in a strange historical parallel, was evolving simultaneous to the growing acceptance of mirror-glass façades. Christian Metz, in reference to Lacan's analysis of the mirror stage, metaphorically describes the movie screen as a mirror that simultaneously reveals itself as transparent glass. He thereby attempts to describe a psychological structure pertaining to traditional cinema. However, because Graham literally puts into practice this metaphorical talk of a mirror, which is simultaneously transparent, an entirely different situation arises that Metz was not able to consider in his theory. Therefore, it can be said that Graham's *Cinema* is designed to translate a psychological structure that metapsychological film theory locates in an unconscious »private« sphere into the architecture of the cinema itself. The result is a socialized and historicized experience of the unconscious »private« sphere. All psychological and social relationships resonate in the architecture.

One arrives at a similar conclusion by relating Graham's *Cinema* to Deleuze's theory of the cinema, even though the latter was published later. In the concepts of the »crystal image« and the »time image,« Deleuze attempted to grasp modern cinema's structures that lead to coalescences of the real and imaginary, of the actual and the virtual, of the present and the past. Whereas Deleuze treats these coalescences as an integral determining aspect of modern cinematic language, Graham treats them as an integral determining aspect of his architecture and the herewith conditioned relationship of two audiences to one another and to film.[16] Thus, present and past, imaginary and real, actual and virtual are not primarily aspects that establish an inseparable connection in a cinematic fiction, instead, they are aspects of a historical self-image.

Graham's *Cinema* is inscribed in a historical perspective that Graham outlines, in part, in his »Theater, Cinema, Power« essay, which begins with the origins of Western theater and leads to the »stagecraft and statecraft« of former actor Ronald Reagan.[17] Graham's theme is the insepa-

15 See Graham's description in *Dan Graham: Buildings and Signs* (Chicago: The Renaissance Society at the University of Chicago, Oxford: Museum of Modern Art Oxford, 1981), 46–50.

16 In my essay »Dan Grahams 'Cinema' und die Filmtheorie,« in *Texte zur Kunst* 6, no. 21 (March 1996): 81–98, I explored in greater detail the thematic connections between Graham's cinema architecture and film theory's evolution. An English translation by Brian Currid as »Dan Graham's 'Cinema' and Film Theory« is available at http://www.medienkunstnetz.de/themes/art_and_cinematography/graham/1.

17 In Dan Graham, *Rock My Religion: Writings and Art Projects, 1965–1990*, ed. Brian Wallis (Cambridge, MA/London: MIT Press, 1993), 170–89. Graham refers to Kurt W. Forster, »Stagecraft and Statecraft: The Architectural Integration of Public Life and Theatrical Spectacle in Scamozzi's Theater at Sabbioneta,« in *Oppositions* 9 (Summer 1977): 63–87.

rable connection between political and economic power and a culture of the spectacle, which has the power to falsify historical memory. Graham pointed to this power by drawing connections to the architectural history of theaters and cinemas, only to invert it at the same time. The best example is Jan Duiker's 1934 *Handelsblad Cineac* in Amsterdam. Duiker's conception is in the tradition of Bauhaus and Brechtian theater. He sought to demystify the cinematic experience by allowing passersby to see into the technical processes (analogous to Benton's producerism). From the street, one can see into the projection room.

That would, however, not touch at all upon the imaginary identifications of the filmgoers or the way in which power is exerted to condition these imaginary identifications. Because Graham's Cinema does not expose technical functional conditions, but rather, psychological ones, that is, those of the projection screen, which is penetrated by another audience's gaze, rather than the projection booth, an irresolvable tension in the situation arises. Consequently, psychological functional conditions were shifted—under their own premises—into another multiple critical perspective, resulting in a space in which historical memory could be reoriented and structured differently.

Graham's *Cinema* argument can be better understood—if indirectly—through returning to Graham's film performances from 1968 to 1973, in particular to his film *Body Press*, in which two naked performers in a mirrored cylinder stand back to back, each pressing the back of one of the two cameras against his or her body, moving it in a double helix around his body. The cameras are then reversed, and the process is repeated. The films were projected on opposite sides of the gallery space.

Whereas Graham was concerned with the psychological perception conditions in *Cinema*, his early film performances were concerned with physiological perception conditions. The methodology of his approach to media and perception conditions is, however, comparable. It is based on an indispensable two-sidedness, structured to ensure that it contravenes itself self-reflexively.

Graham was inspired to work with film by the films of Bruce Nauman and Richard Serra. Both, however, worked with a static camera and with no direct relationship between the camera and the performer's body. In Nauman's work, the film image is a kind of window: the gaze at the performer is directed outward. In Serra's work, the film image is a frame, constituting its own visual reality: the gaze at the performer is directed inward; the camera's recordings correspond to the performer's possible self-perception.[18]

This opposition can be related to a 1950s film theory controversy between André Bazin and Jean Mitry. The centrifugal conception of the film image as window (Bazin) and its centripetal determination as frame (Mitry). Because Graham equated the performer with the cameraman, and because he worked with two cameras and two performers, he was able to link both referential attitudes in a dynamic orientation process; likewise, he can also merge different channels of perception—the visual and the tactile. The whole situation is constructed so that the »inside«

18 See Benjamin H. D. Buchloh, »Process Sculpture and Film in Richard Serra's Work (1978),« in *Neo-Avantgarde and Culture Industry: Essays on European and American Art from 1955 to 1975* (Cambridge, MA/London: MIT Press, 2000), 405–28.

becomes visible outside, and the »outside« guides the reciprocal internal orientation process, so that a network of reflexive relationships becomes intelligible to the film's spectators.[19]

The same can also be said of Graham's *Cinema*. Whereas in terms of presentation, the film performances referred to the art gallery's architecture; in *Cinema* it relates to the cinema's architecture. That is to say, because Graham abandons the realm of art in the narrower sense, and confronts the medium of film at *the* level where this media has cultural, socioeconomic, political, and institutional meaning, he is in a position to provide his methodological approach with psychological power. Nevertheless, the art gallery is still the site where Graham's *Cinema* model is seen and discussed. In other words, Graham's early film performances and his *Cinema* model employ the two institutions—the art gallery and the cinema—as countersites, reflecting on the conditions of experiencing the one under the conditions of the other.

Heterotopias of the cinematographic

Foucault coined the word heterotopia to define a category of sites in which the imagination can unfold and which are neither utopias nor atopias, but instead, distinct from ordinary places in another way—as countersites. In doing so, however, Foucault merely distinguished heterotopias from ordinary places; he did not address the relationship between various heterotopias. This relationship is precisely the operational basis for both Graham's *Cinema* and Asher's work. That becomes clear if we imagine the places that Foucault singles out as heterotopias: not only the cinema and the museum, but also the mirror, the garden, and the theater.

Foucault defined a heterotopia as an outside place, which makes it possible to connect other sites that would otherwise be incompatible. »Heterotopias,« he explained, »always presuppose a system of opening and closing that both isolates them and makes them penetrable,«[20] and additionally, a system of rites and rules. He did not, however, examine specific forms of practice, which behave differently toward the rites and rules of the heterotopic space, but instead, he presumed that isolation and interpenetration define the heterotopia as such and, thus, do not change, exceed, or transfer it to other contexts. And that is precisely what Graham and Asher do, each in his own way. In relation to the museum and the cinema, they use the »systems of opening and closing« (that are normal for these institutions) in order to transgress it in accordance with its own premises. Their interventions produce heterotopias of a second-order of reflection, for they transfer different heterotopias, which normally seem incompatible, into an immediate and inseparable context. In doing so, they address the institution's structural connections along with its history and relationship to the outside—in the spatial sense and in overarching political, cultural, and socioeconomic senses.

19 On this, see the detailed analysis of Graham's early films by Eric de Bruyn, »The Filmic Topology of Dan Graham,« in *Dan Graham: Works, 1965–2000* (Düsseldorf: Richter, 2001), 329–56.

20 Michel Foucault, »Of Other Spaces,« trans. Jay Miskowiec, in *Diacritics* 16 (Spring 1986), 22–27, esp. 26.

21 Gilles Deleuze, »Three Questions about *Six fois deux*,« trans. Rachel Bowlby, in *Jean-Luc Godard: Son + Image, 1974–1991*, ed. Raymond Bellour and Mary Lea Bandy (New York: The Museum of Modern Art, 1992), 35–41, esp. 41; the interview originally appeared in *Cahiers du cinéma*, no. 271 (November 1976).

Dan Graham, *Body Press* (1970–72), film stills

Yet, this kind of relational structure is not a totality, and it does not consist of individual lines. It is appropriate here to cite what Deleuze said with reference to Godard:

I think it is Godard's force of living and thinking, and of showing the AND in a very new way, and making it operate actively. The AND is neither the one nor the other, it is always between the two, it is the boundary, there is always a boundary, a vanishing trace or flow, only we don't see it, because it is scarcely visible. And yet it is along this vanishing trace or flow that things happen, becomings are made, revolutions are sketched out.[21]

The AND marks both a boundary and a breach in that boundary, drawing both sides into »a nonparallel development, a trace or flow where we no longer know who is pursuing whom or for what purpose.« It stands for a connection of openings and closings, which does not run within the boundaries of a system, but breaks through its boundaries. Thus, it evokes a whole that represents itself not as a self-contained unity, but as an irreducible multitude.

Translated from the German by Steven Lindberg.

Adolf Loos, *Bedroom* (c. 1930)

Helmut Draxler

Letting Loos(e)
Institutional Critique and Design

Critique of categories

Within the tradition of critical thinking,[1] the consensus is that criticism is only worthy of the name if it moves beyond its specific objects of investigation and addresses the categories that are used to order and classify them. Kant, however, kept these two areas distinct from one another: the categories constitute the object realm of experience, and the concepts used on the level of reflection provide the methodological tools. These tools are not derived from the actual experience itself but, rather, from the reason for the experience. It is possible to ask to what extent this division continues to influence our thought systems today—shaped by growing institutional specialization and an ever-increasing concentration within highly specific intellectual and practical milieus. Even when the »order of things«[2] is placed at the center of our theoretical curiosity, everyday academia still speaks a different language and the reproduction of categories probably establishes its fundamental, functional rationality. It appears to be increasingly difficult to understand this process of specialization historically and to really grasp its significance. To weigh up the alternatives that are both opened up and closed down by specialization remains one of the most important theoretical and political challenges, in particular because criticism within the academic and institutional categories is often seen to be of great value, although it does not actually address the categories themselves. In art history and art criticism it is above all the constitutive function of the category of art that—in opposition to other concepts and fields such as culture and design—tends to determine the unchallenged horizons of thinking. This not only affects notions of authorship, the work, reception, and mutual relations between practical and theoretical approaches, as well as the specific psychological dynamics that play a role, but often also the critical attitude that develops toward a certain notion of art, culture as a whole, or design. As long as criticism moves within the tracks laid down by specialization, it will do more than reproduce the logic of specialization. The challenge would be to operate professionally,

1 For example, Theodor W. Adorno, »Cultural Criticism and Society,« in *Prisms* (Cambridge, MA/London: MIT Press, 1967); Judith Butler, »Was ist Kritik? Ein Essay über Foucaults Tugend,« in *Deutsche Zeitschrift für Philosophie* 50, no. 2 (2002): 249–66.
2 Michel Foucault, *The Order of Things* (London: Tavistock, 1970).

working both within the categories, i.e., in a specialized and differentiated manner, at the same time as critically addressing the relations and historical dynamism between the categories and venturing into other categories as non-specialists.

More »running-room« against crime

In his 2002 essay »Design and Crime,« Hal Foster reviews the cultural-critical hypothesis of the increasing aestheticization of everyday life. From art nouveau aspirations to a synthesis of the arts to the Bauhaus legacy of the »political economy of the sign« (as bemoaned by Jean Baudrillard), to books designed by Bruce Mau that transformed an »intellectual medium« into a design construct, lifestyle rules the world: from Martha Stewart to Microsoft, from designer drugs to designer babies. In the guise of design, neoliberal capitalism takes its revenge on post-modernism. Viennese modernism is then conjured up as a countermeasure, with Adolf Loos and Karl Kraus rigorously defending functional decisions and opposing superficial decoration. Foster even adopts Loos's emphatic equation of ornament and crime, and, citing Kraus, demands more cultural »running room«—such as might be found in the ability to distinguish an urn from a chamber pot.

That Loos's own »designs,« and in particular his spectacular interiors, are ultimately no less »totalitarian« than art nouveau may well seem to bear no weight within this generously sketched overview of our modern world. It is, however, certainly significant that a great many artists who would clearly see themselves as within the critical modernist and avant-garde tradition, and especially such artists who are seen as engaged in institutional critique today, have a quite different relationship to design. Many of them work professionally or artistically as designers of catalogues and exhibitions, and they also use layouts and displays of information, reconstruct the historical relations of exchange between art and design, and reflect the strategic implications of design as en element of pop culture for the social positioning of their own art-work. To put it bluntly, a reference to design might be seen today as a constitutive factor for artistic practice. Whereas since the 1960s artists have continuously sought to explore the space between art and design,[3] theory has remained caught up in the old modernist oppositions that come with a purely negative concept of design. Not even the most decisive rhetoric will be able to conceal the weaknesses of this approach.

To see the world as contaminated by design is, in itself, the expression of a totalizing ap-proach, in that it desires to see the world as a single entity. Here, capitalism appears as the agent of the whole, and aestheticization as its most powerful weapon. A look at the peripheries in this world, which have long been arriving at the centers, will suffice to challenge this theory of total aestheticization. But not only that: the structure of the argument itself reproduces the old gnostic worldview of the total depravity of earthly existence, which in turn can be overcome only by

3 Even in the case of Marcel Duchamp it would be possible to argue that he worked as a designer after giving up painting. His designs for posters and book covers, and exhibition and window displays are a crucial part of his work. On the signi-ficance of the »art mineur« form of window display art, which Apollinaire used in reference to Duchamp, see Herbert Molderings, *Kunst als Experiment: Marcel Duchamps »3 Kunststopf-Normalmaße«* (Munich: Deutscher Kunstverlag, 2006).

means of some true inner fire. It is precisely at this juncture that the »running rooms« Foster calls for are lost.

»Design and Crime« raises a number of theoretical, historical, and, ultimately, art-critical issues, especially when it comes to understanding important areas of contemporary art.[4] To draw so uncritically on Adolf Loos is not only problematic due to the gender-political implications of his rhetoric,[5] but also because this rhetoric, just like that of Louis Sullivan, is deeply bound up with evolutionary and biologistic notions of pure functionality. The social Darwinist implication of the arguments of functional aesthetics have generally been too little researched, precisely because critical tradition waited far too long to actually address the historical—and dated—preconditions and implications of its own rhetoric. The flipside of criticism, that often bizarre ideological space in whose name it is carried out, can no longer be ignored—if criticism is to be worthy of the name. Peter Bürger's emphatic concept of »life praxis« (*Lebenspraxis*) that he sees as the aim of the avant-garde would be a further example of an approach in which the removal of the distinction between art and life and an ensuing loss of the »running rooms« that are situated between these categories appear as the goal of critical practice.

Another interesting contribution made by Foster is the historical genealogy that he draws up on the basis of T. J. Clark's »bad dream of modernism,« and according to which all the various utopian dreams of modernism sooner or later end up as a kind of spare parts depot for late capitalist accumulation. It cannot be denied that the historical avant-gardes from Constructivism to Surrealism provided a set of visual methods that feed into advertising, fashion, and video clips to this day, but it seems doubtful that these »facts« can really be understood as the ongoing decline of artistic integrity working hand in hand with institutional and commercial success. Perhaps integrity and the ability to resist have always been a little overestimated, in line with the idealized images artists have of themselves. And perhaps the original dreams, too, were problematic enough, whether these were dreams of closed communities or of a new humankind, or of totally spontaneous and indirect processes of design. The idea that goals like these could be promoted by means of abstract graphic works was probably just as simplistic. By contrast, in any case, it would be fair to say that the relationship between visual language and utopian thinking rested far more on difference than has usually been assumed. And it is this difference that ultimately prevents us from seeing modernism as a one-dimensional history of the decline of true faith. Instead, we can recognize a multilayered image of the interrelationships of artistic and ideological, aesthetic and political issues that are being continually renegotiated and are forced to reflect on their own historicity. And wouldn't an art history of design be just the place to look at these differences and interrelationships as cultural »running rooms«?

4 It also raises art-historical issues, since one of Loos's goals when he made his apodictic claim was to put an end to a complex debate that had been conducted by Gottfried Semper, Alois Riegl, and Wilhelm Worringer on the role of the ornament. Their concern was the supremacy of technology/technique or form/design, and of abstraction or realism, and this debate ultimately contributed to the establishment of art history as an academic discipline. On the debate on the ornament in modernism, see Maria Ocón Fernández, *Ornament und Moderne: Theoriebildung und Ornamentdebatte im deutschen Architekturdiskurs 1850–1930* (Berlin: Reimer, 2004).

5 In Loos's text »Ornament und Verbrechen« (1908), the ornament has obvious feminine connotations, and the proximity to Otto Weininger's *Sex and Character* (1903) is conspicuous.

Martha Rosler, *Service. A trilogy on colonialization* (1978), book cover

This would mean not thinking of the division between art and design in terms of a rigid oppositional dualism, but as a bipolar set of relations,[6] in which various options are expressed as to what can be seen as art within bourgeois societies, and which also define a certain cultural »running room« within which it is possible to negotiate, and where it is possible to distinguish between autonomy and function, self-realization and commissioned work, production and criticism. The distinction should not be made categorically within the continuum of art and design with its various political and aesthetic implications. Instead of creating rigid divisions, it would make more sense to introduce subtle distinctions as to what art and design are each able to achieve, where the differences and the common ground might lie, what they might learn from one another, and how the historical division between them came about in the first place.

Reforms of design

It is notable that the categorical division of art and design that today causes such confusion really only became standard in the 1950s. Surprisingly, it was rather the designers who were explicitly in favor of this, and the Ulm School of Design is a good example: the school tolerated no artists within the strictly scientific and functional canon. This actually implies the triumph of a substantial concept of art from which all notions of craftsmanship have been removed. By contrast, in the design as *Gestaltung* (formation) theory of the Bauhaus or the Construction theory of Soviet Productivism, the borders between architecture, art, and design were clearly permeable. Whereas the concept of design with its origins in Renaissance art theory (»disegno«) still points to a unity of the arts based on the art of drawing and thereby indicates a process of design, sketching, or the finding of form, *Gestaltung*, inspired by the Bauhaus foundation course, is more reminiscent of sculptural approaches that nonetheless seemed to be readily transferable from a playful approach to form to the actual management of social relations.

6 For a critique of rigid dualistic concepts from the psychoanalytical viewpoint, see Wolfang Trauth, *Zentrale psychische Organisations- und Regulationsprinzipien und das psychoanalytische Verständnis von Abwehr und Regulation* (Munich: Psychoanalytischer Verlag, 1997), 64–131.

Fareed Armaly, *BREA-KD-OWN* (1993),
page of exhibition catalogue

The points of transition between these conceptual traditions are, however, highly fluid. For both, *Gestaltung* and design, a general orientation on industrialization and the impetus of social reform are decisive,[7] linked with a more or less explicit reference to the history of utilitarian aesthetics, set against art's claim to autonomy and its »revolutionary« political rhetoric. For the latter, the aspect of design as formation, or *Gestalten,* increasingly lost its value even before Duchamp, as early as the Romantic period. Perhaps art and design could be understood as complementary areas in which different needs or even »regimes of the aesthetic«[8] within the bourgeois world are expressed.

Design's wish to reform society could not be implemented without an inner divide between the idealistic aim and social, technological, and market realities. In addition, with the simultaneous advent of the post-Fordist economy, postmodern culture, and new technologies from the 1970s, conceptions of design have increasingly lost their social goals. Today, the pressure to conform to alleged economic necessities is high. It is precisely design's success as an exemplary discipline in service economies that has undermined its inherent political function. Even criticism of brands, corporate identities, and neoliberal self-designs is now assuming brand-like status, in the form of »no logo« or radicalized theory designs. And, conversely, criticism frequently crops up as guerrilla marketing in the designs of the big brands themselves. In the process, the concept of design itself has to a large extent lost its own constitutive tension—that of finding a compromise between commission and authorship, or of maintaining critical practice within an expanding digital visual culture.

Without therefore ignoring the contradictions within the discipline, it must be possible to point out the potential that lies somewhere between strict methodology and practical competencies in everyday culture. The question remains, whether »cultural running rooms« for design can be found between media, pop culture, and the world of globally operating business, and to what extent the interdisciplinary model of design and its historical, socially reforming aims can still form a starting point for both critical and artistic interest.

7 To be understood in the sense of opposition movements.
8 As in Jacques Rancière, *Die Aufteilung des Sinnlichen: Die Politik der Kunst und ihre Paradoxien* (Berlin: b-books, 2006).

Interdisciplinarity instead of transgression

The starting point for a »design history of institutional critique« must surely be Dan Graham's pioneering essay of 1986 »Art as Design, Design as Art.« This work's significance for so many young artists lay in the fact that it placed the history of Pop art, the architecture of Robert Venturi, and Conceptual art between On Kawara and John Knight within the context of the art and design debate, without really making these terms of reference explicit. Graham took the title from Sterling McIlhany's book *Art as Design: Design as Art. A Contemporary Guide*, which came out in New York in 1970 and stopped at a mere list of points of contact after Pop art. By contrast, Graham's essay highlights an interdisciplinary space of mutual references, a space that is, at least implicitly, clearly distinct from the logic of transgression that avant-garde art pursues. Interdisciplinarity is now significant both in terms of the methodological self-determination of design and also in terms of the understanding of institutional critique as a practice that interlinks and confronts various artistic realms and forms of cultural articulation.

One thing that Graham does not look at, however, is the history of design as social reform, which resurfaced in the 1960s and 1970s in the name of »visual communication« as a critical tool in addressing contemporary visual culture. In this respect, its relationship to or influence on the history of Conceptual art has received too scant attention. Not only the obvious points of reference such as On Kawara's postcards or John Knight's *Journal Piece*, which Graham does discuss, but also Daniel Buren's stripes, Hans Haacke's data sheets and charts, and even Michael Asher's purist interventions can be read with this history in mind—leaving aside concrete poetry, and the whole of modernism à la Mallarmé, with its »typographic« significance for the work of an artist like Marcel Broodthaers. Precisely the antiformalist impulse of Conceptual art has led it to search out the art-extraneous sources for its own tactics and forms of presentation.

It seems to me, therefore, that it is not possible to grasp the formal question of institutional critique without reference to the history of design. It is by no means a matter of purely ideal intervention, but a set of methods that range from didactic ordering of information to specific visual communication strategies to questions of identity in relation to one's own work—is it a »service« for the project's commissioning institution, for example. Here we can already see that this view of design is not reduced to formal issues but also that models of authorship, the status of criticism that a design of artwork can claim, and even the definition of the institutional in general, can be of interest for institutional critique.

Nowadays, design as art is tainted with the reputation of being mere craft. Only formal stringency or criticism is seen as capable of holding up against this. But even criticism has to be formed or designed in one way or another. There can be no pure deconstruction without at least some elements of construction. It is a matter of the proportions of the means and the ends, the artistic and the political intentions. Here, too, it is not principal decisions but rather proportion and balance that are needed. Where is criticism coming from and in whose name is it spoken? Is it speaking for itself or on behalf of someone else, and what would the difference be? How could criticism as criticism be distinguished from criticism as art, and the latter as criticism of other art from mere competition between artists? Especially a position of pure criticism, which believes that it takes place outside of social determination, readily leans toward the idealistic,

and in any case remains unclear as to the conditions of its own stance. In comparison to this, the authorship model of design, film, and other areas of popular culture, which consists in accepting the given conditions without surrendering to them, is not per se corrupt.[9] For it seems to me that it is a prerequisite—and not the downfall—of art, design, and critical thinking to address issues of the means of production, the financial conditions, artistic control, and critical content from within.

Nonetheless, it is necessary to admit that it is not only abstract images but also critical artistic practices that all too easily become mere décor, and the line between accepting given conditions critically and surrendering to them is exceedingly thin and itself subject to historical change. An interpretation based entirely on the logic of ornament and crime would not even be precipitous in the case of Daniel Buren, where it seems to be so evident that a situational sign, which in the 1960s functioned merely as an indicator for intervention, has transformed over the decades more and more into an element of form and design. Buren's stripes do bear their own historicity and indicate in their obvious designed-ness something beyond them, utilizing their decorative nature for the production of self-reflective situations.

All the talk of »services« that in the early 1990s amounted to an attempt to emphasize affirmatively the role of artists within the institution, in contrast to pure criticism, also clearly highlights the state of affairs. The various facets of a working relationship within and with the institution have long since been reinterpreted productively, such as when invitations and announcements become the focus (Robert Barry), or an artist has his or her own name removed from the list of participants in an exhibition (Christopher D'Arcangelo), small gifts are designed for the visitors to an exhibition (Louise Lawler), or the exhibition and catalogue design are seen as an original artistic contribution.[10] The problem inherent to all of these approaches is not a matter of design, but the self-understanding of artistic work, whether these practices are taken to be a new aspect of work or genre within the art business or a one-dimensional service similar to that of the cleaning staff or the museum guards. Here it is all too easy to create idealistic, projected identifications. What, however, makes all of these tasks so attractive is the tension between institutional logic and the artistic intervention and not the assumption of a unique or absolute standpoint that is deemed to be correct. Only where this tension is preserved can these interventions ultimately make sense as »works,« and this is significant insofar as the transgression of the notion of the work, as of art in general, still depends on whatever is to be transgressed and therefore cannot ever arrive at some kind of realm beyond. This can at least be understood as an opportunity to no longer see the work as an autonomous whole, but rather, as the interface where discourses, practices, and institutional and design initiatives meet.

9 Artistic sell-out is the theme of many films, including Billy Wilder's *Sunset Boulevard*, Antonioni's *La Notte*, and Godard's *Le Mépris*.

10 For example, Judith Barry/Ken Saylor, or Julie Ault/Martin Beck. These projects refer back to Marcel Duchamp's exhibition designs of the 1940s, which have also become paradigms of »installation art.« See Lewis Kochur, *Displaying the Marvelous: Marcel Duchamp, Salvador Dali, and Surrealist Exhibition Installations* (Cambridge, MA/London: MIT Press, 2001).

Form as institution

The concept of institutional critique includes a lack of clarity as to which understanding of the institution it refers to, whether institutions are taken to be concrete entities such as museums, movie theaters, or galleries whose selection and presentation policies are to be questioned; whether it is a matter of the institution of art as a whole, as Peter Bürger sees it—with the avant-garde countering the institution with »life praxis«; or even whether we are dealing with every conceivable form of institution and an anarchistic politics—as when Bakunin says that he is not in favor of a better constitution, but rather, of none at all. There is no doubt that the idea of an institution-free space charged with some notion of true and authentic life prior to any form of society is, in biopolitical terms, extremely problematic. Already in the early 1970s, Cornelius Castoriadis pointed out that the notion of a society that was utterly transparent unto itself was not a utopia but, in fact, no society at all, and that the critique of social institutions itself had always had the effect of creating institutions.[11] Therefore, most of the practices that are termed institutional critique actually address processes that take place between the institutions and the social framework within which the institutions operate: mainly concerning relations between inside and outside and making institutional processes visible (Daniel Buren and Michael Asher); processes such as economic conditions and dependencies (Hans Haacke); also notions of the public and the private and the various spatial functions that correspond to these; and processes of identity formation and the participation of the public in the institution (Andrea Fraser, for example, or Fareed Armaly's *Orphée 1990*). The dynamics that take effect between different social fields, and the various logics of inclusion and exclusion pertaining to the institutions, have increasingly become the focus of attention.

From the design point of view, the aim of exerting direct political influence on society, which was a key aspect from the early Arts and Crafts movement right up to the Ulm School of Design, has also become problematic. The idea that a bit of decoration and a bit more light and more green spaces would suffice to considerably improve society and thus avert revolution now seems truly naïve.[12] And yet the question remains, as to how design should be understood today, located somewhere between conformist logo design and fantastic visions of social change, and also whether the reform history of design in contrast to the just-as-metaphorical revolutionary history of art might not harbor the advantage of being able to see the concept of the institution in a different light—perhaps as the institutional entity in Castoriadis's sense. Here, the institutional and the instituting moment do not disappear as opposites; they remain in touch with one another, as a social space that will always have to be designed and formed, a space that is never just posited but that has to find its way between criticism and the given. This would correspond more to an interdisciplinary model than to a model of transgression. Criticism here does not manifest itself as an absolute system of values, but as a productive factor that opens up more cultural »running rooms« than it closes down.

11 Cornelius Castoriadis, *The Imaginary Institution of Society* (Cambridge, MA/London: MIT Press, 1987).
12 See, for example, Le Corbusier, *Vers une architecture* (Paris: Crès et Cie, 1920).

Louise Lawler, *Untitled* (1982)

Re-entry of design

A prerequisite of any critical and artistic approach to design is to neither negate the difference between art and design nor to turn it into an existential absolute. It is equally inadmissible to understand the difference as either more fundamental or more gradual, as here we are dealing instead with different orders, or categories, which define the broad realm of artistic and cultural practices in different ways. As for film or advertising, it is often claimed that design is the »art of the twentieth century.«[13] But this claim, rooted in anti-idealistic functional aesthetics, just eradicates the difference between the systems and skirts the issue. Today we have conceptual design just as we have commercial art. These relations of exchange cannot be simply understood as different forms of interaction between different fields, but as the expression of complex mutual interaction, whereby the objects, attributes, and criteria of the individual fields can be interchanged almost at will, without in fact departing from the horizon of the categories of the field in question. The design historian Beat Schneider has shown how unconvincing the current criteria for differentiation actually are.[14] And yet every student intuitively understands the difference between art and design. This also shows how difficult it is for the concept of design to lay claim to a critical approach, as it always runs the danger of reproducing the categories of its own field. Does this mutual influence and interdependency of the two categories ultimately also lead to a post-Fordian economic logic, profiting from the vague distinctions between the two fields found in contemporary trends such as »creative industries« and »visual industries«? Are the »interdisciplinary« forms that have emerged since the 1960s therefore trends in de-specialization that arise in opposition to specialization, or does the logic of specialization depend on movements of fusion and synthesis, which are the basis for establishing and justifying specialization? And

13 For example, Dieter Weidmann, *Design des 20. Jahrhunderts*, cited in Beat Schneider, *Design — Eine Einführung: Entwurf im sozialen, kulturellen und wirtschaftlichen Kontext* (Basel: Birkhäuser, 2005), 221.
14 Schneider discusses the criteria that are used to distinguish between the material act of creation, the unity of draft and completion, the difference between a unique object and a mass product, a commission and an independent work, and also the cult status of objects. He compares communication theory and semiotic aspects. Schneider, *Design – Eine Einführung*, 224–25.

how could these interdisciplinary points of reference be seen as critical when they harbor a very specific economic logic?

The sociologist Dirk Baecker recently suggested understanding design as the interface of communication in service to »opening and restricting of freedoms to act.«[15] This idea owes a great deal to Niklas Luhmann's communication theory, which posits the possibility of calculating the improbable. Here, art is described as the vehicle that frees up interface design from its uncommunicative and categorical inflexibility, which is highly improbable, and then closes down the resulting open situation by means of a further intervention: »Art is the re-entry of design into design,«[16] writes Baecker. This can also be understood as the reintroduction of the instituting element into the institutional. But of course this functional definition remains unsatisfactory—seeing art merely as second-order design or metadesign. This simply denies the differences between these two historical forms of praxis, and also the fact that both art and design have given rise to theoretical metalevels. Whether art can at all be considered in terms of aspects of communication theory is dubious, at least since Adorno, and this clearly shows that functional definitions of art and design as communication media do not tell us anything about the value systems pertaining to them. But the functional definitions do achieve something. Even if they are not capable of setting out a strict system of how the categories relate to each other, they can demonstrate certain parallels in the ways in which art, design, media, and forms of communication work, at least in the sense that all these categories work in a way that cannot be defined and described once and for all. The »running rooms,« as the possibility of calculating the improbable, define their context but not a specific categorical character. And it is the »interfaces« between the categories that constitute each specific character, for an interface begins at the point of difference between two or more realms and then goes on to move across this difference to make a relationship between the realms visible. Interfaces and »running rooms« can therefore be seen as the social and media forms in which difference and points of reference can be negotiated. They by no means define the end of critique in the sense of an auto-poetic self-referentiality; quite the opposite—the goal must be to provide them with critical content.

Translated from the German by Greg Bond.

15 Dirk Baecker, *Form und Formen der Kommunikation* (Frankfurt: Suhrkamp, 2005), 9.
16 Ibid., 271.

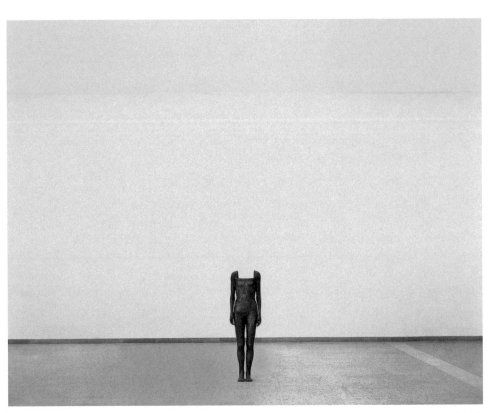

Little Warsaw, *The Body of Nefertiti* (2003),
Hungarian Pavilion, *Biennale di Venezia*

Edit András

Transgressing Boundaries
(Even Those Marked Out by the Predecessors)
in New Genre Conceptual Art

One should realize that even the aim of re-writing or globalizing Conceptualism, considering it as a broader term than just a specific North American and/or western European art practice, when applied to eastern Europe, still focuses on the art activity of socialism well after the political changes.[1] The paradoxical situation, however, is that the once progressive avant-garde art of the 1970s, which attracted so much Western attention in the time of the cold war, has by now lost much of its credibility in the local art scenes by becoming one of the obstacles of the new, ambitious art of younger generations carrying on the legacy of Conceptualism.[2] Partly as a consequence of the generation gap in the ex-Eastern European countries, a strong aspiration can be traced among emerging artists and curators to leave behind the past and to be identified as Europeans without any further distinction, claiming the division of Europe to be a purely political construction that became obsolete after the collapse of the Soviet satellite system. Nevertheless, the legacy of the socialist past still saturates the context they operate in, regardless of their opposing desire.

Tracing the difficulties that previous generations of Conceptual art coming from behind the Iron Curtain faced while seeking broader recognition, we can acknowledge that any art with latent or explicit political connotations »was not readily accepted by Conceptual art in general«[3] (that is, by the North American canon of hard-core Conceptualism). The conceptually based

The author wishes to express her gratitude to Georg Schöllhammer and Hedwig Saxenhuber, editors of *Springerin* (where a preliminary version of this research was published), to Sabine Breitwieser, Director of Generali Foundation, and to Alexander Alberro and Sabeth Buchmann, the editors of this volume, for having faith in my activity. Special thanks go to Bálint Diószegi and Barbara Dean for their assistance in the English version of the text.

1 Desa Philippi, »Matter of Words: Translations in East European Conceptualism,« in *Rewriting Conceptual Art*, ed. Michael Newman and Jon Bird (London: Reaktion Books, 1999), 152–68. László Beke, »Conceptualist Tendencies in Eastern European Art,« in *Global Conceptualism: Points of origin, 1950s–1980s*, exh. cat., ed. Philomena Mariani (New York: Queens Museum of Art, 1999), 41–52.

2 Over-evaluation of the »Great Generation« of the 1960s and 1970s to the detriment of the production of younger generations is quite common in the scene, which is also echoed in the following statement regarding Conceptualism: »...a genuinely new aesthetic language was not created in the 1990s because this had been accomplished decades before.« Beke, »Conceptualist Tendencies,« 42.

3 Alexander Alberro, »A Media Art: Conceptualism in Latin America in the 1960s,« in Newman, Bird, *Rewriting Conceptual Art*, 149.

feminist art of the same period couldn't even get its share of local recognition within the closed, male-dominated circle[4] of the so-called »secondary publicity.«[5] The neo-Conceptualism of the 1990s and the turn of the millennium,[6] which is the focus of my attention, suffers equally from the difficulty of reading the context of the transition from outside, which itself is too controversial and hybrid in nature, and from the authoritarian power and desire for regulation by the recent local art establishment, recruited from the ex-opposition encampment of official socialist culture.

My aim is not to stuff local art practices into the straitjacket of conceptualist terminology as it is defined by Anglo-Saxon theory, based on Anglo-American practice, but rather, to expose the fact that the heritage of conceptual strategies is still very vivid and pertinent in the frame of the post-socialist condition, even if it appears and functions quite differently than in the heyday of the movement's pioneers. In my case-study I would like to analyze two recent, very complex projects by the Budapest-based duo Little Warsaw and the related local reactions. My aim is to explore the current possibilities for critical art practices utilizing the legacy of Conceptualism in an ex-socialist country and the differences between western and eastern European conceptual practices.

In order to understand the context of the neo-Conceptualism developed in the region, one must take into account not just today's socio-political and cultural conditions, but also those special circumstances within which the predecessors operated more than thirty years ago. Since the events and discourses of the region are not included in mainstream art histories beyond the national one, one can refer to it as a starting point for elaborating more nuanced problems. As more and more political secret agents became visible[7] and a growing number of essays based on the research of the newly opened archives came to light, it became clear that the division between the official and unofficial cultures in the period of socialism wasn't such a black-and-white structure as it appeared to be in the time of the cold war. Instead of total repression by state cultural policy and a heroic resistance on the part of the opposition, a constant negotiation for power, a kind of tug-of-war, was going on, continuously reshaping the terrain for cultural activity.[8] For the countercultural camp, getting a share of the power was at stake, while keeping its autonomy for defining progressive art.[9]

4 For example, Orsolya Drozdik's activity is still underestimated in the reference books of the period. Compare: Gábor Andrási, et al., Hungarian Art in the 20th Century (Budapest: Corvina, 1999); Orshi Drozdik: Adventure & Appropriation 1975–2001, exh. cat., ed. Dóra Hegyi and Franciska Zólyom (Budapest: Ludwig Museum Budapest—Museum of Contemporary Art, 2002).

5 Hans Knoll, ed., Die Zweite Öffentlichkeit—Kunst in Ungarn im 20. Jahrhundert (Dresden: Verlag der Kunst, 1999).

6 See Sándor Hornyik, »Conceptualism in the Hungarian Art of the Nineties,« in Művészettörténeti Értesítő (Budapest), LI, 3–4 (2002): 251–64; Erzsébet Tatai, »Neoconceptual Art in Hungary,« in Conceptual Art at the Turn of Millenium, ed. Jana Gerzová and Erzsébet Tatai (Budapest/Bratislava: Praesens, 2001); Erzsébet Tatai, Neokonceptuális művészet Magyarországon a kilencvenes években (Neo-conceptual Art in Hungary in the 1990s), (Budapest: Praesens, 2005), 114–41.

7 Beyond politicians, more and more names pop up even from the pool of internationally recognized artists, such as, Gábor Bódy and István Szabó, movie directors who cooperated with the government as secret agents for the so-called III/3 division of the Ministry of Internal Affairs, which collected information about private citizens. The Office recruited their agents by blackmailing them with the threat of making their creative work impossible.

8 See Serguei Alex. Oushakine, »The terrifying mimicry of samizdat,« in Public Culture 13, no. 2 (2001): 191–241; Edit Sasvári, A balatonboglári kápolnatárlatok (Church exhibitions in Balatonboglár), (Budapest, 1999).

All information coming from outside was filtered through the context of the local power dynamics. In the 1960s and 1970s, the main fault line was not drawn between different artistic approaches and strategies following and opposing each other, as in the Western countries. In Hungary, they got along quite well: Those who were not included in the category of »supported« artists, but in that of »tolerated« or »prohibited« ones,[10] formed a loose alliance against the controlling official cultural policy. In no way did they represent a common way of thinking or a homogeneous trend or style, but they were connected in their temporarily shared position in the local scene of being more or less excluded from official venues and commissions, whether they strictly opposed the political regime or whether the regime found their activity disturbing or dangerous and considered their art unsuitable for their conception of progressive art.

This structure discolored the local variations of the art movements and trends of the time. For instance, in the 1950s and early 1960s, all forms of abstraction were considered to be carrying alien and threatening bourgeois ideology, corresponding perfectly with the aim of Western cultural policy of supporting postwar abstraction as the perfect manifestation of the free, self-expressing individualism of Western democracies.[11] While American and English Pop art was the product of the economic boom of the postwar period and the launch of consumer capitalism, Hungarian Pop art grew out of the context of the planned economy, where, not only were consumer products in short supply, but also brands and advertisements were an unknown phenomenon. Elements of popular culture—cut-outs from magazines, junk materials—signified youthful rebellion in the tightly controlled, dry, gerontocratic official culture. Hungarian artists were not aware of the contrasting positions of Abstract Expressionism and Pop art; therefore, they used the elements and methods of both for conveying messages about the socialist condition.[12]

Concerning Conceptual art of the 1970s, the institutional critique, so inherent in the movement in its Western formations, was flexible enough to be converted into the critique of the socialist regime in its Eastern variant, and to convey a coded political message, so it obviously became the most conscious device of the underground, countercultural force.[13] »On the other hand, the 'immaterial' nature of conceptualists' works, and the 'poorness' of the media employed … made communication easier and censorship more difficult.«[14] For Sándor Hornyik, the explanation could be found in the fact that in Hungary, of the different constructions of Conceptualism, the one associated with Kosuth was picked up in the proper operation of the information-filter, which also functioned in the case of social sciences. As he argues, semiotics and Structuralism, for example, could be pressed through the filter, »as they were compatible with the

9 »…early works of Szentjóbi and Erdély tested the limits of political protest, and the authorities' willingness to tolerate it, in their own and in all Eastern European countries.« Beke, »Conceptualist Tendencies,« 48.

10 See László Beke, »Dulden, verbieten, unterstützen—Kunst zwischen 1970 und 1975,« in Knoll, *Die Zweite Öffentlichkeit*, 212–34.

11 Eva Cockroft, »Abstract Expressionism, Weapon of the Cold War,« in *Art in Modern Culture: An Anthology of Critical Texts*, ed. Francis Frascina and Jonathan Harris (London: Phaidon Press, 1992), 82–90.

12 Katalin Keserü, *Variations on Pop Art: Chapters in the History of Hungarian Art between 1950 and 1990*, (Budapest: Uj Művészet Kiado, 1993).

13 This was reflected in the broad local usage of the term »Conceptualism«, as a term for covering any kind of progressive art of the time. See Miklós Peternák, A konceptuális művészet hatása Magyarországon« (The influence of Conceptual art in Hungary), http://www.c3.hu/collection/koncept/index0.html#csil.

14 Beke, »Conceptualist Tendencies,« 42.

rationalism of Marxism«;[15] the richness of Hungarian literature on linguistics could be added to the components in favor of adapting the »exclusive or strong« type of Conceptualism, using the term coined by Peter Osborne.[16] Contrasting its Western counterpart, however, the Hungarian conceptual movement had nothing to do with the art market as no such thing existed. Similarly, the contribution to the deconstruction of modernism, by which conceptual tendencies played a crucial role in Western countries, where they were able to expand their critical scope to include questions of identity, representation, and institutional critique in the activities of the second and third generations, was absent in the genealogy of conceptual movements in Hungary. Hungarians lacked this transformation since modernism was an active agent in the opposition to an ideology-driven official culture. Furthermore, modernism worked well for the artists and critics as a field of projection, a kind of dreamland of freedom and equality beyond the physical constraints they experienced in their everyday lives behind the wall. The liberal Western art world also greatly supported this status quo, the fossilization of modernism: the »freedom-fighters« being existentially threatened embodied the lost paradise of art being socially significant. So, while Conceptualism in Western countries played an active role in the critique of modernism, the local eastern variants were deeply embedded in it; therefore, the critique of modernism has remained unfinished business in Hungary well after the political changes.[17]

In 1989, with the dismantling of the Berlin Wall and the fall of the Iron Curtain, the physical division between the Eastern and Western blocs, along with the inner cultural division, disappeared. The local art scene was busy canonizing the former oppositional artists and the machinery of restitution began. The tumultuous political changes opened up pathways for recognition of previously ostracized artists and critics, which led to prestigious cultural and academic positions. This long-overdue recognition served as compensation for the neglect these artists and critics had endured during the previous cultural administration. With recognition came glorification: Now these artists and art professionals tended to refer to themselves as the »Great Generation.« They gradually took over the task of establishing and institutionalizing the new canon based on their moral capital accumulated during the time of repression.

Archives for collecting and preserving immaterial conceptual works and documentation of performances were established throughout the ex-Eastern bloc, including Hungary,[18] while objects were commodified by the »art market fever« of the late 1990s. On one hand, the sanctuaries of the neo-avant-garde have the mission of keeping alive the cult of the previous period's cultural heroes, and guarding the myth of greatness connected to the political opposition. Today, this attitude permeating the whole structure of art institutions has become a barrier to any kind

15 Hornyik, »Conceptualism in the Hungarian Art of the Nineties,« 263.
16 Peter Osborne, »Conceptual Art and/as Philosophy,« in Newman, Bird, Rewriting Conceptual Art, 47–65.
17 See also: »Western influence and the discursive construction of postmodernity in the cultural debates of post-Socialist Eastern Europe: The case of Hungary and Russia,« lecture given by Anna Szemere at the 27th meeting of »Social Theory, Politics, and Arts,« Golden Gate University, San Francisco, CA, 2001, 18–20 October; Edit András, »Who is Afraid of a New Paradigm? The Old Practice of Art Criticism of the East versus the New Critical Theory of the West,« in MoneyNations. Constructing the Border—Constructing East-West, ed. Marion von Osten and Peter Spilmann (Vienna: Edition Selene, 2003), 96–105. Hans Belting, »Europe: East and West at the Watershed of Art History,« in Art History after Modernism (Chicago: University of Chicago Press, 2003), 54–61.
18 http://www.artpool.hu/

of critical analysis of the past. At the same time, this mentality preserves the paternal, patroniz-
ing, and infantilizing attitude of socialism, and also overshadows contemporary art activity.[19]
On the other hand, the boom of the art market was combined with the euphoria over the admis-
sion to the European Union, a euphoria that went hand-in-hand with amnesia, eager to bury the
recent past, the last half century. As a result of this twofold tendency, the socialist past became
taboo, or hardly accessible, a forgettable issue for art making practices. Despite the climate of
collective amnesia, the remnants of the socialist structure are everywhere and haunt us, since
the psychological process of working through the double trauma (of the repressed existence in
socialism and the decline of social significance of art within capitalism) is hardly over.

Profit-oriented predatory capitalism, built on the ruins of socialism, and quite mixed with it,
is in full swing by now, and, as a side effect, art collecting has become hip in the nouveau-riche
circles. In the United States »[m]any in the multinational corporate world of the 1960s likewise
imagined ambitious art not as an enemy to be undermined or a threat to consumer culture, but
as a symbolic ally.«[20] On the contrary, the nouveau riche in Hungary, who were educated in
socialism, and entered the field of art collecting with no serious competitors, chose to rely on the
traditional art of the previous decades as their partners. Only a few looked upon radical contem-
porary artists as equals, and most regarded them as losers in the economic race of transition, a
race in which the only measure of worth was financial success. Thus, the frontline of Hungarian
entrepreneurs, innovative and risk-taking, made their alliances with those who worked in tradi-
tional genres of painting and sculpture. The transformation of the site that in the 1970s had
hosted the most radical, underground art, the infamous Club of Young Artists, into the biggest
private art institutions' headquarters,[21] symbolically embodies a hidden message. A new art
patronage, and art for comforting and pleasing untrained but wealthy audiences, took the place
of advanced and critical art.

Little Warsaw—a Hungarian artist duo; a collaboration between Bálint Havas and András
Gálik[22]—started in a local art scene of the late 1990s that was characterized by the features
described above, but Little Warsaw definitely never intended to fit in. What they actually did was
put aside all the fundamental notions and unwritten agreements on which the scene operated:
that is, they turned them upside down. The community, particularly the one that felt addressed
by their actual art projects, never failed to reflect on them accordingly.

They were trained as painters by newly appointed teachers, established figures in the scene,
first and second generation conceptual artists.[23] For the young apprentices, Conceptualism at
that time meant some exhausted, outdated movement, esoteric, aesthetic, and dry, which, as such,

19 Very recently a young art historian was appointed to the post of the Director of the Kunsthalle.
20 Alexander Alberro, *Conceptual Art and the Politics of Publicity* (Cambridge, MA/London: MIT Press, 2003), 2.
21 See: http://www.kogart.hu/main.php
22 »...the name 'Little Warsaw' first appeared as the title of their exhibition in the Polish Institute in 1996. It soon started
 functioning as an umbrella term, a logo that marks a mental orientation and a working method.« Lívia Páldi, »Little Warsaw
 1996–2002,« in *Little Warsaw* (Budapest: Műcsarnok/Kunsthalle, 2003), 9. See also Maya and Reuben Fawkes, »Little
 Warsaw: Strategies of Removal and Deconstruction,« in *Umelec: Contemporary Art and Culture*, no. 3 (2005): 38–40.
23 András Gálik's professor was Dóra Maurer, a conceptual artist of the 1970s; Bálint Havas's professor was Zsigmond
 Károlyi, a postconceptual artist of the 1980s. My thanks go to Little Warsaw for their extensive correspondence regarding
 their activity and ideas, while they never burdened my ideas and interpretation.

was accessible only to a closed, trained circle, isolated even within the art scene. In the 1990s, artists came to wide prominence using idea-based Conceptualism, whether with respect to dematerialization following the footsteps of local hardliners, or in a more sensual meaning, adjusted to the up-to-date reconfiguration of the movement.[24] Thus, neo-Conceptualism was frequently their starting point, and not their final goal. They were also definite about not connecting to the newly grounded art market through the gallery system; from the very beginning, they articulated a critique of making and distributing luxury consumer products. They discarded both of these local strategies and looked for new possibilities for art making, responsive to the changed discursive conditions.

In the turbulence of the early period of transition—they started their studies right after the political changes—they faced the insignificance of art and culture as active agents in the social sphere and the ineffectiveness of the rigid institutional structure, incapable of reflecting changes. They felt a strong need to redefine art, to extend it into the public realm, well beyond art's traditional borders. Their main intention was to communicate with a much wider audience than the narrow subculture. By establishing their own institutions,[25] they were able to escape from the elitist ghetto.

Following their studies at the art academy, they clearly did not want to join the different generational transformations of local Conceptualism, nor did they want to enlarge the growing pack of painters. They therefore placed sculpting, a traditional genre, center stage, thus crossing borders not just between two opposing fine art disciplines, but also between the art making practices of the professional and the outsider. And this border-crossing was just the very beginning. Contrary to their predecessors, they did not have a phobic relationship to the physical object: instead, it signified to them something they could hold onto in the flood of images of virtual reality, which strongly influenced the local scene and attracted a branch of painters who obsessively imitated virtual images.[26] Little Warsaw had no aversion to classical art making practices. For them, the real target of the thought process expanded far beyond the artistic object itself, it was the very nature of the context in which the art object existed with its complex social and psychological embedment within invisible power relations. Hence, they were interested in re-contextualizing and thereby re-evaluating classical art media (instead of imitating the digitized world's new image producing techniques) providing a subtle analysis of the context, through strategies such as mixing, changing, and dislocating it, while constantly testing its flexibility and limitations. The social sphere where art operates in a broader sense was the key site for them to examine.

In terms of orientation, they opposed the dominant direction of artists' migration toward the Western market in the 1990s and the aspirations of previous generations. On par with topical Western movements, in the name of universalism they were eager to discover neighboring coun-

24 Tatai, *Neokonceptuális művészet Magyarországon.*

25 They created an independent studio-cum-gallery in Hajós street. See: Páldi, »Little Warsaw 1996–2002.« In 2001, Little Warsaw ran a public research program »The Artwork of the Week«. They investigated through around fifty examples how different Budapest-based art practices related to the idea of the commodified autonomous art object.

26 At the exhibition *Áthallás* (Crosstalk), Műcsarnok/Kunsthalle, Budapest, 2000 they exhibited a monumental rubber cast of an ornamented gate with a lying figure in a helmet at the block of flats built for army officers in 1929, almost the only work that was not a painting of the new style. See Páldi, »Little Warsaw 1996–2002,« 34.

tries, which had become totally out of fashion after the disintegration of the socialist camp. They navigated further East at a time when solidarity between the ex-fellow camp residents simply evaporated in their competition to curry favor from the West.

Since they interrogated rather than accommodated the given institutionalized art system, considering it a network of communication between interrelated fields (gallery, museum, education, art criticism, audience, etc.) that together frame and sustain art's ideological system, it comes as no surprise that they provoked harsh responses and stirred scandals both locally and globally.

Their first conflict-provoking project on an international scale was *The Body of Nefertiti* in the Hungarian Pavilion at the Venice Biennial in 2003, which tracked the complex discursive exchanges among different participants in the current art establishment, exposing hidden exclusionary and authoritarian purposes in the very name of »pure« and »authentic« art. Little Warsaw intended to add a cast body to the famous Nefertiti bust,[27] which had been taken to Berlin from Egypt in the early twentieth century, and exhibit the new, completed sculpture in the Hungarian Pavilion of Venice. The body and bust were united cautiously in Berlin for a few sacred moments, a process that was filmed, but they were not allowed to bring the bust itself to Venice. At the biennial, one could see the torso sculpted by Little Warsaw but without the famous head, only a video-projection showing the actual animating act, the process of joining head and torso. The cast bronze body was neither a fallible, fragile one following the classical body standard, nor the contemporary healthy, athletic body ideal, as the purpose of the project was not any kind of reconstruction or modernization. The headless body in the pavilion stood for the desire of wholeness, for re-humanizing a sacred and thus tabooed art piece.

The project was closely related to key Conceptual art strategies, despite the fact that it did not dwell on dematerialization and reduction, or on prioritizing the idea: Little Warsaw proceeded in exactly the opposite direction, placing at the heart of their project the point central to all sculpting: animation, giving soul to dead matter. But, also, on the other hand, the headless body and, especially, the void, opened the piece to the age-old issue of admiring ruins and remnants of the past as the physical imprints of our notion of history, as well as iconoclastic tradition and the very current issue of demolishing statues. Mieke Bal's arguments on the nature of visuality as being impure, (im)material, and eventful, since »[e]very act of looking fills the hole,«[28] could also be applied to this artwork, which operates on the meaningful presence of a void. I do not wish to get into the debate on visual culture, but, if we take it as a »performing act of seeing, not the materiality of the object seen,«[29] then Little Warsaw's activity could surely be interpreted in terms of visual culture.

The project likewise involved a great deal of further conceptual interventions and questioning: crossing borders between times, ancient and current, between Art (with a capital letter) preserved in a museum for eternity and contemporary art, still fighting for legitimacy, between

27 Ägyptisches Museum und Papyrussamlung, Berlin-Charlottenburg; See Geoffrey Thorndike Martin, *A Bibliography of the Amarna Period and its Aftermath* (London: Kegan Paul International, 1991); Joyce Tyldesley, *Nefertiti, Egypt's Sun Queen* (London: Viking, 1998).

28 Mieke Bal, »Visual Essentialism and the Object of Visual Culture,« in *Journal of Visual Culture*, vol 2 (1) (2003): 16.

29 Ibid., 11.

The head of Nefertiti combined with
cast bronze body, Altes Museum, Berlin

household name (a celebrity-kind of art piece) and unknown young artists from the margins,
between the geopolitical places of the makers (Egypt), the owners (Germany), the users (Hungary),
and the audiences (Venice). The group raised fundamental questions about art's institutions at
the start of the new millennia, with regard to national representation within the structure and
power mechanisms of global culture, opposing the established binary logic of the two. They also
problematized the interpretation of art—still strongly influenced by the concept of modernity
and modernism—as being structured around the concept of beauty, the aesthetic qualities of the
object, and its ownership. With all these »illegal« border crossings (such a familiar operation
along the margins!), they upset art's governing conventions and its power-related status quo.

Relying on Mieke Bal's argument that »Chronology itself is Eurocentric ... the imposition
of European chronologies can be seen as one of the techniques of colonization,«[30] what Little
Warsaw did was completely subvert the linear reading of traditional art history along the lines
of chronology, upsetting the hierarchy of old and new art, and smashing the strict distinction
between classified art, as being part of the art historical canon and contemporary art, as being
excluded from the scope of academic art history, simultaneously challenging the boundaries
between art history and art criticism. The »in between time,« the time of excavation and the
provenance of the property of a well-established German museum came into play as well, posing
very sensitive questions of ownership and cultural continuity, as echoed not surprisingly in the
Egyptian and German press. (Concerning the ruling laws, lawyers could have argued either
position on the question of whether the Bust of Nefertiti should remain in Berlin or be returned
to Egypt.[31])

The virtual (Venice) and actual (Berlin) dislocation of the bust attempted to discard the
assumption that museums are a special place for acquiring, preserving, and presenting art pieces

30 Ibid., 16.
31 See the two symposium papers by Stephen Urice, »The beautiful one has come—to stay« and by Kurt G. Siehr,
»The beautiful one has come—to return. The return of the bust of Nefertiti from Berlin to Cairo« at *Imperialism, Art
and Restitution: A Conference of the Whitney R. Harris Institute for Global Legal Studies*, School of Law, Washington
University in St. Louis, 26 March 2004, http://law.wustl.edu/igls/Conferences/2003-2004/imperialismagenda.html.

in isolated sterility, or at least challenge museology with its nineteenth century notions combined with the idea of functionalist expositions. Instead of the geometrical pedestal as a remnant of worshipping abstraction and purity and as a trace of the illusion of the neutrality of art and its presentation, the young artists provided the bust with a more human »pedestal,« in other words, they offered the audience a field for projection to create personal narratives. The temporary act of dislocation was taken literally and stirred latent desires for changing the status quo of the piece's ownership, as the Egyptian authorities jumped on the opportunity to reclaim the bust.[32]

The object of appropriation was very carefully chosen by Little Warsaw. They selected a short but very active and rebellious period of Egyptian history, which had been forgotten for centuries as a result of a burst of activity, erasing all traces of the period, which was rife with fundamental changes regarding politics, religion, and even the practice of power.[33] Someone from the eastern European region has a close and intimate relationship to vanishing and newly appearing histories, as people might experience a total rewriting of their own histories even within a lifespan. And the other way around, someone from the region has been through exclusion from even the rewritten (art)history elaborated from a Western perspective,[34] despite current opposing claims.[35] The two male artists chose to deal with a powerful woman, since they came from a country where gender consciousness had hardly entered the art discourse.[36] In the mainstream strategy of appropriation in the 1990s, ownership and authorship were subverted, but the hierarchy of art remained intact. In Little Warsaw's operation, problematizing authorship was merely a side effect, as the object of their appropriation was recharged with radical, critical content indicating questions of power relations; that is, who is allowed to criticize the system and reuse others' objects? who is allowed to enter the global scene with this operation, and who can achieve recognition?

The studio of Thutmos,[37] where the bust came from, stands for the profession of sculpting, and presented a tribute to the predecessors. By appropriating a valuable find, the young artists reversed the operation of art institutions intervening from the inside. Following the logic of institutionalization, able to domesticate all kinds of critical practices outside of the institution (like Dada, Russian avant-garde, Conceptualism, institutional critique, etc.), they took an object out of the museum by reappropriating it, and added their own activity to the provenance of the object. As the original function of the bust is unclear, Little Warsaw offered an interpretation by creating a hybrid statue from the torso, which subverted the segregation of different art making practices in different times, thus turning over the linearity of classification and traditional art

32 Barnabás Bencsik, ed., *The Body of Nefertiti. Little Warsaw in Venice 2003*, Supplement to the catalogue *High-Angled Lowlands: Current Art from Hungary*, ed. Barnabás Bencsik (Berlin: Neuer Berliner Kunstverein, 2006).

33 See Páldi, »Little Warsaw 1996–2002.«

34 For example, Hal Foster et al., eds., *Art since 1900. Modernism, Antimodernism, Postmodernism* (London: Thames & Hudson, 2004).

35 Belting, »Europe: East and West.«

36 In their recent project *Only Artists* (2006), they appropriated and exhibited a tapestry of the Hungarian woman artist Noémi Ferenczy, which shows a woman carrying a sign with the text »Esküszünk, esküszünk, hogy rabok tovább nem leszünk / We truly swear, We truly swear the tyrant's yoke / No more to bear!« quoted from Sándor Petőfi's »National Song,« 1848, a poem from the 1848 revolution.

37 Dorothea Arnold, »The workshop of the sculpture Thutmose,« in Dorothea Arnold, *The Royal Woman of Amarna: Images of Beauty from Ancient Egypt* (New York: Metropolitan Museum of Art, 1997).

history. The act of unification of the bust and body served as a solidarity gesture and functioned as a symbolical site for the re-unification of Berlin and also Germany, a process in which the body, made by Eastern Europeans, served as a substitute for all the archeological finds of the tomb of Thutmos, which arrived in East Berlin after World War II—the bust stood for West Berlin's Charlottenburg, where it was guarded in the time of separation.[38]

The critics in the Egyptian press accused the artists of disrespect for ancient masters and ancient art, and even of humiliating Nefertiti with an inappropriate body. While the Egyptian authorities were against fusing different cultures as a contemporary art strategy, in their own arguments they were not bothered by mixing different periods and cultures.[39] Their main accusation, based on the banning of nakedness by Islam, was directed at a piece that was made long before the Arabic invasion into the ancient empire of Egypt. They made their point in the name of universal beauty, universal values of art, which were ruined in their eyes by Little Warsaw's intervention, but relied on the impact of the postcolonial discourse and claim for restitutions in their particular intention for getting the treasure »back« to its »original« place. Although they tried to conceal the power relations behind the attack against an advanced contemporary art project, in their eyes, the crime became more serious given that it was committed by some unknown fellows.[40] One would think that the anonymity of the artists, their shared, collaborative authorship hidden behind an enigmatic name (through which they could undercut the fallacy of authorship), might also be behind the lack of broader media coverage of the project in the trend-setting, star-making forums.

The site of the exhibition, a national pavilion in an international venue brings the question of nation-building into play. The exhibitions in the Hungarian National Pavilion still served as a tool for official representation well after the political changes, and its commissars were appointed by the authorities of the Cultural Ministry accordingly. In 1993, Joseph Kosuth, the famous American artist, represented Hungary as a compensatory symptom of the nationalistic ambitions of the local regime (the members of which could hold on to the use of the name of the Hungarian hero, and freedom fighter[41]). At the same time, through this choice, the exhibition took the side of Western-type hard-core Conceptualism, the authority of which was debated by younger generations in the Anglo-Saxon art world.[42] In 1995, György Jovánovics, a leading member of the Great Generation, was selected as the national representative in a gesture of restitution and as a tribute. The curatorial position of the national pavilion could first be obtained through an open competition in 2003. The winner, Little Warsaw, which consciously operated outside of the local institutional system, was drawn into a controversial situation by getting the »once in a lifetime opportunity« to enter the highest sanctuary of the national art narrative.[43] So they had to avoid the trap of getting caught in the binarism of national representation and/or local context

38 I wish to express my gratitude to Ernő Marosi for calling my attention to this aspect of the project.

39 See Urice and Siehr, conference papers at *Imperialism, Art and Restitution*.

40 See, for example, Jeevan Vasagar, »Egypt angered at artists' use of Nefertiti bust,« in *Guardian Unlimited* (12 June 2003).

41 Lajos Kossuth (1802-94) was the leading figure of the 1848–49 revolution in Hungary.

42 Tony Godfrey, *Conceptual Art* (London: Phaidon, 1998).

43 As a side project of their contribution to the Venice Biennale, Little Warsaw published a reader of sixteen interviews conducted with various international artists and professionals on the very idea of national representation. Little Warsaw, *Monitor—Arsenale vs. Giardini* (Budapest: Műcsarnok/Kunsthalle, 2003).

unavailable to outsiders as opposed to universalism with some local color and/or faceless global-ism, with its constraint of taking on the one side or the other. They were able to avoid exclusion-ary identifications by conquering a space in between these fixed categories, a site of resistance of both. Through the nomadic strategy of interpenetrations of different discourses, they could overcome the national-universal and local-global split and undermine other assumptions rooted in this binary thought. Despite being fateful agents of one of them, they functioned, instead, as transcultural mediators in the communication of different communities.

The other conceptually oriented project I intend to analyze, along with its subsequent re-sponse in Budapest, was shown in Amsterdam at the exhibition *Time and Again* (2004).[44] This time, Little Warsaw took a Hungarian public monument made in 1965, József Somogyi's[45] statue of János Szántó Kovács, from Hódmezővásárhely, a southeastern Hungarian town, to the Stedelijk Museum in Amsterdam. In this case, the target of their operation was the art making practice in their recent past outside of the museum, in the public space of socialism, which is still part of their visual environment on the one hand, and on the other, the investigation of how this particular context could operate in an international framework. This time the dislocation wasn't just virtual, the statue with its pedestal was moved to the prestigious art museum.[46] As it turned out, this dislocation and artistic intervention touched a very sensitive spot in the Hungarian art community, and it raised a harsh debate.

The Széchényi Art Academy, an institute established by leading artists in the new era, pub-lished a petition and collected signatures against Little Warsaw's action, just like in the old days of rebellion against the official cultural policy. Both the leaders of the cultural right wing and representatives of the liberal left (among them György Jovánovics) signed the petition side by side, something that rarely happens nowadays.[47] After the fall of the Iron Curtain, it became obvious that the seemingly homogenous countercultural bloc of socialist times was in fact very diverse and split apart accordingly. With the presentation of Little Warsaw's project, however, which reused and recontextualized an art object, these groups were suddenly reunited against what seemed to be a common enemy. The situation is further complicated by the fact, which actually shows the very complex nature of the post-socialist discourse, that in the once-official newspaper of state-socialism, the same critic who accused Little Warsaw of barbarism (for changing the original context of the statue) had been one of the official guards of socialist cultural policy for a good twenty years.[48] Thus, the ex-opponent of official socialist culture and the ex-beneficiary found a common cause against Little Warsaw's deconstructive project.

44 *Time and Again*, Episode 2 of *Who if not we...? 7 episodes on (ex)changing Europe*, Stedelijk Museum CS, Amsterdam, 23 Oct. 2004–30 Jan. 2005. »Time and Again,« in *Who if not we...?*, ed. Maria Hlavajova and Jill Winder, exh. cat. (Amster-dam: Stedelijk Museum, 2004), 31–53. The sketch published in the catalogue relates to their project that had been planned but could not be realized. Instead, the project was changed to the analyzed project, which is not documented in the catalogue.

45 József Somogyi (1916–93), a very influential Hungarian sculptor; 1963–94 professor at the Academy of Fine Arts, Budapest; 1974–87 dean of the institute.

46 Originally they intended to exhibit the statue together with its pedestal, but some problems occurred relating to the static capacity of the building's floors.

47 See *Much traveled monument: Little Warsaw: Instauratio*, http://www.exindex.hu/index.php?l=en&t=tema&tf=12_en.php; and József Mélyi, »A Szántó Kovács-ügy« (The case of Szántó Kovács), in *Élet és Irodalom*, XLIX. 3. (21 January 2005): 19.

48 Gyula Rózsa, »Kis magyar falu« (Little Hungarian Village), in *Népszabadság* (16 December 2004), http://www.nol.hu/cikk/344806/.

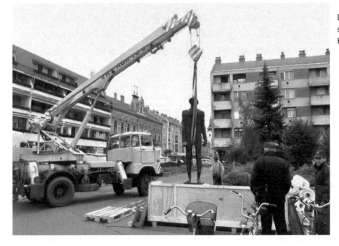

Dismantling of József Somogyi's statue of János Szántó Kovács, Hódmezővásárhely

In 1965, the state of Socialist Realism was at stake because its definition had started to become vague. Likewise, 1965 was the year of the original unveiling of the statue of János Szántó Kovács, the early-twentieth-century agrarian-proletarian leader. This very statue became a site of struggle, where competing positions concerning state control of art versus artists' freedom of expression were being contested. Thus, according to the standards of the more schematic examples of the official style, it was accused of not being heroic and elevated enough and it was celebrated by others, especially by the art community, for pushing the envelope. The case was further complicated by the fact that, in the years of consolidation after the 1956 revolution, the accusation wasn't articulated by the representatives of power, but in the very name of »the people.«[49] The once-explosive debate was soon forgotten; yet, in some textbooks, the statue represents a diluted form of Socialist Realism, no longer observing the once-so-important subtleties and distinctions of the style. It was also forgotten by those guarding the myths of oppositional art, for whom this statue had the symbolic meaning of resistance, an issue that was rendered irrelevant within the new circumstances. The Western audience, including the professional community, removed not only historically but geographically from the scene, proved to hold its own stereotypes, left-over rhetoric from the cold war.

All of these issues came into play when Little Warsaw re-unveiled the statue. This reanimation, the second unveiling of the statue, once again stirred debate, now in the homeland. The artists were attacked by the local press because of the presentation of the statue, which stood on its feet in the museum rather than high on a pedestal. In terms of conception, the statue was pulled down to earth from the realm of ideology and became a fragile, vulnerable human being contradicting the eternal life of the public monument as it was conceived. The project was also accused of mistakes that had actually been made by the curators of the prestigious western European institution, or to put it psychologically, had been caused by their unconscious slips, very useful ones for analyzing suppressed feelings. The authorities of the museum in Amsterdam

49 See *Lelepleztek egy szobrot. A művészet legyen mindenkié* (Let Art Belong to Everybody—A Statue Unveiled), a documentary film made by Boris Palotai in 1965.

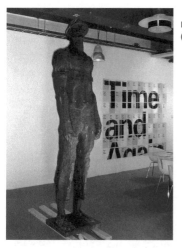

Little Warsaw, contribution to *Time and Again*
(2004), Stedelijk Museum, Amsterdam

interpreted the statue using old stereotypes and clichés about the ex-region behind the Iron Curtain, namely, the related museum tag identified the peasant leader as a communist worker and the place where it used to be located, a small Hungarian village, thus giving the installation dramatic overtones. Although Little Warsaw was accused of neglecting to explain the original context, they clearly showed—even if unintentionally—the encounter of a work from New Europe with the dominant voice of art discourse dictated by the old division. While the topic that the exhibition was organized around was topical, focusing on issues of memory and history, the rhetoric was not updated, and remained embedded in the old, controlling structure.

According to the change of rhetoric after the long period of socialism, the main problem, as voiced by the press at home and by the art professionals signing the petition, was the offense against human rights. The artists were accused of not asking for permission from the artist's heirs, and also noted was the humiliation endured by the statue and indirectly Somogyi, the sculptor. Actually, the statue was not destroyed and it got back to its original site fully intact, so the gesture was really not against the art object, either. On the contrary, the artists lifted up the veil of ignorance covering the statue, whose story had sunk into oblivion. Little Warsaw had dug it up from the past, and along with it, the wounds and scars of the past, which had never properly healed. The issue at stake was indeed gate-keeping. Who has the right to dig up the past, break apart the preserved ideas of socialism and the related art practice? Who had a share in its construction? And, perhaps most importantly, who has the right to process and recontextualize objects and ideas of the past in the present?

The traditional nationalist ideology of older forms of public art, in the form of conservative figurative monuments, flooded the public spaces of Hungarian towns and villages well after socialist times, even into the mid-1990s, as illustrated by the installation of several statues of Saint Stephan, the first Hungarian king. When Little Warsaw's project pushed the limits of sculpture, people found plenty to criticize, but no one protested against the return of an outdated public art practice. Where was the art community's concern for the issue of sculpting at that time? Little Warsaw entered the current debate on public art, as it is conceived locally and outside of the local context. By this appropriation, the artists' goal was not to question the ownership and

stardom of the object, as the one chosen was not at all a well-known icon, but to investigate the legacy of socialism in art making practices, and expose hidden operations whose intention is to sustain the status quo. Touching a taboo issue, they drew attention to the consequences of the collective amnesia regarding the legacy of the socialist past, which the art community has failed to confront and work through. At the same time, they provided a framework for a discourse on public art, which has kept a low profile in the shadow of the emerging art market. Regarding the burning issue of navigation between the local context and global recognition, they offered a dialogue, rather than pinning down the artistic operation in one position or the other.

In contemporary art behind the mental walls of Europe, the psychological process of working through the trauma of the socialist past indisputably began with the Albanian artist Anri Sala's famous video *Intervista*, which documented the discovery of the buried past of the artist's mother's involvement in socialism. The issue was unfolded via a personal narrative; therefore, it was deeply touching, making the experience digestible even for someone unfamiliar with the local context. In Hungary, the very idea of interpreting the socialist past in art popped up in the work *The Spirit of Freedom* by Tamás St. Auby right after the political changes, but, later, as the region slipped into collective amnesia, the scene became characterized by lack of any critical comments in relation to the past. Direct political comments, whether relating to the past or to the present, were banned by the local unwritten tradition of coded language, partly due to the assumptions of the adapted and fossilized local modernism and partly because of the long history of using coded language as a method of operation within censorship. The »crime« Little Warsaw committed was to touch taboo issues and provide a warning that facing the past and raising questions is essential for recovery and for moving on.

Further analyzing the discourses mobilized in Little Warsaw's local reception, the conception of modernity came to help the hidden intention of censoring new, advanced art. Those who accused the action of being uncivilized took for granted the notion of civilization as a justified cultural hierarchy favoring a Western perspective, as if it was not already deconstructed in critical theories, and as if the exclusive nature of the term was not invested in Western powers with full authority to subjugate different cultures as upholders of cultural standards, which is being critiqued loudly in museum discourse nowadays.

The project clearly shows how the changed sociopolitical position pushed the representatives of the once rebellious avant-garde into a position of guarding the standards. Little Warsaw's effort at dusting off the past, in this case a socialist monument, was not celebrated, but on the contrary, policed. This time, however, the policing was not done by another country's cultural leadership or by the state cultural bureaucracy, but by the art community itself. One would suspect that behind the collective attack lurks fear, namely, of the anti-establishment attitude of the artist-duo, as seen by the bearers of the canon. One cannot help but notice the presence of territorial anxiety behind the vehement attack in defense of the status quo. The message conveyed is not to dwell on the past but to leave it as it is.

50 Suzanne Lacy coined the term in 1993. See Suzanne Lacy, ed., *Mapping the Terrain: New Genre Public Art* (Seattle: Bay Press, 1995).

51 See Miwon Kwon, *One Place after Another: Site-specific Art and Locational Identity* (Cambridge, MA/London: MIT Press, 2004).

52 Bal, »Visual Essentialism.«

Little Warsaw's activity could be interpreted in the framework of »new genre public art«[50] as well, in which the site could be as diverse as an artistic genre (in their case, sculpture in the museum or in the public space) or a discursively determined site as a field of knowledge, or a cultural debate, or a way of communicating.[51] Or maybe we can label their activity as »new genre conceptual art,« as it differs greatly from post- and neo-Conceptualism, let alone hard-core Conceptualism, yet is undeniably and deeply conceptual. Quite similarly to Duchamp's ready-made, *Fountain*, Little Warsaw's projects for opening up new discursive fields were treated in the same way, being censored by the art community. The long-term symptoms of the traumatized past could be detected in the short-sighted reaction of the locally and globally isolated art community, which, regardless of the changed conditions in a post-socialist country, did not admire interventionist strategies for their critical capacities and also did not consider them as communicative possibilities for art, being stuck in the past, while denying the analyses of it.

Almost one hundred years after Duchamp's explorations on the nature of the art object, and almost half a century after his followers' explorations, Little Warsaw returned to the complexity of the Duchampian questions, and, by reversing the reductionist process, reclaimed the materialized object without any fear of the fathers, as the notion of art was being replaced by the very context of the object in their investigations. In their projects, this context was stretched well beyond the art object, penetrating into different discursive fields, and into burning sociopolitical issues transgressing even tabooed geopolitical boundaries. Their practice engaged in problematizing received notions of art historical writing, as their context transgressed not just spatial, but temporal dimensions, too. They were aware of the impossibility of working outside of the institutions, lacking the illusions of those who earlier believed it possible to work outside of the system; instead, they highlighted the way it operates. Their works could be seen as theoretical works, referring to Mieke Bal's category,[52] not just helping us to think, but rather, making visible all the blind spots that could not be seen from either the dominating Western perspective or from the local point of view. What they are making and proposing is to mediate between different cultural communities and different notions of art, thus stimulating new discourses and new ways of thinking about art that are capable of transforming and adapting Conceptualism's most valuable legacies to today's conditions.

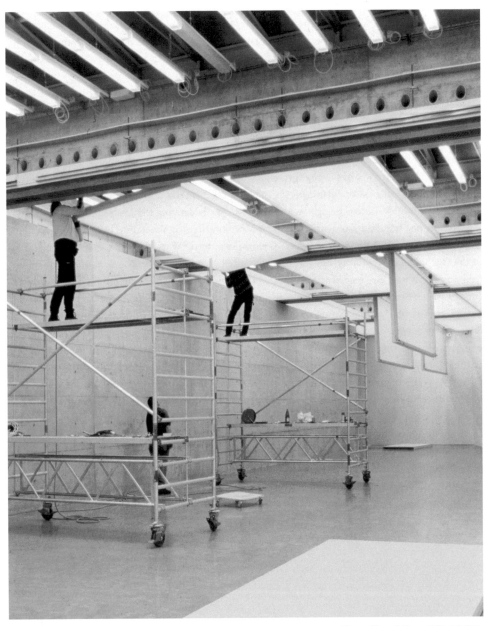

The making of, Generali Foundation
(1998), dismantling of ceiling panels
during installation

Sabeth Buchmann

Under the Sign of Labor

From the dematerialized object to immaterial labor

With its interest in linguistics and information theory, Anglo-American Conceptual art as it emerged in the mid-late 1960s marked a break with the industrially coded production aesthetics of Pop art and Minimal art. Linked to this was the notion that the replacement of author-centered object production by linguistic or information-based propositions represented a challenge not only to any traditional »material-object paradigm« (Art & Language) but also to those aspects of craft-based »production values« which are crucial to claims concerning authorship and the »work.« Which helps to explain how and why the history of Conceptual art has been written (misleadingly) as the history of a »dematerialization of the object.«[1] Without wishing to go into detail on critiques of the concept of dematerialization, which have been sufficiently documented,[2] I would like nonetheless to take this concept as a starting point. I am interested here not in discussing the status of the object in the context of post-conceptual practice, or in relativizing problematic issues within the discourse of dematerialization, but in the revaluation of »work« that inheres in the concept. Lucy Lippard was not alone in seeing one of Conceptual art's main goals in replacing the traditional art object with distribution-oriented sign systems in order to free artistic production from the logic of the marketplace and anchor it within a non-institutional, non-commercial public sphere.[3] Although this goal was not achieved, Conceptual art was successful in establishing the idea that instead of being measurable only in terms of the fact of material production, the form of art's symbolic value should be equally open to calibration using scales of social productivity: what traditionally was identified with art in categories of object-based works was put forward here as an avant-garde demand for art as a form of communication that generates publicness. As the works of early Conceptual art show, this amounted to a

1 Lucy R. Lippard and John Chandler, »The Dematerialization of Art,« in *Art International*, vol. 12, no. 2 (1968): 31–36. See also Lucy Lippard, *Six Years: The Dematerialization of the Art Object from 1966 to 1972* (New York: Praeger, 1973).

2 See for example Charles Harrison, »Einleitung,« in *Art & Language: Terry Bainbridge, Michael Baldwin, Harold Hurrell, Joseph Kosuth*, ed. Paul Maenz and Gerd de Vries (Cologne: DuMont, 1972), 11–17; and Pamela M. Lee, »Das konzeptuelle Objekt der Kunstgeschichte,« in *Texte zur Kunst*, vol. 6, no. 21 (March 1996): 120–29.

3 Lippard, »Escape Attempts,« in *Reconsidering the Object of Art*, ed. Ann Goldstein and Anne Rorimer, exh. cat. (Los Angeles: Museum of Contemporary Art, 1995), 16–39.

new notion of the public that was projected onto such various interrelated spheres as urban space, social movements, the mass media, new technologies, libraries, etc.

We can assume, along with the philosopher Jacques Rancière, that at the basis of such a discourse of the public lies not only the avant-garde notion of transferring art to life, but also simple, classical images of the »emulating artist,« who in contrast to the »standard« worker, who is excluded »from participation in what is common to the community,« »provides a public stage for the 'private' principle of work.«[4] But as standard categories of material production become obsolete with the relativization of author-fixated forms and notions of the work, then the question arises as to the status of the artistic work that is to be exhibited in the realm of the public. On the basis of Maurizio Lazzarato's idea of »immaterial labor,«[5] which refers to service-oriented activities in the realm of education, research, information, communication, and management, a possible answer to this question might lie in linking Chandler's and Lippard's discourses of dematerialization with the modes of representing labor in the neo-conceptual movements of the 1980s and 1990s.

From »the faking of« ...

If the dematerialization discourse is interpreted in the sense of superimposing »material« with »symbolic« production, it can be seen as corresponding to a social process: »the reconfiguration of labor relations in the major industrial nations« that began in the early 1970s.[6] In their book *The Labor of Dionysus*, Toni Negri and Michael Hardt write: »The most important general phenomenon of the transformation of labor that we have witnessed in recent years is the passage toward what we call the factory society... . All of society is now permeated through and through with the regime of the factory, that is, with the rules of specifically capitalist relations of production.«[7] The two authors conclude that »the traditional conceptual distinction between productive and unproductive labor and between production and reproduction ... should today be considered completely defunct.«[8] Negri and Hardt thus broaden prevailing concepts of value to such an extent that »immaterial« or self-utilizing forms of labor can be included.[9]

4 Jacques Rancière, »On Art and Work,« in *The Politics of Aesthetics* (New York/London: Continuum), 42–43.

5 See Maurizio Lazzarato, »Immaterielle Arbeit: Gesellschaftliche Tätigkeit unter den Bedingungen des Postfordismus,« in Toni Negri, Maurizio Lazzarato, and Paolo Virno, *Umherschweifende Produzenten: Immaterielle Arbeit und Subversion* (Berlin: ID Verlag, 1998), 39–52.

6 Michael Willenbücher, *Migration—Illegalisierung—Ausnahmezustände: Der Illegalisierte als Homo Sacer des Postfordismus*, unpublished Magister thesis (Heidelberg: Ruprecht-Karls-Universität, 2005).

7 Antonio Negri and Michael Hardt, *The Labor of Dionysus: A Critique of the State Form* (Minneapolis: University of Minnesota Press), 9–10.

8 Ibid., 10.

9 Negri und Hardt, for instance, take recourse to the Marxist concept of »general intellect,« according to which knowledge and intellectual capacities are accumulated and mobilized in the sense of labor's self-amortization. But in the way that the authors take account of social and symbolic forms of value production, they differ from the Marxist theory of value. They affirm the networks of producers that, according to their depiction, refuse control by capital and thus have greater connection to value creation and production. All the same, this could be criticized as an idealistic option, since companies also absorb such projects to promote the abolition of all wage guarantees. It has for example been pointed out a number of times that this process, which Negri and Hardt consider a positive development, leads to a more extensive exploitation, to new forms of control in the lowest-wage service economy, and finally contributes to corporations penetrating more and more into the social realm.

Although these discourses were not yet public in the 1980s—at least not in the art context—comparable revisions of the traditional concept of labor and production can be detected, albeit in an entirely different theoretical realm. These included, above all, Jean Baudrillard's proposition—put forward as early as the 1970s—that »production« (homologous with the industrial age) had been replaced by »simulation« (homologous with the information age).[10] Backed up by discourses on the »immaterial« (Lyotard),[11] postmodern media theory was increasingly to take on the role of a social theory[12] and as such be able to find its way into those (neo-)conceptual forms of thought and praxis that overlapped with the approaches of poststructuralism, deconstruction, and cultural studies that were emerging at the time. In contrast to the focus on linguistics that still determined the discourse on the dematerialization of the object, here semiotics enhanced by cultural criticism came onto the scene, no longer measuring the »real« as a fact of material production, but rather as an effect of a process of »de-realization« driven forward by media technology. Concepts often used at the time, such as »simulacrum,« »surrogate,« and »fake,«[13] as well as the founding of fictional »corporate identities,« provide a sense of how references to ideas like »labor« and »production« have undergone a form of virtualization, and, even if only »simulated,« a form of corporate privatization.

The fact that the playful analogy of artistic self-organization and fictional »corporate identities« was to turn into economic reality in the 1990s could be one of the reasons why postmodernist media theory slowly went out of fashion. So-called reality had returned to the art world, and not as a result of the crisis in the art market that took place in the interim. Political and economic discourses around post-Fordism, service culture, and neoliberalism, including the concepts they used for capital, labor, and production such as »flexibilization,« »deregulation,« and »mobilization,« became key terms within those post-conceptual developments that took recourse to approaches from the 1970s (such as site-specificity, identity, and institutional critique) and thereby positioned themselves against the ongoing demand of the art market for »good craftsmanship« and quantifiable »production values.« Parallel to this, the economic situation of those institutions and artists dependent on public funding became more drastic, as the cultural sphere was increasingly hit by cuts, meaning that budgets for production formats not adequate to the art market became scarcer and new forms of »aggressive sponsoring«[14] found their way into museums and art associations. Thus, any talk of »fictional corporate identities« became hopelessly obsolete when, due to a mix of voluntary and forced self-determination, artists saw themselves confronted with the necessity of organizing their own financial means for production, work spaces, exhibition sites, contacts, possibilities of distribution, and publics. Hence, the discourse

10 Jean Baudrillard, *Symbolic Exchange and Death* (London: Sage Publications, 1993).

11 Consider in this context the 1985 exhibition *Les Immatériaux* at Centre Georges Pompidou, Paris.

12 Katja Diefenbach, *Theorien der neuen Technologien: Zur Bedeutung der Informations- und Kommunikationstechnologien im Spätkapitalismus*, unpublished Magister thesis (Munich: Ludwig-Maximillian-Universität, 1992).

13 See Stefan Römer, *Künstlerische Strategien des Fake: Kritik von Original und Fälschung* (Cologne: DuMont, 2001).

14 See Walter Grasskamp, *Kunst und Geld: Szenen einer Mischehe* (Munich: Beck, 1998); Hans Haacke, »Der Kampf ums Geld: Sponsoren, Kunst, moderne Zeiten,« in *Frankfurter Allgemeine Zeitung* (11 October, 1995); Dierk Schmidt, »Sponsorenstress: Ein Beitrag zur politischen Kampagne,« in *A.N.Y.P.* 9 (1999): 32–33; Hubertus Butin, »When Attitudes Become Form Philip Morris Becomes Sponsor,« in *The Academy and the Corporate Public*, ed. Stephan Dillemuth (Bergen: Kunsthøgskolen; Cologne: Permanent Press Verlag: 2002), 40; Alice Creischer and Andreas Siekmann, »Sponsoring and Neoliberal Culture,« in ibid., 58.

on the »mobilized relation between capital and labor«[15] became increasingly obsolete with the increasing entanglement of self-organized, institutional, corporate, and state economies. This was a process that became a major issue and also a subject in their work for artists who sought to integrate into their works the changing conditions of labor and production and the discourse on the public and the private that these conditions engendered.

... to »The making of«

In the following I will explore the 1998 exhibition *The making of*, organized by the artist Mathias Poledna at the Generali Foundation in Vienna, in which the artist himself, together with Simon Leung, Dorit Margreiter, and Nils Norman participated. This exhibition both explicitly and implicitly addressed the problems sketched above. For example, it was concerned with the transformed modes of presenting and publishing artistic work within the tradition of Conceptualism, as related to »low-capital, labor intensive industries,«[16] as a characteristic of the economics of post-Fordism marked by mass unemployment. In *The making of*, this included critical revisions of techniques of site specificity, identity critique, institutional critique, postproduction, and cultural research, and hence revisions of conceptual notions of the work that intended to historically illuminate the blind spots of modernist art discourse—its overlapping with phenomena of everyday life, commodity and media culture, architecture, and design. *The making of* was framed by an exhibition design that contained references to Michael Asher's 1977 solo show in Eindhoven's Stedelijk Van Abbemuseum, Daniel Buren's exhibition *Frost and Defrost* (1979, Otis Art Institute, Los Angeles),[17] and information on the corporate design of the Generali Foundation itself. Asher's concept had been to dismantle fifteen glass ceiling panels from one of the exhibition spaces of the Van Abbemuseum, and to then determine the duration of the exhibition as the time required for the installation team—working to a fixed schedule—to reinstall the glass panels.[18] Poledna then cited this idea by also taking down the ceiling panels and having them placed in the entryway of the Generali Foundation's exhibition space. Instead of reinstalling them, as Asher did, Poledna gave them a new function as bearers of information with passages from a Generali Foundation handbook on questions of design and quotations from the building's architects Jabornegg & Pálffy. In this way, the works presented became legible in the context of a highly charged contemporary debate on the autonomy of commissioned art.[19] It was, of

15 See Willenbücher, *Migration—Illegalisierung—Ausnahmezustände.*

16 See »Substituting one Fungus for Another: Nicolas Tobier in Conversation with Nils Norman,« in *The making of*, ed. Mathias Poledna (Vienna: Generali Foundation; Cologne: Buchhandlung Walther König, 1998), 207.

17 »In this site-specific work the ceiling panels in both gallery rooms were removed and covered with striped paper. The panels were reinstalled by units of seven per day per room to their original place in the ceiling. At the same time objects left in room B used for installation were put back a piece at a time in the storage room. The evolution of the work was documented in the catalog.« See Daniel Buren, *Frost and Defrost*, exh. cat. (Los Angeles: Otis Art Institute, 1979). Quoted from http://percept.home.cyberverse.com/percept/exhibitions.html

18 See Michael Asher's description of his exhibition concept: »I propose that before the exhibition opens on August 3, all the glass ceiling panels in rooms 1, 2, 3, and 4, plus all the glass panels in one half of the museum shall be removed, which would leave rooms 10, 9, 8, 7, and part of rooms 5 and 6 open for exhibition. Starting August 3 and working 4 hours every morning during each day of the work week, an exhibition crew will replace the ceiling panels.« Quoted in Michael Asher, »August 3–August 29, 1977 Stedelijk Van Abbemuseum Eindhoven, Netherlands,« in *Writings 1977–1983 On Works 1969–1979*, ed. Benjamin H. D. Buchloh (Halifax: Press of the Nova Scotia College of Art and Design, 1983), 174–83, here: 178.

course, inevitable that this debate would also affect the Generali Foundation itself, as it is publicly seen to be a private art institution funded by an insurance company, especially since the Generali Foundation took a particular interest in the tradition of Conceptual art and its associated forms of institutional critique. This show made reference to a paradigmatic work of institutional critique and to Poledna's own involvement as a graphic artist in the corporate design of the Generali Foundation, references which mutually influenced each other, and the selected form of exhibition design clearly showed that the relationship between the two can hardly be limited to a polarized view of critique, on the one hand, and affirmation on the other.[20] For it was precisely from his position of involvement that Poledna formulated a position of critical distance that is seldom encountered in what are otherwise generalizing attacks on art as service. As Poledna explained in the interview for the exhibition catalogue:

Interestingly, the Generali Foundation—as far as I know—voluntarily subscribed to the corporate aesthetics of the Generali, in that the logo, typefaces, colors, etc., correspond to a great extent to the logic of representation of the Generali Insurance Company. At the same time, the terms that appear in this text—position, identity, form, content, style, format—are constantly applied in art contexts. This reciprocal saturation of different rhetoric becomes particularly virulent when the language appears to indicate that the artists of the exhibition are speaking for themselves.[21]

Thus, in his eyes, the differences between »'free' and contractual artistic work are generally less [great] than assumed. Precisely because artistic projects are considered non-determined, one is confronted more with implicit expectations and general assumptions, that—consciously or not—inscribe themselves into the respective approaches.«[22]

In light of the reference to Asher, Poledna's statement can help to explain further aspects of the exhibition design that affect the relationship between public and private work discussed above. For what category does corporate identity belong to, and can focusing attention on it, as Asher's intervention did, allow the distinctions between »visible« and »invisible,« »standardized« and »flexible,« »physical« and »intellectual« labor and their proper evaluation to become evident? By using the ceiling panels as an exhibition display and as bearer of information with the aim of making architecture the object of the exhibition (allowing it to block the lines of vision in the exhibition space), Poledna modified Asher's reflection of the shifting relationship between artistic and institutional labor economy in the sense of an overview of »architecture, corporate design, and institutional self-portrayal.«[23] Using Asher's design as a point of departure, the distinction between private labor, which is private because it is usually invisible, and public, or usually visible labor, was expanded by an implicit reference to the equivalence of symbolic and corporate capital.[24] In this way, the exhibition also addressed the various institutional, social, and art critical evaluations of the role of the artist and the role of the service provider.

19 See the debate on Andrea Fraser's *A project in two phases* (1994–95).
20 See Helmut Draxler's contribution in this volume.
21 »Blanks and Side Effects: Sabeth Buchmann in Conversation with Mathias Poledna,« in Poledna, *The making of*, 223–24.
22 Ibid., 220.
23 Ibid., 225.
24 Pierre Bourdieu, *Distinction: A Social Critique of the Judgement of Taste* (Cambridge, MA: Harvard University Press, 1996).

The combination of historical and site-specific, topical reference to labor's (self-)representation staged in *The making of* carried yet another discourse with it—the discourse rooted in the avant-garde tradition that claims that making production visible amounts to turning art into social productivity. According to the standard view, this takes place only when the limits of the institution of art are transgressed and other social fields are entered. As the art and culture critic Christian Höller writes in his catalogue contribution: »In symbolic-political production, therefore, working with overlapping and permeating contexts is inherent. Contexts understood as 'institutional' require, though, a more complex positioning than the following alternatives suggest for the moment; direct linkage (for instance onto the exhibiting institution) or unbound 'outer' orientation.«[25]

In the light of the polarization of institutional and social fields, as addressed by Poledna and Höller, the exhibition design for *The making of* offered a starting point at the end of the 1990s for reworking apparently stagnating institution-critical practices—including criticism of these practices themselves—by virtue of a broadly framed discourse on the reciprocal relationship between processes of corporatization and shifting modes of labor and production. As far as the visibility of non-artistic, that is, industrial and standard »labor« in the context of the Generali Foundation is concerned, here, too, a link can be made to what Poledna envisioned as the »interrelations between architecture, corporate design, and institutional self-portrayal.«[26] In the interview quoted above, the artist noted that the ceiling »actually displays an outside of this relatively hermetic space« of the Generali Foundation: »After the dismantling of the ceiling panels the room evokes the image of an industrial shed, or backyard industry. On the lot where the foundation is now situated, there was originally a shed in which hats were produced. My concern was to advance other images against the original appearance of an architecture which oscillates between a supposedly pragmatic understanding of classical modernism and a certain late-eighties look.«[27]

That means that just a few years after the reconstruction of the building, the basic design principle—the avoidance of »irregular contours« to create a »clear image«[28]—surfaces in *The making of* as a historically determined motif. The proposition implicit in this intervention, that this image could already soon prove to be something worthy of revision, also resonates in Nils Norman's contribution, *Proposal 10*. Corresponding to the symbolic reconstruction of a history of industrial production eradicated by the architecture of the Generali Foundation, the piece foresaw »the radical redevelopment of the Generali Foundation, Vienna… consisting of various architectural, bureaucratic, environmental, and psychological interventions.«[29] Nils Norman's proposal of an alternative foundation that issued from the interest he noted in »alternative economic forms«[30] as a consequence of the closure of industrial companies and the resultant mass unemployment also addressed the possibility that the Generali Group might someday turn to

25 Christian Höller, »The Making of ... Political Contexts? Preliminary Work on a Symbolic Political Context Understanding,« in Poledna, *The making of*, 173.

26 Buchmann/Poledna, »Blanks and Side Effects,« 225.

27 Ibid.

28 See »Exhibition Design,« in Poledna, *The making of*, 85.

29 Norman, »Proposal 10,« in Poledna, The making of, 128.

30 Ibid.

Nils Norman, *Proposal 10* (1998)

marketing concepts that are socially more productive and invest its money in ecology and related socio-technological projects—things that themselves have in the meantime become a feature of a deregulated variant of »do-it-yourself« culture.[31]

The idea that a new understanding of work and production could have an influence on the respective relations of visibility of »standard« private labor and »artistic« public labor is one of the subtexts of Dorit Margreiter's spatial and video installation *Into Art*. Analogous to the exhibition design, here, too, cultural and corporate forms of capital are related to the material and symbolic value of those fields of labor and activity in which institutional and social contexts as well as »autonomous« and service-oriented forms of labor overlap in terms of their compatibility with media-effective image functions. In an interview with me for the catalogue to *The making of*, Margreiter explains, that »the art-place itself already presents a medial construction ... a site of production and reproduction of the symbolic ...«[32] Here, we again see a typical argument of media theory approaches in the 1980s, which considers the notion of production as an effect of technologically supported processes of »de-realization.« On the other hand, the notion of the »social factory« is also apparent here, coined to refer to the de-differentiation and immaterialization of realms of production and reproduction.

Appropriating the genre of a trailer for a TV soap, *Into Art* simulates the self-representation of a private art institution according to the standards of the »creative industry.« Following the sketch printed in the exhibition catalogue:

The series begins with a director being appointed to the institution which at the time had been in existence for three years. At this time there was a restructuring not only of staff but also of programmatic orientation. The newly constructed museum building is supposed to reinforce the role of art as an image bearer for the corporation, at the same time the new institution is supposed to develop its own profile within the context of international art discourse.[33]

31 See Tobier/Norman, »Substituting one Fungus for Another,« 208.
32 See »Definitions of a Building Site: Sabeth Buchmann in Conversation with Dorit Margreiter,« in Poledna, *The making of*, 204.
33 See Dorit Margreiter, »Into Art,« in Poledna, *The making of*, 109.

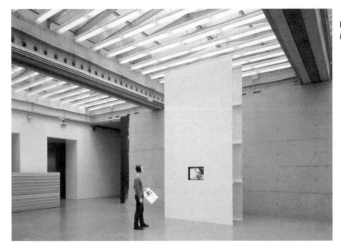

Dorit Margreiter, *Into Art* (1998), installation view

The accompanying storyboards, which were installed in the exhibition as user-friendly text panels on the rear of the wall construction, included fragmentary information on the life and work of the actors. These were characterizations of functions within the institution and also of »freelance« jobs as well as information on individual preferences in terms of fashion and leisure activities, cultural habits, social activities, and sexual and family relations. In line with the principles of the »social factory,« professional and personal worlds as depicted here oscillate, as in the case of »Peter,« who defines himself as »someone who works in 'art-related' contexts. Growing up in a working class family he gained early experience in political work at the grass roots level. At the institution he works to make a living in the development team. Here he is not recognized as an artist. In a different scene, however, he is a well-known, important figure. At the beginning of the series, he organizes an exhibition and a panel on 'minority politics.' He has tried repeatedly to change the institutional exhibition program from 'below,' but has had only limited success.« The »possible topics« attributed to him are »'class,' political activism, institutional recognition, alternative spaces, economic situation, etc.«[34] As can be deduced not only from the figure of Peter, but also from the other roles sketched, they not only illustrate structural characteristics, but also individual and psychological aspects. This not only distinguishes Margreiter's work from classical forms of institutional critique, but could also indicate that the category of the institution is here seen as a category of the »social factory.« Seen in this way, the exhibition title—*The making of*—proves to be a »making of the self,« where the issue is a post-Fordist intersection of institutional, cultural, and private spheres of life and work.

Even if limited to a few brief selections, the locations and staging of roles presented suffice to make comparisons to the Generali Foundation, the location being visited while viewing *The making of*. The reflection of and on the corporate design of the Generali Foundation that the exhibition design engenders is varied in *Into Art* by representing realms of labor and production such as project development, communication, design, the making of exhibition displays, exhibition assembly, and control. As such they affect management, image design, »internal and exter-

34 Ibid., 114.

nal means of communication,«[35] and therefore those activities where Maurizio Lazzarato's defi-
nition of »immaterial labor« could be applied. In *Into Art*, we become aware of this by way of
fragmentary scenes from daily activity, intercut with staged snapshots and documentary material
from the archive of the Generali Foundation. The interesplicing of »real« and »fictional« material
—found footage, artistic documentation, and fictional elements of plot—serves on the one hand
to counter the fiction that institutional structures can simply be made legible by way of critical
reflection; at the same time, an implicit de-differentiation of real and fictional characters is enacted
here, with a view to making intelligible the transformed relations of the visibility and represen-
tation of private and public labor.[36] Employees play themselves, in *both* public and private
moments. Institutional stagings of roles, including an actress miming the role of the artist—
which could also be her own role—take on the character of a soap opera, which in turn allows
the de-differentiation of public, private, and media spheres of (re)production and labor to become
»reality.« In this way, what Margreiter intends with her definition of the art institution as a
»media construction« and »production and reproduction of the symbolic« becomes visible: that
is, (re)gauging the relationship between »autonomous art« and »service-oriented art« in the con-
text of an institutional logic that seeks to integrate artistic labor's media-effective publicity
potential in the sense of »corporate identity.« In her function as a graphic designer, she is, as she
explained to me in the above quoted interview, »involved with the make up of the institution ...
with the image it imparts and wants to impart.«[37] That means that *Into Art* not only sharpens
this image by way of focusing attention on the production and design of catalogs, posters, and
invitations—but also sets this against the value system that still sees art as the opposite of »func-
tion.«

But in the context of the exhibition design for *The making of*, *Into Art* reverses the opinion
of critics at the time, according to which »paid institutional critique« forced the artists into the
role of affirmative service providers. In contrast, by restaging the corporate identity, it became
clear that its key theme was emphasizing the institution's role as a site of artistic production.
The institution cannot do without the autonomy of the producer if it wants to »bring sense into
these [its] rules, to make them alive.«[38] These rules are fictionalized in *Into Art* in the form of
ready-made plot lines that, by way of a casual camera technique and sometimes blurry visual
aesthetic, evoke a pseudo-unprofessional image that could let *Into Art* pass as an artistically
well-versed form of corporate self-representation. But it is precisely this that lends the video
trailer the appearance of a »real« production, as is typical of media formats that suggest authen-
ticity. All the same, *Into Art*'s editing, which combines various levels and forms of representation,
makes it possible to experience the »real« as the result of visual-technological »de-realization.«
For instance, Margreiter's staging of a »real« institution presents a link between site-specificity
with media-supported techniques of postproduction, allowing for reflection on the fictionalized
representation of labor and production as corporate image. While this might sound like the
practical application of the theory of the spectacle, it is given a particular twist in *Into Art* to

35 »Exhibition Design«, in Poledna, *The making of*, 85.
36 See on this Rancière's argument in favor of fiction, in »On Art and Work.«
37 Buchmann/Margreiter, »Definitions of a Building Site,« 196.
38 »Exhibition Design«, in Poledna, *The making of*, 85.

the extent that it measures the image function of artistic labor as public labor within the economic morality that demands the production of social values under the conditions of publicity. If the actors who appear are characterized by various social origins, cultural and institutional positions, forms of private and professional life, and emotional and psychological positions, they also allow the art institution presented to appear as a representative social structure, while making it clear that it consists of subjects and subjectivities that cannot be depicted in a merely structural conception of the institution. Instead, the people involved are service providers on a freelance basis and salaried employees whose activities in the meantime hardly differ from artistic labor, a state of affairs that Poledna describes as the »hipness-phantasma of deregulated labor.«[39] This idea can serve to name an essential aspect of Margreiter's staging of roles, to the extent that the presented mix of work and leisure exudes the impression of a creative, vivid dynamism. This impression is amplified by the sound samples from television series such as *Dallas*, *Melrose Place*, *Tatort*, etc., thus associating the figures represented with the consumption and temporal structure of media formats. The layers of image, text, and sound are sampled and disassociated from one another in an avant-garde manner, thus counteracting the construction of simplifying, totalized images; this is then complemented by the suggestion of flexibilized attitudes of reception, amplified by the inserted zapping noises of a remote control. The open beats and bass mixed into the soundtrack suggest the question as to »our« relationship to corporate patterns of identification: do we see ourselves in a relationship based on free choice (corresponding to spaces for free expression as they are projected onto artistic autonomy), or in a relationship of enforced choice (corresponding to the »self-determined« acceptance of economically determined circumstances)? That we become »fictional authors« of fictional series can be interpreted as a reflection of the increasing influence of participating consumers and fans in the product design of the culture industry—a phenomenon that shows the totalizing function of the cultural imperative to be creative.[40]

In that *Into Art* allows this distinction to appear questionable by means of the chosen methodological-thematic and technological-formal structure, it marks a further characteristic of the »social factory,« as according to Negri and Hardt, to the extent that freedom of choice presents itself here as a version of the dominant credo of production. From the corporate executive to the freelance graphic designer who is »really« an artist, all are subjected to this credo, even the viewer participating by way of an imaginary zap function.

Thus *Into Art* can be seen to imply both a distance to the idealistic equation of art and autonomy and the cultural-pessimist equation of art and entertainment or service industry— whereby the latter view is often used as a way of legitimizing the former. This distance is apparent because the conflictual interest in art's (critical) potential for publicity here does not take place along clearly defined front lines, but rather in the midst of a general reconfiguration of social labor relations, of which it is a constitutive element. This position was ultimately presented by *Into Art*'s spatial installation itself, to the extent that it placed the represented fictional location and the real space that was used by the visitors, and also the museum wardens and cashier

39 Buchmann/Poledna, »Blanks and Side Effects,« 225.
40 See Marion von Osten and Peter Spillmann, eds., *Be Creative—Der kreative Imperativ* (Zurich: Museum für Gestaltung, 2003).

staff, in a relationship with the usually invisible administration. The notion of surveillance that resonates here can be seen as the extension of the decision to let the employees play their own roles, as »real« as if the camera were always there. The control-society implications of video technologies find their correspondence in the double-wall construction that Margreiter had placed in the exhibition space, as a reference to Poledna's intervention in the sense of a reflection on the determination of artistic freedom by way of architectural conditions. The height of the two walls was conceived so that they could not fit into the exhibition space without dismantling the ceiling.[41] As the artist explained to me in our interview: »The ways and means in which both walls stand with relation to one another, lets them appear cast aside and also suggests the possibility that they could, potentially, stand in a different way to each other or could be duplicated.«[42] The decision to insert the walls as simultaneously site-specific, flexible, and performative spatial elements—as wall, presentation surface, and backdrop at the same time—placed them in a structural and metaphorical relationship to the technical apparatus installed in the space between the two walls, which could only be seen from one side. The stills showing technical equipment, such as a camera lens, electric cables, volume and remote controls that were included in the video trailer suggest that the selected form of visualization was based on principles from avant-garde or apparatus theory. But perhaps it is not merely what has become a standard unveiling of the process of production (if you can afford transparency, you must be doing honest and good work) that lies at the heart of this observation of the intersection of display and technology in the installation, but the inherent relationship between autonomous and corporate production, and thus the relationship between public and private labor. Here, techniques of visualization cannot automatically be equated with a reflexive critique of the fetish, but contain for their part mechanisms of corporate image formation. Seen in this way, *Into Art*'s operative dramaturgy thus works with both public and institutional as well as private and individual modes of production and reception. »Corporate identity« thus appears as an externalized as well as internalized relationship, into which the »average« media consumer is structurally and mentally integrated.

Margreiter's fictional (self-)representation of a private art institution takes the goal of experimental film and alternative video—to reach an extra-institutional audience—and transforms it into the »thesis« of the reciprocal penetration of avant-garde (public), ordinary (private), and corporate (private-public) forms of labor and production. In contrast to Asher's intervention—which places generally invisible physical labor on the stage of artistic work, thereby focusing attention on the hierarchical relationship of difference between the positions of the commissioning institution, the »delegating« artist, and the worker charged with carrying out the task—*Into Art* deals with the erosion and partial reversal in the evaluation of visible, public, and invisible, private labor.

Thus, in Margreiter's sketch of a Generali-like institution, corporate image intermingles with social modes of experience; such a transparent view of the realm in which one's staff operates is normally only entrusted to a target group considered trustworthy. And the capacity to represent

41 See Buchmann/Margreiter, »Definitions of a Building Site,« 197.
42 Ibid.

oneself as a »whole person« is part of the repertoire of »immaterial labor.« As shown for instance in Harun Farocki's film *Die Schulung* (1987), training for managers not only focuses on »rhetoric« and »dialectic,« but also, in the form of Brechtian role playing, it attempts to teach the participants the ability to assess themselves, for a good atmosphere can only be disseminated by those who have both themselves and their private lives well under control. If »I« feel comfortable in my role, there is a good chance that the person opposite me will do the same: and precisely this can be decisive for a sales talk or successful service.

Seen in this light, *Into Art* can be considered a topical reenactment of those versions of historical institutional critique that have integrated labor both in a material as well as a performative sense into artistic work, that is, not just by »representing.« In the context of the Generali Foundation's collecting strategy, which takes an expanded view of sculpture and above all focuses on formats including media such as photography, television, video, and digital technologies, Silvia Eiblmayr describes the »performative« as the »pivotal point in the dialectic of the link between the artistic conception of the artwork and the way it is perceived. … Here the 'theatrical' aspect typical of all of these expanded forms in the visual arts merges with linguistic dimension.«[43] But this also means that the »space or the location where the artwork takes place, is exhibited, or performed is integrated into its own conception in a reflexive manner.«[44]

I certainly do not intend to reproduce here the misleading equation of theatrical performance and linguistic performativity, but nonetheless Margreiter's installation seems to me to be mobilizing both of these categories. This occurs on the one hand in reference to the way in which labor is represented both as real and symbolic production, and, on the other, the way in which the visitors are addressed as both clientele and participating actors. Performance und performativity are not limited to their »social significance,« which is attributed primarily to »signifying or discursive forms of practice.« Instead, »we use labor to focus on value-creating practices.«[45] To this extent, *Into Art* counters those dominant economic trends according to which the semiotic representation of work is equated with the fact of production. But the latter includes in the sense of the »factory society« not just material »hardware,« but also nonmaterial »software.«

This means that the ability of contemporary capitalism to »give subjectivity itself a value in its various forms as communication, engagement, desires, etc.,«[46] compels us to redraw the traditional boundaries between private and public categories and spheres of labor and production. This necessity also surfaces in Simon Leung's contribution for *The making of*. In *Squatting Project Wien* he literally squatted in front of buildings that belong to Generali and had himself photographed. As he explained in an interview conversation with Nicholas Tobier, published in the exhibition catalogue, »the body works structurally in several ways: through repetition, through the semiotics of squatting, but also pictorially—it's figure and ground.«[47] When Leung

43 Silvia Eiblmayr, »Schauplatz Skulptur: Zum Wandel des Skulpturbegriffs unter dem Aspekt des Performativen,« in *White Cube/Black Box,* ed. Sabine Breitwieser (Vienna: Generali Foundation, 1996), 89.

44 Ibid., 87.

45 Hardt, Negri, *Labor of Dionysus*, 8.

46 See Willenbücher, *Migration—Illegalisierung—-Ausnahmezustände* on Paolo Virno's *A Grammar of the Multitude* (Los Angeles: Semiotext(e), 2004), and Sandro Mezzadra's »Taking Care: Migration and the Political Economy of Affective Labor,« working paper for Center for the Study of Invention and Social Process (CSISP), Goldsmiths College, University of London, March 2005.

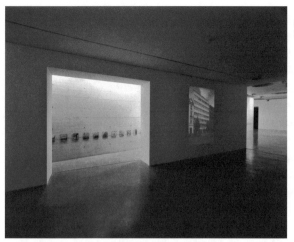

Simon Leung, *Squatting Project Wien* (1998), installation view

then explains that it is decisive »what kind of photographic object you think it is,«[48] we can assume that he is driving at the de-differentiation immanent in performative and conceptual art of subject/object, reality/representation, image/copy, production/reproduction.

Reproduced using the code of architectural photography, the body here takes on a productive semiotic function within an indexical system that can be interpreted according to linguistically and visually formalized rules. In *Squatting Project Wien* this system can be read as positing an equation between nonproductive real estate ownership and self-utilizing performative work, which makes the characteristics of contemporary capitalism presented by Paolo Virno legible on and through the body of the artist. According to Leung's interpretation, the artist's (invisible) capital—communication, commitment, desire—proves to be a literally »incorporated« mechanism in the logic of corporate value creation. But ironically, the analogy suggested by the title of the work and the photographed pose between squatting as a bodily gesture and squatting as taking possession of property raises the question of whether the photographs are a quasi-private act of the reproduction of corporate self-representation or a public staging of the »unemployed« (private) body, whose incompatibility with a corporate logic of valuation surfaces precisely in the claim to semiotic equivalence.

That artistic involvement in an institutional and corporate structure as a »site of symbolic and material production and reproduction« stands in a relationship of both compatibility and incompatibility with the dominant economy of the sign can also be seen as the subtext of Mathias Poledna's contribution to the exhibition, *Fondazione*. This was a semi-documentary video on the archive of the history of the labor movement and socialism founded by the radical left-wing publisher, millionaire, and Generali stockholder Giangiacomo Feltrinelli. Poledna's playful use of the documentary film genre to portray an institution far from the art world that can be vaguely linked to the Generali Foundation might be explained in terms of the documentary film's synthesizing function. The »connection between architecture, corporate design, and

47 »Or Is This Nothing: Nicholas Tobier in Conversation with Simon Leung,« in Poledna, *The making of*, 179.

48 Ibid.

institutional self-representation« made in the exhibition design of *The making of* becomes legible
by virtue of the kind of film montage selected as a syntax of heterogeneous elements, where it is
not a specific institution or a specific genre, but the aesthetic and scientific method of the produc-
tion of signs that comes to the fore within a concrete thematic context. This way of proceeding
can also be verified by way of the bench designed as a »bulletin board« that was placed before
the film screen, since its double function as a piece of furniture and a bearer of information clear-
ly relates, in a manner that is charged with information aesthetics, to the historical discourse
on the »dematerialized object.« With this reference to kinds of works that focus on presenta-
tion, reception, and distribution—and with the addition of techniques of postproduction —
the combination of symbolically interrupted documentation and furniture thus presented a site-
specific relationship to media information landscapes. On an abstract level, this can be seen as
a recourse to both linguistic-semiological and also identity and institutional critique traditions
in Conceptualism, which »can be drawn from design, architecture, media all the way to political
resistance.«[49] Against this backdrop, the decision to integrate a film narrative on an archive of
the history of the labor movement and socialism into the context of an exhibition whose subtext
was the (reciprocal) relationship of autonomous art and service-oriented, corporate and com-
missioned work, represents—on the level of content—the historicization of the methods and
procedures used. The selected genres that were combined with one another—documentary, narra-
tion, and fiction—were well-suited to deconstruct the monolithic topos of artistic production,
and the sound design composed of well-known film music by Luciano Berio, Giorgio Gaslini,
and Nino Rota made it legible as (medial and) cultural knowledge, albeit knowledge excluded
by art history. As a reflexive structural element, the soundtrack was associated with images of
high voltage wires; the function of these wires as recurring »title-design«[50] was both that of a
narrative abstraction and a point of intersection between the assembled forms of representation.
By including media reports on Feltrinelli's eventful life, the motif of the high voltage wires is
given a historic charge, as the viewer learns that the millionaire lost his life in 1972 attempting
to blow up a power pole near Milan.

In the figure of Feltrinelli as a vibrant and emblematic figure of the New Left, various narra-
tive lines meet that condense to form a fragmentary and associative and also anecdotal reflection
on the construction of (political) history. In this way, the abstract narrative logic of *Fondazione*
avoided a coherent, significant recourse to the Generali Foundation as a concrete institution.
Instead, this was an attempt at an artistic epistemology that declared the archive a »workplace,«
and therefore a location where the avant-garde claims that still reside in the self-image of insti-
tutional critique underwent a historical revision. On the one hand, the archive founded in 1961
by Feltrinelli can illuminate methods of the historical and academic study of industrial labor and
its forms of organization that can be implicitly or explicitly linked to both the historical and the
postwar avant-gardes. This means that they can be related to the history of collective interest
groups such as the trades unions, works councils, political parties, organized and spontaneous
or »wild« strikes, etc. On a second level that is mediated here, Poledna's contribution can also

49 Buchmann/Poledna, »Blanks and Side Effects,« 227.

50 Ibid., 228.

highlight the significance of publications by authors from the circle of the Italian Autonomia Operaia labor group in the German art context in the 1990s, including Negri and Hardt's *The Labor of Dionysus*, or Lazzarato's treatment of »immaterial labor,« which appeared in 1998 in Negri und Virno's volume *Umherschweifende Produzenten: Immaterielle Arbeit und Subversion* in the same year as *The making of*. In this way an analogy is drawn between the topos of media technology that resonates here and the historicization of proletarian or Fordist labor, whose transformation into a »social factory« as claimed by the above-named authors has since become an frequently cited subject within cultural and art discourse engaged in a critique of capitalism.[51] This means that here reflections on the historicization—according to Jacques Rancière's definition—of private forms of labor were presented on the stage of an institution whose interest is to integrate the public character of artistic labor into its own corporate identity. But in Poledna's design, the question of whether and to what extent such a discourse of labor justifies comparing the two institutions recedes behind the more fundamental question of the methods with which »history« or cultural significance is produced. This question is tellingly posed in *Fondazione* by an art critic, »played« by Matthias Dusini, who in the role of a television reporter does an interview with the library director David Bidussa. His task is to produce an image of the self-understanding of the Fondazione Feltrinelli. The camera shows him talking about the library's function and its collection, as well as transformed methods of bibliography. In this context, he points to the original 1835 manuscript of Charles Fourier's *La fausse industrie*; the fact that the library owns it is due to the »accumulation of sources,« as embodied in the initial »work ethic« of the library.[52] Or we are informed about files on the »the structure of the CUB—Confederazione Unitaria di Base—forms of representation of factory workers who belonged to the extreme left.«[53] Answering the reporter's question about how one gets hold of such material, Bidussa explains that, in »Italy the courts throw away files after twenty-five years if they are no longer necessary for cases. In this way the authorities who are responsible for public security have become information agencies for political extremism.«[54] By this point at the latest, we get the distinct impression that Bidussa maintains a distanced relation to the history represented by this archive. This impression is underscored when he contradicts the supposition that the Fondazione Feltrinelli »belongs to the left, if not the far left.«[55] He then points to seminars that have taken place there where »assistants and researchers« have participated »whose political spectrum extends from the left to the extreme right—including a position which one could call post-fascist.«[56]

51 See Stephan Geene, *money aided ich-design: techno/logie. subjektivitäet. geld* (Berlin: b_books, 1998); Marion von Osten, ed., *Norm der Abweichung* (Zurich: Edition Voldemeer, 2003); Silvia Eiblmayr, ed., *Arbeit**, exh. cat. (Innsbruck: Galerie im Taxispalais, 2005); Beatrice von Bismarck and Alexander Koch, eds., *Beyond Education: Kunst, Ausbildung, Arbeit und Ökonomie* (Frankfurt: Revolver, 2005).

52 See Mathias Poledna with Matthias Dusini, »Fondazione,« in Poledna, *The making of*, 145–63, here 152.

53 Ibid., 156.

54 Ibid.

55 Ibid., 155.

56 Ibid.

Mathias Poledna, *Fondazione* (1998),
installation view

The fact that Feltrinelli, expecting a state coup on the part of the fascist Right, propagated the militant struggle of the Left and was ultimately forced to go underground where he sought to continue to organize his social-revolutionary struggle,[57] can give a sense of the Fondazione's changed self-understanding. Bidussa's indifference as to the political interests of the users of the archive is shown again when he claims that an analysis of treatments of worker organization and representation in a sewing machine factory is formally no different than the analysis of the catechism for first communicants.

As in Poledna's study *Scan* (1996), a two-part video on questionable methods of the historicization of pop culture and punk design, using the Jamie Reid Collection at London's Victoria and Albert Museum as an example, the issue is methodological and ideological processes of revaluing historical material. Similarly, *Fondazione* focuses on the question of the forms of categorization and the constitution of the storage media in the way they influence the status of the archived material. In *Scan*, Poledna argues by way of the example of the *God Save the Queen* cover that what was »originally conceived of as mass-cultural and serially produced, suddenly emerges as dadaist collage—an extremely bibliophile artefact«[58]; equally, *Fondazione* can demonstrate how methods of archiving ultimately distort and destroy what they claim to preserve and historicize. This is also true, on a structural level, of the research medium chosen by Poledna. For example, Franco Berardi, a political fellow traveler of Toni Negri, explains in an interview with the newspaper *Jungle World* that the late 1970s, when the »classical factory conflict« approached its end, was also the beginning of an era when »the costs of communication technologies dramatically sank: video tape, radios, offset printers, photocopiers, later desktop publishing, all of that eased the access to the production of signs to an extent never before known.«[59] In other words, the dissociation from the material fact of production that resonates in the topos of the dematerialized object surfaces as a phenomenon of a techno-linguistic turn that corresponds

57 See Henner Hess, »Feltrinelli and the Gruppi di Azione Partigiana (GAP),« in Poledna, *The making of*, 161–62.
58 Buchmann/Poledna, »Blanks and Side Effects,« 230.
59 »Vom Subjekt zum Superorganismus: Ein Gespräch von Stephan Gregory mit Franco Berardi über seinen Weg
 von Operaisten zum Cybernauten, die mentale Arbeit und die virtuelle Macht,« in *Jungle World* (24, 7 June, 2000)

with the increasing importance of information and knowledge production that Lazzarato describes with the concept of »immaterial labor«—ultimately a form of labor that, as has been shown, can be applied to *The making of.*

The documents collected by the Fondazione Feltrinelli, which according to Bidussa are merely holdings of information with a purely academic value, are emblematic of a history of the labor movement and socialism that is politically no longer accessible. This is a history that has been recoded through methods of archiving. In the 1990s debates on the dominance of immaterial labor in the context of the service industry and corporate culture, there was often a clear sense that an attempt was being made to set aside post-Conceptualism and institutional critique as failures. *The making of*, produced in the wake of these discussions, pieces together and advances an impressively forceful case for the need to prolong methodological and political reflection on the functioning of cultural institutions—and, in particular, the continuation of the type of reflection that considers not only the (material) conditions of public labor but also of the (immaterial) signs produced in its name.

Translated from the German.

Maria Eichhorn, *Maria Eichhorn Public Limited Company* (2002), presentation at *Documenta11*, Kassel, detail; see 211

Elizabeth Ferrell

The Lack of Interest in Maria Eichhorn's Work

Entering Maria Eichhorn's exhibition space at *Documenta11*, visitors encountered a strikingly stark presentation.[1] A row of documents lined the facing wall at eye level. These were not original legal papers but enlarged transparencies of them mounted in three light boxes flush with the wall. Back-lit and professionally-mounted, the simulacral documents radiated the aura of institutional signage. A utilitarian bench of beech and green linoleum invited visitors to peruse the documents.

Those visitors who accepted the invitation soon realized they were inspecting the founding papers of the Maria Eichhorn Public Limited Company, the corporation which provides the piece's title. Various contracts, reports, and audits marched by in chronological order, guiding visitors through the company's formation. As the company's name asserts, the artist was the central player in this formulaic script, but the performative body one might expect of her role was abstracted and reduced to a mere barcode of identity—name, address, date of birth. The documents not only expunged the artist's persona but bracketed her creativity as well. Under the watchful eye of notaries, judges, and auditors, she dutifully followed the required bureaucratic procedures, stifling all hope of spontaneous action in this process piece.

The farther visitors progressed, the documents began to cite each other with greater frequency. Once the company had been founded, subsequent legal procedures contributed little to its development; they simply inscribed it in further levels of institutional legitimacy. Circularities abounded until the documents no longer seemed to authenticate but simply to bolster one another in a constellation of pointless paperwork. Through this slow, po-faced delegitimization, visitors possibly began to suspect that the company was an elaborate hoax. Eichhorn's self-effacing complacency came to resemble the hijacker's smooth infiltration.

Finally, visitors received proof, emblazoned in black and white, that Eichhorn's was no ordinary Public Limited Company. Rather than offer the company's 50,000 one euro shares on the public market, Eichhorn used the founding capital to immediately buy back the stocks so

I would like to thank Professor Anne Wagner, Alexander Alberro, and Maria Eichhorn for their generous guidance and assistance with this paper.

1 Platform 5 of *Documenta11* was held in Kassel, Germany from 8 June to 15 September 2002.

that the company owned itself or, in the artist's words, »belongs to no one.«[2] Eichhorn accomplished this tautology by pushing the illogic of the corporation to its absurd limit. Like all joint-stock companies, the Public Limited Company separates ownership from use value: shareholders purchase rights to a percentage of the company's profit but do not receive management rights.[3] Legally, the company is a sovereign entity, a juristic person. The corporation's independent status allows its shareholders to gain profit without risk, thus enabling the massive investment and accumulation of capital characteristic of late capitalism. Eichhorn's small modification (her re-acquisition of the stocks) drove this autonomy to a self-defeating extreme, annulling property and stagnating speculation.

Perhaps visitors only grasped the mortifying self-sufficiency of Eichhorn's Public Limited Company when they encountered the cash it employed, a neat stack of 100 five-hundred euro notes hermetically sealed in a glass and steel wall-safe. Lit with the same steady glow as the documentary sequence, the money blended seamlessly with the wall-text, asserting an uncanny equivalence between the cash and the simulacral documents that purportedly testified to the abstraction of these all too material bills into the stock market's invisible circuits of exchange. The hallucinatory disjunction between materiality and immateriality drove home the interruptive-logic of Eichhorn's gesture—its insistence on halting the invisible flow of capital and making it visible.

But this gesture was even more insistent. It not only halted the flow of capital but completely stifled it in tautological isolation. Removed from circulation, the stagnating money lost value as inflation increased.[4] Visitors surely noted the safe's resemblance to museum vitrines that simultaneously display and quarantine autonomous art objects. As the object in question was 50,000 euro notes, this teasing effect of visual access and tactile denial had a particularly taunting tone that made the absurdity of autonomous money painfully clear. The piece thus exaggerated to the point of defeat the absurd basis of stock market finance, the fiction that money is self-generating.[5] Forced to attend to the cash as they would an art object, visitors may have been struck by the peculiar nature of money as a commodity whose physical qualities are completely subordinate to its symbolic equivalency, whose use value derives solely from its exchange value.

Eichhorn's piece was by no means the only contribution to *Documenta11* that addressed economic relations.[6] Thomas Hirschhorn's *Bataille Monument* and Cildo Meireles's *Disappearing/Disappeared Element: Imminent Past* exemplified the dominant approach to this theme. With the help of local residents, Hirschhorn erected an impromptu library, television studio, exhibition, and snack bar in the Friedrich-Wöhler-Siedlung housing complex on the outskirts

2 Maria Eichhorn, »Maria Eichhorn Public Limited Company,« in *Maria Eichhorn Public Limited Company* (Munich: Verlag Silke Schreiber, 2001), unpaginated.

3 Rudolf Hilferding, *Finance Capital: A Study of the Latest Phase of Capitalist Development*, trans. Morris Watnik and Sam Gordon (London: Routledge and Kegan Paul, 1910, 1981), 114.

4 Eichhorn, »Maria Eichborn Public Limited Company,« unpaginated.

5 Fredric Jameson, »Culture and Finance Capital,« in *The Cultural Turn: Selected Writings on Postmodernism, 1983–1998* (New York/London: Verso, 1998), 151–52.

6 Themes of globalization and social action in spectacle society were repeatedly invoked by exhibition organizers as well. See especially *Democracy Unrealized: Documenta11_Platform 1*, ed. Okwui Enwezor et al. (Ostfildern-Ruit: Hatje Cantz, 2002).

Maria Eichhorn, *Maria Eichhorn Public Limited Company* (2002), presentation at *Documenta11*, Kassel

of Kassel. At the snack bar, tenants sold concessions free from overhead and taxes. This artificial black-market soon became a festive site for a community that would have otherwise benefited little from »Documenta.«[7] Meireles took a similarly community-oriented though more conceptual approach, selling popsicles of pure ice in the exhibition space and throughout the city. As a pleasurable service based on the slight-of-hand transformation of water into a commodified dessert, the piece offered an appropriately cool meditation on consumerism.[8]

Even from these preliminary sketches, the bold contrast between Hirschhorn's and Meireles's engagements with late capitalism and Eichhorn's is strikingly apparent. Both of the former artists prompt slightly perverse forms of direct exchange that promote community interaction. Eichhorn's work differs from this approach in three significant ways. First, it borrows its form from financial speculation rather than commodity exchange. Second, while the other works simulate economic activities operating on the fringe of the dominant economy, Eichhorn's work is inscribed deep within it, wallowing in its bureaucracy. Third, the casually subversive, at times festive, commerce fostered by the two pieces differs dramatically from Eichhorn's stark negation of property and exchange.

How can we account for the stringency of Eichhorn's piece? Is there a precedent for its adamant refusal of ownership and speculation? How should we view its unabashed engagement with the bureaucracy and abstractions of late capitalism, especially when most contemporary works seek to escape these conditions?

In what follows, I attempt to answer these questions by situating Eichhorn's »financial pieces« within the legacy of conceptual artists' efforts to modify the material conditions of art in the late 1960s.[9] Specifically, I read her works' stalwart refusal of ownership and speculation as enacting the anti-capitalist fantasies nascent in dealer Seth Siegelaub's 1971 contract »Artist's Reserved Rights Transfer and Sale Agreement.« As a practical translation of the idealism under-

7 Thomas Hirschhorn, »Bataille Monument,« in *Contemporary Art: From Studio to Situation*, ed. Claire Doherty (London: Black Dog, 2004), 133–47.

8 Cildo Meireles, »Disapearing/Disappeared Element: Imminent Past,« in *Documenta11_Platform 5: Exhibition Catalogue* (Ostfildern-Ruit: Hatje Cantz, 2002), 576.

girding conceptual practices, Siegelaub's contract is often touted as a prime example of either Conceptual art's failure to achieve its critically-declared revolutionary goals or, worse, its complete collapse of art and capitalism. Eichhorn makes this controversy the heart of her »financial works.« She recuperates the contract's innate criticality by intensifying its strategies and applying them directly to the financial forms characteristic of late capitalism. In doing so, she asserts that the lessons of Conceptual art lie in its supposed failure: that its critical potential rests in its fitful attempts to renegotiate the material conditions of art by directly engaging the structures that govern them. Her practice thus challenges critics who champion recent project works as correctives to Conceptual art.

We can begin to account for the stringency of Eichhorn's practice if we read her work through the critical reassessment of Conceptual art that began in the late 1980s when she was studying at the Hochschule der Künste in Berlin. The second reception of Conceptual art was highly influential to artists of Eichhorn's generation, that cohort born in the early 1960s, who rose to prominence in the subsequent decade. Of particular interest here is the new relationship critics drew between conceptual practices and late capitalism. The art historian Benjamin Buchloh provided the most influential articulation of this relationship in his 1989 catalogue entry for *L'art conceptuel: Une perspective* at the Musée d'Art Moderne in Paris.[10]

In his essay, Buchloh charted Conceptual art's capitulation to capitalism. According to Buchloh, Conceptualism reduced art to its »legal organization and institutional validation« by severing its last ties to the material, visual, and aesthetic.[11] Conceptual works and the intellectual labor that produced them thus mirrored the post-industrial economy of the 1960s with its valorization of bureaucracy, spectacle, and advertising. Conceptual art played a pivotal role in Buchloh's Adornian account of modernism as it eroded the last delicate barrier protecting autonomous artistic experience from the rationalizations of capitalism.[12]

Buchloh's grim account was a pessimistic version of critic and curator Lucy Lippard's earlier tale of Conceptual art's failed radicalism. Lippard was deeply involved in the artists' rights movement of the late 1960s, and she attributed similarly radical aspirations to the »dematerialization« of the art object.[13] She presented non-object art as a revolutionary attempt to elude the

9 I use the term »financial pieces« to describe Eichhorn's works that directly address the economy. Works that fall under this category include, *Purchase of the Plot at Corner Tibusstraße/Breul, Province Münster, Hall 5, No. 672* (1997), *Sale/Purchase of Objects from Haus Lange and Haus Esters* (1997), *Joint Account No. 1711601, Bank of Fukuoka, Yahata Branch 411* (2001), *Money at the Kunsthalle Bern* (2001), and *Maria Eichhorn Public Limited Company* (2002). This paper focuses on her Münster and *Documenta* pieces. For a more comprehensive account of Eichhorn's diverse practice see Carolyn Christov-Bakargiev, »Notes on Some Works by Maria Eichhorn,« in *Afterall*, no. 1 (1999): 29–45.

10 This landmark exhibition was the first attempt by a major institution to present a comprehensive history of Conceptual art. Benjamin H. D. Buchloh, »From the Aesthetic of Administration to Institutional Critique,« in *L'art conceptuel: Une perspective* (Paris: Musée d'Art Moderne de la Ville de Paris, 1989), 41–53. Later published as »Conceptual Art 1962–1969: From the Aesthetic of Administration to the Critique of Institutions,« in *October* 55 (Winter 1990): 105–43.

11 Ibid., »Conceptual Art 1962–1969«: 119.

12 Ibid., 142–43.

13 See Lucy Lippard and John Chandler, »The Dematerialization of Art,« in *Art International*, vol. 12 (February 1968): 31–36; Lucy Lippard, »557,000,« reprinted in *Conceptual Art: A Critical Anthology*, ed. Alexander Alberro and Blake Stimson (Cambridge, MA/London: MIT Press, 1999), 178–85; and »Escape Attempts,« in *Six Years: The dematerialization of the art object from 1966 to 1972* (Berkeley, CA: Univ. of California Press, 1973), vii–xxii. The essay »Escape Attempts« was added to the 1997 reprint.

market and elitist institutions, both of which supported »the greedy sector that owned everything that was exploiting the world and promoting the Vietnam war.«[14] But in less than a decade, Lippard declared that the radical potential of Conceptual art, like the politics that fostered it, was already foreclosed. She announced this postmortem in her 1973 anthology:

> Hopes that »conceptual art« would be able to avoid the general commercialization ... were for the most part unfounded. It seemed in 1969 ... that no one, not even a public greedy for novelty, would actually pay money, or much of it, for a Xerox sheet referring to an event past or never directly perceived, [etc.] ... Three years later, the major conceptualists are selling work for substantial sums here and in Europe. ... Clearly, whatever minor revolutions in communication have been achieved by the process of dematerializing the object ..., art and artist in a capitalist society remain luxuries.[15]

Buchloh's revisionist history is more insidious than Lippard's front-line report. It is more cynical—offering a narrative not of botched resistance but of outright collusion. Buchloh reassesses the movement in part to account for the conservative turn of the 1980s.[16] From this later perspective, he does not think Conceptual art's revolutionary project failed; he simply doubts it ever existed.[17] Overtly countering the utopianism he associates with Lippard, he writes: »It seems obvious, at least from the vantage of the early 1990s, that from its inception Conceptual art was distinguished by its acute sense of discursive and institutional limitations, its self-imposed restrictions, its lack of totalizing vision, its critical devotion to the factual conditions of artistic production and reception without aspiring to overcome the facticity of these conditions.«[18] Wryly complacent about institutions, Buchloh's conceptual artists were driven to dematerialize art by modernism's auto-critique rather than radical politics.

Viewing Eichhorn's *Documenta* piece in light of this critical reappraisal, its excessive engagement with the bureaucratic structures of late capitalism is an almost parodic performance of Buchloh's »aesthetics of administration.«[19] Did Eichhorn intend the piece to evoke the contentious history of Conceptual art? Why would she exaggerate the most maligned aspect of it? What does her effusive enactment of art's merger with the economy say about earlier conceptual practices and the revisionist history of them? Prior to creating her Public Limited Company, Eichhorn conducted a research project on arguably the most concrete manifestation of Conceptual art's collusion with capitalism, Seth Siegelaub's »Artist's Reserved Rights Transfer and Sale Agreement.« Her interest in and knowledge of the material conditions of Conceptual art indicate that there *is* a connection between the controversy surrounding them and her »financial pieces.« A closer look at her research will help clarify the nature of this connection.

14 Lippard, »Escape Attempts,« xiv.

15 Lippard, *Six Years*, 263.

16 Buchloh, »*Conceptual Art 1962–1969*«: 105–107.

17 Significantly, Siegelaub accused Buchloh's account of being both depoliticizing and dehistoricizing. See his response to Buchloh's essay »Addendum,« in *L'art conceptuel: Une perspective* (Paris: Musée d'Art Moderne de la Ville de Paris, 1989), 257–58.

18 Buchloh, »*Conceptual Art 1962–1969*«: 141.

19 Buchloh's term.

Eichhorn first contacted Siegelaub in 1996 to propose their collaboration on a book exploring the social and historical implications of his »Agreement.« The former art dealer agreed, and since then, Eichhorn has been involved in research, manuscript preparation, and other projects sparked by the book.[20] Although historical in content, the project is forward-looking. Eichhorn believes that the lessons gleaned from the controversial »Agreement« will be beneficial to contemporary practice. Her goal is to use »the 'artist's contract' as a starting point for questioning possible ways to deal with the sale, purchase and resale of works today.«[21]

Siegelaub was a primary catalyst of New York's Conceptual art scene.[22] His representation of leading figures such as Carl Andre, Robert Barry, Douglas Huebler, and Lawrence Weiner exceeded dealers' normal involvement. With a disconcerting mix of entrepreneurial zeal and Marxist idealism, he delighted in the challenges of presenting and promoting non-object works in the conservative art world. The »Agreement« was one manifestation of this fraught negotiation. Drafted in 1971 with lawyer Bob Projansky, the »Agreement« thwarted owners' exclusive control over works by guaranteeing artists a number of continued rights, including consultation over rentals and reproductions and notification upon transfer of ownership. It also stipulated that artists receive fifteen percent of resale profits. Siegelaub's celebrity and marketing savvy ensured that the »Agreement« was widely distributed internationally.[23]

Siegelaub framed the contract as a practical translation of the anti-capitalist idealism he associated with the artists' rights movement and conceptual practices. When he wrote the contract, the Art Worker's Coalition (AWC) was the focal point for artists' rights activism.[24] Its roster included Lippard, Siegelaub, and many of the conceptual artists the latter represented. The »Agreement« addressed two major issues of the AWC, extending artists' power over their works and curbing art speculation. In the article accompanying the contract's publication in *Studio International*, Siegelaub carefully frames it as a response to these concerns: »The Agreement has been designed to remedy some generally acknowledged inequities in the art world, particularly artists' lack of control over the use of their work and participation in its economies after they no longer own it.«[25]

20 Eichhorn considers her research on the contract integral to her artistic practice. One example of this imbrication was the exhibition she produced at the Salzburger Kunstverein in 1998 titled, »'The Artist's Reserved Rights Transfer and Sale Agreement' by Bob Projansky and Seth Siegelaub.« The show consisted of materials for the book including artists' interviews, Siegelaub's archive, and a publication with the same title as the exhibition. Over and above that, the exhibition gave a current overview of the Resale Royalty Right in European and international copyright laws, and a videotape of the lecture Siegelaub presented at the beginning of the exhibition. Besides the lecture, very little mediating explanation accompanied the documents, which were displayed on long utilitarian tables. The presentation anticipated the perfunctory aesthetic of Eichhorn's *Documenta* piece.

21 Maria Eichhorn, »Talk: Maria Eichhorn,« in *Let's Talk About Art #0002* (Kitakyushu: Center for Contemporary Art, 2002), 9.

22 For more on this controversial figure see Alexander Alberro, *Conceptual Art and the Politics of Publicity* (Cambridge, MA/London: MIT Press, 2003).

23 Copies and guidelines for use were distributed at *Documenta 5* and published in *Studio International*, vol. 151 (April 1971): 142–44.

24 The coalition formed in 1969 from the controversy that erupted when the Greek sculptor Vassilakis Takis physically removed his sculpture from The Museum of Modern Art's exhibition *The Machine as Seen at the End of the Mechanical Age*. For details see Alberro, *Conceptual Art*, 125–28.

25 Seth Siegelaub, »The Artist's Reserved Rights Transfer and Sale Agreement,« in *Studio International*, vol. 151 (April 1971): 142.

The AWC's antiestablishment fervor echoed the battle cries of May 1968 and protests against the Vietnam War, but it also reflected discontent over the recent commercialization of the New York art world.[26] The 1960s saw the expansion of both the art market and the city's gallery system. In the estimation of AWC members, these reified structures now exercised total control over their works.[27] They saw the reinforcing network of gallery promotions, art press advertisements, and collections as completely determining the price and status of their works with little regard for the works themselves. Within the system, the use value of the artwork (its individual material qualities and aesthetic merit) became insignificant and disassociated from its all-important exchange value. This perceived fate of the artwork is essentially that of all commodities under late capitalism where goods are no longer produced to fulfill human needs but simply to fuel the accumulation of capital in the form of money, pure exchange value.[28] At AWC meetings, members repeatedly named art investing as the exemplary abuse.[29] Speculation was a perfect target since its separation of artists from financial benefits and disregard of use value overtly reduced art to its exchange value.

Like Lippard and many of the artists Siegelaub represented, he believed similar concerns motivated the formal innovations of Conceptual art. He promoted works that resisted being reduced to late capitalistic commodities. Whether process- or language-oriented, these non-object practices counteracted the abstracting force of the art system by undermining exchange and emphasizing use.[30] In doing so, they separated purchase from the exclusive right to use, the relationship that characterizes ownership under capitalism.[31] Siegelaub presented the contract's guarantee of artists' continued control over their works as complimenting this affront to private property. He explained this relationship in a 1973 statement: »The economic aspect of Conceptual art is perhaps the most interesting. From the moment when ownership of the work did not give its owner the great advantage of control of the work acquired, this art was implicated in turning back on the question of the value of its private appropriation. How can a collector possess an idea?«[32] Despite Siegelaub's strategic promotion, the contract failed to gain momentum in the art world and is used by only a few artists today.[33]

26 For more on the art market's development in the 1960s see Alberro, *Conceptual Art*, 6–10.

27 Analysis of the AWC adapted from Andrea Fraser, »What's Intangible, Transitory, Mediating, Participatory, and Rendered in the Public Sphere? Part II,« in *Museum Highlights*, ed. Alexander Alberro (Cambridge, MA/London: MIT Press, 2005), 55–80.

28 Jameson, »Culture and Finance Capital.«

29 Fraser, »What's Intangible,« 56–61.

30 This summary grossly simplifies the diverse practices Siegelaub represented. Robert Barry's »sculptures« involving the release of invisible gases and Lawrence Weiner's »word paintings« respectively exemplify each category.

31 »Property,« in: *Palgrave's Dictionary of Political Economy*, vol. 3, ed. Henry Higgs (New York: Augustus M. Kelley, Bookseller, 1963), 229–33.

32 Quoted in Alberro, *Conceptual Art*, from Michael Claura and Seth Siegelaub, »L'art conceptual,« in *XXe siècle* 41 (December 1973); reprinted in *Conceptual Art: A Critical Anthology*, ed. Alexander Alberro and Blake Stimson (Cambridge, MA/London: MIT Press, 1999), 289.

33 Hans Haacke uses Siegelaub's »Agreement.« Reasons for the contract's failure remain murky. Alberro notes that many dealers were afraid the fifteen-percent clause would scare-off collectors. Alberro, *Conceptual Art*, 168. The interviews Eichhorn conducted about the contract indicate that some artists thought it was too conciliatory with the existing system. Though revealing, these later interviews do not necessarily provide a reliable account of artists' initial opinions of the contract though many stress that their opinions have not changed since 1971.

Revisionist historians gave little credence to Siegelaub's efforts to frame his »Agreement« within the radical ferment surrounding Conceptual art. In their account, the contract was the poster-child for the »aesthetics of administration.« They read its blatant inscription of conceptual works into the market's bureaucracy as evidence of capitalistic affinities latent in the works themselves. Art historian Alexander Alberro encapsulated this assessment in his comprehensive 2003 study of Conceptual art's economic implications:

> Although the Agreement, drafted to help destabilize the calcified art industry, may have been politically progressive in intention, it had the opposite effect, leading Conceptual art into what Lippard condemns as »the tyranny of a commodity status and market-orientation.« For the Agreement's precise limitations served to confine even work that existed only as abstract idea or, alternately, only as widely dispersed documentation within its capital relations, and thus inserted Conceptual art into the art market as a pure commodity or bill of sale.[34]

Eichhorn's research refuses the black-and-white finality of this judgment. By taking Conceptual art's integration with capitalism as an object of investigation rather than condemnation, she suggests that there is something useful in this supposed failure. In particular, the interviews she conducted with artists (who either use the »Agreement« or similar contracts) tell a more subtle story; a story in which the tensions the contract provokes cannot be dismissed as simply evidence of collusion because they illuminate important issues pertaining to the material conditions of art under late capitalism.[35] This heuristic purpose is not immediately apparent in the interviews. Many artists object to the »Agreement« in ways that reiterate the revisionist judgment of it. They complain that the contract substitutes artworks with their legal validation and that the fifteen-percent resale commission makes artists complicit in speculation. In general, the artists agree that not only the contract but their generation, in general, failed to modify the art market's capitalistic structures.

However, a crucial ambivalence pervades their pessimism. Artist after artist contradicts himself, unable to decide whether the »Agreement« failed because it was too opposed to the system or, by contrast, not radical enough. As artist Daniel Buren waffles, »… the contract looks pretty good. But, in fact, as soon as you start to think about it, it's just idealistic. … And then it's not going far enough.«[36] This vital ambiguity is at the heart of the »Agreement«—the inevitable result of its attempt to subvert capitalist logic from within. This conflicted purpose is what makes the contract, like all good weapons, simultaneously volatile and useful. Several artists articulate the lean hope that the contract and conceptual practices left a legacy of contesting property relations. As Siegelaub muses in a 1996 interview with Eichhorn and critic Ute Meta Bauer:

34 Alberro, *Conceptual Art*, 169.

35 She conducted fifteen interviews total. My analysis is based on those interviews available to me—Carl Andre, Daniel Buren, Jenny Holzer, Adrian Piper, Seth Siegelaub, and Lawrence Weiner. I thank Maria Eichhorn for graciously providing them.

36 Maria Eichhorn, »Interview with Daniel Buren, 1997,« in *Public Art: A Reader*, ed. Florian Matzner (Ostfildern-Ruit: Hatje Cantz, 2004), 427.

37 Maria Eichhorn and Ute Meta Bauer, »Interview with Seth Siegelaub,« in *Art Gallery Exhibiting—The Gallery as a Vehicle for Art*, ed. Paul Andriesse (Amsterdam: Uitgeverij De Balie, 1996), 212.

No matter how hard you try to do away with the values of capitalist society—property and ownership, the eternal object, etc. —you cannot overcome the system. Maybe you can play with it for a while, working with its contradictions. ... Most of these revolutionary »conceptual« projects have been absorbed by the system, but not entirely, far less so than paintings. Some of these works cannot be co-opted, digested, or made into property values or nice art history.[37]

Thus, Eichhorn's research suggests that by directly engaging capitalist logic, Conceptual art did not fail, but rather, mapped the terrain between art and the economy, marking the fissures and fault-lines that indicate the pressures bearing on art production under late capitalism. Her »financial works« aggravate these sensitive points. I do not wish to assert that Eichhorn's research was the direct inspiration for her »financial works« or that this connection fully accounts for these complex pieces. However, I do believe that her political goals and concern for artists' rights resonate with those of first generation conceptual artists. Her research on the »Agreement« is evidence of this sympathy.

In *Maria Eichhorn Public Limited Company*, she drew on the dubious lessons of Siegelaub's contract to undermine the system from within. The Public Limited Company manifested the contract's innate radicalism by applying its stipulations directly to financial structures. The piece did not renegotiate private ownership but abolished property. It did not curb speculation but completely stymied the circulation of capital. Eichhorn's incorporation of her name in the title drew attention to the artist's agency, indicating that an important aspect of the work was the artist's ability to control (to the point of deformation) a specific structure of ownership. She thus transferred the central goal of the »Agreement« to the Public Limited Company. For Eichhorn, the public forums (the commercial register, newspaper, etc.) that ensconced the company composed an essential aspect of the work's presentation.[38] Her concern with publicity recalled conceptual artists' desire for the democratic distribution of their works though it lacked the sexiness of their media optimism.[39] While the piece performed the contract's anti-capitalist dream, it did not present a utopian illusion. The numbing bureaucratic nature of the process, the documents, and their punctilious presentation made clear the cost of this subversion.

It was exactly this cost that most artists and critics of 1990s project art sought to avoid. The jaded second reception of Conceptual art influenced the critical appraisal of newly emerging project works such as Eichhorn's. Many critics explained the resurgence in non-object practices as a return to the material conditions initiated by Conceptual art; however, they also presented these practices as correctives to its disastrous approach. This oedipal relationship figures prominently in the writings of critic Nicolas Bourriaud. In his highly influential books *Relational Aesthetics* (1998) and *Postproduction* (2000), Bourriaud connects project works to »the tertiary sector, as opposed to the industrial or agricultural sector, i.e., the production of raw materials.«[40]

38 Maria Eichhorn, »Maria Eichhorn Public Limited Company,« unpaginated.

39 The piece affirmed the belief in rationality and publicity that much conceptual and institutional critique art promoted (Frazer Ward, »The Haunted Museum: Institutional Critique and Publicity,« in *October* 73 [Summer 1995]: 71–89). Her use of bureaucratic forums, in particular, supported the relationship Ward draws between the bourgeois public sphere and the institution of art.

40 Nicolas Bourriaud, *Postproduction: Culture as Screenplay: How Art Reprograms the World* (New York: Lukas and Sternberg, 2000), 7.

Like Buchloh and many others, he attributes Conceptual art with the shift away from the object-oriented or »industrial« production characteristic of early 1960s art.[41] Bourriaud undercuts this familiar legacy, however, by asserting that contemporary works emulate the tertiary sector in a way that achieves the resistant ends conceptual works never reached.

Specifically, he proposes that these interactive pieces »rematerialize« the art of immediate experience innate in Conceptual art's dematerialization. That is, they »contract« viewers to perform »models of sociability« without resorting to actual contracts, à la Siegelaub.[42] The works foster casual, direct encounters that, unlike Conceptual art's reified relations, resist alienating spectacle culture: »When entire sections of our existence spiral into abstraction as a result of economic globalization ... it seems highly logical that artists might seek to *rematerialize* these functions and processes. ... Not as objects, which would be to fall into the trap of reification, but as mediums of experience: by striving to shatter the logic of the spectacle, art restores the world to us as an experience to be lived.«[43]

Using props to prompt tasks and interactions, the works make »the forms and cultural objects of our daily lives *function*,« »scrambling ... boundaries between consumption and production« as »meaning is born of collaboration and negotiation between the artist and the one who comes to view the work.«[44] By restoring utility to empty commodities and melding production and consumption into pure experience, project artists, Bourriaud contends, create the art of pure use value that conceptual artists failed to produce.

A central contradiction pervades Bourriaud's characterization of project art's relationship to the larger economic sector. He mobilizes two opposing descriptions of late capitalism: one resembles finance capital while the other approaches the fantasy of post-industrial society theorized by sociologist Daniel Bell.[45] In *The Coming of the Post-Industrial Society, A Venture in Social Forecasting* (1976), Bell predicted that the growing service sector would soon overthrow the alienated relations of industrial manufacturing and commodity culture.[46] Services, in his estimation, fostered direct human contact and resisted capital accumulation by combining production and consumption. Bourriaud offers a strikingly similar account of the tertiary sector to describe project works. Of course, as the inconsistencies in Bourriaud's writings admit, Bell's utopian version of the service economy never came to pass.[47]

41 Ibid., 39 and Nicolas Bourriaud, *Relational Aesthetics*, trans. Simon Pleasance and Fronza Woods (Paris: Les Presses du Réel, 1998), 29.

42 Bourriaud, *Relational Aesthetics*, 25.

43 Bourriaud, *Postproduction*, 26.

44 Ibid., 14.

45 I am using »finance capital« here like Hilferding; the term also fits Jameson's definition of late capitalism.

46 Daniel Bell, *The Coming of the Post-Industrial Society, A Venture in Social Forecasting* (New York: Basic Books, 1976). This description of Bell's theories relies on Jean-Claude Delaunay and Jean Gadrey, *Services in Economic Thought: Three Centuries of Debate* (Boston/Dordrecht/London: Kluwer Academic Publishers, 1992), 86–87.

47 By the late 1970s, economic theorists had already countered Bell with evidence that the service sector was not growing to benefit the public, but rather, to meet the demands of a new stage of capitalism characterized by globalized production, marketing, and finance (ibid., 95–101).

48 For example, art historian Miwon Kwon notes that many critics celebrated community-based art in the 1990s for enacting a communist model of collective labor. She disparages this assessment for relying on the »idealistic assumption that artistic labor is itself a special form of unalienated labor, or at least provisionally outside of capitalism's forces.« Miwon Kwon,

The confusion in Bourriaud's account is typical of critical assessments that extol 1990s interactive practices for fulfilling Conceptual art's anti-capitalist aims.[48] Critics present the works as reflecting the economy so that the works appear to be in critical dialogue with it. To draw this connection, however, they must conjure imaginary versions of it. Their resort to phantom economies indicates that these practices do not engage the real conditions of late capitalism but, rather, pose alternatives and offer escapes.[49] Many of the practices not only shy away from direct critical engagement, but verge on mystification.

Works fitting Bourriaud's rubric dominated *Sculpture. Projects in Münster 1997*, the exhibition for which Eichhorn created one of her first »financial pieces.«[50] The critic Walter Grasskamp remarked in the catalogue that »works offering a service [were] numerous.«[51] These works fostered a »festival« atmosphere, which Grasskamp interpreted as »an attitude of« playful »irony« and gentle »skepticism« »toward the campaign.«[52] While similarly service-oriented, Eichhorn's contribution contradicted these whimsical works in both tone and critical-edge. At the time she was deeply engaged in researching the »Agreement«. Her project applies the principles of Siegelaub's contract to real-estate, that exemplary form of property and fodder for speculation.[53] Like her later *Documenta* piece, it illustrated her recuperation of the »aesthetics of administration« for critical ends.[54]

The piece consisted of the bureaucratic steps required to obtain a plot of land—from selection, to purchase, to entry in the land-registry. Its descriptive title, *Erwerb des Grundstückes Ecke Tibusstraße/Breul, Gemarkung Münster, Flur 5, No. 672* (Purchase of the Plot at Corner Tibusstrasse/Breul, Province Münster, Hall 5, No. 672; 1997), indicated this focus on process and dryly stated as it is designated in the land register. Purchase funds included the project budget and a contribution from the Landesmuseum, the institution sponsoring the exhibition. As with her Public Limited Company, the work's presentation was dispersed throughout the city: the plot of land that marked her physical contribution could only be understood in light of doc-

One Place After Another: Site-Specific Art and Locational Identity (Cambridge, MA/London: MIT Press, 2002), 96–97. Like Bourriaud, contemporary artist Andrea Fraser characterizes project works as a form of service. Although she relies on a similarly fictional version of the tertiary sector, her account is more subtle than Bourriaud's. She sees 1990s »service art« as an extension of the material conditions prompted by Conceptual art, but her tale is one of legacy rather than oedipal triumph (Fraser, »What's Intangible«).

49 Despite his attempts to connect »relational« project works with the tertiary sector, Bourriaud acknowledges and defends their tendency for escapism. In *Relational Aesthetics*, he contrasts these works to directly critical, »propagandist art«: »They are aimed at the formal space-time constructs that do not *represent* alienation, which do not *extend* the division of labour into forms. The exhibition is an interstice, defined in relation to the alienation reigning everywhere else« (82–83).

50 *Sculpture. Projects in Münster 1997* was held from 22 June to 28 September.

51 Walter Grasskamp, »Art and the City,« in *Sculpture. Projects in Münster 1997*, ed. Klaus Bußmann, Kasper König, and Florian Matzner (Ostfildern-Ruit: Verlag Gerd Hatje, 1997), 37.

52 Ibid., 39. Two examples he provides are Tobias Rehberger's rejected proposal, *Open Pool and Mobile Bar*, to transform Donald Judd's *Untitled* (1977) sculpture into a temporary bar and Rirkrit Tiravanija's proposal, *Untitled, 1997 (The Zoo Society)*, to direct an amateur puppetry society in the Zoological Gardens.

53 Description of *Acquisition of a Plot...* adapted from Maria Eichhorn, »Maria Eichhorn,« in Bußmann, König, Matzner, *Sculpture: Projects in Münster 1997*, 131–41.

54 It may seem that I am simply placing Eichhorn within the legacy of institutional critique that Buchloh charts. In his account, Conceptual art's fall from the aesthetic is redeemed by institutional critique artists who redirect investigation from the art object to its frame. My argument is different because I assert that Eichhorn recovers criticality by exaggerating the financial practices associated with Conceptual art that Buchloh would judge irredeemable.

uments displayed at the land-register and Landesmuseum.[55] Eichhorn appropriately sold the property after the temporary exhibition.

Of course, Eichhorn did not simply replicate a standard real-estate transaction, collect the profit, and go on her merry way. Similar to her Public Limited Company, she manipulated the form to divert the normal process and yield subversive results. She stipulated in the mortgage agreement that the entire resale value would go to a local tenant's association, *Verein zum Erhalt preiswerten Wohnraums e.V.* (Association for the Preservation of Affordable Housing), rather than the joint-owners, the Landesmuseum and herself. The Association formed in 1989 to protest the demolition and replacement with luxury condominiums of houses at Breul 31–38 and Tibusstraße 30a–c—precisely the terrain to which Eichhorn returned.[56] This development scheme was symptomatic of real-estate trends in the inner city where property remains scarce. Rising property values were driving many long-term residents to the less expensive outskirts in the typical pattern of gentrification. The Association successfully thwarted the development by rallying public support. Today, the city owns the building and the Association acts as its tenant and administrator.

It is difficult not to see Eichhorn's advance designation of resale value as an adaptation of Siegelaub's fifteen-percent clause to the real-estate market. Like the »Agreement«, her stipulation commandeered bureaucratic processes to emphasize use, frustrate speculation, and defy the definition of ownership as the exclusive right to profit. Eichhorn's contract amplified the »Agreement's« radical potential. Unlike Siegelaub's fifteen percent of any reasale profit to the artist, it avoided any trace of collusion with investing: by channeling one hundred percent of the plot's worth to tenants, it fed the money directly into the property's use and thus foreclosed its further abstraction in speculation.

55 The majority of sculptures were scattered throughout the inner city and the park-like Promenade that surrounds it. The corner of Breul and Tibusstraße is directly across from the Promenade, well within the exhibition route.

56 Description of the Association from Eichhorn, »Maria Eichhorn,« in Bußmann, König, Matzner, *Sculpture: Projects in Münster 1997*, 133. The Association used the substantial resale earnings for renovations.

Maria Eichhorn, *Purchase of the Plot at
Corner Tibusstrasse/Breul, Province Münster,
Hall 5, No. 672* (1997); see 211

Eichhorn's action also redressed one of capitalism's most blatant illogicalities—the separation of use from ownership in the tenant-landlord relationship.[57] This division makes »housing a private investment in capitalist society,« a situation that generates many abuses by exacerbating »the disparity between the requirements of the housing market and the social needs of the citizens.«[58] Eichhorn closed this disparity by harnessing the market to meet the tenants' needs. The Association was the perfect centerpiece for Eichhorn's project because its plight exemplified the inequities in the social relations of property and its communal ownership modeled a solution to these inequities that resonated with the socialist subtext of Siegelaub's contract.

Like the dry display of her Public Limited Company, Eichhorn's presentation at Münster played with materiality and immateriality, riffing on the conceptualist legacy to expose the institution of art's ongoing imbrication with late capitalism's most fundamental aspects. Displaying an empty lot is similar to displaying a vitrine of cash: both materialize capital in a way that undercuts our expectations of its use value both as art and commodity. Approached in the wake of a visit to Dan Graham's glass *Fun House für Münster* or Franz West's *Autostat* (an amorphous mass of bubblegum-pink sheet metal), Eichhorn's »sculpture« may have struck visitors as visually unspectacular if they noticed its »presence« at all.[59] By reducing site-specific sculpture to its site alone, she drew visitors' attention to the normally overlooked land that anchors all public sculpture.[60] This was not any swatch of land, but a plot—a section of the earth's surface delineated

57 In both her *Documenta* and Münster pieces, Eichhorn uses financial structures that separate use from ownership. This separation already destabilizes the normal capitalist conception of ownership, but to ends that, unlike Siegelaub's contract, further the inequitable distribution of capital. Nevertheless, this instability makes the structures prime targets for Eichhorn's manipulation.

58 Rosalyn Deutsche, »Property Values,« in *Evictions: Art and Spatial Politics* (Cambridge, MA/London: MIT Press, 1996), 178. Deutsche is discussing Hans Haacke's *Shapolsky et al. Manhattan Real Estate Holdings, A Real-Time Social System as of 1 May 1971* (1971).

59 Graham's and West's sculptures were located in the Promenade across the street from Eichhorn's plot. The physical subtlety of Eichhorn's intervention recalls Michael Asher's thrice repeated *Installation Münster* for which he moved a caravan to various locations in the city.

60 The 1987 Münster exhibition is a landmark for »site-specific« sculpture (Grasskamp, »Art and the City,« 25–31). During this show, the plot at Breul and Tibusstraße was the site of Richard Deacon's monumental sculpture *Like a Snail (A)*.

by the land-register for possession.[61] As with Gordon Matta-Clark's *Reality Properties: Fake Estates* (1973–74), the vacant lot (stripped of its use as either a dwelling or a foundation for sculpture) disrupted viewers' expectations to expose the normally obscured financial forces that commodify land while conveying the illogical disjunction of these forces from use.[62]

By creating a public sculpture through the machinations of private property, Eichhorn foregrounded the by now widely-known fact that ostensibly community-oriented exhibitions like Münster's also serve elite economic interests.[63] The empty plot dumbly materialized the project funds, calling attention to the exhibition's material conditions. Her casting of the sponsoring institution in the role of real-estate speculator hinted that those conditions are deeply enmeshed in late capitalism.

The piece in fact drew considerable attention to Münster's impacted real-estate market and the demographic shifts it spurred. Because the city owned the plot, its sale required the approval of the municipal real-estate department. The mayor supported the transaction, but the department balked at the idea of transforming the controversial site into an art piece. The debate moved into the city council where many members were also reluctant to draw attention to the area's dubious history especially since the issues were still highly pertinent.[64] The final vote divided the council along ideological lines, the larger liberal contingent winning by a slim margin.[65]

The controversy surrounding Eichhorn's piece attested to its political potency. It also evidenced the political and economic interests undergirding the exhibition that the piece merely implied. Most likely, the final vote did not merely reflect the council's solid liberal conscious but its recognition that both the exhibition and sculptures it leaves behind bolster the city's property values.[66] Eichhorn's transitory »sculpture« drew attention to this conflicted nexus of community and private, economic and artistic interests without contributing to it. It avoided the inadvertent violence of much public sculpture by refusing to physically impose on the surrounding community, foregoing aesthetics to benefit local inhabitants financially.

Both pieces discussed here counter utopian visions of not only the art world but late capitalism. They demonstrate that capitalism is material, locally grounded, and fraught with conflicts and negotiations. This account contradicts the neo-liberal championing of the contemporary market as invisible, global, and frictionless. While her works avoid easy answers, they are by no means defeatist. She dispels both the idealism and pessimism that cloud the history of Conceptual art to breathe new life into its political goals. Over thirty years ago Siegelaub asked, »How can a collector possess an idea?«[67] Critics were quick to answer his rhetorical question. Eichhorn impertinently asks this question again to illuminate the effects of late capitalism on art produc-

61 Eichhorn, *Münster*, 132–33.
62 Jeffrey Kastner et al., eds., *Odd Lots: Revisiting Gordon Matta-Clark's Fake Estates* (New York: Cabinet Books, 2005).
63 Deutsche, *Evictions* and Kwon, *One Place After Another*.
64 Information and papers pertaining to the proceedings obtained from the artist.
65 The final breakdown of votes was: 6 »yes« (from the Social-Democratic, Leftist, and Green parties) to 4 »no« (from the Conservative party).
66 Maria Eichhorn, »Maria Eichhorn Public Limited Company,« unpaginated.
67 Quoted in Alberro, *Conceptual Art*, 1.
68 Maria Eichhorn, »Maria Eichhorn Public Limited Company,« unpaginated.

tion today: »When a work is freed from the idea of ownership in both material and non-material respects, it can neither be possessed nor sold; the mechanisms of circulation have no way to exploit it, have no effect. How is such a work created?«[68]

Through her art, she tellingly searches for a response.

Maria Eichhorn Aktiengesellschaft (2002)
Maria Eichhorn Public Limited Company (2002)
Documenta11, Kassel

Media, materials, events: Notarized incorporation and inaugural meeting of the supervisory board. Public limited company. Memorandum of association. Articles of association. Minutes of the first meeting of the supervisory board. Founder's report on the formation of the company. Report of the members of the managing board and the supervisory board on the company forma-tion audit. Report on the formation audit. Company's application for entry in the commercial register. Commercial register card. Public announcement of the company's registration. Contract concerning the transfer of all shares to the company. 50,000 euros in 500 euro bills. Bank safe deposit box. Safe. Bench. Lectern. Publication *Maria Eichhorn Aktiengesellschaft/Maria Eichhorn Public Limited Company.* Text »Maria Eichhorn Public Limited Company. Public limited company. Development, function, structure, and meaning of the public limited company. Raising capital, mobility of capital. Stock market. The responsibility of the combine. Sale, speculation. Law. The obligation to publish, codetermination. Self-determination. The question of the concept of value. The concept of value. Money, commodity. Increasing capital by destroying (liquidating) capital. The accumulation (increase, growth) of value and the reduction (loss) of value. The public nature or accessibility of a work. The saleable vs. the non-saleable, the relations of ownership of the work, copyright. The ownership of knowledge. The conditions of artistic theory and practice, eliminating those conditions.« Corporate tax declarations. Annual accounts and reports of the managing board. Progress reports. Supervisory board meetings. Etc.

Places, institutions: Klaus Mock Notary Office, Berlin. Mittelweg 50, 12053 Berlin (main office of Maria Eichhorn Aktiengesellschaft). Charlottenburg district court trade register, Berlin. Chamber of Industry and Commerce. Documenta GmbH, Kassel. Tax Office for Corporations III, Berlin.

Erwerb des Grundstückes Ecke Tibusstraße/Breul, Gemarkung Münster, Flur 5, Nr. 672 (1997)
Purchase of the Plot at Corner Tibusstrasse/Breul, Province Münster, Hall 5, No. 672 (1997)
Sculpture. Projects in Münster 1997

Media, materials, events: Property corner of Tibusstrasse/Breul, Province Münster, Hall 5, No. 672. Text »What is the origin of a city? Land register and cadastre. To whom does the city belong? How public is public space? How private is private property? The city of Münster. Purchase of land (acquisition of land). Which piece of land? Location/position. Change of ownership/change of property. Real value/symbolic value«. Purchase and sale of plot at corner Tibusstraße/Breul, Province Münster, Hall 5, No. 672. Notarial registration of the real agreement. Signing of the bill of sale. Bills of sale. Entry of the changes in the land register. Extract from the land register. Cadastral map. Documentation of the property purchase. Documentation of the work of the »Verein zur Erhaltung preiswerten Wohnraums e.V.,« Münster. Publications, city maps, photographs. Resurveying of the property. Transfer of the proceeds from the property sale to the building renovation budget of the »Verein zur Erhaltung preiswerten Wohnraums e.V.« Etc.

Places, institutions: Land registry, Münster district court. Westfälisches Landesmuseum. Landschaftsverband Westfalen-Lippe. Plot at corner Tibusstrasse/Breul, Province Münster, Hall 5, No. 672. Verein zur Erhaltung preiswerten Wohnraums e.V., Münster. Real Estate Office (Liegenschaftsamt) of the City of Münster.

Henrik Olesen

Pre Post: Speaking Backwards

-From March 27 to April 24, 1971, I will be at Pier 18 at 1 a.m.
 each night; I will be alone, and will wait at the far end for
 one hour.

-To anyone coming to meet me, I will attempt to reveal something
 I would normally keep concealed: censurable occurrences and habits,
 fears, jealousies,—something that has not been exposed and that
 would be disturbing for me to make public.

-My intention is to meet each person individually, so that he alone
 will have possession of the information given.

-I will document none of the meetings. Each visitor, then, can make
 any documentation he wishes, for any purpose; the result should be
 that he bring home material whose revelation could work to my
 disadvantage—material for blackmail.[1]

SEX (IN PUBLIC)

In 1850 the City of London erected seventy-four new public urinals in response to the general public's indignation about men pissing in the streets and the resulting stench. Most of the urinals were constructed to accommodate one person, but there were also variants designed for four persons (not for two, which was unacceptable), and the largest had standing room for six full-grown men. These utilities were generally positioned in the vicinity of main intersections and thoroughfares, but some also found their way into deserted backyards at a safe distance from most residences.[2] Quickly they revealed themselves as spaces suitable for cruising and male-to-male sex across the societal divides of age, class and effeminacy. Their comparative comfort

1 Vito Acconci, *Untitled (project for Pier 18)* 1971. Performed at Pier 18, West Street and Park Place, New York.
2 Randolph Trumbach, »London,« *Queer Sites—gay urban histories since 1600*, ed. by David Higgs, Routledge
 (1999), p. 106.

offered a superior alternative to cold parks. On 11 February 1873, in just such a urinal, the thirty-three-year-old Pre-Raphaelite painter Simeon Solomon was arrested for having sex with George Roberts, a sixty-year-old stableman. Solomon and Roberts were both charged with indecent exposure and the attempt to commit *buggery*. The original law in the UK criminalizing sodomy, the Buggery Act, was passed in 1533 and survived in various forms until 1967. »In Britain... sodomy carried the death penalty until 1861, but it was *after* the reduction of this penalty (between ten years and life) that the real process of social definition, and an increase in social hostility, began.«[3] Solomon was found guilty, fined one hundred pounds, and later sentenced to eighteen months hard labour. Robert's fate is unrecorded. At the intervention of a wealthy cousin, Solomon's sentence was subsequently reduced to police supervision. Frequently exhibited at the Royal Academy, his paintings were already known to the public for their »ambiguous,« androgynous same-sex and homo-social subjects. Following the scandal of his sexual adventures, Solomon, feeling ostracized, fled to Paris, perhaps in the hope that in his absence the outrage would abate. Unrepentant, irrepressible, on 4 March 1874 he was again arrested in a *pissoir* with an infamous nineteen-year-old Parisian who later continued his career blackmailing and robbing rich, older homosexuals. This time, Solomon spent three months in prison and was fined sixteen francs. This new incident led to him being abandoned by his circle of friends and patrons, ruining his artistic career. In response he is said to have started drinking heavily and begging for money on the street.[4]

> The first organ to be privatised, to be excluded from the social field, was the anus.
> It gave privatisation its model, just as money was expressing the new abstract status
> of the fluxes.[5]

> The anus is so well hidden that it forms the subsoil of the individual, his »fundamental« core.
> It is his own property, as the thief's grandfather explains in Darien's *Le voleur* (»your thumb
> belongs to you so you must not suck it; you must protect what is yours«) Your anus is so
> totally yours that you must not use it: keep it to yourself.[6]

The surveillance and policing of sex and meeting places in order to defeat dissident sexual subcultures was, however, by no means new. For instance, in London a series of incursions as early as 1699, 1707, and 1726 resulted in the closing down of more than twenty proto-gay clubs and bars. These »Molly houses«—as they were then known—ranged from simple drinking holes to lively venues featuring dancing. Some even had backrooms for sexual activity. One wide-eyed witness recorded: »I found between forty and fifty Men making Love to one another, as they call'd it. Sometimes they would sit on one another's Laps, kissing in a lewd Manner, and

3 Jeffrey Weeks, »Preface To The 1978 Editions,« in Guy Hocquenghem, *Homosexual Desire* (first printed by Editions Universitaires 1972), Duke University Press (1993), p. 39.

4 Ibid. p. 2, see also, Ray Anne Lockard, »Simeon Solomon« (1840–1905), in *glbtq an encyclopedia of gay, lesbian, bisexual, transgender, & queer culture*. http://www.glbtq.com.

5 Deleuze and Guattari, »L'anti-oedipe, capitalisme et schizophrénie,« Paris, 1972. (Quoted in *Homosexual Desire*).

6 Ibid., 3., Guy Hocquenghem, p. 100.

using their Hands indecently. Then they would get up, Dance and make Curtsies, and mimick the voices of Women. *O, Fie, Sir! —Pray, Sir. —Dear Sir. Lord, how can you serve me so? — I swear I'll cry out. —You're a wicked Devil. —And you're a bold Face. —Eh ye little dear Toad! Come, buss!* Then they'd hug, and play, and toy, and go out by Couples into another Room on the same Floor, to be marry'd, as they call'd it.«[7]

In chilly February 1726 police raids, forty men were arrested in a single club. The spate of raids continued and at the end of the month the number of arrests had dramatically increased. None of the men were caught *in flagrante delicto*, although, a few were discovered with their trousers unbuttoned. Most were set free due to lack of evidence. Several of the men were fined, imprisoned, or subjected to public abuse. Three men were hanged. In the same year informants were dispatched to apprehend men in cruising areas. These police operations were far from unassisted. Poverty and promises of immunity from prosecution forced a number of men into jobs as informants and entrappers. Thomas Newton, a thirty-year-old hustler amongst those arrested in February 1726, was released after two months and became an active informer, probably because he was granted immunity. His testimonies mainly concerned the men that had slept with him and in some cases, led to their imprisonment or death. Newton would accompany the law enforcement authorities, armed with arrest warrants, to the »The Sodomite's Walk, » a cruising area in Moorfield Park. Constables Willis and Stevenson developed a scheme in which Newton was effectively used as bait. What follows is Newton's description of a set-up encounter: »I was no stranger to the Methods they used in picking one another up. So I takes a Turn that way, and leans over the Wall. In a little Time a Gentleman passes by, and looks hard at me, and at a small distance from me, stands up against the Wall, as if he was going to make Water. Then by Degrees he sidles nearer and nearer to where I stood, 'till at last he comes close to me.—*'Tis a very fine Night*, says he. *Aye*, says I, *and so it is*. Then he takes me by the Hand, and after squeezing and playing with it a little (to which I showed no dislike), he conveys it to his Breeches, and puts [his penis] into it. I took fast hold, and call'd out to Willis and Stevenson, who coming up to my Assistance, we carried him to the Watch house.«[8]

A testimony to resistance, and in the fine tradition of »Sodomites Walk« nearly two centuries later New York's cruising areas—secret paths winding through the straight grid of Manhattan— had nicknames like: »the Fruited Plain,« »Vaseline Alley,« and »Bitch's Walk.« »The Cock Suckers Hall« (Sharon Hotel) and »The Sunken Gardens«—the much frequented public toilets at Times Square, were other hot dots on this clandestine map.[9]

7 *Select Trials*, 2nd edn, London, 1742; *The London Journal*, 30 July 1726, as quoted in Rictor Norton, »Mother Clap's Molly House,« in *Homosexuality in Eighteenth-Century England: A Sourcebook*.
http://www.infopt.demon.co.uk/eighteen.htm

8 Ibid.

9 George Chauncey, »Privacy Could Only Be Had In Public: Forging a Gay World In The Streets,«
in *Gay New York*, Basic Books: A Subsidiary of Perseus Books (1994), pp. 182, 197.

(IMAGES)

In paintings and watercolors such as: *Turkish Bath scene Self-Portrait* (1918) showing the artist with a group of naked men in a bath house, *On »That« Street* (1932), or *Man and Sailors (Sands Street, Brooklyn)*(c. 1930), New York artist Charles Demuth depicted sex places—streets, beaches, bathhouses and public toilets. (These public spaces were also frequented by policemen seeking to arrest homosexuals.) His *Three Sailors on the Beach* (1930) pictures a sailor undressing while his companions are engaged in sexual activity. One offers his dick to the other, who is sitting with his legs spread displaying a hard-on. For the record, Demuth was not alone with his artistic celebration of male-to-male sex in public. Previously, French artist Jean-Frédéric Bazille's painting *Scène d'été (Summer Scene)* (1869) exposed a group of scantily clothed males flirting and cruising in a park. (Incidentally, this work was painted shortly after his friend Édouard Manet's *Déjeuner sur l'herbe* (1863), which immortalized lesbian artist and model, Victorine Meurent.) Bazille's work may have inspired some of Thomas Eakin's better known compositions such as *The Swimming Hole* (1885) after Walt Whitman's poem »Leaves of Grass« (1855). Henry Scott Tuke's beach and boat paintings such as *All Hands to the Pumps* (1888–89) and *The Diver*, (1918) also contributed to this unacknowledged genre of outdoor homoerotic art. Tuke rarely painted the genitals of his models. He generally arranged them so that anatomical details were concealed from the sun. Although center stage, shadows or draped pieces of clothing obscure the privates, perhaps to avoid censorship.

LOSS OF VITALITY

Of the men loving male artists known to have populated the cultural landscape of London in the 1700s, most were upper-class and some, it can be reasonably presumed, must have been involved in the Molly subculture. Researchers of non-dominant social groups and sub-cultural practices must, as a matter of principal, interpret what cannot be found. The arrangement of gay-lesbian history, culture, and identity—on the one hand, and the visual arts and visual culture on the other—opens up a lot of contradictions and conflicts. »The historical record itself has been so constructed, managed and published that material of direct interest to gay and lesbian studies has often literally dropped out of immediate view or have completely disappeared.«[10] It was a common practice for the families and estates of artists who were, or were suspected of being, homosexual to destroy private documents such as letters and diaries, or even works of art, after their death. (John Singer Sargent, Thomas Eakins) »The history of the destruction of the visual records of homosociality, homoeroticism, and homosexuality—whether through mundane neglect or systematic suppression—is such that some of the most ordinary questions (was such-and-such an artist homosexual? Who owned such-and-such an image?) cannot be definitively answered.«[11]

10 Whitney Davis, »Introduction,« in *Gay and Lesbian Studies in Art History*, ed. Whitney Davis, Harrington Park Press (1994), pp. 2–3.
11 Ibid.

Washington Allston was born in 1779 in South Carolina. He later became a leading figure of the Romantic Movement in the United States. In 1810 he went to London to study at the Royal Academy. This eight-year sojourn abroad is considered as the most important period in Allston's production: »His greatest years were spent in England (1810–18), where his work revealed a sophisticated and controlled, yet romantic mind... In England and Europe Allston was the intimate of intellectuals and in frequent contact with the best of Western art. He returned to the United States, where artistic stimulation was lacking, and, as a result, his own work eventually lost its vitality.«[12] This »loss of vitality« has been sited as a consequence of his sexual preferences, and as evidence of »the guilt and fear often experienced by gay men in nineteenth-century America.«[13] Desire for other men was equated to a »propensity to sin« that haunted Allston throughout his life. »Feelings of guilt deeply affected his productivity and inhibited his completion of many important projects, including major commissions from the United States government.«[14] Categorized as a Romantic, Allston is best known for his religious motifs and landscape paintings. His body of work and the »lack of vitality« are understood in relation to the categories of quality norms within Romanticism and not through any other taxonomy.

MADE UP

- Observation of manipulations
- Manipulation of observations
- Information gathering
- Information dispersal (or display)[15]

Art historian Phoebe Lloyd suggested that Washington Allston might have been blackmailed and had to escape London's sex-panic during yet another intense period of legal persecution of sodomites in the early eighteenth century.[16] If he frequented the same-sex spaces at night, the parks, the urinals, or the Molly houses, he would have met other men, among them his personal Judas. »The Molly houses brought together men who shared a common legal risk, making a collective response possible.«[17] Not that their legal status was their prime motivation or concern. It seems highly probable, that artists like Washington Allston or Simeon Solomon were enjoying sex in the urinals or in London parks, getting drunk at the Molly houses, meeting men, and generally cutting a figure in their respective homo-subcultures.

12 *The Columbia Encyclopedia*, Sixth Edition (2001), see biographies by J. B. Flagg (1892, repr. 1969) and E. P. Richardson (1948).

13 Richard G. Mann, »Guilt and Fear,« in *American Art: Gay Male, Nineteenth Century*, glbtq, op. cit. (q. 4).

14 Ibid.

15 Bruce Nauman, excerpt from »Dance Piece, Work and Notes, Early 1970,« in *Artforum*, (December, 1970).

16 I can't find this quote anymore.

17 David F. Greenberg, »The Rise of Market Economies,« in *The Construction of Homosexuality* (Chicago & London: The University of Chicago Press, 1988), p. 349. Press/Chicago & London (1988), p. 349.

Depending what you are after, choose an area, a more or less populous city,
a more or less lively street, build a house. Furnish it. Make the most of its
decoration and surroundings. Choose the season and the time. Gather together
the right people, the best records and drinks. Lighting and conversation
must, of course, be appropriate, along with the weather and your memories.
If your calculations are correct, you should find the outcome satisfying.[18]

»The Molly subculture possessed every characteristic of contemporary Gay subculture: shared friendship networks, styles of clothing, slang and semiotics, folk rituals, literary artefacts such as songs, and self-identification as homosexual.«[19] Many patrons adopted female nicknames such as Dip-Candle Mary (a tallow chandler), Primrose Mary (a butcher), or Miss Sweet Lips (a country grocer). A variety of rituals took place in the Molly houses, some had rooms called »The Chapel« or »The Marrying Room« where wedding nights took place, or other rituals such as »mock birth« or »lying-in«: one man, playing the role of the mother, gave birth to a doll. The Molly house couples always referred to each other as »husband« or »spouse« and never as »wife.« An extensive »Molly dialect« existed, drawn partly from the »Rogues Lexicon« or »Canting Dialect« used by thieves, highway robbers, vagabonds, and female prostitutes. Some forty terms are documented, such as mollies, molly-culls, and mollying-bitches. They used euphemisms such as »the pleasant deed« and »to do the story« and other terms for anal intercourse such as »caudle-making« and »to indorse.« Mollies went »strolling or caterwauling« in »the markets« where they »picked up« with whom they would »make a bargain« or »bit a blow.«[20]

Critical voices towards the homophobic legislation were raised as early as 1725 where the customers of one London Molly-house resisted when the authorities marched in »but a weekly-organized minority was in no position to conduct military struggle.«[21] During the police raids in 1726, a man named William Brown was arrested, when asked why he took such indecent liberties with another man, he answered: »I did it because I thought I knew him, and I think there is no Crime in making what I please of my own body.«[22]

18 »Psychogeographical Game of the Week,« unattributed, *Potlatch* #1 (22 June 1954).
19 Rictor Norton, »Clap, Margaret,« in *Who's Who In Gay & Lesbian History*, eds. Robert Aldrich and Garry Wotherspoon, Routledge (London & New York: Taylor & Francis Group, 2001), pp. 98–100.
20 Ibid. The tradition of homosexual language continued to exist in various forms. For example, as in »Polari,« the most common in 1960s London. A clear definition of Polari is difficult because the slang it used underwent many changes. Its various sources include Italian, English (backwards slang), circus slang, canal-speak, Yiddish, and Gypsy languages. Some of its users were so skilfull that the language developed its own set of grammatical rules. »riah« – hair, »Arthur« and »Barclays« – masturbate, TBH (to be had) – sexually available, »Boner Nochy« – goodnight. From »Hugh Young's Lexicon of Polari« (1996). http://www2.prestel.co.uk/cello/Polari.htm
21 David F. Greenberg, op. cit.
22 Rictor Norton, op. cit., p. 100.

INSCRIPTIONS

PLUSIEURS ÉBAUCHES
DE LA SORTIE DE LA CHAMBRE[23]

Draw an imagery map. Put a goal mark on the map where you want to go. Go walking on an actual street according to your map. If there is no street where it should be according to your map, make one by putting the obstacles aside. When you reach the goal, ask the name of the city…[24]

London wasn't the only place where homo-subcultures flourished. Eighteenth- and nine-teenth-century police reports from major European cities including Amsterdam and Lisbon describe how same-sex networks and dissemination of information functioned. Mobile Queers traveled and settled down in the vicinity of numerous same-sex sites. In Paris, for instance, of the forty-six men incarcerated in Bicêtre prison between 1701 and 1715 for same-sex crimes, only 45.7 per cent were born Parisians. Between 1860 and 1870, only 32.3 percent of the men arrested were born in Paris, 58.5 per cent of them originated in the provinces and 9.2 percent were foreigners.[25]

Many American female sculptors moved to Rome in the 1850s attracted by promising rumors. The naked breasts of Harriet Hosmer's busts *Medusa* (1854) and *Daphne* (ca. 1854) are placed on a pedestal for female admirers. Hosmer was known for her politics and opposition to the »social barriers that kept woman in positions of financial dependence.«[26] *Zenobia in Chains* (1859) for instance, symbolically depicts a woman in bondage. Her contemporaries were shocked by Hosmer's unfeminine appearance and manners, and by her »flamboyant« behavior. »Miss Hosmer's want of modesty is enough to disgust a dog. She has had casts for an entire [nude] model made and exhibited them in a shocking indecent manner to all the young artists who called upon her. This is going it rather strong.«[27] Her colleagues such as Anne Whitney, Emma Stebbings, and Mary Edmonia Lewis[28] worked in a similar vein and were all part of a »strange sisterhood of American lady sculptors who at one time settled upon the seven hills in a white, marmorean flock.« (Henry James). The success of these women didn't, however, protect them from homophobia.

23 *Stéphane Mallarmé, 1896–1870, Sämtliche Dichtungen: französisch und deutsch,* Deutscher Taschenbuch Verlag (1995), p. 204.

24 Yoko Ono, Map Piece, 1971 (detail).

25 Carlier 1887: 444–5, Bibliothéque Nationale, Ms Clairambault 985, »Extraits d'interrogatoires« (statistics provided by Jeffrey Merrick), Michael D. Sibalis, »Paris,« Queer Sites, op. cit., pp. 12–13.

26 Jeffery Byrd, »Hosmer, Harriet Goodhue (1830–1908),« in *glbtq,* op. cit.

27 »Public Faces, Private Lives« in *Improper Bostonians: Lesbian and Gay History from the Puritans to Playland,* ed. Barney Frank/The History Project, Beacon Press (1998). As quoted on The History Project webpage: http://www.historyproject.org/exhibits/public_faces/15.php

28 Mary Edmonia Lewis was the first Black American to receive recognition as a sculptor. Her early works reflected her sympathies with the Abolitionists and the Black Liberation movement. Some works such as *Old Arrow Maker and Daughter* (1872) portray non-dominant social groups including Native Americans. *Forever Free* (1867) shows a black slave in broken chains posing in Roman style.

A frequent exhibitor at the Royal Academy London, the lesbian sculptor Anne Seymour Damer (1741-1807), lived openly with other women. Damer's work, including busts of her lovers *Elisabeth Farren* (ca. 1788) and *Mary Barry* (ca. 1792), is frankly queer, self-defined, and independent. In the diaries and letters of the high society, Damer was attacked for »liking her own sex in a criminal way.« In one such diary she was denounced a »sapphist,« and was ridiculed for wearing men's clothes. The most radical homophobic statement appeared in the poem *A Sapphick Epistle, From Jack Cavendish to the Honourable and most beautiful Mrs. D***** (1778). The true identity of its author is uncertain, it has been suggested that the choice of the fictitious name »Jack Cavendish« was perhaps directed at Elizabeth Cavendish, another known lesbian from the period. Distributed anonymously, *A Sapphick Epistle...* may well have been intended to provoke a public scandal.[29]

Hostile dominant social codes led to a parallel tradition of subversive counter-codes:

THE RED TIE

A performer faces the audience, stage center, wearing a shirt and a pair of pants the same color, color A. He removes the shirt, revealing under it an identical shirt of color B. He removes the pants, revealing under them an identical pair of color B. He removes the shirt, revealing under it an identical shirt of color A. He removes the shirt, revealing under it an identical shirt of color B. He removes the pants, revealing under them an identical pair of color B.[30]

White: Wanking
Mustard: Big Cock
Green: Rent
Lavender: Drag, Cross Dressing
Orange: Anything Anytime (L) or Nothing Now (R)
Beige: Rimming
Black: Paingames, Whipping
Dark Blue: Fucking
Light Blue: Oral Sex
Brown: Shit
Grey: Bondage

29 For positive images, cf. Christopher Marlowe's Edward II (ca. 1692), *The Affectionate Shepard* (1595) from Richard Barnfield or Mary Astell's utopian essay »A Serious Proposal to the Ladies, For the Advancement of their true and greatest Interest By a Lover of Her Sex,« (1694; Part II 1697) an imagining of a flexible separatist community in which middle and upper-class women would live and study, either as a prelude to marriage, or preferably, as a genuine alternative to it.

30 Scott Burton, *Four Changes*. Performed on 28 April 1969, Hunter College, New York.

Olive or Khaki: Military Scenes
Light Pink: Arse Toys
Dark Pink: Nipple Torture
Red: Fisting
Yellow: Piss
Purple: Piercings
Charcoal: Rubber[31]

At the turn of the last century in New York the »red tie« was used by gay men as a code to signal homosexuality.[32] Yet there also lay a danger in using such a code: it was less likely to protect the wearer if more people understood what it signaled. »To wear a red necktie on the street is to invite remarks from newsboys and others—remarks that have the practices of inverts for their theme. A group of friends told me once that when a group of street boys caught sight of the red necktie he was wearing they sucked their fingers in imitation of *fellatio.*«[33] Paul Cadmus's *The Fleet's In* (1934) made use of such a code. The painting depicts a group of sailors partying and drinking with locals near Riverside Drive. Amongst the crowd stands a well-dressed man with neatly combed hair wearing a red tie. It is clear that the detail of the red tie was not a coincidence because it also features in Cadmus's *Shore Leave,* from the previous year. *The Fleets's In* was first included in a 1934 exhibition for the Civil Works Administration at the Corcoran Gallery and provoked hostile reactions. Henry Roosevelt, the president's cousin, was shocked and demanded that the painting be removed. Others were worried that it showed the Navy in a bad light. One reporter, aware of a homosexual subtext, mentioned in an article a telephone call that Cadmus had received from a stranger who asked him: »If he had ever been to Sands Street, near the Brooklyn Navy Yard.« Sands Street was a notorious cruising ground. The same quote reappeared in Newsweek magazine without any explanation. Sands Street was also the setting of Demuth's *On 'That' Street.*

~~MODERNAPHOBIC~~

In his lifetime, the homoerotic watercolors of Charles Demuth were shown only to a small circle of viewers and intimate friends. They were not intended for public viewing, unlike, for instance, Marcel Duchamp's *Fountain* (1917). They might also have been intended to be found after his death. »The late pictures of sailors urinating have the quality of intimate confessions or a memoir discovered long after its author has passed away.«[34] Evidence of unrestricted environ-

31 »The Hanky Code,« as published in the Bay Area Reporter, 1972.
32 The Mollies also had a system of performative signals when out cruising. »If one of them sits on a bench, he pats the backs of his hands; if you follow them, they put a white handkerchief thro' the skirts of their coat, and wave it to and fro; but if they are met by you, their thumbs are stuck in the armpits of their waistcoats, and they play their fingers upon their breasts.« Rictor Norton, op. cit., p. 99.
33 Excerpt from Havelock Ellis, »Sexual Inversion,« in Jonathan Weinberg, *Speaking for vice: Homosexuality in the Art of Charles Demuth, Marsden Hartley, and the First American Avant-Garde*, Yale University press (1993) p. 34.
34 Jonathan Weinberg, »Demuth's Erotic Watercolors« in *Speaking For Vice*, op. cit., p. 108.

ments began to appear in Demuth's work after he settled into New York's Greenwich Village in 1914. It was here that he befriended Duchamp, who often accompanied him to the city's more transgressive nightclubs and salon gatherings where Freudian theories of sexuality were being eagerly debated. In the writing of critics sympathetic to Demuth, the disassociation of his work from its homosexual subject matter was commonplace. In discussing the work of Demuth, ironically Duchamp—who appeared in drag as Rrose Sélavy, and whose own work contains sexual innuendo—warned specifically against giving too much weight to the issue of sexuality because it threatened the integrity of the work of art. »The little perverse tendency that he had was not important in Demuth's life. After all, everybody has a little perverse tendency in him. That quality in him had nothing to do with the quality of his work. It had nothing to do with his art.«[35]

The daring manner in which Demuth responded to the homophobia that greeted his work *Distinguished Air* (1930), is perhaps his most significant historical contribution. Loosely interpreting Robert McAlmon's story of the same title—a story set in a Berlin »queer café«—Demuth portrayed a situation at an exhibition opening, in which a male couple admire Constantin Brancusi's notoriously phallic sculpture, *Princess X* (1916) while an ostensibly straight male gallery-goer admires the crotch of one of the gay men. Ray Gerard Koskovich sees *Distinguished Air* as Demuth's »coming out.«[36] Demuth risked scandal by exhibiting *Distinguished Air* publicly in *A Monologue by the Whitney Museum*. When several curators refused to show *Distinguished Air*, Demuth responded by producing homoerotic watercolors of sailors undressing, fondling themselves and urinating in each other's company. This kind of hostility was not an isolated case in modernity. The surrealist salons, Dada's Cabaret Voltaire, and the situationist's cut-up map of Paris were all artistic spaces or investigations that precursed Conceptual art. But it is significant that even the most avant-garde, experimental (heterosexual) groups didn't attract explicit visual homosexual cultural production or vice versa.

Superbly documented, the surrealists were notorious for their homophobia. In the first session of the legendary »Recherches sur la Sexualité,« on January 27, 1928, 54, Rue de Château, Paris, the following conversation took place:

Pierre Unik: »From a physical point of view I find homosexuality as disgusting as excrements and from a moral point of view I condemn it.«

Raymond Queneau: »It is evident to me that there is an extraordinary prejudice against homosexuality among the surrealists.«

André Breton: »I accuse homosexuals of confronting human tolerance with a mental and moral deficiency which tends to turn itself into a system and to paralyze every enterprise I respect.«[37]

35 Marcel Duchamp, »Interview with Marcel Duchamp at New York City, January 21, 1956,« in Emily Farnham, *Charles Demuth: His Life, Psychology and Works* (Ph.D.diss., Ohio State University, 1959), 973. As quoted in Jonathan Weinberg, op. cit., p. xiii.

36 Jonathan Weinberg, op. cit., pp. 195–200.

37 *Investigating Sex, Surrealist Research 1928–1932*, ed. José Pierre, transl. Malcom Imrie (1992), (London/New York: Verso, 1994), p. 5.

This revulsion for gay men appeared in many surreal works, such as Benjamin Peret's *André Gide's Convention* (ca. 1926–1936).[38] In the poem the communist youth song »Young Guard« is put into the mouth of André Gide. Intended as a snide witticism about homosexual Gide's connection to the communist party, Peret posits Gide enjoying fellatio while being strangled by a communist (penis-) hammer:

Mister Comrade Gide

sings the »young guard« between his arse and his shirt-tails

and tells himself it's time to flash his belly like a red flag

communist

a bit a lot all his heart

not at all

answer the balls of the choirboys he depilates

like a tomato rocked by the wind

Mister Comrade Gide makes a hell of a red flag

[...]

Oh yes Mister Comrade Gide

You'll have the hammer and sickle

the sickle through your guts

and the hammer down your throat[39]

A WHITE TIE

The code said: GET RID OF MEANING. YOUR MIND IS A NIGHTMARE THAT HAS BEEN EATING YOU: NOW EAT YOUR MIND.[40]

The work of sexual dissidents like Sonia Sekula among others, who contributed to Abstract Expressionism during the 1950s, seem today almost forgotten. Sekula showed at the Betty Parsons Gallery in New York in a program that also included Jackson Pollock, Barnett Newman

38 »André Gide's convention« was first published by Editiones Surréalistes in the book *Je ne mange pas de ce pain-lá* (1936). Trans. »I will not eat that sort of bread,« idiomatically: »I'd rather starve« or »I won't stand for it.« The book was illustrated by Max Ernst and published in 249 copies.

39 Translated by Rachel Stella, *Death to the Pigs—Selected Writings of Benjamin Peret*, ed. Rachel Stella (London: Atlas Press, 1988), p. 33.

40 Kathy Acher, *Empire of the Senseless* (New York: Grove, 1988).

41 Forrest Bess, for instance, seems to twist the gender-hierarchy in Abstract Expressionism upside-down. A painting like *The Dicks* (1946) arranges phallic forms into rows. Other works like *#1*(1951) show phallic forms together with inverted triangles and flame-like shapes. *Hermaphrodite* (1958) shows a pill-like shape, isolated by a vast black background, much less sexual. Throughout the 1950s, Bess became deeply troubled by the two sides of his psychological make up. Believing that the fusing of genders within his own body would reveal the »secrets of immortality« to the human race, he underwent surgery. The operation created an opening at the junction of his penis with the scrotum. The idea was that he could reach an intense orgasm, leading to spiritual awakening and eternal rejuvenation, through the insertion of another penis. It is believed that a local doctor was present at the operation he underwent between 1960 and 1961, but many believe that he performed it himself. Arrested twice, in the early 1970s, for disruptive behavior, he was committed to San Antonio Mental Hospital where he lived until his death in November 1977.

and Ad Reinhardt. Betty Parson, a lesbian, also showed men[41] who »although not out in today's sense, were understood by their closer friends in the art community to be devoted to their male partners.«[42] These included Alphonso Ossorio and Leon Polk Smith. But today, the legendary ejaculating Jackson Pollock completely dominantes the notion of sexual potency in Abstract Expressionism. The stories of Pollock taking his dick in his hand and urinating in public make this image even more enticing. »Jack the Dripper« is said to have urinated everywhere, upon the canvases to be given to art dealers he didn't like. He is even said to have wet the bed of Ms. Guggenheim.

XII PAINTER

Meet you at the Frick [Museum] please don't wear pants[43]

In a biography written by Steven Naifeh and Gregory White, they look into the bathroom prac-
tices of Pollock. Somewhere between Freudian penis envy and the softness of a childhood memo-
ry of Marcel Proust, it is said that, »when he [Pollock] stood back and looked at one of his first
drip paintings, a memory suddenly popped into his head. He saw himself standing beside his
father on a flat rock… watching his father pissing, making patterns on the surface of the stone…
and he wanted to do the same thing when he grew up.«[44]

In 1960, for the work *Anthropometries*, »Yves Klein replaced Pollock's brushes with
women's bodies, Pollock's house paint with patented 'YKB' (Yves Klein Blue) paint, Pollock's
supposedly solitary studio with a gallery full of well-dressed spectators, the silence of Pollock's
photographic performance with a string orchestra playing Klein's 'Monotome Symphony,'
Pollock's workers' garb with aristocratic tuxedo and a white tie.«[45]

1. All Substantial Things Which Constitute This Room
2. All The Duration Of 1
3. The Present Moment And Only Then Present Moment
4. All Appearances Of 1 Directly Experienced By You At 3
5. All Of Your Recollection At 3 Of Appearances Of 1 Directly Experienced
 By You At Any Moment Previous At 3
6. All Criteria By Which You Might Distinguish Between Members Of 5
 And Members Of 4
7. All Of Your Recollection At 3 Other Than 5

42 Ann Gibson, »Lesbian Identity and the Politics of Representation in Betty Parson's Gallery,« in *Gay and Lesbian Studies in Art History*, op. cit., p. 248.

43 Frank O'Hara, »The Anthology of Lonely Days,« in *The Collected Poems of Frank O'Hara*, ed. Donald Allen, University of California Press, London (1995), pp. 399–400.

44 Steven Naifeh and Gregory White, *Jackson Pollock: An American Saga*, New York, Clarson N. Potter (1989), p. 541. More on this subject in Jonathan Weinberg, *Urination and its Discontents*, p. 225.

45 Amelia Jones, *Body Art/Performing the Subject*, University of Minnesota Press (1998), p. 86.

8. All Bodily Acts Performed By You At 3 Which You Know To Be Directly
 Experienced By Persons Other Than Yourself

9. All Bodily Acts Directly Experienced By You At 3 Performed By Persons
 Other Than Yourself

10. All Members Of 9 And All Members Of 8 Which Are Directed Towards
 Members Of 1[46]

LECTURE ON NOTHING

We had all leaned against the walls looking at one another for some time. He came over
and asked me to please lean against the opposite wall, which I did.[47]

(Probably as a reaction to the *noise* of Abstract Expressionism) John Cage announced at the
very beginning of a lecture in 1949:

I am here / and there is nothing to say / Nothing more than / nothing /
can be said

Comparing his lecture to an empty glass of milk, he asserted:

Or again / it is like an / empty glass / into which / at any moment /
anything / may be poured[48]

Cage never came out of the closet. Even though nearly everybody in the art world who knew
him also knew about his lifelong relationship with Merce Cunningham; his sexuality was a kind
of open secret within the avant-garde. Public acknowledgement of Cage's sexuality was consigned
to the realm of gossip, understood as a mere diversion from his historical import and achieve-
ments. In his work Cage had long considered the *idea as paramount*. As a gay pre-conceptualist
in the macho, homophobic company of the abstract expressionists of the 1940s and 1950s, the
closet perhaps seemed like a logical answer. When asked to characterize his relationship with
Cunningham, he would say, 'I cook and Merce does the dishes.'[49] The contact that Cage had
with the rest of the gay society was mainly through cruising in the parks.[50] The site of »silence«
was to continue through Cage's production. As Jonathan Katz points out, to be gay in a homo-
phobic culture was to realize that conversation was not always about expression: »If silence was,
paradoxically, in part an expression of Cage's identity as a closeted homosexual during the Col/

46 Victor Burgin, »Text Piece,« detail from the exhibition »Idea Structures,« Camden Art Centre, June 1970.

47 Alison Knowles' memory of the »Nothing« (1968) meeting with Ray Johnson in the Gallery of René Block in New York
 Ina Blom, »Ray Johnson's Postal Performance,« in *The Name of the Game: Ray Johnson's Postal Performance*. Pulle
 issued on the occasion of the exhibition of Ray Johnson at the National Museum of Contemporary Art, Norway, ł
 Fridericianum, Kassel, Museum Het Domein Sittard, 2003.

48 Quotes from »Lecture on Nothing,« taken from Jonathan Katz, *John Cage's Queer Silence or How to Avoid M*queer
 Matters Worse, GLQ, Duke University Press (1999), as found on the Queer Cultural Center webpage: http://
 culturalcenter.org/Pages/KatzPages/KatzWorse.html

49 Ibid, Remy Charlip quoted.

50 Ibid.

War it was also much more than that. Silence was not only a symptom of oppression, it was also, I want to argue, a chosen mode of resistance. Cage became notable precisely for his silences—clear proof of its unsuitability as a strategy of evasion. Closeted people seek to ape dominant discursive forms, to participate as seamlessly as possible in hegemonic constructions. They do not, in my experience, draw attention to themselves with a performative silence, as John Cage did when he stood before the fervent Abstract Expressionist multitude and blasphemed: 'I have nothing to say and I'm saying it.«[51]

LOUD

I have no idea how or where I managed to find the picture of him shirtless and nailed to his car, his arm pit hair on sexy display. I do remember jerking off to the picture and being called a freak in the school lunchroom for talking about my new favourite artist. I trust that following powerful life sources such as libido always lead you to interesting places. While given the hardcore SM vision of the pierced [Chris] Burden, my fascination could have led me towards building a home dungeon in my first apartment.
Bill Arning

Conceptual art was produced in many still unacknowledged spaces. Lesbian initiatives such as projects at »Womanspace« have, in particular, been extremely overlooked. Founded at the New Woman's Building in Los Angeles, 1973, one of its first projects »Lesbian Week,« included an exhibition, entertainment, dancing, lectures about lesbian heritage, and workshops. Arlene Raven—one of the cofounders of »The Feminist Studio Workshop,« initiated a series of lesbian-based projects as well, such as the Nathalie Barney Collective that focused on historical research and documentation of lesbian artists. Other artists like Betty Lane began mapping the women's movement in 1969, documenting »women of diverse ages, classes, and races at women's demonstrations, meetings, and other events around the world.«[52] Ironically, in the exhibitions, texts and catalogues that are generally taken as framing the art practices in the canonized space of Conceptual art, most of the idea-based »homosexual« art-pieces came from straight artists like to Acconci, Robert Morris,[53] or Chris Burden.[54] In works such as *Openings* (1970) and

Ibid.

Harmony Hammond, *Lesbian Art in America—A Contemporary History* (New York: Rizzoli, 2000), pp. 22–3.

In his poster for the exhibition »Labyrinths-Voice-Blind Time« (1974), at the Castelli-Sonnabend Gallery, Robert Morris played himself as a gay leather fetishist.

ny other idea-based art projects offer a variety of cross-identifications, reflections of body-practices, sex-spaces, cs, such as in projects by Hélio Oiticica, Geoffrey Hendricks, or the cut-ups (1966), films from Brion Gysin / William ughs. Still though, a basic cultural standard is brought into focus, for example, by saying that »Burroughs may be ht he's a man. What I mean is that the fact he's gay is incidental. He's very much homosexual but when you meet Lite's not what you would think of him ... that's not somehow the axis.« Norman Mailer, quoted by Ted Morgan in

55 Open Outlaw: The Life and Times of William S. Burroughs (New York: Henry Holt, 1991), p. 581.

to tran s a super-8 film that shows Acconci carefully plucking the hairs around his navel, in a somewhat willful attempt conventi is his masculinity; »giving himself a surrogate cunt and assigning himself the specularized vulnerability that house: tali ly aligns with femininity.« In the *Trappings* performance he situated himself inside a closet in a German ware the rest of h to his penis which he had dressed in girl dolls clothes, allowed him to »see« his penis as separate from ody (Amelia Jones).

Trappings (1971), Vito Acconci[55] illustrates the essential conflicts related to the history of spatial hegemony: what kinds of bodies are dominating what kind of spaces. In the infamous *Seedbed* (1972), Acconci lay hidden under a newly constructed wooden floor in the gallery. (Sexually) activated/stimulated by the sound of footsteps of the visitors entering the exhibition space, he fed his sexual imagination by listening to the person(s) moving on the floor above him. Masturbating and whispering a vocabulary describing these (creative) sexual fantasies, the voice of Acconci was heard both from a sound system and the ground of the gallery architecture. Intended was an intersubjective exchange of identities, where the frank desires from the artist-body penetrate the (interpretive) visitor-body. Exclusively dedicated to each single visitor of the gallery: the Vito-Acconci-body is all-over-the-place. An interpretation of Acconci staging the idea of the *incorporation of any cultural body in a piece of art*, today moves into imposing a subject of representation that is absolutely heterosexual and exclusively masculine.

```
wall/floor/space.
distance/diagonals/center.
horizontal-vertical.
actions-gestures.
masculine-feminine:
        I    you
          we 56
```

A central reflection in sexual politics has always been about the position of »others« and the question of who may speak about the »other.« When I try to index a piece like *Seedbed*—and its symbolic positioning of *other bodies* within the Conceptual art movement—there seems to be a plain disagreement in the rules of the sexual-bodily exchange. As a gay man it doesn't make any sense that you are not supposed to join in when you enter a jack-off party.

MR SMITH

```
Information is content.
Content is fiction.
Content is messy.57
```

56 Klaus Rinke and Monika Baumgartl, *Primary Demonstrations (Time-Space-Body-Actions)* (1971). Performed at Kunsthalle Baden-Baden, May 1971.

As one of the only, albeit unacknowledged and systematically excluded, conceptual artists to contextualize explicit homosexual imagery, filmmaker and performance artist Jack Smith is outstanding. Early on, he was praised by a small group of devotees, including Susan Sontag and Jonas Mekas for helping to »inaugurate a new sexually and artistically radical film practice.«[58] In 1962, Smith shot *Flaming Creatures* in sets built on the roof of the Windsor Theatre in New York. At midnight on 29 April 1963, the film premiered at the Bleecker Street Cinema. In New York in March 1964, the police confiscated the film during a screening and arrested four of Smith's colleagues including Jonas Mekas.

1. During the third annual experimental film festival in Knokke-le-Zout, Belgium, *Flaming Creatures* is banned by The Belgium Ministry of Culture.
2. On February 3, 1964, *Flaming Creatures* is shown together with rushes of Smith's *Normal Love* at the Gramercy Arts. The theatre is closed two weeks later for screening unlicensed films.
3. On March 3, *Flaming Creatures* and *Normal Love* are seized at The Bowery Theatre by detectives from The New York City District Attorney's office.
4. The March 17 screenings of *Flaming Creatures* and Kenneth Anger's *Scorpio Rising* are shut down at the New Bowery Theatre.
5. On June 12, *Flaming Creatures* is declared obscene in New York Criminal Court.
6. On April 1, 1965, Albuquerque, New Mexico, police confiscate *Flaming Creatures* during a screening sponsored by the Action Committee On Human Rights.
7. In 1966, The National Students Association files an amicus curiae brief in support of the *Flaming Creatures* case as appeals make their way to the U.S Supreme Court.
8. On January 19, 1967, police seize a print of *Flaming Creatures* prior to its screening at the University of Michigan, Ann Arbor.
9. The U.S Supreme Court refuses to review the original conviction against *Flaming Creatures*. Associate Justice Abe Forbes publicly states that he would have reversed the original Criminal Court decision.
10. In July 1968, Strom Thurmond, ranking republican on the Senate Judiciary Committee, arranges a screening of *Flaming Creatures* in the Senate office building, and furnishes stills to members of Congress and the press, claiming to have »shocked Washington's hardened press corps.«[59]

ETC.

57 Lee Lozano, *Form and Content* (detail), 19 July 1971.
58 Michael Moon, »Flaming Closets,« in *Out In Culture—Gay, Lesbian, and Queer Essays on Popular Culture,* eds. Corey K. Creekmur and Alexander Doty, (Durham & London: Duke University Press, 1995), p. 289.

In response to the police censorship of *Flaming Creatures*, on 13 April 1964, Susan Sontag wrote a defense review in the *Nation*, titled *A Feast for Open Eyes*.[60] However, by framing the work of Smith outside any relations to same-sex practices, anti-gay legalization, or homosexual cultural history as such, and instead, by praising *Flaming Creatures* for its »joy and innocence,« Sontag also unintentionally locked away for decades to come the possibility of connecting Smith's methods and (homosexual) imagery to the strategies of conceptual and critical cultural production: »There are no ideas, no symbols, no commentary or critique of anything in *Flaming Creatures*. Smith's film is strictly a threat to the senses.«[61]

What kinds of standards establish what kind of image? A letter dedicated to Jonas Mekas, the director of the Homosexual League of New York, made clear that he found *Flaming Creatures*: »long, disturbing and psychologically unpleasant.... Why don't filmmakers produce an authentic film about a love affair or something between two boys which takes place in the contemporary homosexual setting?«[62] The relentless chronological non-existence of homosexual sites and images in the canonized history of visual culture suggests that no adequate language existed to either repress or promote a homosexual imagery outside its own culturally ghettoized site. As Smith formulated it: »I have to forget language. All I can do with no education, nothing, no advice, no common sense in my life, an insane mother I mean, no background, nothing, nothing, and I have to make art, but I know under these conditions the one thing I had to find out was if I could think of a thought that has never been thought of before, then it could be in language that was never read before.«[63]

HTIMS KCAJ

Craig Owens comes to mind: »perhaps the most eloquent testimony to the end of Western Sovereignty has been that of Paul Ricoeur who wrote in 1962, that the plurality of cultures is never a harmless experience:[64]

When we discover that there are several cultures instead of just one and consequently at the time when we acknowledge the end of a sort of cultural monopoly, be it illusory or real, we are threatened with the destruction of our own discovery. Suddenly it becomes possible that there are just others, that we ourselves are an 'other' among others. All meaning and every goal

59 Excerpt from »An Anecdoted Chronology«, ibid. pp.258-261.
60 Re-printed as »From Jack Smith's Flaming Creatures,« in *Flaming Creatures—Jack Smith—His Amazing Life and Times*, eds. Edward Leffingwell, Carole Kismaric, Marvin Heiferman, A Lookout Book, The Institute for Contemporary Art, P.S. 1 Museum, Serpent's Tail (1997), p. 65.
61 Ibid.
62 Edward Leffingwell, »The Only Normal Man in Baghdad,« ibid. p. 74.
63 »Uncle Fishook and the Sacred Baby Poo-Poo of Art« (Jack Smith in conversation with Sylvére Lotringer), *Wait for Me at the Bottom of the Pool—The Writings of Jack Smith*, eds. J. Hoberman and Edward Leffingwell, (New York/London: High Risk Books, ICA/P.S.1,1997), p. 114.
64 Craig Owens, »The Discourse of Others: Feminists and Postmodernism,« in *Beyond Recognition— Representation, Power, and Culture*, eds. Scott Bryson, Barbara Kruger, Lynne Tillman, and Jane Weinstock (Berkeley/Los Angeles/London:

having disappeared, it becomes possible to wander through civilizations as if through vestiges and ruins. The whole of mankind becomes an imaginary museum: where shall we go this week-end—visit the Angkor ruins or take a stroll in the Tivoli in Copenhagen? We can very easily imagine a time close at hand when any fairly well-to-do person will be able to leave his country indefinitely in order to taste his own national death in an interminable, aimless voyage.

The voyage of Jack Smith *was* to consist of a certain element of aimlessness: »My life has been a nightmare because of that damn film« he said to Sylvére Lotringer, »that sucked up ten years of my life.«[65]

Cut this text into three columns[66].

A	B	C
In 1850 the City of Lon response to the general p ts and the resulting stenc modate one person, but t (not for two, which was or six full-grown men. T ity of main intersections into deserted backyards a y revealed themselves as across the societal divides (ETC.)	don erected seventy-fou ublic's indignation about h. Most of the urials we here were also variants d unacceptable), and the la hese utilities were general and thoroughfares, but s t a safe distance from mo spaces suit able for cruis of age, class and effemina	r new public urinals in men pissing in the stree re constructed to accom esigned for four persons rgest had standing room f ly positioned in the vicin ome also found their way st residences. Quickly the ing and male-to-male sex cy. Their comparative co

Then, let A, B, and C be the three alternatives, and let 1, 2, and 3 be three individuals. Suppose individual 1 prefers A to B and B to C (therefore A to C), individual 2 prefers B to C and C to A (and there-fore B to A), and individual 3 prefers C to A and A to B (and therefore C to B).[67]

The way out is the way in[68]

University of California Press, 1994), pp. 166–67.

65 Jack Smith in conversation with Sylvére Lotringer, op. cit., p. 110.

66 Brian Gyson, *Cut-Ups Self-Explained* (1970), William S. Burroughs, Brion Gysin, »The Third Mind« (New York: Viking Press, 1978).

67 *Three Works by David Askevold* (1970), (detail) »Six Years: The Dematerialization of the Art Object from 1966 to 1972,« edited and annotated by Lucy R. Lippard, University of California Press (1973), p. 206.

68 William Burroughs quoted in Karl Holmqvist, *I on a lion in Zion*, Revolver (2005), p. 85.

The author wishes to express his gratitude to Dominic Eichler for his help.

The editors of this volume would like to thank
the Generali Foundation-team, especially Gudrun Ratzinger, Julia Heine, Cosima Rainer,
and Susanna Yezbek; Nora M. Alter, Marius Babias, Rainer Bellenbaum, Chris Caes,
Katja Diefenbach, Jonathan Flatley, Stephan Geene, Moira Hille, Clemens Krümmel,
Susanne Leeb, Paweł Polit, Lisa Rosenblatt, Dierk Schmidt, and Michael Willenbücher,
as well as the University of Florida Fine Arts Scholarship Enhancement Award Fund.

Contributors

Alexander Alberro

is associate professor of art history at the University of Florida. He is the author of *Conceptual Art and the Politics of Art History* (2003), editor of *Two-Way Mirror Power: The Writing of Dan Graham* (1999) and *Museum Highlights: The Writings of Andrea Fraser* (2005); and coeditor of *Conceptual Art: A Critical Anthology* (2000) and *Recording Conceptual Art* (2001). Lives in Gainesville, Florida.

Edit András

is a senior research fellow at the Institute for Art History of the Hungarian Academy of Sciences, Budapest. She has written extensively on the subject of contemporary art in the U.S.A. as the New York correspondent for a variety of Hungarian art magazines. Her texts have been published in a volume entitled *Kötéltánc* (Rope-dancing, 2001). Her other field of interest is contemporary art and theoretical aspects of the transition in the ex-Socialist block. Her essays on the region have appeared in a number of journals and exhibition catalogues. Lives in Budapest and Long Island.

Ricardo Basbaum

is an artist, curator and assistant professor of art history at the Art Institute at the UERJ—State University of Rio de Janeiro. He is author of *Além da pureza visual* (Beyond visual pureness; 2006) and the artists' books *G. x eu* (1998), and *NBP x eu-você* (2003). He is editor of *Arte Contemporânea Brasileira: texturas, dicções, ficções, estratégias* (2001), and co-editor of the art magazine *Item*, published in Rio de Janeiro. His art work has been shown internationally in numerous solo and group exhibitions. Lives in Rio de Janeiro.

Benjamin H. D. Buchloh

is Florence and Franklin D. Rosenblatt Professor of Modern Art at Harvard University. He is the author of a wide range of volumes, most recently: *Gerhard Richter: Paintings 2003–2005* (2006); *Art Since 1900* (2005), coedited with Hal Foster, Rosalind Krauss, and Yve-Alain Bois; *Allan Sekula* (2002); and *Neo-Avantgarde and Culture Industry: Essays on European and American Art from 1955 to 1975* (2001). He is also the author of numerous essays on twentieth century art, and is a core member of the editorial board of the critical journal *October*. Lives in Boston and New York City.

Sabeth Buchmann

is professor of history of modern and post-modern art at the Academy of Fine Arts Vienna. She is collaborating with Helmut Draxler and Stephan Geene on a research project on film, avant-garde and biopolitics at the Jan-van-Eyck-Academy in Maastricht (March 2004– December 2006). Author of *Denken gegen das Denken: Produktion—Technologie— Subjektivität bei Sol LeWitt, Yvonne Rainer und Hélio Oiticica* (2006); co-editor of *Wenn sonst nichts klappt: Wiederholung wiederholen* (2005), and together with Helmut Draxler, Clemens Krümmel, and Susanne Leeb of the publication series *PolyPeN—Reihe zur Kritik der Kunstkritik*. She is a regular contributor of art critical texts to catalogues and magazines, among them *Texte zur Kunst*. Lives in Berlin and Vienna.

Thomas Crow

is the director of the Getty Research Institute, and professor of art history at the University of Southern California, and a contributing editor of *Artforum*. His publications include *Painters and Public Life in Eighteenth-Century Paris* (1985), *Emulation: Making Artists for Revolutionary France* (1995), *Modern Art in the Common Culture* (1996), *The Rise of the Sixties: American and European Art in the Era of Dissent* (1996), and *The Intelligence of Art* (1999). Crow's most recent texts focus on single artists, including Gordon Matta-Clark (2003), Robert Smithson (2004), and Robert Rauschenberg (forthcoming). Lives in Los Angeles, California.

Helmut Draxler

is professor of aesthetic theory at the Merz-Akademie in Stuttgart. His recent publications include essays on Andreas Hofer, Michael Krebber, Heimo Zobernig, Mike Figgis, and Fareed Armaly. He is author of numerous essays on the condition of art criticism; co-editor of the publication series *PolyPeN—Reihe zur Kritik der Kunstkritik*. His collected writings will be published in 2006. He is collaborating with Sabeth Buchmann and Stephan Geene on a research project on film, avantgarde and biopolitics at the Jan-van-Eyck-Academy in Maastricht. Lives in Berlin.

Elizabeth Ferrell

is a graduate student in the History of Art at University of California, Berkeley. She is writing a dissertation on post-Conceptual art and institutional critique. Lives in Berkeley, California.

Isabelle Graw

is founding editor of the art magazine *Texte zur Kunst*, and professor for art theory at the Hochschule für bildende Künste, Städelschule Frankfurt am Main. She is author of *Silberblick. Texte zur Kunst und Politik* (1999), and *Die bessere Hälfte. Künstlerinnen im 20. und 21. Jahrhundert* (2003). She is a regular contributor to *Artforum*, and is currently preparing a study on the market's impact on art works. Lives in Berlin.

Helen Molesworth

is chief curator of exhibitions at the Wexner Center for the Arts. She is the editor of a number of books and exhibition catalogues, among them *Work Ethic* (2003), *Part object part sculpture* (2005), and *Louise Lawler—Twice Untitled and Other Pictures (looking back)* (2006); founding editor of the journal *Documents*. Her essays have also appeared in *October*, *Art Journal*, *Frieze*, and a number of exhibition catalogues. Lives in Columbus, Ohio.

Luiza Nader

is a doctoral candidate and teaching assistant at the Institute of Art History at Warsaw University in Poland. Her recent research involves a comparative study of Conceptual art in Poland and the United States.

Henrik Olesen

is an artist and writer. Author of *What is authority?* (2002). His writings mostly focus on aspects of queer politics in modern and contemporary art. His work as an artist has been shown internationally in a number of solo and group exhibitions. Lives in Berlin.

Gregor Stemmrich

is professor for art history of the twentieth century at the Dresden Academy of Fine Arts. He is editor of *Minimal Art. Eine kritische Retrospektive* (1995), *Jasper Johns. Interviews, Statements, Skizzenbuchnotizen* (1997), *Jeff Wall: Szenarien im Bildraum der Wirklichkeit* (1997), and *Kunst/Kino* (2001); and co-editor of *Having Been Said— Writings and Interviews of Lawrence Weiner 1968–2003* (2004). Lives in Berlin.

Index

Photo and Text Credits

If not stated otherwise: courtesy of the artists.

Cover: Jarosław Kozłowski, *Metafizyka* (1972), installation view 2004, © Generali Foundation Collection, photo Werner Kaligofsky

Generali Foundation

Sabine Breitwieser, Artistic and Managing Director

Administration
Susanna Yezbek, Assistant to the Director, Administration Manager
Elisabeth Michl, Administration, Cash Management

Collection, Reference Room
Doris Leutgeb, Collection and Reference Room Manager
Agnes Falkner, Collection Assistant, Picture Archives
Georg Kolmanitsch, Gallery Manager
Gudrun Ratzinger, Reference Room

Communication and Marketing
Franz Thalmair, Communication and Marketing Manager
Astrid Steinbacher, Front Office and Communication

Exhibitions and Publications
Cosima Rainer, Assistant Curator, Exhibition Co-ordination
Bettina Spörr, Assistant Curator, Exhibition Co-ordination
Julia Heine, Publication Manager

Technical Installations, Art Handling
Thomas Ehringer, Technical Systems and Gallery Manager, Head
Didi Sommer, Audiovisual Engineering

Board of Governors
Dietrich Karner, President
Karl Stoss, Vice President
Werner Moertel
Walter Steidl

Managing Board
Sabine Breitwieser
Klaus Edelhauser
Burkhard Gantenbein
Wolfgang Steinwendner

Artistic Advisory Board (2004–2006)
Tuula Arkio, General Director of Finnish National Galleries, Helsinki
Jan Debbaut, Art Historian, London
Ida Gianelli, Director Castello di Rivoli, Turin

The Generali Foundation is the art association of the Generali Group
based in Vienna; its purpose is the support and promotion of
contemporary art. Members are the Generali Holding Vienna AG,
the Generali Versicherung AG and the Generali Rückversicherung AG.